What Do Pictures Want?

What Do Pictures Want?

The Lives and Loves of Images

W. J. T. Mitchell

*The
University
of Chicago Press
Chicago and
London*

W. J. T. MITCHELL is the Gaylord Donnelley Distinguished Service
Professor in the Department of English Language and Literature, the
Department of Art History, the Committee on Art and Design, and the
College at the University of Chicago. He is the editor of the journal
Critical Inquiry and author or editor of numerous books, most recently
Picture Theory, Landscape and Power (2nd ed.), and *The Last Dinosaur
Book,* all published by the University of Chicago Press.

The University of Chicago Press, Chicago 60637
The University of Chicago Press, Ltd., London
© 2005 by The University of Chicago
All rights reserved. Published 2005
Printed in the United States of America

14 13 12 11 10 09 08 07 06 05 2 3 4 5
ISBN: 0-226-53245-3 (CLOTH)

The University of Chicago Press gratefully acknowledges the generous
support of the University of Chicago's Division of Humanities toward
the publication of this book.

Library of Congress Cataloging-in-Publication Data

Mitchell, W. J. Thomas, 1942–
 What do pictures want? : the lives and loves of images / W.J.T. Mitchell.
 p. cm.
 Includes bibliographical references and index.
 ISBN 0-226-53245-3 (cloth : alk. paper)
 1. Art. 2. Visual communication. I. Title.
 N7565.M523 2005
 701—dc22 2004008501

This book is printed on acid-free paper.

For Carmen Elena Mitchell & Gabriel Thomas Mitchell

Contents

Illustrations

COLOR PLATES (FOLLOWING PAGE 106)

Preface

Picturing things, taking a view, is what makes us human; art is making sense and giving shape to that sense.　　　GERHARD RICHTER, *The Daily Practice of Painting (1995)*

As subjects, we are literally called into the picture, and represented here as caught.
　　　JACQUES LACAN, *The Four Fundamental Concepts of Psychoanalysis (1978)*

This book is divided into three parts, the first dealing with images, the second with objects, and the third with media. The logic of this structure is as follows. By "image" I mean any likeness, figure, motif, or form that appears in some medium or other. By "object" I mean the material support in or on which an image appears, or the material thing that an image refers to or brings into view. I also want, of course, to evoke here the concepts of objecthood and objectivity, the notion of something that is set over against a subject. By "medium" I mean the set of material practices that brings an image together with an object to produce a picture. The book as a whole, then, is about pictures, understood as complex assemblages of virtual, material, and symbolic elements. In the narrowest sense, a picture is simply one of those familiar objects that we see hanging on walls, pasted into photo albums, or ornamenting the pages of illustrated books. In a more extended sense, however, pictures arise in all other media—in the assemblage of fleeting, evanescent shadows and material supports that constitute the cinema as a "picture show"; in the stationing of a piece of sculpture on a specific site; in a caricature or stereotype realized in a pattern of human behavior; in "pictures in the mind," the imagination or memory of an embodied con-

sciousness; in a proposition or a text in which "a state of affairs," as Wittgenstein put it, is projected.[1]

In its most extended sense, then, a picture refers to the entire situation in which an image has made its appearance, as when we ask someone if they "get the picture." Heidegger proposed, famously, that we live in "the age of the world picture," by which he meant the modern age in which the world has *become* a picture—that is, has become a systematized, representable object of technoscientific rationality: "World picture . . . does not mean a picture of the world but the world conceived and grasped as picture."[2] He thought that this phenomenon (what some of us have been calling "the pictorial turn")[3] was a historical transformation equivalent to the modern age: "the world picture does not change from an earlier medieval one into a modern one, but rather the fact that the world becomes picture at all is what distinguishes the essence of the modern age."[4] Heidegger pinned his philosophical hopes on an epoch beyond modernity and beyond the world-as-picture. He thought the pathway to this epoch lay not in a return to prepictorial ages or a willed destruction of the modern world picture but in poetry—the kind of poetry that opens us to Being.

The argument of this book is that pictures, including world pictures, have always been with us, and there is no getting beyond pictures, much less world pictures, to a more authentic relationship with Being, with the Real, or with the World. There have been different kinds of world pictures in different places and eras, and that is why history and comparative anthropology are not just descriptions of events and practices but of *representations* of events and practices. Pictures are our way of gaining access to whatever these things are. Even more emphatically, they are (as philosopher Nelson

1. Ludwig Wittgenstein, *Tractatus Logico-Philosophicus*, trans. D. F. Pears and B. F. McGuinness (London: Routledge & Kegan Paul, 1922), 4.023, p. 21. My extension of the pictorial concept is very much in the spirit of Douglas Crimp's opening remarks in "Pictures," *October* 8 (Spring 1979): 75–88: "it is not confined to any particular medium: instead it makes use of photography, film, performance, as well as traditional modes of painting, drawing, and sculpture. . . . Equally important . . . picture, in its verb form, can refer to a mental process as well as the production of an aesthetic object" (75).

2. Martin Heidegger, "The Age of the World Picture," in *The Question concerning Technology*, trans. William Lovitt (New York: Harper & Row, 1977), 116–54; quotation is from p. 130.

3. See W. J. T. Mitchell, "The Pictorial Turn," in *Picture Theory* (Chicago: University of Chicago Press, 1994), 11–34.

4. Heidegger, "The Age of the World Picture," 130.

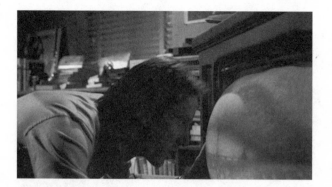

FIGURE 1 Still from *Videodrome* (dir. David Cronenberg, 1983). Max Wren prepares to thrust his head into the beckoning mouth of the television screen.

Goodman puts it) "ways of world*making*," not just world mirroring.[5] Poetry (as "making," or poiesis) is foundational to picturing. Pictures are themselves products of poetry, and a poetics of pictures addresses itself to them, as Aristotle proposed, as if they were living beings, a second nature that human beings have created around themselves.[6] A poetics of pictures, then, in contrast with a rhetoric or hermeneutics, is a study of "the lives of images," from the ancient idols and fetishes to contemporary technical images and artificial life-forms, including cyborgs and clones. The question to ask of pictures from the standpoint of a poetics is not just what they mean or do but what they *want*—what claim they make upon us, and how we are to respond. Obviously, this question also requires us to ask what it is that we want from pictures.

The answer is most vividly provided by the genre of horror film. A still from David Cronenberg's *Videodrome* (fig. 1) perfectly illustrates the picture-beholder relationship as a field of mutual desire. We see the face of Max Wren (James Woods) approaching the bulging screen of a television set in which the lips and teeth of his new lover, Nicki Brand (Deborah Harry), are depicted. Max is deciding whether to plunge his head into the imaged mouth, which has been calling him to "come to me, come to Nicki." The picture tube, the television set itself has come alive, distended veins pulsing

5. See Nelson Goodman, *Ways of Worldmaking* (Indianapolis: Hackett Publishing Co., 1978).

6. For further discussion of poetics in Aristotle's sense, see chapter 1 below.

FIGURE 2 Barbara Kruger, *Untitled (Help! I'm locked inside this picture.)*, 1985. Zindman/Fremont photography. Courtesy: Mary Boone Gallery, New York.

under its plasticine surface as the set throbs, pants, and purrs. Not just the image of Nicki Brand but the material support in which she appears vibrates with desire. Max, for his part, is both attracted and repelled. He wants to merge with the picture, to penetrate the screen/mouth/face it presents to him, even at the risk of being engulfed and swallowed by it. If we had only this picture to work from, we would have to say that the answer to our question is, pictures want to be kissed. And of course we want to kiss them back.

Not every picture dramatizes its desires quite so explicitly and obscenely.

Most of the pictures we value highly are much more discreet about the libidinal fields they construct, the deadly kisses they invite. Cronenberg's marvelous tableau may be kept in mind, however, as a kind of uncensored snapshot of the lives and loves of images, both our wish to penetrate them and our fear of being swallowed up by them.[7] (I trust that there's no need for me to comment on the heavy quotient of what is called male fantasy in this scene.)

A picture, then, is a very peculiar and paradoxical creature, both concrete and abstract, both a specific individual thing and a symbolic form that embraces a totality. To get the picture is to get a comprehensive, global view of a situation, yet it is also to take a snapshot at a specific moment— the moment when the click of a camera shutter registers the taking of a picture, whether it is the establishment of a cliché or stereotype, the institution of a system, or the opening of a poetic world (perhaps all three). To get the whole picture of pictures, then, we cannot remain content with the narrow conception of them, nor can we imagine that our results, no matter how general or comprehensive, will be anything more than *a* picture of images, objects, and media as they appear to some of us at this moment. For whatever that picture is, as Barbara Kruger has shown (fig. 2), we ourselves are in it.

7. See part 3, "Media," for further analysis of this scene.

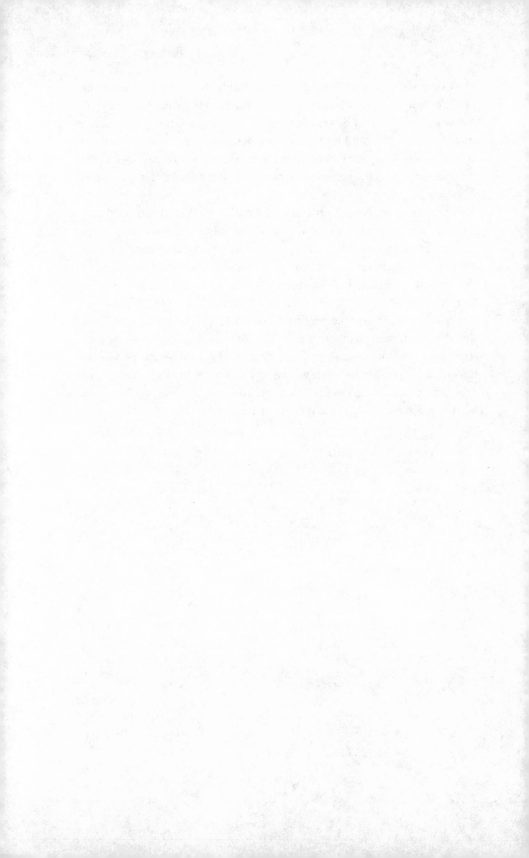

Acknowledgments

All the usual suspects and more could be named (but not blamed) as the culprits who made this book possible: my colleagues at the University of Chicago; the editorial collective of *Critical Inquiry;* the numerous individuals whose ideas have been ruthlessly pillaged and appropriated here, and whose names will appear, not nearly often enough, throughout these pages. Perhaps most crucial to the unfolding of this book were the sponsors of the several occasions for which many of the following essays were first written, and the editors of the journals and collections in which they were first published (more detailed information for previously published chapters appears in the chapter notes). "Vital Signs," the first part of chapter 1, was the title of an NYU/Columbia seminar I gave with Michael Taussig in the fall of 2000; part 2, "Cloning Terror," was written for Hans Belting and Peter Weibel's "Iconoclash" symposium at the Zentrum für Kultur und Medien in Karlsruhe, Germany, July 2002. "What Do Pictures Want?" was written for a University of Melbourne symposium, "Picture Theory," in 1994, and subsequently appeared in *October* 77 (Summer 1996) and in Terry Smith's *In Visible Touch: Visual Culture, Modernity, and Art History* (Sydney: Power Publications, 1997). "Drawing Desire" was written at the invitation of Marina Grzinic for a colloquium with Slavoj Žižek in Ljubljana, Slovenia, the Academy of Sciences, December 2002. "Founding Objects" was written for Lisa Wainwright's eponymous panel on trash at the 2001 meeting of the College Art Association of America. "Offending Images" was written for the conference held by the University of Chicago's Cultural Policy program in February 2000 on the controversy surrounding the Sensation exhibition at the Brooklyn Museum, and appears in *Unsettling "Sensation": Arts-Policy Lessons from the Brooklyn Museum of Art,* edited by

Larry Rothfield, the principal organizer of the symposium (New Brunswick, NJ: Rutgers University Press, 2001). "Empire and Objecthood" was the keynote address of the Tate Britain's July 2001 conference, "Art and the British Empire." "Romanticism and the Life of Things" was the keynote address of the annual meeting of the North American Society for the Study of Romanticism in September of 2000, and appeared in *Critical Inquiry*'s special issue, "Things" (Fall 2001), edited by Bill Brown. "Addressing Media" was the germ of a keynote address at the symposium inaugurating media studies at the University of Cologne in December of 1999 (Gabriele Schabacher et al.); a very much shorter version appears in the *Die Address des Mediens*, the proceedings of that conference, along with the German version of "The Surplus Value of Images." The latter essay was written for the Association of Art Historians' annual meeting in 1999, when the meeting's theme was "Image and Value"; an English version appears in *Mosaic* 35, no. 3 (September 2002). "Abstraction and Intimacy" was written as a response to an invitation from Rochelle Feinstein to reflect on the contemporary fortunes of abstraction; it was further developed for symposia at the Tapies Fundacion, Barcelona (1997), and the University of Chicago (2001). "What Sculpture Wants" was written for the Phaidon catalog of the works of Antony Gormley. "The Ends of American Photography" was written in close conversation with Joel Snyder for a conference on American photography at the Beaubourg Museum in Paris in 1994 and was a companion piece to his unpublished essay, "Once upon a Time in America: The 1937 MoMA Exhibition and the Beginnings of American Photography." "Living Color" was written at the invitation of Klaus Milich as the W. E. B. Du Bois Lecture in May 2002 at Humboldt University in Berlin. "The Work of Art in the Age of Biocybernetic Reproduction" was written at the request of John Harrington, the dean of humanities at Cooper Union, on the occasion of the inauguration of its new president in November of 2000. It was later published in *Modernism/Modernity*. "Showing Seeing" was written for the Clark Institute conference "Art History, Aesthetics, and Visual Studies," May 2001, at the invitation of Michael Ann Holly. It has appeared in the Clark Institute's proceedings of that conference, and in *The Journal of Visual Culture* 1, no. 2 (Summer 2002).

I must also thank various institutions that helped with time or money to finish this project: the Division of Humanities at the University of Chicago, with a small but crucial research budget; the Franke Institute for the Humanities, whose fellowship program gave me time to work; the Ameri-

can Academy in Berlin, which spoiled me rotten in the spring of 2002. The Benenson Lectures in Art History at Duke University in the spring of 2000 gave me the opportunity to think through many of the issues with the help of a great group of scholars. The Alfonso Reyes Lectures in Mexico City, November 2002, provided a venue for some final rethinking, a process which would have gone on forever if not for the constant prodding of my editor, Alan Thomas.

I have tried in the following pages to give credit to the many friends, colleagues, and (even) antagonists who have helped to shape the ideas of this book, but I should mention several individuals without whose help I would have given up long ago. Joel Snyder, who has tested, challenged, and extended every thought I have had for the last twenty years; Ellen Esrock, who has made it possible to feel my way through this topic without knowing where it was going; Bill Brown, whose writings and advice have been a constant source of inspiration; Janice Misurell-Mitchell, who always turns out to be right in the long run; Arnold Davidson, my spiritual smarter brother; Eduardo de Almeida, who assisted in the research and guided my entry into the mediated teaching of media; my mother, Leona Gaertner Mitchell Maupin, who has been my ideal reader ever since I have been a writer; my fabulous, creative children, Carmen and Gabriel Mitchell, who are pictures of perfection, and want nothing—or everything.

Part One

Images

Image is everything.
Andre Agassi, Canon Camera commercial

THE OBSERVATION THAT "image is everything" has usually been a matter of complaint, not celebration, as it is in Andre Agassi's notorious declaration (made long before he shaved his head, changed his image, and became a *real* tennis star instead of a poster boy). The purpose of this first section is to demonstrate that images are not everything, but at the same time to show how they manage to convince us that they are. Part of this is a question of language: the word *image* is notoriously ambiguous. It can denote both a physical object (a painting or sculpture) and a mental, imaginary entity, a psychological *imago*, the visual content of dreams, memories, and perception. It plays a role in both the visual and verbal arts, as the name of the represented content of a picture or its overall formal gestalt (what Adrian Stokes called the "image in form"); or it can designate a verbal motif, a named thing or quality, a metaphor or other "figure," or even the formal totality of a text as a "verbal icon." It can even pass over the boundary between vision and hearing in the notion of an "acoustic image." And as a name for likeness, similitude, resemblance, and analogy it has a quasi-logical status as one of the three great orders of sign formation, the "icon," which (along with C. S. Peirce's "symbol" and "index") constitutes the totality of semiotic relationships.[1]

I am concerned here, however, not so much to retrace the ground covered by semiotics, but to look at the peculiar tendency of images to absorb and be absorbed by human subjects in processes that look suspiciously like those of living things. We have an incorrigible tendency to lapse into vitalistic and animistic ways of speaking when we talk about images. It's not just a question of their producing "imitations of life" (as the saying goes), but that the imitations seem to take on "lives of their own." I want to ask, in the first chapter, precisely what sort of "lives" we are talking about, and how images live *now*, in a time when terrorism has given new vitality to collective fantasy, and cloning has given a new meaning to the imitation of life. In the second chapter I turn to a model of vitality based in desire—in hunger, need, demand, and lack—and explore the extent to which the "life of images" expresses itself in terms of appetites. In the third chapter ("Drawing Desire") I turn this question around. Instead of asking what pictures want, I raise the question of how we picture desire as such, especially in that

1. Hume's three laws of psychological association (resemblance, contiguity, and cause and effect) loosely correspond to Peirce's semiotic triad. See W. J. T. Mitchell, *Iconology: Image, Text, Ideology* (Chicago: University of Chicago Press, 1986), 58.

most fundamental form of picture-making we call "drawing." Finally (in "The Surplus Value of Images"), I will turn to the question of value, and explore the tendency to both over- and underestimate images, making them into "everything" and "nothing," sometimes in the same breath.

One never knows what a book is about until it is too late. When I published a book called *Picture Theory* in 1994, for instance, I thought I understood its aims very well. It was an attempt to diagnose the "pictorial turn" in contemporary culture, the widely shared notion that visual images have replaced words as the dominant mode of expression in our time. *Picture Theory* tried to analyze the pictorial, or (as it is sometimes called) the "iconic" or "visual," turn, rather than to simply accept it at face value.[1] It was designed to resist received ideas about "images replacing words," and to resist the temptation to put all the eggs in one disciplinary basket, whether art history, literary criticism, media studies, philosophy, or anthropology. Rather

"Vital Signs" was the title of an NYU/Columbia seminar I gave with Michael Taussig in the fall of 2000, and I owe much to the collaboration with Professor Taussig in the following pages. "Cloning Terror" was originally written for the Iconoclash symposium held at the Zentrum für Kultur und Medien in Karlsruhe, Germany, in July 2002.

1. Citations to specific works will appear in the following chapters, but some key figures and tendencies may be remarked at the outset. The notions of a "society of the spectacle" (Guy Debord), of "surveillance society" (Michel Foucault), and the rule of "simulation" (Jean Baudrillard) are certainly foundational moments, as is the emergence of "gaze theory" in feminism (Joan Copjec, Laura Mulvey, Kaja Silverman, Anne Freedberg) and the extension of Frankfurt School critical theory to the visual field (Susan Buck-Morss, Miriam Hansen). There are now too many anthologies in visual culture, visual studies, the "hegemony of vision," and "scopic regimes" to count: among the most important figures in this area are Norman Bryson, James Elkins, Martin Jay, Stephen Melville, and Nicholas Mirzoeff. German art historians such as Gottfried Boehm, Horst Bredekamp, and Hans Belting are exploring notions such as *bildwissenschaft, bildanthropologie,* and the concept of an "iconic turn." This list does not even touch upon the important work of film scholars (Tom Gunning, Miriam Hansen) and anthropologists (Michael Taussig, Lucien Taylor), or the new work in aesthetics, cognitive science, and media theory.

than relying on a preexisting theory, method, or "discourse" to explain pictures, I wanted to let them speak for themselves. Starting from "metapictures," or pictures that reflect on the process of pictorial representation itself, I wanted to study pictures themselves as forms of theorizing. The aim, in short, was to picture theory, not to import a theory of pictures from somewhere else.

I don't meant to suggest, of course, that *Picture Theory* was innocent of any contact with the rich archive of contemporary theory. Semiotics, rhetoric, poetics, aesthetics, anthropology, psychoanalysis, ethical and ideological criticism, and art history were woven (probably too promiscuously) into a discussion of the relations of pictures to theories, texts, and spectators; the role of pictures in literary practices like description and narration; the function of texts in visual media like painting, sculpture, and photography; the peculiar power of images over persons, things, and public spheres. But all along I thought I knew what I was doing, namely, explaining what pictures are, how they mean, what they do, while reviving an ancient interdisciplinary enterprise called iconology (the general study of images across the media) and opening a new initiative called visual culture (the study of human visual experience and expression).

Vital Signs

Then the first review of *Picture Theory* arrived. The editors of *The Village Voice* were generally kind in their assessment, but they had one complaint. The book had the wrong title. It should have been called *What Do Pictures Want?* This observation immediately struck me as right, and I resolved to write an essay with this title. The present book is an outgrowth of that effort, collecting much of my critical output in image theory from 1994 to 2002, especially the papers exploring the life of images. The aim here is to look at the varieties of animation or vitality that are attributed to images, the agency, motivation, autonomy, aura, fecundity, or other symptoms that make pictures into "vital signs," by which I mean not merely signs *for* living things but signs *as* living things. If the question, what do pictures want? makes any sense at all, it must be because we assume that pictures are something like life-forms, driven by desire and appetites.[2] The question of how

2. I came across Alfred Gell's *Art and Agency: An Anthropological Theory* (Oxford: Clarendon Press, 1998) too late to fully reckon with it in this book, but some aspects of his theory

that assumption gets expressed (and disavowed) and what it means is the prevailing obsession of this book.

But first, the question: what do pictures want? Why should such an apparently idle, frivolous, or nonsensical question command more than a moment's attention?[3] The shortest answer I can give can only be formulated as yet another question: why is it that people have such strange attitudes toward images, objects, and media? Why do they behave as if pictures were alive, as if works of art had minds of their own, as if images had a power to influence human beings, demanding things from us, persuading, seducing, and leading us astray? Even more puzzling, why is it that the very people who express these attitudes and engage in this behavior will, when questioned, assure us that they know very well that pictures are not alive, that works of art do not have minds of their own, and that images are really quite powerless to do anything without the cooperation of their beholders? How is it, in other words, that people are able to maintain a "double consciousness" toward images, pictures, and representations in a variety of media, vacillating between magical beliefs and skeptical doubts, naive animism and hardheaded materialism, mystical and critical attitudes?[4]

The usual way of sorting out this kind of double consciousness is to attribute one side of it (generally the naive, magical, superstitious side) to someone else, and to claim the hardheaded, critical, and skeptical position as one's own. There are many candidates for the "someone else" who believes that images are alive and want things: primitives, children, the masses, the illiterate, the uncritical, the illogical, the "Other."[5] Anthropologists have traditionally attributed these beliefs to the "savage mind," art historians to

are quite compatible with my own. If I understand Gell correctly, he is arguing that "aesthetics" is not an anthropological universal; what is universal, for Gell, is "a species of anthropological theory in which *persons* or 'social agents' are . . . substituted for by *art objects*" (5). I would concur, with the qualification that the "lives" of inanimate art objects may be modeled on those of animals and other living things, not just persons.

3. I'm well aware that some critics will regard the mere entertainment of this question as a regressive, even reactionary move. Victor Burgin, for instance, regards the "focus on the internal life of the autonomous object" as one of the chief "pitfalls" (along with formalism) that awaits "the art theorist with no grasp of semiology" (*The End of Art Theory* [Atlantic Highlands, NJ: Humanities Press International, 1986], 1).

4. The echo of W. E. B. DuBois' concept of "double consciousness" is not accidental here. See *The Souls of Black Folk* (Chicago: A. C. McClurg, 1903).

5. Slavoj Žižek calls this Other "the subject supposed to believe," the necessary counterpart to "the subject supposed to know." See *The Plague of Fantasies* (New York: Verso, 1997), 106.

the non-Western or premodern mind, psychologists to the neurotic or infantile mind, sociologists to the popular mind. At the same time, every anthropologist and art historian who has made this attribution has hesitated over it. Claude Lévi-Strauss makes it clear that the savage mind, whatever that is, has much to teach us about modern minds. And art historians such as David Freedberg and Hans Belting, who have pondered the magical character of images "before the era of art," admit to some uncertainty about whether these naive beliefs are alive and well in the modern era.[6]

Let me put my cards on the table at the outset. I believe that magical attitudes toward images are just as powerful in the modern world as they were in so-called ages of faith. I also believe that the ages of faith were a bit more skeptical than we give them credit for. My argument here is that the double consciousness about images is a deep and abiding feature of human responses to representation. It is not something that we "get over" when we grow up, become modern, or acquire critical consciousness. At the same time, I would not want to suggest that attitudes toward images never change, or that there are no significant differences between cultures or historical or developmental stages. The specific expressions of this paradoxical double consciousness of images are amazingly various. They include such phenomena as popular *and* sophisticated beliefs about art, responses to religious icons by true believers *and* reflections by theologians, children's (*and* parents') behavior with dolls and toys, the feelings of nations and populations about cultural and political icons, reactions to technical advances in media and reproduction, *and* the circulation of archaic racial stereotypes. They also include the ineluctable tendency of criticism itself to pose as an iconoclastic practice, a labor of demystification and pedagogical exposure of false images. Critique-as-iconoclasm is, in my view, just as much a symptom of the life of images as its obverse, the naive faith in the inner life of works of art. My hope here is to explore a third way, suggested by Nietzsche's strategy of "sounding the idols" with the "tuning fork" of critical or philosophical language.[7] This would be a mode of criticism that did not dream of getting beyond images, beyond representation, of smashing the false images that bedevil us, or even of producing a definitive sepa-

6. See David Freedberg, *The Power of Images* (Chicago: University of Chicago Press, 1989), and Hans Belting, *Likeness and Presence* (Chicago: University of Chicago Press, 1994). For more detailed discussion, see chapter 3 of the present text.

7. Friedrich Nietzsche, *Twilight of the Idols* (orig. pub. 1889; London: Penguin Books, 1990), 31–32.

ration between true and false images. It would be a delicate critical practice that struck images with just enough force to make them resonate, but not so much as to smash them.

Roland Barthes put the problem very well when he noted that "general opinion . . . has a vague conception of the image as an area of resistance to meaning—this in the name of a certain mythical idea of Life: the image is re-presentation, which is to say ultimately resurrection."[8] When Barthes wrote this, he believed that semiotics, the "science of signs," would conquer the image's "resistance to meaning" and demystify the "mythical idea of Life" that makes representation seem like a kind of "resurrection." Later, when he reflected on the problem of photography, and was faced with a photograph of his own mother in a winter garden as the "center" of the world's "labyrinth of photographs," he began to waver in his belief that critique could overcome the magic of the image: "When I confronted the Winter Garden Photograph I gave myself up to the Image, to the Image-Repertoire."[9] The *punctum,* or wound, left by a photograph always trumps its *studium,* the message or semiotic content that it discloses. A similar (and simpler) demonstration is offered by one of my art history colleagues: when students scoff at the idea of a magical relation between a picture and what it represents, ask them to take a photograph of their mother and cut out the eyes.[10]

Barthes' most important observation is that the image's resistance to meaning, its mythical, vitalistic status, is a "vague conception." The whole purpose of this book is to make this vague conception as clear as possible, to analyze the ways in which images seem to come alive and want things. I put this as a question of desire rather than meaning or power, asking, what do images want? rather than what do images mean or do? The question of meaning has been thoroughly explored—one might say exhaustively—by hermeneutics and semiotics, with the result that every image theorist seems to find some residue or "surplus value" that goes beyond communication, signification, and persuasion. The model of the power of images has been ably explored by other scholars,[11] but it seems to me that it does

8. Roland Barthes, "Rhetoric of the Image," in *Image/Music/Text,* trans. Stephen Heath (New York: Hill & Wang, 1977), 32.

9. Roland Barthes, *Camera Lucida,* trans. Richard Howard (New York: Hill & Wang, 1981), 75.

10. I owe this pedagogical exercise to Tom Cummins.

11. Most notably by David Freedberg. See discussion below and in chapter 3.

not quite capture the paradoxical double consciousness that I am after. We need to reckon with not just the meaning of images but their silence, their reticence, their wildness and nonsensical obduracy.[12] We need to account for not just the power of images but their powerlessness, their impotence, their abjection. We need, in other words, to grasp *both* sides of the paradox of the image: that it is alive—but also dead; powerful—but also weak; meaningful—but also meaningless. The question of desire is ideally suited for this inquiry because it builds in at the outset a crucial ambiguity. To ask, what do pictures want? is not just to attribute to them life and power and desire, but also to raise the question of what it is they *lack,* what they do not possess, what cannot be attributed to them. To say, in other words, that pictures "want" life or power does not necessarily imply that they *have* life or power, or even that they are capable of wishing for it. It may simply be an admission that they lack something of this sort, that it is missing or (as we say) "wanting."

It would be disingenuous, however, to deny that the question of what pictures want has overtones of animism, vitalism, and anthropomorphism, and that it leads us to consider cases in which images are treated as if they were living things. The concept of image-as-organism is, of course, "only" a metaphor, an analogy that must have some limits. David Freedberg has worried that it is "merely" a literary convention, a cliché or trope, and then expressed further anxieties over his own dismissive use of the word *merely.*[13] The living image is, in my view, both a verbal and a visual trope, a figure of speech, of vision, of graphic design, and of thought. It is, in other words, a secondary, reflexive image of images, or what I have called a "metapicture."[14] The relevant questions, then, are what are the limits of this analogy? Where does it take us? What motivates its appearances? What do we

12. Not that the recognition of this imperative is original with me. One might begin with the explorations of semiotics by Roland Barthes and Julia Kristeva, with their respective emphases on the *punctum,* or wound, and the *chora,* concepts that take us beyond the threshold of intelligibility, discourse, and communication into the life of the sign.

13. Freedberg, *The Power of Images,* 293. Freedberg worries that the notion of "live images" may be "merely literary clichés, merely conventional metaphors for artistic skill." Yet he recognizes that "the issue revolves round 'merely.'" The designation of the living image as a literary cliché only postpones the question of the image by relegating it to another medium (language) and another form (verbal narrative).

14. See "Metapictures," chap. 2 of W. J. T. Mitchell, *Picture Theory* (Chicago: University of Chicago Press, 1994).

mean by "life" in the first place?[15] Why does the link between images and living things seem so inevitable and necessary, at the same time that it almost invariably arouses a kind of disbelief: "Do you really *believe* that images want things?" My answer is, no, I don't believe it. But we cannot ignore that human beings (including myself) insist on talking and behaving as if they *did* believe it, and that is what I mean by the "double consciousness" surrounding images.

Cloning Terror

The philosophical argument of this book is simple in its outlines: images are like living organisms; living organisms are best described as things that have desires (for example, appetites, needs, demands, drives); therefore, the question of what pictures want is inevitable. But there is also a historical dimension to the argument that needs to be made explicit. To paraphrase Marx, if people make images that seem to have lives and desires of their own, they do not always do it in the same way, nor under conditions of their own choosing. If the phenomenon of the living image or animated icon is an anthropological universal, a feature of the fundamental ontology of images as such, how does it change over time, and from one culture to another? And why does it impress itself so forcibly on our attention at this specific historical moment? If the living image has always been the subject of a double consciousness, of simultaneous belief and disavowal, what conditions are making the disavowal more difficult to maintain today? Why, in other words, do various forms of "iconoclash"—the war of images—seem so conspicuously a part of the pictorial turn in our time?[16]

15. I recommend here Michael Thompson's essay, "The Representation of Life," in *Virtues and Reasons: Essays in Honor of Philippa Foot*, ed. Rosalind Hursthouse, Gavin Lawrence, and Warren Quinn (Oxford: Clarendon Press, 1995), 248–96, which argues that life is a logical category that does not admit of an empirical, positive definition. The logical status of life-forms is what permits the application of "life-predicates" to nonliving things like images, and vice versa, so that living things, biological organisms "proper," are discussed as if they were images.

16. As stated earlier, "Cloning Terror" was originally written for the Iconoclash symposium held at the Zentrum für Kunst und Medientechnologie in Karlsruhe, Germany, in July 2002. The Iconoclash concept (and the associated exhibition) were conceived by Hans Belting, Bruno Latour, Peter Weibel, and Peter Galison, among others. See the exhibition catalog,

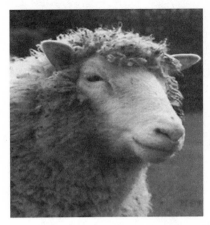

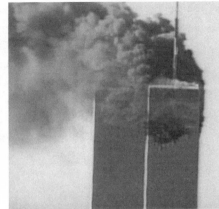

FIGURE 3
Dolly the sheep.
Roslin Design.

FIGURE 4
World Trade Center under attack,
September 11, 2001. Reuters.

The answer to this question cannot be obtained abstractly. It must be sought in the specific, concrete images that most conspicuously embody the anxiety over image-making and image-smashing in our time. Consider two images that so clearly define our historical moment. The first is Dolly the sheep (fig. 3), the cloned animal that became the global icon of genetic engineering, with all its promises and threats. The second is the twin towers of the World Trade Center at the moment of their destruction (fig. 4), a spectacle that ushered in a New World Order defined by terrorism. The potency of these images doesn't reside merely in their presentness or topical currency but in their status as enigmas and omens, harbingers of uncertain futures. They also exemplify the sensuous spectrum of image anxiety in our time, ranging from the overwhelmingly traumatic spectacle of mass destruction on the one hand to the subtle creepiness of the cloned sheep, which, as visual image, is quite unremarkable, but as *idea* is a figure of considerable dread.

The clone signifies the potential for the creation of new images in our time—new images that fulfill the ancient dream of creating a "living im-

Iconoclash: Beyond the Image Wars, ed. Bruno Latour and Peter Weibel (Karlsruhe, Germany: ZKM/Center for Art and Media; Cambridge, MA: MIT Press, 2002).

age," a replica or copy that is not merely a mechanical duplicate but an organic, biologically viable simulacrum of a living organism. The clone renders the disavowal of living images impossible by turning the concept of animated icon on its head. Now we see that it is not merely a case of some images that seem to come alive, but that living things themselves were always already images in one form or another. We register this fact every time we say something like "She is the image of her mother," or remark on the link between the very idea of species and the specular image.[17] With the clone, these commonplaces take on a new resonance, a classic instance of what Freud called the Uncanny, the moment when the most ordinary forms of disavowed superstition (monsters in the closet, toys coming alive) come back as undeniable truths.

The image of the World Trade Center, by contrast, signifies the potential for the destruction of images in our time, a new and more virulent form of iconoclasm. The towers themselves were already widely recognized as icons of globalization and advanced capitalism, and that is why they were the target of attack by those who regarded them as symbols of decadence and evil.[18] The destruction of the towers had no strategic military (as distinct from symbolic) importance and the murder of innocent people was, from the point of view of the terrorists, merely a regrettable side effect ("collateral damage" is the military euphemism) or merely instrumental to the aim of "sending a message" to America. The real target was a globally

17. See the *Oxford English Dictionary* definition of *species:* "The outward appearance or aspect, the visible form or image, of something, as constituting the immediate object of vision"; "The image of something as cast upon, or reflected from, a surface; a reflection"; "A thing seen; a spectacle; esp. an unreal or imaginary object of sight; a phantom or illusion." For further elaboration see my essay "What Is an Image?" in *Iconology: Image, Text, Ideology* (Chicago: University of Chicago Press, 1986), chap. 1.

18. From the beginning, their designer, Yamasaki, regarded the towers as "a symbolic monument for a new millennium that was to lead to world peace through global trade" (quoted in Bill Brown, "The Dark Wood of Postmodernism," MS in progress, p. 31). There is, of course, considerable resistance to talking about the towers as symbols or icons, because it seems to minimize the real human tragedy involved in their destruction. Readers responding to my article, "The War of Images," in *The University of Chicago Magazine* (December 2001): 21–23 (http://www.alumni.uchicago.edu/magazine/0112/features/remains-2.html) accused me of not knowing that this event really happened! Even a commentator as shrewd and unsentimental as Noam Chomsky, in his otherwise brilliant diagnosis of September 11, seems unable to accept the notion that the towers were attacked because they were symbols. See his *9-11* (New York: Seven Stories Press, 2001), 77.

recognizable icon, and the aim was not merely to destroy it but to stage its destruction as a media spectacle. Iconoclasm in this instance was rendered as an icon in its own right, an image of horror that has imprinted itself in the memory of the entire world.

Both Dolly and the World Trade Center are living images or animated icons. Dolly was literally a living organism that was also the exact genetic duplicate of its parent. The "twin towers" were (as their "twin" designation indicates) already anthropomorphized, perhaps even clonelike. And they were most certainly alive in the sense that historian Neil Harris has explored in his book *Building Lives*. Harris's aim is "to see what might happen by treating buildings as if they formed some kind of special species, a hybrid class . . . whose defined life stages merited systematic examination."[19] Harris notes that we often talk about buildings as if they were living things, or as if their intimate proximity to living beings made them take on some of the vitality of their inhabitants. The analogy between the living human body and the building is as ancient as the figure of the body as a temple for the spirit. Insofar as buildings are conceived in the mind of an architect, grow up out of the ground, and then become the habitat of other living organisms, from people to parasites, they are like plants that shoot up out of the earth, as in Terry Gilliam's film *Brazil*, in which skyscrapers erupt from the ground like Jack's beanstalk. As they age they become, like persons, shabby and disreputable, or eminent and distinguished. When they are abandoned, they are haunted by the ghosts of those who once dwelt in them, and are shunned like a corpse from which the soul has departed; when they are destroyed, they leave ghostly replicas in memory and other media.

Harris is quick to disavow the animistic overtones in the "conceit" of buildings as living things. It is, he admits, "just a conceptual convenience," but one that is "deeply rooted" in our ways of thinking about buildings and the imagery used to describe them. In a move that has an almost ritual familiarity, Harris displaces the literal belief in the animism of buildings onto a primitive people—"the Taberma, a Voltaic culture in Africa who conceive of their houses as humans and whose language and behavior reflect such convictions. The Taberma greet their houses, feed them, eat and drink with them."[20] But we moderns engage in the very same conceit when we at-

19. Neil Harris, *Building Lives* (New Haven, CT: Yale University Press, 1999), 3.
20. Ibid., 4.

tribute speech acts to the White House or the Pentagon. In the case of the World Trade Center, this anthropomorphism helps to explain why, in critic Bill Brown's words, they exemplify "the social afterlife of things, the ceaseless circulation of the towers on behalf of various agendas, be it selling hamburgers or waging wars."[21]

But Dolly and the World Trade Center have an additional dimension of vitality in that they are symbols of forms of life—let us call them biotechnology and global capitalism respectively—that participate in the life process they stand for. They do not merely "signify" these life-forms in some arbitrary or purely conventional way, like the bare words *biotechnology* or *global capitalism*. They both stand for and act as symptoms of what they signify. The twin towers were not merely abstract signs of world capital, but what Coleridge called "living symbols" that have an "organic" connection with their referents, the subject of biography rather than history.[22] Both Dolly and the WTC were also, from certain points of view, "offending images,"[23] or symbols of forms of life that are feared and despised. That is, they were offensive to certain eyes, constituting an affront or visual insult to those who hate and fear modernity, capitalism, biotechnology, globalization.[24] At the same time, they are prime targets for offense in the form of destructive or disfiguring actions. The clone (not Dolly herself so much as the idea she exemplifies) is regarded by religious conservatives as a monstrous, unnatural life-form that should be destroyed, and prevented by law from being created in the first place. The twin towers were well known to be a target for destruction well before the events of 9/11. From certain points of view, the moral imperative is to offend the images themselves, to treat them as if they were human agents or at least living symbols of evil, and to punish them accordingly.

Why did a sheep become the icon of cloning and biotechnology? Other animals had been more or less successfully cloned before Dolly, and yet none of them achieved the global publicity achieved by this particular creature. The answer may lie partly in the preexisting symbolic connotations of

21. Bill Brown, "All Thumbs," *Critical Inquiry* 30, no. 2 (Winter 2004): 457.

22. See Eric Darton, *Divided We Stand: A Biography of New York's World Trade Center* (New York: Basic Books, 1999).

23. See chapter 5 below.

24. It's worth noting here that the twin towers were widely despised by architects and architectural critics, who deplored their lack of respect for their surroundings and their egregious dominance of the Manhattan skyline.

the sheep as a figure of pastoral care, harmlessness, innocence, sacrifice, and (more ominously) of masses led by authoritarian elites—sheep to the slaughter. To some eyes, the seemingly benign image of the cloned sheep is no less a horror than the catastrophic image of terrorist destruction. The creation of an image can be just as deep an abomination as its destruction, and in each case there is a kind of paradoxical "creative destruction" at work.[25] The clone, to some people, represents the destruction of the natural order, and reminds us of the innumerable myths that treat the creation of artificial life as the violation of fundamental taboos. From the story of the Golem to Frankenstein to the cyborgs of contemporary science fiction, the artificial life-form is treated as a monstrous violation of natural law. The second commandment, prohibiting the making of graven images, is not just a ban on idolatry but a ban on the making of images of any kind, and it may well be based on the belief that images will inevitably take on "a life of their own" no matter how innocent the purposes of their creators.[26] When Aaron makes a golden calf to "go before" the Israelites as their idol, he tells Moses that the calf seemed to come into being all by itself: "I cast [the gold] into the fire and this calf came out" (Exod. 32:24 [KJV]). Aaron's "casting" of the sculpture is rendered ambiguously accidental, as if he were casting a pair of dice, not casting molten metal into a preexisting form. The calf is a magical, uncanny creation, an image or idol with a life and shape of its own making, which may be why it is so often referred to as the "molten calf."[27] Only God is allowed to make images, because only God is possessed of the secret of life. The second commandment is the perfect expression of a jealous God who wants not only exclusive worship but exclu-

25. I'm using this phrase in the sense pioneered by the economist Joseph Schumpeter, as a description of the "evolutionary process" that is essential to capitalism. See "The Process of Creative Destruction," in *Capitalism, Socialism, and Democracy* (London: Allen & Unwin, 1943).

26. Pier Cesare Bori notes that "the cult of images, whatever they may represent" is the "most urgent meaning of the condemnation of idolatry" (Bori, *The Golden Calf and the Origins of the Anti-Jewish Controversy,* trans. David Ward [Atlanta: Scholars Press, 1990], 9). See Joel Snyder's brilliant reading of the second commandment in relation to the "automatic" production of images in photography: "What Happens by Itself in Photography," in *The Pursuits of Reason,* ed. Hillary Putnam, Paul Guyer, and Ted Cohen (Austin: University of Texas Press, 1992), 361–73.

27. For a survey of the many disputes over the interpretation of this passage, see Brevard Childs, *The Book of Exodus: A Critical, Theological Commentary* (Louisville: Westminster Press, 1974), 555–56.

sive custody of the secret of life, which means exclusive rights to the production of images.[28]

The figure of the clone combines our fears about both natural and divine law. A recent cartoon in the *Chicago Tribune* captures this convergence perfectly (fig. 5). Michelangelo's God is shown reaching out to give the touch of life and encountering, not the receptive gesture of the awakening Adam, but a white-coated lab technician with his test tubes, saying, "Thanks, but we've got it covered." That is why the objections to cloning seem to go beyond pragmatic or practical considerations. It would be one thing if people wanted to prohibit reproductive cloning only because it has not yet been perfected, and has a tendency to produce deformed or unviable organisms. But as a thought experiment, just ask yourself the following: if tomorrow a scientist announced that reproductive cloning had been perfected so that organisms (including animals and human beings) could be produced that were perfectly engineered in every respect; free of birth defects; healthy, beautiful "twins" of their parent-donors—would that overcome the objections to cloning? I think not. It might produce a realignment of the political opposition to cloning, however, and separate those with practical objections from those who have more metaphysical reservations based in natural or supernatural law. The true meaning of the second commandment, the blanket prohibition on the making of images, would finally become clear.

The second commandment is even more clearly in the background of the destruction of the twin towers. As an icon of modern global capitalism, the towers were seen by Islamic fundamentalists as no less an idol than the Buddhist monuments destroyed by the Taliban in Afghanistan in the spring of 2001. The last words uttered by the 9/11 terrorists as the planes they hijacked collided with the towers were, no doubt, "God is great." The Qur'an's instructions on the Muslims' sacred duty to destroy idols are practically identical to those found in the Jewish and Christian scriptures. And the act of destruction as a holy duty is not some private or secret activity. It should preferably be conducted in public, in full view, as an

28. The link between the knowledge of image-making and the secret of life is perhaps the underlying sense of the opposition between the tree of life and the tree of knowledge. Bori notes that idolatry is the equivalent of "original sin" (the eating of the tree of knowledge). See Bori, *The Golden Calf,* p. 9. Milton's *Paradise Lost* reinforces this equation by suggesting that Adam and Eve began to worship the tree of knowledge as an idol after eating from it.

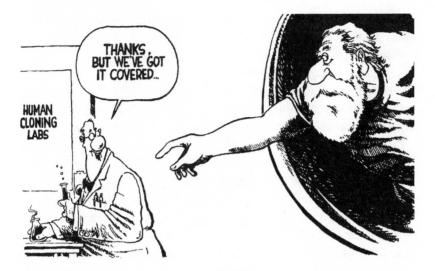

FIGURE 5 "Thanks, but we've got it covered." Richard Locher, Chicago *Tribune*.

admonitory exhibition.[29] The widely televised spectacle of the destruction of Saddam Hussein's statue in Baghdad during the second Gulf War was clearly a staged ritual meant to achieve iconic status. The uncertainty about the ritual—whether it was more humiliating to the effigy to decapitate it, or to wrap the head in an American flag—reflects the degree to which iconoclastic calculations were part of the conscious media strategy for the American military. The disfiguring, vandalizing, or humiliating of an image (like the mutilation of a living human body—cutting off hands or feet, blinding) can be just as potent as its actual destruction, since it leaves an imprint in the mind of the idolater of the grave consequences that attend the sin of idolatry. In other words, iconoclasm is more than just the destruction of images; it is a "creative destruction," in which a secondary image of defacement or annihilation is created at the same moment that the "target" image is attacked.[30] That is why composer Karlheinz Stockhausen's description of the 9/11 spectacle as "Lucifer's greatest work of art," however disturbing it

29. Outside the gates of Mecca, archaic pre-Islamic stone idols are allowed to remain standing, but piles of rocks are placed near them so that pious Muslims can stone the idols.

30. As the events of 9/11 unfolded, it was widely speculated that the timing of the destruction of the second tower, just a few minutes after the first, was part of an effort to stage

might have been at the time, was strangely accurate, and why we should not forget that the creation of the twin towers was already seen by many as a destruction of lower Manhattan.[31]

The ancient superstitions about images—that they take on "lives of their own," that they make people do irrational things, that they are potentially destructive forces that seduce and lead us astray—are not quantitatively less powerful in our time, though they are surely different in a qualitative sense. They have taken on radically new forms in the context of new scientific and technical possibilities, new social formations, and new religious movements, but their deep structure remains the same. That structure is not simply some psychological phobia about images, nor is it reducible to straightforward religious doctrines, laws, and prohibitions that a people might follow or violate. It is, rather, a social structure grounded in the experience of otherness and especially in the collective representation of others as idolaters. Accordingly, the first law of iconoclasm is that the idolater is always someone else: early Christian anti-Semitism routinely invoked the story of the golden calf to suggest that the Jews were inherently unbelievers, deniers of the divinity, from the Original Sin of Adam to the Crucifixion of Jesus.[32] The grammar of iconoclasm can, in fact, be conjugated rather straightforwardly around the first, second, and third persons, singular and plural—"I," "You," "We," and "They." "I" am never an idolater because I only worship the true god, or my images are merely symbolic forms and I am an enlightened, modern subject who knows better than to worship mere images. "They" are the idolaters who must be punished, and their idols destroyed. "You," finally, may or may not be an idolater. If you

the spectacle of destruction for the world's media apparatus. The notion that the destruction of an image may also be an image in its own right was a leitmotif of the Iconoclash symposium in Karlsruhe and the accompanying exhibition catalog.

31. "At a Hamburg press conference in 2001 Stockhausen said he believed that the destructive activities of Lucifer (the Devil) were apparent in the world today, for example in New York. When asked to be more specific Stockhausen said the terrorist attack on the World Trade Centre was Lucifer's greatest work of art. Johannes Schulz of NDR, just one of the reporters in attendance, filed a malicious report (omitting the word Lucifer and the context of the question) which was subsequently broadcast on German radio. Before the broadcaster had clarified its original mistake other networks world-wide picked up the story, humiliating the composer cruelly and unjustly. Many newspapers set the record straight in future articles, but inevitably these corrections achieved less prominence." From the unofficial Stockhausen Web site: http://www.stockhausen.org.uk/ksfaq.html.

32. See Bori, *The Golden Calf*, 16–17.

are one of "Them," you probably are. If you are one of "Us," you had better not be, because the penalty for idolatry is death. "We" do not suffer idols or idolaters in our midst.

The second law is that the iconoclast believes that idolaters believe their images to be holy, alive, and powerful. We might call this the law of "secondary belief," or beliefs about the beliefs of other people. Iconoclasm is not just a belief structure but a structure of *beliefs about other peoples' beliefs*. As such, it depends upon stereotype and caricature (image repertoires that reside on the borders of social difference). Stereotypes might be seen as the images that govern a normative picture of other people. A stereotype establishes the general set of beliefs and behaviors that are attributed to others (as humorist Garrison Keillor characterizes the typical Minnesotans of the fictitious Lake Wobegon on *The Prairie Home Companion:* "all the men are strong, all the women are good-looking, and all the children are above average"). The caricature, on the other hand, takes the stereotype and deforms or disfigures it, exaggerating some features or rendering the figure of the Other in terms of some subhuman object in order to ridicule and humiliate (all the men are curs, all the women are bitches, and all the children are mischievous monkeys).[33] A typical strategy of caricature is to render the human features in terms of some lower life-form, usually an animal. Similarly, a recurrent trope of iconoclasm is the accusation of animism and animal worship: the claim that idolaters are worshipping the images of brutes, and that this worship transforms the idolater into a brutish, subhuman creature who can be killed without compunction. The iconoclast, in short, is someone who constructs an image of other people as worshippers of images, and who sets out to punish those people for their false beliefs and practices, and to disfigure or destroy their images—both the images constructed and worshipped by the idolaters and the images of them constructed and reviled by the iconoclasts. In this whole process, real human bodies inevitably become collateral damage.

The deep structure of iconoclasm, then, is alive and well in our time. It may even be a more fundamental phenomenon than the idolatry it seeks to overcome. My sense is that real idolaters (as contrasted with the demonic images fantasized by iconoclasts) are generally rather liberal and flexible about their beliefs. For one thing, most idolaters do not insist that other

33. A more comprehensive discussion of this topic in the context of racial stereotyping and caricature will be found in chapter 14 below.

people worship their idols. They regard their sacred images as theirs, and would regard it as improper for other people to adopt them. Polytheism, paganism, and a genial pluralism about gods and goddesses is the general attitude one associates with actually existing forms of idolatry, as distinct from the phantasmatic projections of Hollywood movies and iconoclastic phobias. Iconoclasm, by contrast, is mainly a product of the three great religions of the Book (the same book, basically). It proceeds from the first principle that images are something to be suspicious of, that they are dangerous, evil, and seductive. It tends to be rather draconian in its sense of the appropriate punishment for idolatry, and rather lurid in its attribution of horrible beliefs and practices to idolaters. The place where idolatry and iconoclasm converge, most notably, is around the issue of human sacrifice. One of the chief arguments for a no-nonsense, zero-tolerance approach to idolaters is that they are reputed to make human sacrifices to their graven images, to kill children or virgins or other innocent victims in obscene, murderous rituals[34] ("You . . . took the sons and daughters that you bore to me and sacrificed them to those images as food" [Ezek. 16:20 (KJV)]). The attribution of this sort of practice to idolaters makes a good pretext for murdering them, making them into a sacrifice to the nonimageable, invisible God who will be pleased by our moral seriousness. The second commandment generally overrides the commandment against killing persons, since idolaters have, in some sense, ceased to be persons at all.

The symmetry between iconoclasm and idolatry explains how it is that acts of "creative destruction" (spectacular annihilation or disfigurement) create "secondary images" that are, in their way, forms of idolatry just as potent as the primary idols they seek to displace. The pleasure principle that governs Hollywood films and video games at this moment in history has never been more obvious: it is the spectacle of violent destruction, from car crashes and the hand-to-hand combat of martial arts movies to visions of entire cities and the world itself enveloped in catastrophic destruction. The image of the destruction of the twin towers (rehearsed in numerous disaster films) has become an idol in its own right, justifying a war on terrorism that plunges the world's most powerful nation into an indefinite state of emergency and unleashes the most reactionary forces of religious fundamentalism within that nation. It will also no doubt inspire acts of

34. See Moshe Halbertal and Avishai Margalit, *Idolatry* (Cambridge, MA: Harvard University Press, 1992), 16, for further discussion.

imitation and repetition, attempts to stage equally spectacular feats of iconoclasm. Thus "terrorism" has become the verbal idol of the mind for our time, a figure of radical evil that need only be invoked to preempt all discussion or reflection. Like cloning, terrorism is an *invisible* idol, a shape-shifting fantasy that may be instantiated in almost any form, from the stereotyped (or "racially profiled") figure of the brown person with an Arab surname to the caricature of the zealous fanatic, the suicide bomber as psychotic. Insofar as terror is a collective state of mind more than any specific military action, the strategic choices of the U.S. government—pre-emptive warfare, suspension of civil liberties, expansion of police and military powers, and repudiation of international judicial institutions—are perfect devices for cloning terror, for spreading the fantasies of dread and the conditions for their global circulation.

The "building lives" of the twin towers are perhaps most spectacularly figured in the most literal fact about them: that they were *twin* towers, and almost identical twins at that. The first reaction to their destruction was an impulse to clone—to raise the buildings from the dead by erecting replicas of them or (even more ambitious) to rebuild them in even taller, more grandiose forms.[35] Temporary attempts at memorialization, such as the "towers of light" installation at Ground Zero, were remarkable for their un-canny appropriateness as phantasmatic, ghostly spectacles of resurrection. The (generally unconscious) awareness that the light towers device had been previously explored by Hitler's architect and armaments minister, Albert Speer, as a crucial feature of the iconography of Nazi mass rallies only added to the sense of the enigmatic hovering around the spectacle. Clearly something more permanent is wanted—by the people of New York City, by Americans and others, and by the Ground-Zero site itself. If buildings, like all other images, want something, they are called into existence by desire as well.

So what do the twin towers want? What would be adequate to the symbolic, imaginary, and real trauma wrought by their destruction? Clearly the first answer is "nothing," and the maintenance of an *empty* space, the hollowed-out subbasement or "tub" (respected, notably, in architect Daniel

35. I am grateful to David Dunlap, architecture critic of the *New York Times,* for sharing his thinking about the "twin-ness" of the towers with me. See his article on the motif of twin towers in architecture in the *Times,* November 2, 2001, edition: "Even Now, a Skyline of Twins."

Liebeskind's proposed memorial) has been a recurrent motif in images of commemoration. On the constructive side, it is notable that the public was quite dissatisfied with the first attempts to replace the towers with some functional, merely adequate architectural complex that would satisfy the many competing interests in the site. Something more was clearly wanted, and the grandiosity of the proposals has mirrored the public longing for an adequately spectacular monument. The indelible image of the towers' destruction demands a counterimage of commemoration and resurrection. To my mind, the most satisfying proposal so far, both at the level of image and concept, is one that has absolutely no chance of being realized. It is a proposal not by an architect but by the sculptor Ed Shay, who envisions the erection of twin towers on their original sites, fused at the top by a combination of Gothic arch and Borrominian knot (fig. 6). This solution strikes me as both simple and elegant, respecting the original footprints of the twin towers but going beyond them to bring something new (and yet logically predictable and calculable) into the world. The upper floors could be illuminated at night as a memorial beacon, a vortical torch shape suggesting an eternally unified flame growing out of the twin supports. However, the important thing is not that such a megastructure be built but that it be imagined, if only as a visible answer to the "divided we stand" symbolism noted by Eric Darton in the title of his book about the World Trade Center.[36]

The image of the clone, for its part, presents a more insidious and gradual object of iconoclastic fervor, a more subtle horror along with a more utopian prospect. Arnold Schwarzenegger's film *The Sixth Day* suggests in its very title the linkage between ancient religious law and modern technophobia. The "Sixth Day" law gets its name from the biblical creation myth, in which God creates human beings on the sixth day. This law prohibits human cloning, though it permits the cloning of pets and other nonhuman organisms. In the movie, human cloning is banned because it turned out to be impossible to reproduce the memories and personalities of cloned persons, so the new organisms (created fully grown) come out as psychopaths. Even newer technology, however (pioneered in secret by an evil corporation suspiciously similar to Microsoft), has discovered a way to clone the mind as the well as the body, and to produce clones who can carry on when their "parent" organism has been killed. This is a handy device for

36. Eric Darton, *Divided We Stand: A Biography of New York's World Trade Center* (New York: Basic Books, 1999).

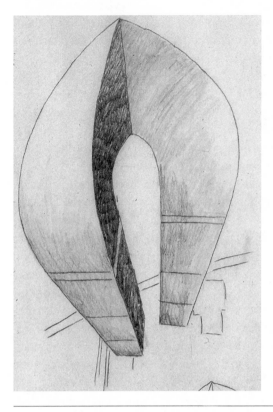

FIGURE 6
Ed Shay, proposal for rebuilt
World Trade Center, 2002.
Courtesy of the artist.

ensuring the viability of a squad of hired assassins who always seem to be killing themselves in high-speed car chases. Needless to say, this death squad is no match for the combined force of two Arnold Schwarzeneggers, a dynamic duo in which it is impossible—even for Schwarzenegger himself—to tell who is the original, and who is the clone.

Perhaps someday we will design replicas of ourselves that can live together in peace and harmony without iconoclasm or its evil twin, idolatry. On the positive side, this is clearly what cloning signifies, what the desire to clone entails. Clones just want to be like us, and to be liked by us.[37] They want us to attain ever more perfect realizations of our genetic potential. Mimesis, as anthropologist Michael Taussig argues, in both traditional and modern societies, has never been simply the production of the "same," but

37. See chapter 12 for more on this subject.

a mechanism for producing difference and transformation: "the ability to mime, and mime well, in other words, is the capacity to Other."[38] Therapeutic cloning aims to replace worn-out organs and tissues, to restore burned-out cartilage and brain cells. Reproductive cloning aims to give us a kind of genetic and genealogical immortality, to fulfill even more perfectly a desire that is already manifested in the motivations for having "one's own" biological children as opposed to adopting. In a rather straightforward sense, then, the desires of clones are simply our own human desires to reproduce and to improve. At the same time, of course, they activate the deepest phobias about mimesis, copying, and the horror of the uncanny double. In the latest installment of the *Star Wars* saga, we are not surprised to learn that those hordes of identical white-armored storm troopers who mindlessly march to their destruction are all clones of a single daring bounty hunter, genetically modified to reduce individual initiative. The clone is the image of the perfect servant, the obedient instrument of the master creator's will. But the cunning of the master-slave dialectic, Hegel reminds us, can never be stabilized; the servant is destined to revolt against the master.

The clone, then, shows us why the lives of images are so complex, and why the question, what do pictures want? will never be settled with some unequivocal answer. The clone is what Walter Benjamin called a "dialectical image," capturing the historical process at a standstill. It goes before us as a figure of our future, threatens to come after us as an image of what could replace us, and takes us back to the question of our own origins as creatures made "in the image" of an invisible, inscrutable creative force. Strange as it sounds, then, there is no way we can avoid asking what pictures want. This is a question we are not used to asking, and that makes us uncomfortable because it seems to be just the sort of question that an idolater would ask, one which leads the process of interpretation toward a kind of secular divination. What do the images want from us? Where are they leading us? What is it that they *lack*, that they are inviting us to fill in? What desires have we projected onto them, and what form do those desires take as they are projected back at us, making demands upon us, seducing us to feel and act in specific ways?

A predictable objection to my whole argument here is that it attributes a power to images that is simply alien to the attitudes of modern people.

38. Michael Taussig, *Mimesis and Alterity* (New York: Routledge, 1993), 19.

Perhaps savages, children, and illiterate masses can, like sheep, be led astray by images, but we moderns know better. Historian of science Bruno Latour has put a decisive stumbling block in the way of this argument in his wonderful book, *We Have Never Been Modern*. Modern technologies, far from liberating us from the mystery surrounding our own artificial creations, have produced a new world order of "factishes," new syntheses of the orders of scientific, technical factuality on the one hand and of fetishism, totemism, and idolatry on the other. Computers, as we know, are nothing but calculating machines. They are also (as we know equally well) mysterious new organisms, maddeningly complex life-forms that come complete with parasites, viruses, and a social network of their own. New media have made communication seem more transparent, immediate, and rational than ever before, at the same time that they have enmeshed us in labyrinths of new images, objects, tribal identities, and ritual practices. Marshall McLuhan understood this irony very clearly when he pointed out that "by continuously embracing technologies, we relate ourselves to them as servomechanisms. That is why we must, to use them at all, serve these objects, these extensions of ourselves, as gods or minor religions. An Indian is the servo-mechanism of his canoe, as the cowboy of his horse, or the executive of his clock."[39]

So we must ask the question, what do pictures want from us? and stay for the answers, even though the question seems impossible to begin with. We might even have to entertain what I would call a "critical idolatry" or "secular divination" as an antidote to that reflexive critical iconoclasm that governs intellectual discourse today. Critical idolatry involves an approach to images that does not dream of destroying them, and that recognizes every act of disfiguration or defacement as itself an act of creative destruction for which we must take responsibility. It would take as its inspiration (as I have already suggested) the opening pages of Nietzsche's *Twilight of Idols,* in which Nietzsche recommends "sounding out" the idols with the hammer, or "tuning fork," of critical language. The idols that Nietzsche wants to strike are, as he says, "eternal," which I take to mean indestructible. The proper strategy, then, is not to attempt to destroy them, an iconoclasm that is doomed to failure, but to play upon them as if they were musical instruments. The power of idols over the human mind resides in their

39. Marshall McLuhan, *Understanding Media* (first pub. 1964; Cambridge, MA: MIT Press, 1994), 46.

silence, their spectacular impassiveness, their dumb insistence on repeating the same message (as in the baleful cliché of "terrorism"), and their capacity for absorbing human desire and violence and projecting it back to us as a demand for human sacrifice. It also resides in their obdurate indestructibility, which only gains strength from the sense of futility that accompanies the vain attempt to destroy them. "Sounding" the idols, by contrast, is a way of playing upon them. It does not dream of breaking the idol but of breaking its silence, making it speak and resonate, and transforming its hollowness into an echo chamber for human thought.

The dominant questions about pictures in recent literature about visual culture and art history have been interpretive and rhetorical. We want to know what pictures mean and what they do: how they communicate as signs and symbols, what sort of power they have to effect human emotions and behavior. When the question of desire is raised, it is usually located in the producers or consumers of images, with the picture treated as an expression of the artist's desire or as a mechanism for eliciting the desires of the beholder. In this chapter, I'd like to shift the location of desire to images themselves, and ask what pictures want. This question certainly does not mean an abandonment of interpretive and rhetorical issues, but it will, I hope, make the question of pictorial meaning and power appear somewhat different. It will also help us grasp the fundamental shift in art history and other disciplines that is sometimes called visual culture or visual studies, and which I have associated with a pictorial turn in both popular and elite intellectual culture.

To save time, I want to begin with the assumption that we are capable of suspending our disbelief in the very premises of the question, what do pictures want? I'm well aware that this is a bizarre, perhaps even objectionable, question. I'm aware that it involves a subjectivizing of images, a dubious personification of inanimate objects; that it flirts with a regressive, super-

This chapter is a slightly modified and condensed version of an essay entitled "What Do Pictures Want?" that appeared in *In Visible Touch: Modernism and Masculinity,* ed. Terry Smith (Sydney, Australia: Power Publications, 1997). A shorter version appeared as "What Do Pictures *Really* Want?" in *October 77* (Summer 1996): 71–82. I would like to thank Lauren Berlant, Homi Bhabha, T. J. Clark, Annette Michelson, John Ricco, Terry Smith, Joel Snyder, and Anders Troelsen for their help in thinking about this knotty question.

stitious attitude toward images, one that if taken seriously would return us to practices like totemism, fetishism, idolatry, and animism.[1] These are practices that most modern, enlightened people regard with suspicion as primitive, psychotic, or childish in their traditional forms (the worship of material objects; the treating of inanimate objects like dolls as if they were alive) and as pathological symptoms in their modern manifestations (fetishism either of commodities or of neurotic perversion).

I'm also quite aware that the question may seem like a tasteless appropriation of an inquiry that is properly reserved for other people, particularly those classes of people who have been the objects of discrimination, victimized by prejudicial images—"profiled" in stereotype and caricature. The question echoes the whole investigation into the desire of the abject or downcast Other, the minority or subaltern that has been so central to the development of modern studies in gender, sexuality, and ethnicity.[2] "What does the black man want?" is the question raised by Franz Fanon, risking the reification of manhood and negritude in a single sentence.[3] "What do women want?" is the question Freud found himself unable to answer.[4] Women and people of color have struggled to speak directly to these questions, to articulate accounts of their own desire. It is hard to imagine how pictures might do the same, or how any inquiry of this sort could be more than a kind of disingenuous or (at best) unconscious ventriloquism, as if Edgar Bergen were to ask Charlie McCarthy, "What do puppets want?"

1. See chapter 7 of the present text for a detailed discussion of these concepts.

2. The transferability of minority and subaltern characteristics to images will of course be a central issue in what follows. One might begin with a reflection on Gayatri Spivak's famous question, "Can the Subaltern Speak?" in *Marxism and the Interpretation of Culture*, ed. Cary Nelson and Lawrence Grossberg (Urbana: University of Illinois Press, 1988), 271–313. Her answer is no, an answer that is echoed when images are treated as the silent or mute sign, incapable of speech, sound, and negation (in which case the answer to our question might be, pictures want a voice, and a poetics of enunciation). The "minority" position of the image is best seen in Gilles Deleuze's remarks on the way the poetic process introduces a "stutter" into language that "minorizes" it, producing "a language of images, resounding and coloring images," that "bore[s] holes" in language "by means of an ordinary silence, when the voices seem to have died out." See Deleuze, *Essays Critical and Clinical*, trans. Daniel W. Smith and Michael A. Greco (Minneapolis: University of Minnesota Press, 1997), 109, 159.

3. Franz Fanon, *Black Skin, White Masks* (New York: Grove Press, 1967), 8.

4. Ernest Jones reports that Freud once exclaimed to Princess Marie Bonaparte, "Was will das Weib?" (What does woman want?) See Peter Gay, *The Freud Reader* (New York: Norton, 1989), 670.

Nevertheless, I want to proceed as if the question were worth asking, partly as a kind of thought experiment, simply to see what happens, and partly out of a conviction that this is a question we are already asking, that we cannot help but ask, and that therefore deserves analysis. I'm encouraged in this by the precedents of Marx and Freud, who both felt that a modern science of the social and the psychological had to deal with the issue of fetishism and animism, the subjectivity of objects, the personhood of things.[5] Pictures are things that have been marked with all the stigmata of personhood and animation: they exhibit both physical and virtual bodies; they speak to us, sometimes literally, sometimes figuratively; or they look back at us silently across a "gulf unbridged by language."[6] They present not just a surface but a *face* that faces the beholder. While Marx and Freud both treat the personified, subjectified, animated object with deep suspicion, subjecting their respective fetishes to iconoclastic critique, much of their energy is spent in detailing the processes by which the life of objects is produced in human experience. And it's a real question whether, in Freud's case at least, there is any real prospect of "curing" the malady of fetishism.[7] My own position is that the subjectivized, animated object in some form or other is an incurable symptom, and that Marx and Freud are better treated as guides to the understanding of this symptom and perhaps to some transformation of it into less pathological, damaging forms. In short, we are stuck with our magical, premodern attitudes toward objects, especially pictures, and our task is not to overcome these attitudes but to understand them, to work through their symptomatology.

5. In saying that pictures have some of the features of personhood, of course, I am begging the question of what a person is. Whatever the answer to that question, it will have to include some account of what it is about *persons* that makes it possible for pictures to *impersonate* them as well as represent them. This discussion might start from the origin of the word *per-sonare* (to "sound through"), which roots the figure of the person in the masks used as iconic figures and as megaphones in Greek tragedy. Persons and personalities, in short, may derive their characteristic features from image-making as much as pictures derive their features from persons.

6. I am quoting here John Berger's remark on the gaze of the animal in his classic essay, "Why Look at Animals," in *About Looking* (New York: Pantheon Books, 1980), 3. For more on this matter, see my "Looking at Animals Looking," in *Picture Theory* (Chicago: University of Chicago Press, 1994), 329–44.

7. Freud's discussion of fetishism begins by noting that the fetish is a notoriously *satisfactory* symptom, and that his patients rarely come to him with complaints about it. "Fetishism" (1927), in *Standard Edition of the Complete Psychological Works of Sigmund Freud* (London: Hogarth Press, 1961), 21:152–57.

The literary treatment of pictures is, of course, quite unabashed in its celebration of their uncanny personhood and vitality, perhaps because the literary image does not have to be faced directly, but is distanced by the secondary mediation of language. Magic portraits, masks, and mirrors, living statues, and haunted houses are everywhere in both modern and traditional literary narratives, and the aura of these imaginary images seeps into both professional and popular attitudes toward real pictures.[8] Art historians may "know" that the pictures they study are only material objects that have been marked with colors and shapes, but they frequently talk and act as if pictures had feeling, will, consciousness, agency, and desire.[9] Everyone knows that a photograph of their mother is not alive, but they will still be reluctant to deface or destroy it. No modern, rational, secular person thinks that pictures are to be treated like persons, but we always seem to be willing to make exceptions for special cases.

And this attitude is not confined to valuable artworks or pictures that have personal significance. Every advertising executive knows that some images, to use the trade jargon, "have legs"—that is, they seem to have a surprising capacity to generate new directions and surprising twists in an ad campaign, as if they had an intelligence and purposiveness of their own. When Moses demands that Aaron explain the making of the golden calf, Aaron says that he merely threw the Israelites' gold jewelry into the fire "and this calf came out" (Exod. 32:23 [KJV]), as is if were a self-created auto-

8. Magical pictures and animated objects are an especially salient feature of the nineteenth-century European novel, appearing in the pages of Balzac, the Brontës, Edgar Allan Poe, Henry James, and of course throughout the gothic novel. See Theodore Ziolkowski, *Disenchanted Images: A Literary Iconology* (Princeton, NJ: Princeton University Press, 1977). It's as if the encounter with and destruction of traditional or premodern "fetishistic" societies produced a post-Enlightenment resurgence of subjectivized objects in Victorian domestic spaces.

9. The full documentation of the trope of the personified and "living" work of art in Western art-historical discourse would require a separate essay. Such an essay might begin with a look at the status of the art object in the three canonical "fathers" of art history, Vasari, Winckelmann, and Hegel. It would find, I suspect, that the progressive and teleological narratives of Western art are not (as is so often suggested) focused primarily on the conquest of appearance and visual realism, as on the question of how, in Vasari's terms, "liveliness" and "animation" are to be infused into the object. Winckelmann's treatment of artistic media as agents in their own historical development, and his description of the Apollo Belvedere as an object so full of divine animation that it turns the spectator into a Pygmalion figure, a statue brought to life, would be a central focus in such an essay, as would Hegel's treatment of the artistic object as a material thing that has received "the baptism of the spiritual."

maton.[10] Evidently some idols have legs too.[11] The idea that images have a kind of social or psychological power of their own is, in fact, the reigning cliché of contemporary visual culture. The claim that we live in a society of spectacle, surveillance, and simulacra is not merely an insight of advanced cultural criticism; a sports and advertising icon like Andre Agassi can say that "image is everything," and be understood as speaking not only *about* images but *for* images, as someone who was himself seen as "nothing but an image."

There is no difficulty, then, in demonstrating that the idea of the personhood of pictures (or, at minimum, their animism) is just as alive in the modern world as it was in traditional societies. The difficulty is in knowing what to say next. How are traditional attitudes toward images—idolatry, fetishism, totemism—refunctioned in modern societies? Is our task as cultural critics to demystify these images, to smash the modern idols, to expose the fetishes that enslave people? Is it to discriminate between true and false, healthy and sick, pure and impure, good and evil images? Are images the terrain on which political struggle should be waged, the site on which a new ethics is to be articulated?

There is a strong temptation to answer these questions with a resounding yes, and to take the critique of visual culture as a straightforward strategy of political intervention. This sort of criticism proceeds by exposing images as agents of ideological manipulation and actual human damage. At one extreme is the claim of legal theorist Catherine MacKinnon that pornography is not just a representation of violence toward and degradation of women but an *act* of violent degradation, and that pornographic pictures—especially photographic and cinematic images—are themselves agents of violence.[12] There are also the familiar and less controversial arguments in the political critique of visual culture: that Hollywood cinema constructs women as objects of the "male gaze"; that the unlettered masses

10. Pier Bori notes that the "self-creating" account of the making of the calf was a crucial part of the exculpation of Aaron (and the condemnation of the Jewish people) by the church fathers. Macarius the Great, for instance, describes the gold thrown into the fire as "turned into an idol as if the fire imitated [the people's] decision" (Bori, *The Golden Calf* [Atlanta: Scholar's Press, 1990], 19).

11. Or wings. My colleague Wu Hung tells me that flying statues of Buddha were a common phenomenon in Chinese legends.

12. See Catherine MacKinnon, *Feminism Unmodified* (Cambridge, MA: Harvard University Press, 1987), especially pp. 172–73 and 192–93.

are manipulated by the images of visual media and popular culture; that people of color are subject to graphic stereotypes and racist visual discrimination; that art museums are a kind of hybrid form of religious temple and bank in which commodity fetishes are displayed for rituals of public veneration that are designed to produce surplus aesthetic and economic value.

I want to say that all these arguments have some truth to them (in fact, I've made many of them myself), but also that there is something radically unsatisfactory about them. Perhaps the most obvious problem is that the critical exposure and demolition of the nefarious power of images is both easy and ineffectual. Pictures are a popular political antagonist because one can take a tough stand on them, and yet, at the end of the day, everything remains pretty much the same.[13] Scopic regimes can be overturned repeatedly without any visible effect on either visual or political culture. In MacKinnon's case, the brilliance, passion, and futility of this enterprise is quite evident. Are the energies of a progressive, humane politics that seeks social and economic justice really well spent on a campaign to stamp out pornography? Or is this at best a mere symptom of political frustration, at worst a real diversion of progressive political energy into collaboration with dubious forms of political reaction? Or even better, is MacKinnon's treatment of images as if they had agency a kind of testimony to the incorrigible character of our tendency to personify and animate images? Could political futility lead us toward iconological insight?

In any event, it may be time to rein in our notions of the political stakes in a critique of visual culture, and to scale down the rhetoric of the "power of images." Images are certainly not powerless, but they may be a lot weaker than we think. The problem is to refine and complicate our estimate of their power and the way it works. That is why I shift the question from what pictures *do* to what they *want*, from power to desire, from the model of the dominant power to be opposed, to the model of the subaltern to be interrogated or (better) to be invited to speak. If the power of images is like the

13. The most egregious example of this shadow politics is the industry of psychological testing designed to show that video games are the causal agent in youth violence. Supported by political interests that would prefer an iconic, "cultural" scapegoat to some attention to the actual instruments of violence, namely guns, enormous amounts of public money are spent annually to support "research" (sic) on the impact of video games. For more details see http://culturalpolicy.uchicago.edu/news_events.html#conf for an account of "The Arts and Humanities in Public Life 2001: 'Playing by the Rules: The Cultural Policy Challenges of Video Games,'" a conference held at the University of Chicago October 26–27, 2001.

power of the weak, that may be why their desire is correspondingly strong: to make up for their actual impotence. We as critics may want pictures to be stronger than they actually are in order to give ourselves a sense of power in opposing, exposing, or praising them.

The subaltern model of the picture, on the other hand, opens up the actual dialectics of power and desire in our relations with pictures. When Fanon reflects on negritude, he describes it as a "corporeal malediction" that is hurled in the immediacy of the visual encounter, "Look, a Negro."[14] But the construction of the racial and racist stereotype is not a simple exercise of the picture as a technique of domination. It is the knotting of a double bind that afflicts both the subject and the object of racism in a complex of desire and hatred.[15] The ocular violence of racism splits its object in two, rending and rendering it simultaneously hypervisible and invisible,[16] an object of, in Fanon's words, "abomination" and "adoration."[17] *Abomination* and *adoration* are precisely the terms in which idolatry is excoriated in the Bible: it is *because* the idol is adored that it must be abominated by the iconophobe.[18] The idol, like the black man, is both despised and worshipped, reviled for being a nonentity, a slave, and feared as an alien and supernatural power. If idolatry is the most dramatic form of image power known to visual culture, it is a remarkably ambivalent and ambiguous kind

14. Fanon, "The Fact of Blackness," in *Black Skin, White Masks*, 109.

15. For a subtle analysis of this double bind, see Homi Bhabha, "The Other Question: Stereotype, Discrimination and the Discourse of Colonialism," in *The Location of Culture* (New York: Routledge, 1994), 66–84.

16. Ralph Ellison's classic novel, *The Invisible Man*, renders this paradox most vividly: it is *because* the invisible man is hypervisible that (in another sense) he is invisible.

17. "To us, the man who adores the Negro is as 'sick' as the man who abominates him" (Fanon, *Black Skin, White Masks*, 8).

18. See, for instance, the description of the idol of Ashtoreth, "the abomination of Sidonians, and Chemosh the abomination of Moab, and . . . Milcom the abomination of the Ammonites" (2 Kings 23:13 [KJV]), and Isaiah 44:19: "shall I make the residue of it an abomination? Shall I fall down before a block of wood?" The online edition of the *Oxford English Dictionary* lays out the doubtful etymology: "Abominable, regularly spelt *abhominable*, and explained as *ab homine*, and explained as 'away from man, inhuman, beastly.'" The association of the animate image with beasts is, I suspect, a crucial feature of pictorial desire. *Abomination* is also a term regularly applied to "unclean" or taboo animals in the Bible. See Carlo Ginzburg on the idol as a "monstrous" image presenting impossible "composite" forms that combine human and animal features in "Idols and Likenesses: Origen, Homilies on Exodus VIII.3, and Its Reception," in *Sight & Insight: Essays on Art and Culture in Honour of E. H. Gombrich at 85* (London: Phaidon Press, 1994), 55–67.

of force. Insofar as visuality and visual culture are infected by a kind of "guilt by association" with idolatry and the evil eye of racism, it is no wonder that intellectual historian Martin Jay can think of the "eye" itself as something that is repeatedly "cast down" (or plucked out) in Western culture, and vision as something that has been repeatedly subjected to "denigration."[19] If pictures are persons, then, they are colored or marked persons, and the scandal of the purely white or purely black canvas, the blank, unmarked surface, presents quite a different face.

As for the gender of pictures, it's clear that the "default" position of images is feminine, "constructing spectatorship," in art historian Norman Bryson's words, "around an opposition between woman as image and man as the bearer of the look"—not images *of* women, but images *as* women.[20] The question of what pictures want, then, is inseparable from the question of what women want. Long before Freud, Chaucer's "Wife of Bath's Tale" staged a narrative around the question, "What is it that women most desire?" This question is posed to a knight who has been found guilty of raping a lady of the court, and who is given a one-year reprieve on his death sentence to go in quest of the right answer. If he returns with the wrong answer, the death sentence will be carried out. The knight hears many wrong answers from the women he interviews—money, reputation, love, beauty, fine clothes, lust abed, many admirers. The right answer turns out to be *maistrye,* a complex middle-English term that equivocates between "mastery" by right or consent, and the power that goes with superior strength or cunning.[21] The official moral of Chaucer's tale is that consensual, freely given mastery is best, but Chaucer's narrator, the cynical and worldly Wife of Bath, knows that women want (that is, lack) power, and they will take whatever kind they can get.

What is the moral for pictures? If one could interview all the pictures one encounters in a year, what answers would they give? Surely, many of the pictures would give Chaucer's "wrong" answers: that is, pictures would want to be worth a lot of money; they would want to be admired and praised as

19. See Martin Jay, *Downcast Eyes: The Denigration of Vision in Twentieth Century French Thought* (Berkeley and Los Angeles: University of California Press, 1993).

20. Norman Bryson, introduction to *Visual Culture: Images and Interpretations,* ed. Norman Bryson, Michael Ann Holly, and Keith Moxey (Hanover, NH: University Press of New England, 1994), xxv. The classic discussion of the gendering of image and gaze remains, of course, Laura Mulvey's "Visual Pleasure and Narrative Cinema," *Screen* 16, no. 3 (1975): 6–18.

21. My thanks to Jay Schleusener for his help with the Chaucerian notion of *maistrye.*

beautiful; they would want to be adored by many lovers. But above all they would want a kind of mastery over the beholder. Art historian and critic Michael Fried summarizes painting's "primordial convention" in precisely these terms: "a painting . . . had first to attract the beholder, then to arrest and finally to enthrall the beholder, that is a painting had to call to someone, bring him to a halt in front of itself and hold him there as if spellbound and unable to move."[22] The paintings' desire, in short, is to change places with the beholder, to transfix or paralyze the beholder, turning him or her into an image for the gaze of the picture in what might be called "the Medusa effect." This effect is perhaps the clearest demonstration we have that the power of pictures and of women is modeled on one another, and that this is a model of both pictures and women that is abject, mutilated, and castrated.[23] The power they want is manifested as *lack,* not as possession.

We could no doubt elaborate the linkage between pictures, femininity, and negritude much more fully, taking into account other variations on the subaltern status of images in terms of other models of gender, sexual identity, cultural location, and even species identity (suppose, for instance, that the desires of pictures were modeled on the desires of animals? What does Wittgenstein mean in his frequent reference to certain pervasive philosophical metaphors as "queer pictures"?).[24] But I want to turn now simply to the model of Chaucer's quest and see what happens if we question pictures about their desires instead of looking at them as vehicles of meaning or instruments of power.

I begin with a picture that wears its heart on its sleeve, the famous "Uncle Sam" recruiting poster for the U.S. Army designed by James Montgomery Flagg during World War I (fig. 7). This is an image whose demands if not desires seem absolutely clear, focused on a determinate object: it wants "you," that is, the young men of eligible age for military service.[25] The im-

22. Michael Fried, *Absorption and Theatricality* (Chicago: University of Chicago Press, 1980), 92.

23. See Neil Hertz, "Medusa's Head: Male Hysteria under Political Pressure," *Representations* 4 (Fall 1983): 27–54, and my discussion of Medusa in *Picture Theory,* 171–77.

24. *Queer* in Wittgenstein's vocabulary is, however, emphatically *not* "perverse" (*widernaturlich*) but "ganz natürlich," even as it is "strange" (*seltsam*) or "remarkable" (*merkwurdiger*). See Ludwig Wittgenstein, *Philosophical Investigations,* trans. G. E. M. Anscombe (Oxford: Basil Blackwell, 1953), 79–80, 83–84.

25. I am invoking here the Lacanian distinction between desire, demand, and need. Jonathan Scott Lee provides a helpful gloss: "desire is that which is manifested in the inter-

mediate aim of the picture appears to be a version of the Medusa effect: that is, it "hails" the viewer verbally and tries to transfix him with the directness of its gaze and (its most wonderful pictorial feature) foreshortened pointing finger that single out the viewer, accusing, designating, and commanding him. But the desire to transfix is only a transitory and momentary goal. The longer range motive is to move and mobilize the beholder, to send him on to the "nearest recruiting station" and ultimately overseas to fight and possibly die for his country.

So far, however, this is only a reading of what might be called the overt signs of positive desire. The gesture of the pointing or beckoning hand is a common feature of the modern recruiting poster (fig. 8). To go any further than this, we need to ask what the picture wants in terms of lack. Here the contrast of the U.S. with the German recruiting poster is clarifying. The latter is an image in which a young soldier hails his brothers, calls them to the brotherhood of honorable death in battle. In contrast, *Uncle* Sam, as his name indicates, has a more tenuous, indirect relation to the potential recruit. He is an older man who lacks the youthful vigor for combat, and perhaps even more important, lacks the direct blood connection that a figure of the fatherland would evoke. He asks young men to go fight and die in a war in which neither he nor his sons will participate. There are no "sons" of Uncle Sam, only "real live nephews," as George M. Cohan put it; Uncle Sam himself is sterile, a kind of abstract, pasteboard figure who has no body, no blood, but who impersonates the nation and calls for other men's sons to donate their bodies and their blood. It's only appropriate that he is a pictorial descendant of British caricatures of "Yankee Doodle," a figure of ridicule that adorned the pages of *Punch* throughout the nineteenth century. His ultimate ancestor is a real person, "Uncle Sam" Wilson, a supplier of beef to the U.S. Army during the War of 1812. One can imagine a scene in which the original prototype for Uncle Sam is addressing not a group of young men but a herd of cattle about to be slaughtered. Small wonder that this image was so readily appropriated for parodic inversion in the figure of

val that demand hollows out within itself . . . it is . . . what is evoked by any demand beyond the need articulated in it" (Lee, *Jacques Lacan* [Amherst: University of Massachusetts Press, 1991], 58). See also Slavoj Žižek, *Looking Awry* (Cambridge, MA: MIT Press, 1992), 134. The verb "to want" can, of course, suggest any of these meanings (desire, demand, need), depending on the context. Žižek has pointed out to me that it would be perverse to read Uncle Sam's "I want you" as "I desire you" rather than as an expression of demand or need. Nonetheless, it will soon be evident just how perverse this picture is!

"Uncle Osama" urging the young men of America to go to war against Iraq (fig. 9).

So what does this picture want? A full analysis would take us deep into the political unconscious of a nation that is nominally imagined as a disembodied abstraction, an Enlightenment polity of laws and not men, principles and not blood relationships, and actually embodied as a place where old white men send young men and women of all races (including a disproportionately high number of colored people) to fight their wars. What this real and imagined nation lacks is meat—bodies and blood—and what it sends to obtain them is a hollow man, a meat supplier, or perhaps just an artist. The contemporary model for the Uncle Sam poster, as it turns out, was James Montgomery Flagg himself. Uncle Sam is thus a self-portrait of the patriotic American artist in national drag, reproducing himself in millions of identical prints, the sort of fertility that is available to images and to artists. The "disembodiment" of his mass-produced image is countered by its concrete embodiment and location *as picture*[26] in relation to recruiting stations (and the bodies of real recruits) all over the nation.

Given this background, you might think it a wonder that this poster had any power or effectiveness at all as a recruiting device, and indeed, it would be very difficult to know anything about the real power of the image. What one can describe, however, is its construction of desire in relation to fantasies of power and impotence. Perhaps the image's subtle candor about its bloodless sterility as well as its origins in commerce and caricature combine to make it seem so appropriate a symbol of the United States.

Sometimes the expression of a want signifies lack rather than the power to command or make demands, as in the Warner Bros. promotional poster of entertainer Al Jolson for its movie *The Jazz Singer* (fig. 10), whose hand gestures connote beseeching and pleading, declarations of love for a "Mammy" and an audience that is to be moved to the theater, not to the recruiting office. What this picture wants, as distinct from what its depicted figure asks for, is a stable relation between figure and ground, a way of demarcating body from space, skin from clothing, the exterior of the body from its interior. And this is what it cannot have, for the stigmata of race and body image are dissolved into a shuttle of shifting black-and-white spaces that "flicker" before us like the cinematic medium itself and the

26. The distinction between the disembodied, immaterial image and the concrete picture will be discussed further in chapter 4.

scene of racial masquerade it promises. It is as if this masquerade finally reduced to a fixation on the orifices and organs of the body as zones of indistinction, eyes, mouth, and hands fetishized as illuminated gateways between the invisible and visible man, inner whiteness and outer blackness. "I am black but O my soul is white," says William Blake; but the windows of the soul are triply inscribed as ocular, oral, and tactile in this image—an invitation to see, feel, and speak beyond the veil of racial difference. What the picture awakens our desire to see, as Jacques Lacan might put it, is exactly what it cannot show. This impotence is what gives it whatever specific power it has.[27]

Sometimes the disappearance of the object of visual desire in a picture is a direct trace of the activity of generations of viewers, as in the Byzantine miniature from the eleventh century (fig. 11). The figure of Christ, like that of Uncle Sam and Al Jolson, directly addresses the viewer, here with the verses from Psalm 77: "Give heed, O my people to my law; incline your ear to the words of my mouth." What is clear from the physical evidence of the picture, however, is that ears have not been inclined to the words of the mouth so much as mouths have been pressed to the lips of the image, wearing away its face to near oblivion. These are viewers who have followed the advice of John of Damascus "to embrace [images] with the eyes, the lips, the heart."[28] Like Uncle Sam, this icon is an image that wants the beholder's body and blood and spirit; unlike Uncle Sam, it gives away its own body in the encounter, in a kind of pictorial reenactment of the eucharistic sacrifice. The defacement of the image is not a desecration but a sign of devotion, a recirculation of the painted body in the body of the beholder.

These sorts of direct expressions of pictorial desire are, of course, generally associated with "vulgar" modes of imaging—commercial advertising and political or religious propaganda. The picture as subaltern makes an appeal or issues a demand whose precise effect and power emerges in an intersubjective encounter compounded of signs of positive desire and traces of lack or impotence. But what of the "work of art" proper, the aesthetic object that is simply supposed to "be" in its autonomous beauty or sublimity? One answer is provided by Michael Fried, who argues that the emergence of modern art is precisely to be understood in terms of the negation or

27. For more on the dialectics of blackface, and the animation of racial stereotypes and caricatures, see chapter 14.

28. See Robert S. Nelson, "The Discourse of Icons, Then and Now," *Art History* 12, no. 2 (June 1989): 144–55, for a fuller discussion.

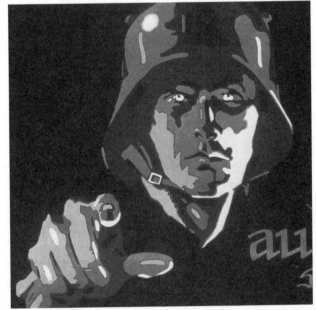

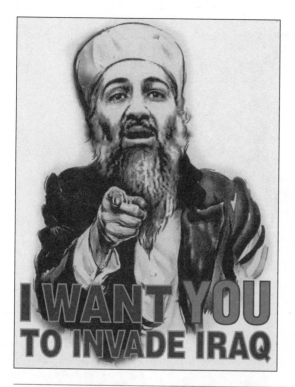

FIGURE 9
Uncle Osama.
Image provided
courtesy of
TomPaine.com,
a project of
the nonprofit
Florence Fund.

FIGURE 10
Warner Bros.
poster of
Al Jolson for
The Jazz Singer.

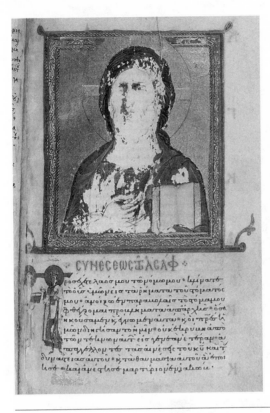

FIGURE 11
Byzantine icon: Christ.
Illuminated manuscript, Psalter
and New Testament (D.O. MS
3), fol. 39r. Byzantine Collec-
tion, Dumbarton Oaks,
Washington, DC.

renunciation of direct signs of desire. The process of pictorial seduction he admires is successful precisely in proportion to its indirectness, its seeming indifference to the beholder, its antitheatrical "absorption" in its own internal drama. The very special sort of pictures that enthrall him get what they want by seeming not to want anything, by pretending that they have everything they need. Fried's discussions of Jean-Baptiste-Siméon Chardin's *Soap Bubbles* and Théodore Géricault's *Raft of the Medusa* (figs. 12, 13) might be taken as exemplary here, and help us to see that it is not merely a question of what the figures in the pictures appear to want, the legible signs of desire that they convey. This desire may be enraptured and contemplative, as it is in *Soap Bubbles,* where the shimmering and trembling globe that absorbs the figure becomes "a natural correlative for [Chardin's] own engrossment in the act of painting and a proleptic mirroring of what he trusted would be the absorption of the beholder before the finished work."

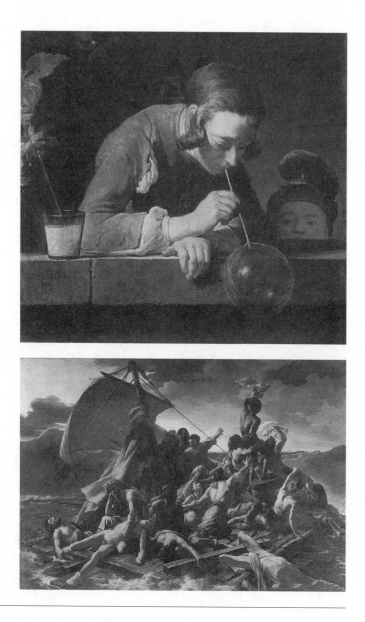

FIGURE 12 Jean-Baptiste-Siméon Chardin, *Soap Bubbles,* ca. 1733. The Metropolitan Museum of Art, Wentworth Fund, 1949 (49.24). Photograph courtesy Metropolitan Museum of Art, New York.

FIGURE 13 Théodore Géricault, *Raft of the Medusa,* 1819. Musée du Louvre, Paris. Photograph Réunion des Musées Nationaux / Art Resource, NY.

Or it may be violent, as in *Raft of the Medusa*, where the "strivings of the men on the raft" are not simply to be understood in relation to its internal composition and the sign of the rescue ship on the horizon, "but also by the need to escape our gaze, to put an end to being beheld by us, to be rescued from the ineluctable fact of a presence that threatens to theatricalize even their sufferings."[29]

The end point of this sort of pictorial desire is, I think, the purism of modernist abstraction, whose negation of the beholder's presence is articulated in theorist Wilhelm Worringer's *Abstraction and Empathy,* and displayed in its final reduction in the white paintings of the early Robert Rauschenberg, whose surfaces the artist regarded as "hypersensitive membranes . . . registering the slightest phenomenon on their blanched white skins."[30] Abstract paintings are pictures that want not to be pictures, pictures that want to be liberated from image-making. But the desire not to show desire is, as Lacan reminds us, still a form of desire. The whole antitheatrical tradition reminds one again of the default feminization of the picture, which is treated as something that must awaken desire in the beholder while not disclosing any signs of desire or even awareness that it is being beheld, as if the beholder were a voyeur at a keyhole.

Barbara Kruger's photo collage "Your Gaze Hits the Side of My Face" (fig. 14) speaks rather directly to this purist or puritanical account of pictorial desire. The marble face in the picture, like the absorbed face of Chardin's boy with a bubble, is shown in profile, oblivious to the gaze of the spectator or the harsh beam of light that rakes its features from above. The inwardness of the figure, its blank eyes and stony absence of expression, make it seem beyond desire, in that state of pure serenity we associate with classical beauty. But the verbal labels glued onto the picture send an absolutely contrary message: "your gaze hits the side of my face." If we read these words as spoken by the statue, the whole look of the face suddenly changes, as if it were a living person who had just been turned to stone, and the spectator were in the Medusa position, casting her violent, baleful gaze upon the picture. But the placement and segmentation of the inscription

29. Fried, *Absorption and Theatricality,* 51, 154.

30. Robert Rauschenberg, quoted in Caroline Jones, "Finishing School: John Cage and the Abstract Expressionist Ego," *Critical Inquiry* 19, no. 4 (Summer 1993), 647. The negative relation of abstraction to Worringer's concept of empathy is explored more fully in chapter 11 of the present text. The trope of the painted surface as a sensitive skin is literalized in the temperature-sensitive paintings of Berlin artist Jurgen Mayer, which invite—in fact *demand* and *need*—a tactile response from the beholder to have their proper effect.

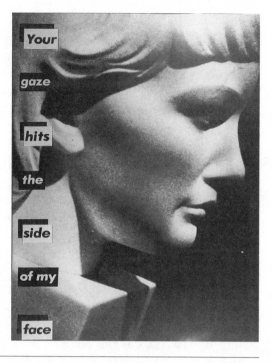

(not to mention the use of the shifters *your* and *my*) make the words seem alternately to float above and to fasten themselves to the surface of the photograph. The words "belong" alternately to the statue, the photograph, and to the artist, whose labor of cutting and pasting is so conspicuously foregrounded. We may, for instance, want to read this as a straightforward message about the gender politics of the gaze, a female figure complaining about the violence of male "lookism." But the statue's gender is quite indeterminate; it could be a Ganymede. And if the words belong to the photograph or the whole composition, what gender are we to attribute to them? This picture sends at least three incompatible messages about its desire (it wants to be seen; it doesn't want to be seen; it is indifferent to being seen). Above all, it wants to be *heard*—an impossibility for the silent, still image. Like the Al Jolson poster, the power of Kruger's image comes from a kind of flickering of alternate readings, one that leaves the viewer in a sort of paralysis. In the face of Kruger's abject/indifferent image, the beholder is simultaneously "caught looking" as an exposed voyeur and hailed as a Medusa whose eyes are deadly. By contrast, Al Jolson's directly hailing image promises a release from paralysis and muteness, a gratification of the

desire of the silent, still image for voice and motion—a demand quite literally fulfilled by the technical characteristics of the cinematic image.

So what do pictures want? Are there any general conclusions to be drawn from this hasty survey?

My first thought is that, despite my opening gesture of moving away from questions of meaning and power to the question of desire, I have continually circled back to the procedures of semiotics, hermeneutics, and rhetoric. The question of what pictures want certainly does not eliminate the interpretation of signs. All it accomplishes is a subtle dislocation of the target of interpretation, a slight modification in the picture we have of pictures (and perhaps signs) themselves.[31] The keys to this modification/dislocation are (1) assent to the constitutive fiction of pictures as "animated" beings, quasi-agents, mock persons; and (2) the construal of pictures not as sovereign subjects or disembodied spirits but as subalterns whose bodies are marked with the stigmata of difference, and who function both as "go-betweens" and scapegoats in the social field of human visuality. It's crucial to this strategic shift that we not confuse the desire of the picture with the desires of the artist, the beholder, or even the figures in the picture. What pictures want is not the same as the message they communicate or the effect they produce; it's not even the same as what they say they want. Like people, pictures may not know what they want; they have to be helped to recollect it through a dialogue with others.

I could have made this inquiry harder by looking at abstract paintings (pictures that want not be pictures) or at genres such as landscape where personhood emerges only as a "filigree," to use Lacan's expression.[32] I begin with the *face* as the primordial object and surface of mimesis, from the tattooed visage to painted faces. But the question of desire may be addressed

31. Joel Snyder suggests that this shift of attention is describable by Aristotle's distinction between rhetoric (the study of communication of meaning and effects) and poetics (the analysis of the properties of a made thing, treated as if it had a soul). Thus, the *Poetics* is concerned with a "made thing" or imitation (tragedy), and the plot is declared to be "the soul of tragedy," a conceit that is further elaborated when Aristotle insists on the "organic wholeness" of poetic creations and treats the study of poetic forms as if he were a biologist cataloguing natural kinds. The question for us now, obviously, is what happens to these concepts of making, imitating, and organicism in an era of cyborgs, artificial life, and genetic engineering. For further thoughts on this question, see chapter 15 below.

32. For a discussion of the animation/personification of landscape as idol, see my "Holy Landscape: Israel, Palestine, and the American Wilderness," in *Landscape and Power*, ed. W. J. T. Mitchell, 2nd ed. (Chicago: University of Chicago Press, 2002), 261–90. Lacan's no-

to any picture, and this chapter is nothing more than a suggestion to try it out for yourself.

What pictures want from us, what we have failed to give them, is an idea of visuality adequate to their ontology. Contemporary discussions of visual culture often seem distracted by a rhetoric of innovation and modernization. They want to update art history by playing catch-up with the text-based disciplines and with the study of film and mass culture. They want to erase the distinctions between high and low culture and transform "the history of art into the history of images." They want to "break" with art history's supposed reliance on naive notions of "resemblance or mimesis," the superstitious "natural attitudes" toward pictures that seem so difficult to stamp out.[33] They appeal to "semiotic" or "discursive" models of images that will reveal them as projections of ideology, technologies of domination to be resisted by clear-sighted critique.[34]

It's not so much that this idea of visual culture is wrong or fruitless. On the contrary, it has produced a remarkable transformation in the sleepy confines of academic art history. But is that all we want? Or (more to the point) is that all that pictures want? The most far-reaching shift signaled by the search for an adequate concept of visual culture is its emphasis on the social field of the visual, the everyday processes of looking at others and being looked at. This complex field of visual reciprocity is not merely a by-product of social reality but actively constitutive of it. Vision is as important as language in mediating social relations, and it is not reducible to language, to the "sign," or to discourse. Pictures want equal rights with language, not to be turned into language. They want neither to be leveled into a "history of images" nor elevated into a "history of art," but to be seen as complex individuals occupying multiple subject positions and identities.[35]

tion of the gaze as a "filigree" in landscape appears in Jacques Lacan, *The Four Fundamental Concepts of Psychoanalysis* (New York: Norton, 1978), 101. On the urges of abstract painting, see chapter 11 of the present text.

33. See Michael Taussig's critique of commonplace assumptions about "naive mimesis" as "mere" copying or realistic representation in *Mimesis and Alterity* (New York: Routledge, 1993), 44–45.

34. I am summarizing here the basic claims made by Bryson, Holly, and Moxey in their editorial introduction to *Visual Culture*. For further discussion of the emergent field of visual culture, see chapter 16 below.

35. Another way to put this would be to say that pictures do not want to be reduced to the terms of a systematic linguistics based in a unitary Cartesian subject, but they might be open

They want a hermeneutic that would return to the opening gesture of art historian Erwin Panofsky's iconology, before Panofsky elaborates his method of interpretation and compares the initial encounter with a picture to a meeting with "an acquaintance" who "greets me on the street by removing his hat."[36]

What pictures want, then, is not to be interpreted, decoded, worshipped, smashed, exposed, or demystified by their beholders, or to enthrall their beholders. They may not even want to be granted subjectivity or personhood by well-meaning commentators who think that humanness is the greatest compliment they could pay to pictures. The desires of pictures may be inhuman or nonhuman, better modeled by figures of animals, machines, or cyborgs, or by even more basic images—what Erasmus Darwin called "the loves of plants." What pictures want in the last instance, then, is simply to be asked what they want, with the understanding that the answer may well be, nothing at all.

Coda: Frequently Asked Questions

The following questions have been raised by a number of respondents to this chapter. I'm especially grateful to Charles Harrison, Lauren Berlant, Teresa de Lauretis, Terry Smith, Mary Kelly, Eric Santner, Arnold Davidson, Marina Grzinic, Geoffrey Harpham, Evonne Levy, Françoise Meltzer, and Joel Snyder for their generous interventions.

1. *I find that when I try to apply the question, what do pictures want? to specific works of art and images, I don't know where to start. How does one proceed to ask, much less answer, this question?* No method is being offered here. This might be thought of more as an invitation to a conversational opening or an improvisation in which the outcome is somewhat indeter-

to the "poetics of enunciation" that Julia Kristeva so cogently transferred from literature to the visual arts in her classic text, *Desire in Language* (New York: Columbia University Press, 1980). See especially "The Ethics of Linguistics," on the centrality of poetry and poetics, and "Giotto's Joy," on the mechanisms of *jouissance* in the Assisi frescoes.

36. Erwin Panofsky, "Iconography and Iconology," in *Meaning in the Visual Arts* (Garden City, NY: Doubleday, 1955), 26. For further discussion of this point, see my "Iconology and Ideology: Panofsky, Althusser, and the Scene of Recognition," epilogue to *Reframing the Renaissance: Visual Culture in Europe and Latin America, 1450–1650,* ed. Claire Farago (New Haven, CT: Yale University Press, 1991), 292–300.

minate, rather than an ordered series of steps. The aim is to undermine the ready-made template for interpretative mastery (for example, Panofsky's four levels of iconological interpretation or a psychoanalytic or materialist model that knows beforehand that every picture is a symptom of a psychic or social cause), by halting us at a prior moment, when Panofsky compares the encounter with a work of art to encountering an acquaintance on the street.[37] The point, however, is not to install a personification of the work of art as the master term but to put our relation to the work into question, to make the *relationality* of image and beholder the field of investigation.[38] The idea is to make pictures less scrutable, less transparent; also to turn analysis of pictures toward questions of process, affect, and to put in question the spectator position: what does the picture want from me or from "us" or from "them" or from whomever?[39] Who or what is the target of the demand/desire/need expressed by the picture? One can also translate the question: what does this picture lack; what does it leave out? What is its area of erasure? Its blind spot? Its anamorphic blur? What does the frame or

37. In Panofsky, "Iconography and Iconology." See my discussion in "Iconology and Ideology: Panofsky, Althusser, and the Scene of Recognition." In shifting the encounter with a picture from a model of reading or interpretation to a scene of recognition, acknowledgment, and (what might be called) enunciation/annunciation, I am of course building upon Althusser's notion of interpellation or "hailing" as the primal scene of ideology, and Lacan's concept of the gaze as the moment when one experiences oneself as seen by the Other. See also James Elkins's interesting study, *The Object Looks Back* (New York: Harvest Books, 1997).

38. I'm thinking here of Leo Bersani and Ulysse Dutoit's explorations of relationality and "the communication of forms" in *Arts of Impoverishment* (Cambridge, MA: Harvard University Press, 1993). See discussion of this point and the problem of treating "our relations with art works as an allegory for our relation to persons" in "A Conversation with Leo Bersani," *October* 82 (Fall 1997): 14.

39. This might be seen as a way of going a bit further with Michael Baxandall's astute insight that our language about pictures is "a representation of thinking about having seen the picture," i.e., "we address a relationship between picture and concepts" (Baxandall, *Patterns of Intention* [New Haven, CT: Yale University Press, 1985], 11). Baxandall observes that this "is an alarmingly mobile and fragile object of explanation," but also "exceedingly flexible and alive" (10). My suggestion here is to take the vitalist analogy one step further and to see the picture not just as an object of description or ekphrasis that comes alive in our perceptual/verbal/conceptual play around it, but as a thing that is always already addressing us (potentially) as a subject with a life that has to be seen as "its own" in order for our descriptions to engage the picture's life as well as our own lives as beholders. This means the question is not just what did the picture mean (to its first historical beholders) or what does it mean to us now, but what did (and does) the picture want from its beholders then and now.

boundary exclude? What does its angle of representation prevent us from seeing, and prevent it from showing? What does it need or demand from the beholder to complete its work?

For instance, the tableau of Diego Velázquez's *Las Meninas* (fig. 15) invokes the fiction of being surprised by the spectator, as if "caught in the act." The picture invites us to participate in this game and to find ourselves not just literally in the mirror on the back wall but in the recognizing gazes of the figures—the infanta, her maids, the artist himself. This, at any rate, looks like the explicit demand of the picture, what it claims to need as a minimum for grasping its magic. But of course the "brute facts" are quite the opposite, and are signaled explicitly by a brute—the nearest figure in the picture, the sleepy, oblivious dog in the foreground. The picture only pretends to welcome us, the mirror does not really reflect us or its first beholders, the king and queen of Spain, but rather (as Joel Snyder has shown) reflects the hidden image on the canvas that Velázquez is working on.[40] All these feints and deceptions remind us of the most literal fact about the picture: that the figures in it do not really "look back" at us; they only appear to do so. One might want to say, of course, that this is just a primordial convention of pictures as such, their innate doubleness and duplicity, looking back at us with eyes that cannot see. *Las Meninas,* however, stages this convention in an enhanced, extreme form, posing its *tableau vivant* for sovereign beholders whose authority is subtly called into question even as it is complimented. This is a picture that wants nothing from us while pretending to be totally oriented toward us.

So it is important to keep in mind that in the game called What Do Pictures Want? one possible answer to the question is "nothing": some pictures might be capable of wanting (needing, lacking, requiring, demanding, seeking) nothing at all, which would make them autonomous, self-sufficient, perfect, beyond desire. This may be the condition we attribute to pictures that we think of as great works of art, and we might want to criticize it; but first we need to understand it as a logical possibility entailed in the very notion of a living thing beyond desire.[41]

2. *The whole effort to portray pictures as animated beings raises a set of*

40. Joel Snyder, "*Las Meninas* and the Mirror of the Prince," *Critical Inquiry* 11, no. 4 (June 1985): 539–72.

41. The position beyond desire is, to my mind, what Michael Fried is gesturing toward in his notions of absorption, presence, grace, and the "conviction" elicited by the authentic masterpiece. See the discussion of "Art and Objecthood" in chapter 7 of the present text, and in *Picture Theory,* chap. 7.

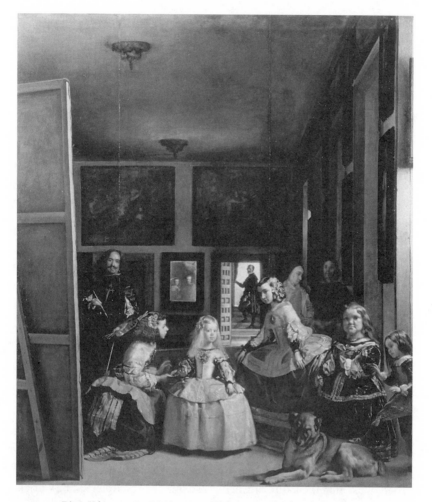

FIGURE 15 Diego Velázquez, *Las Meninas,* 1656. Museo Nacional del Prado, Madrid.

prior questions that are not fully answered here. What constitutes "anima-
tion" or vitality? What defines a living organism as distinct from an inanimate
object? Isn't the notion of the living image a mere conceit that has gotten out
of control? A biology textbook by Helena Curtis[42] gives the following crite-

42. Helena Curtis, *Biology,* 3rd ed. (New York: Worth, 1979), 20–21, quoted in Michael Thompson, "The Representation of Life," in *Virtues and Reasons,* ed. Rosalind Hursthouse, Gavin Lawrence, and Warren Quinn (Oxford: Clarendon Press, 1995), 253–54. On the gene as a fetish concept, see also Donna Haraway, *Modest_Witness@Second_Millennium* (New York: Routledge, 1997), 135.

ria for the living organism: living things are highly organized, homeostatic (stay the same), grow and develop, are adapted, take energy from the environment and change it from one form to another, respond to stimuli, and reproduce themselves. The first thing that must strike us about this list is its internal contradictions and fuzziness. Homeostasis is clearly incompatible with growth and development. "Highly organized" could characterize an automobile or a bureaucracy as well as an organism. Taking energy from the environment and changing it to another form is a common feature of machines as well as organisms. "Responding to stimuli" is vague enough to cover photographic emulsions, weather vanes, and billiard balls. And organisms do not, strictly speaking, reproduce *themselves* when they have offspring—they produce new specimens which are usually of the same species as themselves; only clones can come close to being identical reproductions of themselves. There is, as philosopher Michael Thompson has demonstrated, no "real definition" of life, no set of unambiguous empirical criteria to differentiate living from nonliving substance (including, it must be said, the presence of DNA, which Thompson correctly identifies as the fetish concept of our time). Life is rather what Hegel called a "logical category," one of the primitive concepts that grounds the whole process of dialectical reasoning and understanding.[43] Indeed, the best definition of a living thing is a straightforward dialectical statement: a living thing is something that can die.

The question remains, however: how do pictures resemble life-forms? Are they born? Can they die? Can they be killed? Some of Curtis's criteria don't fit pictures in any obvious way and require modification. "Growth and development" might characterize the process by which an image is realized in a concrete picture or work of art, but once completed, the work is normally homeostatic (unless we think its aging and reception history constitutes a kind of "development" like that of a life-form;[44] remember that Walter Benjamin thought that history and tradition were exactly what conferred "aura"—literally, "breath"—on the work of art). A similar point might be made about the taking of energy from the environment, unless we think of the mental energy required of the beholder as coming from the environment and returning transformed in the act of reception. The re-

43. Thompson, "The Representation of Life."

44. See the discussion of the "lives of buildings" in Neil Harris, *Building Lives* (New Haven, CT: Yale University Press, 1999), and in chapter 1 above.

sponse to stimuli is realized literally in certain "interactive" artworks, figuratively in more traditional works. As for "reproducing themselves," what else is implied when the proliferation of images is discussed in biological figures as a kind of epidemic, as implied in the title of theorist Slavoj Žižek's *The Plague of Fantasies*? How do fantasies come to be like an infectious disease, an out-of-control virus or bacteria? Dismissing these as "merely figurative" forms of life or animation begs the question that is at issue: the life of images, pictures, and figures, including, obviously, their figurative life. The uncontrollability of the conceit of the living image is itself an example of the problem: why does this metaphor seem to have a life of its own? Why is it so routine that we call it a "dead" metaphor, implying that it was once alive and might come alive again?

But rather than allow the biology textbooks to dictate what it means to think of a picture as a living thing, we might be better advised to start from our own ordinary ways of talking about pictures as if they were animated. The praise of the "lifelike" image is, of course, as old as image-making, and the liveliness of an image may be quite independent of its accuracy as a representation. The uncanny ability of pictured faces to "look back" and in the technique of omnivoyance to seem to follow us with their eyes is well established. Digitized and virtual imaging now make it possible to simulate the turning of the face or the body to follow the movement of the spectator. Indeed, the whole distinction between the still and moving image (or, for that matter, the silent and talking image) has routinely been articulated as a question of life. Why is the moving image invariably characterized with vitalist metaphors such as "animation" and "live action"? Why is it not enough to say that the images move, that actions are depicted? Familiarity blinds us to the strange life of these figures; it makes them dead metaphors at the same time it asserts their vitality. To make an image is to mortify and resurrect in the same gesture. Film animation begins, as is well known, not with just any old image material but with the fossil, and the reanimation of extinct life. Winsor McCay, the father of animation, films himself in "live action" sequences viewing the skeleton of a dinosaur in a natural history museum, and wagering his fellow artists that he can bring this creature back to life in three months, a magical feat he pulls off with one of the earliest examples of film animation.[45]

45. For a more detailed discussion, see W. J. T. Mitchell, *The Last Dinosaur Book: The Life and Times of a Cultural Icon* (Chicago: University of Chicago Press, 1998), 25, 62.

Cinema theorist André Bazin opens his discussion of "The Ontology of the Photographic Image" by animating and personifying image-making in a single gesture: "if the plastic arts were put under psychoanalysis, the practice of embalming the dead might turn out to be a fundamental factor in their creation."[46] Bazin assures us, however, that modern, critical consciousness has overcome archaic superstitions about images, corpses, and mummification, and his invocation of psychoanalysis is meant to reassure us of that: "No one believes any longer in the ontological identity of model and image"; now the image simply "helps us to remember the subject and to preserve him from a second spiritual death" (10). But within a few pages Bazin is directly contradicting himself, and asserting a greater magic for photography than was ever possible for painting: "The photographic image is the object itself. . . . It shares, by virtue of the very process of its becoming, the being of the model of which it is the reproduction; it *is* the model" (14). If Winsor McCay's animation brought the fossilized creature back to life, Bazin's images do just the opposite: photography "preserve[s] the object, as the bodies of insects are preserved intact . . . in amber," and the cinematic image is "change mummified, as it were" (14–15). One wonders if director Steven Spielberg was remembering this passage when he decided to use the preservation of dinosaur blood and DNA in the bodies of mosquitoes as the technical premise for the resurrection of dinosaurs in *Jurassic Park*.

So there is no use dismissing the notion of the living image as a mere metaphor or an archaism. It is better seen as an incorrigible, unavoidable metaphor that deserves analysis. One might begin by thinking through the category of life itself in terms of the square of opposition that governs its dialectics:[47]

living	*dead*
inanimate	*undead*

The living organism has two logical opposites or contraries: the dead object (the corpse, mummy, or fossil), which was once alive, and the inanimate object (inert, inorganic), which never was alive. The third opposition is, then, the negation of the negation, the return (or arrival) of life in the

46. André Bazin, *What Is Cinema?* trans. Hugh Gray (Berkeley and Los Angeles: University of California Press, 1971), 9.

47. I follow here Fred Jameson's use of the "semantic rectangle," a logical structure pioneered by the linguist A. J. Greimas and adopted in a variety of forms by Claude Lévi-Strauss and Jacques Lacan. See Jameson, *The Prison-House of Language* (Princeton, NJ: Princeton University Press, 1972), 161–67.

nonliving substance, or the mortification of life in the image (as in a *tableau vivant*, where living human beings impersonate the inanimate figures of painting or sculpture). The figure of the "undead" is perhaps the obvious place where the uncanniness of the image comes into play in ordinary language and popular narrative, especially the tale of horror, when that which should be dead, or should never have lived, is suddenly perceived as alive. (Think here of the exultant mock horror and delight expressed by actor Gene Wilder in *Young Frankenstein* when he declares, "It's alive!" Think again of Bazin's mummy and the endless fascination of Hollywood with myths of the return of the mummy.) No wonder that images have a spectral/corporeal as well as spectacular presence. They are ghostly semblances that materialize before our eyes or in our imaginations.

3. *You slide back and forth between verbal and visual notions of the image, between graphic, pictorial symbols on the one hand and metaphors, analogies, and figurative language on the other. Does the question, what do pictures want? apply to verbal images and pictures as well as to visual ones?* Yes, with qualifications. I've discussed the nature of the verbal image and textual representation at length in *Iconology* and *Picture Theory*. All the tropes of vitality and desire we apply to visual works of art are transferred and transferable to the domain of textuality. That doesn't mean they are transferable without modification or translation. I'm not saying a picture is just a text, or vice versa. There are deep and fundamental differences between the verbal and visual arts. But there are also inescapable zones of transaction between them, especially when it comes to questions such as the "life of the image" and the "desire of the picture." Hence the secondary figure or metapicture of the "dead metaphor" or the oft-noted authorial observation that a text is beginning to "come to life" when it "wants to go on" in a certain way, regardless of the wishes of the writer. The figure of the cliché is an onomatopoetic trope that links the worn-out idea or phrase to a process of picture-making that, paradoxically, is equated with the moment of fresh coinage, the "click" that accompanies the birth of an image in the process of striking a die to make a proof or cast. It is as if the birth of an image cannot be separated from its deadness. As Roland Barthes observed, "what I am seeking in the photograph taken of me . . . is Death." But this cliché or "click" of the camera is "the very thing to which my desire clings, their abrupt click breaking through the mortiferous layer of the Pose."[48]

48. Roland Barthes, *Camera Lucida*, trans. Richard Howard (New York: Hill & Wang, 1981), 15.

4. *You ask us to believe that pictures have desires, but you do not explain what desire is. What theory of desire are you working from? How is desire to be pictured? What model, theory, or image of desire is operating in the desire of pictures? Is this human desire, and if so, what is that? Why do you plunge into the topic of "what pictures want" without first establishing a theoretical framework, such as the psychoanalytic account of desire (Freud, Lacan, Žižek; questions of libido, eros, the drives, fantasy, symptoms, object choice, etc.)?* This question deserves an essay all to itself, which is provided by the next chapter.

Let us say, "This painting has no drawing," as we used to say of certain forms, "They have no life." ︙ YVES BONNEFOY, *"Overture: The Narrow Path toward the Whole" (1994)*

The question of what pictures want leads inevitably to a reflection on what picture we have of desire itself. Some might argue, of course, that desire is invisible and unrepresentable, a dimension of the Real that remains inaccessible to depiction. We might be able to talk about, or at least talk *around*, desire with the technical languages of psychoanalysis or biology, but we can never see, much less show, desire in itself. Art refuses to accept this prohibition, and insists on depicting desire—not just the desirable object, the beautiful, shapely, attractive form, but the force field and face of desire itself, its scenes and figures, its forms and flows. Desire as eros is given the familiar personification of the infantile cupid, the baby archer drawing back his bow and unleashing what Blake called "the arrows of desire." Desire is doubly represented in this allegory, personified as a baby boy and figured as an arrow. It is both the body and the weapon that wounds the body, both an agent (the archer) and the instrument (the bow and arrow).[1] And the very act of image-making itself is often depicted as a symptom of desire— or is it the other way around? Is desire a symptom (or at least a result) of image-making, and the tendency of images, once made, to acquire desires of their own, and provoke them in others? God makes man in his own image, according to Milton, out of a desire not to be alone. Man, as image of God, has desires of his own, and asks for a mate to love him in turn. Nar-

1. Cupid was originally a comely youth, not a baby. The infantilizing of desire in Greek art is perhaps an iconic foreshadowing of Freud's turn to "infantile desire" as a critical concept. My thanks to Richard Neer for pointing this out.

cissus finds his own reflected image in the water, and drowns in the act of taking possession of what he mistakenly supposes to be a beautiful young man who is returning his passionate gaze. Pygmalion makes an ivory statue of a beautiful woman, and falls so passionately in love with it that it comes alive and becomes his loving wife, bearing him a son.[2]

It seems, then, that the question of desire is inseparable from the problem of the image, as if the two concepts were caught in a mutually generative circuit, desire generating images and images generating desire. The great English painter J. M. W. Turner traced the origin of drawing itself to the onset of love, as a way of adding "homely proof" to a truth already expressed in music. Turner's poem, "The Origin of Vermilion, or the Loves of Painting and Music," rewrites the ancient legend that the first drawing was a tracing of the silhouette of the beloved, using vermilion, the red ochre or cinnabar that "chance" put in the artist's hand.

THE ORIGIN OF VERMILION, OR
THE LOVES OF PAINTING AND MUSIC

In days that's past beyond our ken
When Painters saw like other men
And Music sang the voice of truth
Yet sigh'd for Painting's homely proof

Her modest blush first gave him taste
And chance to Vermilion gave first place
As snails trace o'er the morning dew
He thus the lines of beauty drew

Those far faint lines Vermilion dyed
With wonder view'd—enchanted cried

2. Pygmalion's Galatea is awakened from her inanimate form by a kiss (Ovid, *Metamorphoses*, 10.261–326; cf. the devotional kissing of the Christian icon, discussed in chapter 2). This "Pygmalion effect" might be contrasted with the "Medusa effect" and the familiar symptomatology of the "Narcissus effect" as a survey of the basic possibilities in the beholder-image relation: the image as a deadly lure that swallows or drowns the beholder; as a mimetic charm that turns the beholder into a paralyzed image; as a fulfilled fantasy that mates with the beholder. See the discussion by Hillis Miller in *Versions of Pygmalion* (Cambridge, MA: Harvard University Press, 1990), 3. Miller points out that the fashioning of Galatea is a "compensatory gesture" sparked by Pygmalion's vow to remain celibate after his horror at the "loathsome Propoetides," who have denied the divinity of Venus and are punished by being turned into prostitutes.

Vermilions honors mine and hence to stand
The Alpha and Omega in a Painters hand [3]

As the phrase "Loves of Painting" in Turner's title makes clear, this is not just painting as an instrument or object of love but painting as itself a thing that loves, a thing that is drawn toward an object. This becomes clearer if we reflect on the double meaning of *drawing* as an act of tracing or inscribing lines, on the one hand, and an act of pulling, dragging, or attracting, on the other, as when we talk of a horse-drawn buggy, drawing water from a well, drawing back a bowstring to release the arrows of desire, or "drawing and quartering" a human body in that most grotesque form of capital punishment. "Drawing Desire," then, is meant not just to suggest the depiction of a scene or figure that stands for desire, but also to indicate the way that drawing itself, the dragging or pulling of the drawing instrument, is the performance of desire. Drawing draws us on. Desire just *is*, quite literally, drawing, or *a* drawing—a pulling or attracting force, and the trace of this force in a picture. Turner wants to insist that this is a natural force, that the painter works like the snail leaving its glistening trail in the morning dew—drawn on blindly, laying down the sinuous "lines of beauty" (compare Lacan's description of the painter and the "rain of the brush": "If a bird were to paint would it not be by letting fall its feathers, a snake by casting off its scales, a tree by letting fall its leaves?").[4]

William Hogarth's serpentine line of beauty (fig. 16) and the spiraling contours of Blake's and Turner's vortices may be seen, then, as the elementary geometry of the force field of desire.[5] Hogarth associates the serpentine line with the figure of the satanic seducer who "lures the eye" of Eve, drawing her on with his sinuous form. Blake, as we shall see, links the serpentine with the "lineaments of gratified desire" in the human form (fig. 17). Turner, as the greatest English colorist, wants to insist that the birth of drawing is inseparable from the birth of painting. The first drawing is not just some black-and-white schematic outline but the vermilion of the

3. From *The Sunset Ship: The Poems of J. M. W. Turner*, ed. Jack Lindsay (Lowestoft, Suffolk: Scorpion Press, 1966), 121.

4. Jacques Lacan, *The Four Fundamental Concepts of Psychoanalysis* (New York: Norton, 1977), 114.

5. For further elaboration, see my "Metamorphoses of the Vortex: Hogarth, Blake, and Turner," in *Articulate Images,* ed. Richard Wendorf (Minneapolis: University of Minnesota Press, 1983), 125–68.

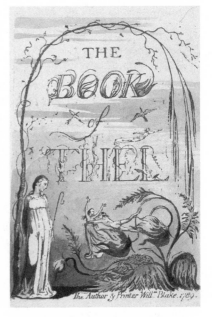

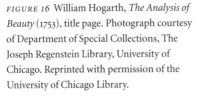

FIGURE 16 William Hogarth, *The Analysis of Beauty* (1753), title page. Photograph courtesy of Department of Special Collections, The Joseph Regenstein Library, University of Chicago. Reprinted with permission of the University of Chicago Library.

FIGURE 17 William Blake, *The Book of Thel* (1789), title page, copy H, plate 2. Lessing J. Rosenwald Collection, Library of Congress. Copyright © 2003 the William Blake Archive. Used with permission.

rosy dawn, the glistening trail of dew, the red of earth and blood, and the blush of love. Turner, drawn to light and color like a moth to the flame, draws desire *in* light and color. Ultimately, one supposes, the birth of color field painting will experiment with a form of pictorial desire that renounces drawing altogether, immersing the beholder in a sea of color from which the figure has been banished.

One might want to begin thinking about pictures of desire, then, not with persons—that is, with personifications and the psychology of desire— but with impersonal, even inanimate pictures of desire as a kind of gravitational pull or magnetism (what I have been calling "desire-as-drawing"), from the ancient materialists' treatment of desire as the fundamental attractive force that binds the universe together (Empedocles' notion that Eros and Strife are the two primal forces), to Aristotle's picture of the planetary spheres as held together by love, with the Beloved in the position of

Unmoved Mover and the lovers in the position of the moving planets,[6] all the way down to the notion of "binding" and "unbinding" in Freud's treatment of the alternation between the pleasure principle and the death drive.[7]

In addition to its antithetical relation to principles of strife or aggression, human desire itself has traditionally been pictured in contrary ways: associated with the dark passions, appetites, and "lower nature" of the brutes on the one hand and idealized as the aspiration to perfection, unity, and spiritual enlightenment on the other. It should come as no surprise that the desires of pictures would be bifurcated along similar lines. There is also the contrast between the Freudian picture of desire as lack and longing for an object, and the Deleuzian picture of desire as a constructed "assemblage" of concrete elements, a "desiring machine" characterized by a joy founded in (but not disciplined by) ascesis.[8] The anti-Freudian, Deleuzian picture of desire is interrupted by pleasure, not driven by it. It is given graphic form in William Blake's reflections on the topic in *There is No Natural Religion*: "The desire of Man being Infinite the possession is Infinite & himself Infinite" (fig. 18); "If any could desire what he is incapable of possessing, despair must be his eternal lot" (fig. 19); "More! More! Is the cry of the mistaken soul, less than All cannot satisfy Man."[9] Blake depicts the "mistaken" picture of desire (the one that leads to despair, or neurosis, psychosis, and the "plague of fantasies," in Freudian terms) as a figure trying to climb a ladder to the moon, crying "I want, I want" (fig. 20). The "mistake" here, however, is not the "desire for the moon," and the moral lesson is not "be satisfied with less." The mistake lies in the fetishistic fixation on a single signifier or part object, the failure to demand totality: not just the moon but the sun and the stars—the whole assemblage—as well. And the "moral" is to insist on the infinity of desire.

6. See F. E. Peters, *Greek Philosophical Terms: A Historical Lexicon* (New York: New York University Press, 1967), s.v. "eros," 62–66.

7. I rely here heavily on Richard Boothby's excellent study, *Death and Desire: Psychoanalytic Theory in Lacan's Return to Freud* (New York: Routledge, 1991). See pp. 83–84. Boothby is especially good at separating Freud's notion of the death instinct from any biological urge to self-destruction, giving it instead a psychological interpretation that connects it to the iconoclastic drive to shatter images, in this case specifically, the imagoes that stabilize the ego or unitary subject.

8. Gilles Deleuze, "What Is Desire?" in *The Deleuze Reader*, ed. Constantin Boundas (New York: Columbia University Press, 1993), 140: "Ascesis has always been the condition of desire, not its disciplining or prohibition. You will always find an ascesis if you think of desire."

9. From *The Poetry and Prose of William Blake*, ed. David Erdman (Garden City, NY: Doubleday, 1965), 2.

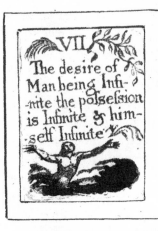

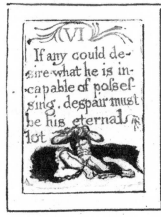

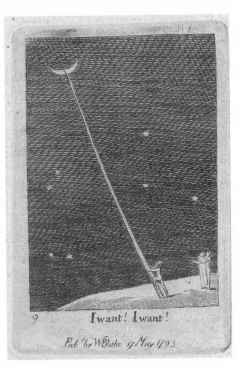

FIGURE 18
William Blake, *There is No Natural Religion* (1788),
VII, "The desire of Man being Infinite," copy L.
The Pierpont Morgan Library, New York City.
© The Pierpont Morgan Library, New York.

FIGURE 19
William Blake, *There is No Natural Religion* (1788),
VI, "Despair must be his eternal lot," copy L.
The Pierpont Morgan Library, New York City.
© The Pierpont Morgan Library, New York.

FIGURE 20
William Blake, *For the Sexes: The Gates of Paradise*,
"I want! I want!" copy D, plate 11, ca. 1825. Lessing J.
Rosenwald Collection, Library of Congress. Copyright
© 2003 the William Blake Archive. Used with
permission.

But what would an insistence on the infinity of desire mean? Does it imply merely that "greed is good," the credo of the capitalist speculator, Gordon Gekko, in Oliver Stone's *Wall Street*? Gekko is asked by his protégé, "When do you have enough? How many cars and planes and houses can you own?" And Gekko's reply is: "You still don't get it, do you, buddy boy. The money is just a way of keeping score." "More, more" is the only point in this game. But Blake (like Deleuze) links desire to ascesis, to the dialectic of binding and unbinding. His infinite desire does not mean the quantitative infinity of "indefinite" extension and expansion but the "definite & determinate Identity" figured by the "bounding line"—the drawn line that leaps across a boundary at the same time that it defines it, producing a "living form."

Blake illuminates the dialectics of desire as expressed in the human body's relation to space. One thinks immediately of the "lineaments of gratified desire" in his scenes of resurrection, repose after sex, liberation from slavery, or "kissing the joy as it flies" (fig. 21). But equally compelling are his images of ungratified desire as despair, or his images of ambivalence and envy in the face of gratified desire. The figure of "Thel" (a name probably derived from the Greek term for "will" or "wish") observes the whirlwind of ecstatic *jouissance*, her body's *contrapposto* expressing both attraction to and repulsion from the scene of gratified desire (fig. 17). This vortex of desire is vividly captured in Blake's engraving for *The Divine Comedy*, "The Circle of the Lustful" (fig. 22), in which Dante is shown collapsed in a swoon after beholding the lovers Paolo and Francesca caught up in the whirlwinds of passion. Most complex, perhaps, is the picture of what might be called "rational desire" in his famous image of the demiurge or creator-god, Urizen, with the compasses (fig. 23). This image captures the moment when desire merges with the drive, when the "binding" and "unbinding" of desire are fused in a single image. Urizen has already inscribed himself inside a circle, and is caught in the act of breaking out of that circle only to inscribe another one. One could hardly ask for a more vivid depiction of what Blake calls the "bounding line," the line that binds, confines, and determines a boundary, and the line that leaps over a boundary, like a gazelle "bounding" over a fence. If this is a picture of the infinite desire for orderly, rational boundedness reproducing itself, we might match it with its unbounded counterpart, the figures of "plague winds" blighting the wheat (fig. 24). From the Blakean perspective, even the "plague of fantasies" presents a beautiful, joyous aspect of exuberance and plenitude, and desire is revealed as a process of creative destruction.

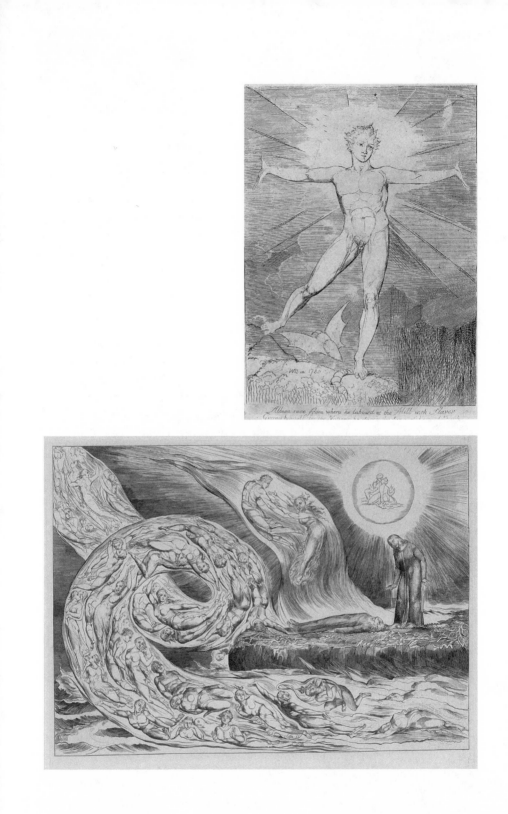

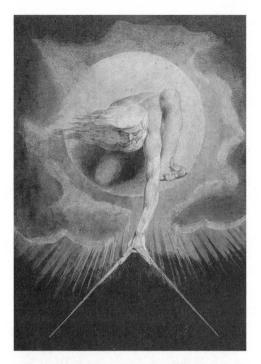

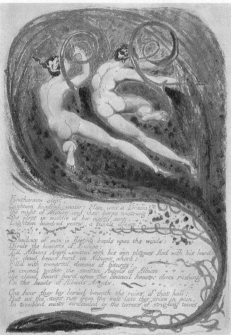

We might contrast these two pictures of desire (psychological and onto-
logical, or Freudian-Lacanian and Blakean-Deleuzian) as based respec-
tively in lack and plenitude, in the longing for an object and the possession
that surpasses any object. Desire as longing produces fantasies, evanescent
specular images that continually tease and elude the beholder; desire as
possession produces (or is produced by) Deleuzian "assemblages." These
two pictures of desire come together, as it happens, in the classical legend
that drawing originated in love. Pliny the Elder's *Natural History* tells the
story (also echoed by Turner) of the Maid of Corinth, who "was in love with
a young man; and she, when he was going abroad, drew in outline on the
wall the shadow of his face thrown by the lamp." This scene, which has been
represented often in Western art (fig. 25), expresses both pictures of desire
in a single scene; it has its cake and eats it too.[10] The shadow is not itself
a living thing, but its likeness and projection of the young man are both
metaphoric and metonymic, icon and index. It is thus a ghostly effigy that
is "fixed" (as in a photographic process) by the tracing of the outline and
(in Pliny's further elaboration) eventually realized by the maiden's father in
a sculptural relief, presumably after the death of the departed lover.[11] So the
image is born of desire, is (we might say) a symptom of desire, a phantas-
matic, spectral trace of the desire to hold on to the loved one, to keep some
trace of his life during his absence. The "want" or lack in the natural image
(the shadow) is its impermanence: when the young man leaves—in fact,
when he moves a few feet—his shadow will disappear. Drawing, like pho-
tography, is seen to originate in the "art of fixing the shadow."[12] The silhou-
ette drawing, then, expresses the wish to deny death or departure, to hold
on to the loved one, to keep him present and permanently "alive"—as in
Bazin's "mummified image" in the film still.[13]

10. See Victor Stoichita's brilliant discussion of this theme in *A Short History of the Shadow*
(London: Reaktion Books, 1997), 16. On the Corinthian Maid, see also Robert Rosenblum,
"The Origin of Painting: A Problem in the Iconography of Romantic Classicism," *Art Bul-
letin* 39 (1957): 279–90.

11. Pliny the Elder, *Natural History* 25.151–52.

12. See William Henry Fox Talbot, "Some Account of the Art of Photogenic Drawing, or
The Process by Which Natural Objects May Be Made to Delineate Themselves without the
Aid of the Artist's Pencil" (London: R. and J. E. Taylor, 1839). Talbot's phrase, "the art of fix-
ing a shadow," is the title of the fourth section of his pamphlet. Thanks to Joel Snyder for this
reference.

13. See discussion of Bazin's metaphor of cinematic "mummification" in chapter 2.

FIGURE 25
Anne-Louis Girodet-Trioson,
The Origin of Drawing, engrav-
ing from *Oeuvres posthumes*,
1819. Photograph courtesy of
The University of Chicago
Library.

Of course, this last remark suggests that the picture could equally well be read as the symptom of a wish for the young man's death, a (disavowed) desire to substitute a dead image for the living being. The picture is as much about "unbinding" the bonds of love, letting the young man depart, disintegrating the imaginary unity of his existence into the separable parts of shadow, trace, and substance. In the world of image magic, the life of the image may depend on the death of the model, and the legends of "stealing the soul" of the sitter by trapping his image in a camera or a manual production would be equally relevant here.[14] We can imagine the young woman coming to prefer her depicted or (even better) sculpted lover as a more

14. George Catlin tells the anecdote of his profile portrait of an Indian warrior, seen by the sitter as a premonition of his "loss of face" (the half that is turned away in a profile). This premonition is fulfilled when the warrior gets into a fight with one of his comrades over the supposedly mutilated likeness and has half his face blown off in the ensuing struggle. See *North American Indians* (New York: Penguin Books, 1996), 240; originally published as *Letters and Notes on the Manners, Customs and Conditions of the North American Indians* (1844).

pliable and reliable partner, and rejecting the young man should he ever re-
turn to Corinth.[15]

In the version of this painting by Anne-Louis Girodet-Trioson (fig. 25),
desire itself appears in the form of cupid, who holds up the torch to create
the projected shadow *and* guides the young woman's hand to trace the sil-
houette, lending her his arrow to use as the drawing instrument. This might
be called the dissemination of desire, which plays at least three roles here as
agent within the scene, supplier of the tool or instrument of drawing, and
stager or scenographer who sets up the entire tableau. Desire is thus at both
"ends" of the scene of love, and in the middle and all around it.

There is simply no getting around the dialectics of life and death, desire
and aggression, in the fundamental ontology of the image. The Freudian
fort-da game of appearance and disappearance, the endless shuttling of the
image between presence and absence, duck and rabbit, is constitutive of the
image. Which is also to say that the capacity for image formation is consti-
tutive of desire in both the Freudian and Deleuzian framework. Images
both "express" desires that we already have, and teach us how to desire in
the first place. As singular objects of longing and lack, figures of the quest
for pleasure, they paradoxically unleash a multitude of images, the plague
of fantasies. As assemblages, constructed collectivities, they "create a desire
by constructing the plane which makes it possible."[16] In this plane, Deleuze
argues, pleasure only figures as "an interruption in the process of desire as
constitution of a field of immanence" (139). I take this field to be, among
other things, the site of the picture as a material assemblage of image and
support, virtual and actual signifiers, and a situation of beholding.

Perhaps that is why I resist starting with Freudian theory to address the
desire of pictures. If one were to start from Freud, Lacan, Žižek, and com-
pany, one would quickly encounter the whole problematic of images and
pictures in the form of the imago, fantasy, fetishism, narcissism, the mirror
stage, the Imaginary and Symbolic, representation, representativity, and
representability; screen memories, symptoms, and (in Lacan) the montage
of the drives.[17] In other words, one would find that the model of desire is al-
ready constructed around a set of assumptions about the nature of images,
their role in psychic and social life, their relation to the Real, to fetishism,

15. A suggestion I owe to Geoffrey Harpham.

16. Boundas, ed., *The Deleuze Reader*, 137.

17. "If there is anything resembling a drive it is a *montage*" (Jacques Lacan, *Four Funda-
mental Concepts of Psychoanalysis* [New York: Norton, 1977], 169).

obsession, ego construction, object choice, identification, and any number of topics. And then, having reconstructed the psychoanalytic picture of desire, and the role of images in that picture, one would be back to the initial question: what do *pictures* want?[18] I prefer to start in this place, and to let psychoanalytic and other pictures of desire come into play as needed, as they appear in specific cases. Perhaps iconology has some insight it can bring to psychoanalysis.

There are clearly other reasons for delaying the onset of Freudian vocabularies in thinking about images. For one thing, the use of these terms is a guarantee (especially in the United States) of producing resistance in a certain common reader who decided long ago to tune out when terms like *ego* and *superego* and *narcissism* and *castration* take over. I prefer to start from a more generally accessible vernacular framework, the ordinary language of images, and from the work of art historians, iconologists, and aestheticians whose main emphasis is on images in the world rather than in the psyche. I hope it is not regarded as anti-intellectual of me to admit to some impatience with the authoritative (and authoritarian) aura of the One Who Is Supposed to Know the Freudian tongues. I like it best when a Freudian talks to a non-Freudian, as in the writing of theorists Leo Bersani and Ulysse Dutoit, or when Žižek talks to himself.

There is also, more fundamentally, the structural hostility of psychoanalysis toward images and visual representation. Classically, the Freudian attitude is that the image is a mere symptom, a substitute for an impossible desire, an illusory semblance or "manifest content" that is to be decoded, demystified, and ultimately eliminated in favor of a latent content expressed in language. In *The Interpretation of Dreams*, Freud remarks on "the incapacity of dreams" to express logical connections and latent dream-thoughts because, like "the plastic arts of painting and sculpture," they "labour . . . under a similar limitation as compared with poetry," the inability to speak for themselves.[19] At best, "the function of the imago is its power to unify and integrate," but this has the unfortunate tendency "toward temporal inertia

18. We might think of this alternative strategy as Blakean and Deleuzian. It treats desire as an assemblage, a concrete constellation of elements, figure-ground relations, and conjunctions manifesting the lineaments of "gratified desire" or "joy."

19. See Sigmund Freud, *The Interpretation of Dreams*, trans. and ed. James Strachey (New York: Avon Books, 1965), 347. See also my discussion in *Iconology* (Chicago: University of Chicago Press, 1986), 45.

and fixity" in the formation of the human subject.[20] Psychoanalysis, as is often observed, was fundamentally constituted as a linguistic turn and a turn away from reliance on the visual observation of symptoms. In contemporary, post-Lacanian thought, there is a tendency to treat fantasy, the scopic drive, the imagoes (ego ideals and ideal egos), stable constituted selves, unitary subjectivities—as false images that bamboozle the Ones Who Are Supposed to Believe. If fantasies are a plague, psychoanalysis is the cure. The paradoxical result of the psychoanalytic suspicion of images is that the discourse most fully equipped to produce an analysis of desire is, to some extent, disinclined to ask questions about what pictures want.

Žižek plays both sides, I think, in the love-hate relation of psychoanalysis to the image and its iconoclastic critical reflexes. He debunks the authoritarian figure of the One Who Is Supposed to Know, and criticizes the idea that images are merely false symptoms or illusions that can be swept away by critique. "Fantasy does not simply realize a desire in a hallucinatory way: rather its function is similar to that of Kantian 'transcendental schematism': a fantasy constitutes our desire . . . it teaches how to desire."[21] Fantasy, moreover, is not exclusively a private or subjective theater for Žižek. It is "outside," and it is where the truth is displayed for all to see, especially in the spectacles and narratives of mass culture. Fantasy corresponds, roughly, to media, and specific fantasies to the images that circulate in the media.

It is when Žižek turns to his Manichean ethical/political allegory of the stabilized image of a unitary ego (bad) in a struggle against the disintegrating tendencies of the death drive (good) that the rhetoric of iconoclasm returns, and my resistance is activated. "The properly modern ethics of 'following the drive' clashes with the traditional ethics of leading a life regulated by proper measure and subordination of all its aspects to some notion of the Good" (37). The "common wisdom" that some kind of negotiation between these demands is possible is immediately dismissed: "the balance between the two can never be achieved: the notion of reinscribing scientific drive into the constraints of life-world is fantasy at is purest— perhaps the fundamental Fascist fantasy" (38). (Perhaps I am not understanding what is meant by fascism here. To me, fascism occurs when the police are breaking into private homes at night, and a state has declared an indefinite state of emergency that justifies everything it does and consoli-

20. Richard Boothby, *Death and Desire: Psychoanalytic Theory in Lacan's Return to Freud* (Routledge, 1991), 25.

21. Slavoj Žižek, *The Plague of Fantasies* (New York: Verso, 1997), 7.

dates all power in the hands of a leader and a political party—the present condition, by the way, of my own country.) "Negotiation" between modern and traditional ethics strikes me as difficult, but not impossible, and I don't see why such negotiations are a "fascist fantasy." When, in a similar vein, Žižek characterizes the struggles of leftist "rainbow coalition" politics in the United States as "an abandonment of the analysis of capitalism as a global economic system" (128), and dismisses these efforts as not only failures but mere symptoms of the system they oppose, then one wants to turn the debate onto a more specific and local political terrain. Perhaps these claims make a kind of sense in Ljubljana that is not evident to someone from Chicago.

So there are two Žižeks for me: the good Žižek, who is an anarchist, a magnificent if sometimes perverse interpreter and speculative theorist, not to mention a fabulous stand-up comedian; this is the figure from whom I "learn, learn, learn," to quote him quoting Lenin. But then there is the bad Žižek, who is a fundamentalist, a paranoiac, a Leninist, and (that terrible temptation) a moralist.[22] Probably the two are inseparable, and I am not urging that one of them be abandoned; my sense is that the "Žižek effect" absolutely depends on the co-presence of both sides. The good Žižek affirms the Imaginary and plunges us into the Real; the bad Žižek pronounces the law of the Symbolic. I prefer to "learn, learn, learn" from the good Žižek, from his relentless positive engagement with fantasy-as-collective-reality and bracket the politics that motivates it—a politics that I do not find useful in a U.S. context, whatever force it might have in the specific situation in Slovenia. In his embrace of the plague of fantasies, Žižek advances the Freudian tradition toward a Nietzschean "sounding-out" of the images and idols we have created.

So my aim here is to delay, not prevent, the onset of Freudian categories for the picturing of desire. For finally, the categories of death and desire elaborated by Freudian theory take us into the heart of the lives of images. Other disciplines—art history, aesthetics, visual culture, film and media studies, anthropology, theology—make the question of what pictures want unavoidable, but psychoanalysis may be the only discipline that really allows us to answer it by plumbing the depths of the image—to sound out the idols. Here is a beginning, then, to reformulating the question of the desiring image in terms of Freudian categories.

22. Arnold Davidson reminds me that Freud regarded the position of the pervert as the equivalent of the anarchist, and paranoia as the symptom of the fundamentalist.

1. *Desire versus drive.* What difference does it make if we construe what pictures want as a question of desire or drive? One way to frame this issue would be to contemplate the difference between the still and moving image, the singular and the serial image, or (as we will see) between the picture (as a concretely embodied object or assemblage) and the image (as a disembodied motif, a phantom that circulates from one picture to another and across media). The picture wants to hold, to arrest, to mummify an image in silence and slow time. Once it has achieved its desire, however, it is driven to move, to speak, to dissolve, to repeat itself. So the picture is the intersection of two "wants": drive (repetition, proliferation, the "plague" of images) and desire (the fixation, reification, mortification of the life-form). One sees this clearly in the scene of the Corinthian Maid (fig. 25). There the outline drawing, the fatherly potter who will materialize and fix the image in three dimensions, the youth himself, and his shadow are all co-present in the scene of the birth of an image. The drive of pictures (to replicate themselves as images, mere shadows or traces) is here captured within a single, still image. The scene is a metapicture of what pictures want, and how people help them get it. Perhaps it is a Deleuzian assemblage, showing the possibility of (for a moment) eating one's cake and having it too. I will leave it to others to speculate on what it means that the model in this case is a male, the painter a female, and the sculptor her father. This scene of the origins of painting in desire clearly does not conform to the stereotyped scene of the male artist and the feminized model-image.

2. *The scopic drive.* No discussion of what pictures want can get very far without engaging the question of desire and aggression in the visual field, and, indeed, the very structure of visual cognition and recognition as fundamental social practices. The role of images in relation to the scopic drive, therefore, needs to be fully explored, not by reducing images to mere symptoms of the drive, but as models and constitutive schematisms for the visual process itself. If pictures teach us how to desire, they also teach us how to see—what to look for, how to arrange and make sense of what we see. Beyond that, if Lacan is correct that the drives can only be represented by a montage, then seeing itself only becomes visible and tangible in pictures of various kinds. The question of the picture as a condensation of the scopic is also an inevitable part of investigating the limits of a purely visual notion of the picture, and the very concept of visual media as such.[23]

23. These issues will be explored in more detail in the final chapter.

3. *Demand/Desire/Need.* What do pictures need? A material support, a bodily medium (paint, pixels), and a place to be seen. What do they demand? To be looked at, to be admired, to be loved, to be shown. What do they desire? Since desire emerges in the gap between demand (the wish to see or the symbolic mandate: "thou shalt not look") and need, it is conceivable that pictures could desire nothing. They could have everything they need, and their demands could be all fulfilled. But in fact, most pictures want something. Consider the average portrait, standing in a portrait gallery with hundreds of others, waiting for someone to pay attention to it. Average portraits—that is, the conventional, official images of forgotten personages by forgotten painters—are the most forlorn figures of longing for recognition. No one cares about them except historians and specialists. Yet captured there on the canvas is the shadowy likeness of a once-living individual, one who probably regarded himself with considerable self-esteem, an attitude validated by his ability to command a portrait to be made. This picture is caught in the labyrinth of desire, its demands to be noticed, admired, and taken at its "face value" (pun intended) continually outstripping its bare need to exist (which is also somewhat doubtful, since no one would miss it if it disappeared). A similar fate befalls family photos when all their relatives are gone and no one recognizes them anymore. By contrast, the portrait of the Duchess in Browning's "My Last Duchess" is beyond desire: she lacks nothing, smiling from behind the curtain where the Duke has hidden her "as if she were alive," tormenting her murderer with her continued ability to dispense her "looks" as freely as ever.[24] By further contrast, we might consider Oscar Wilde's picture of Dorian Gray, which has registered upon its surface the disfiguring effects of every unbounded drive to which Dorian has surrendered himself.

4. *Symbolic/Imaginary/Real.* The picture, of course, is a convergence of all three. There are no pictures without language, and vice versa; no pictures without real things to represent, and a real object in which to make them appear. That is surely the lesson of the Saussurean sign, with its word/image signifier/signified emblem, the bar between them an irruption of the Real, the index, the existential sign. The Peircean triad of Symbol, Icon, and Index corresponds quite strictly to the Lacanian, and in more than just a

24. See my discussion of this poetic painting in my essay "Representation," in *Critical Terms for Literary Study,* ed. Frank Lentricchia and Thomas McLaughlin (Chicago: University of Chicago Press, 1990), 11–22.

structurally semiotic register. The symbol, for Peirce, is a "legisign," a sign by convention, law, legislation; the index has a "real" or existential relation to what it stands for: it is the scar or trace of the trauma, the part object or shadow as a "shifter" that is connected to and moves with its referent. And the icon, finally, is the "firstness" of phenomenological apprehension, the basic play of presence and absence, substance and shadow, likeness and difference that makes perception and imaging possible. The Imaginary, properly the realm of pictures and visual images, is traditionally associated with fixation and binding in Freudian theory (hence the Mirror Stage gives a "false image" of the body as stabilized and unified). But the Imaginary goes well beyond its "proper" boundaries, and permeates the realm of the Symbolic (literally in the figures of writing, and figuratively in the verbal image or metaphor, the conceit or analogy). So the Imaginary is on both sides, allied with both the primary and secondary process as an intersection of drive (repetition, reproduction, mobility, unbinding) and desire (fixation, stabilizing, binding). Recall here Blake's capturing of the dialectic of the Imaginary, when he speaks of the graphic lines he engraves on copper plates as "bounding lines," a pun which unites the figures of binding as holding inside a boundary, and bounding as a leaping motion. The Imaginary is articulated by the "bounding line," as he puts it, that creates "definite & determinate Identity" and allows us to distinguish one thing from another (the image as "species" marker). But the Imaginary also makes the line leap and pulsate with life, suggesting the motion and vitality that is captured, even in the still image, the material excess that turns the virtual image into a real picture—an assemblage.

5. *Love, desire, friendship, jouissance.* What happens to these four ways of relating to a libidinal object when an image or picture is involved?[25] An exact correspondence emerges between these relations and the standard array of sacred icons and iconic practices: love belongs to the idol, desire to the fetish, friendship to the totem, and *jouissance* to iconoclasm, the shattering or melting of the image. When a picture wants love, or more imperiously, when it demands love, but does not need or return it, but looms in silence, it becomes an idol. It wants sounding. When it asks to be shattered, disfigured, or dissolved, it enters the sphere of the offending, violent, or sacrificial image, the object of iconoclasm, the pictorial counterpart to the

25. These are "the four fundamental modes of relating to a libidinal object," according to Žižek, *The Plague of Fantasies*, 43.

death drive, or the ecstatic shattering of the ego associated with the orgasm. When it is the object of fixation, compulsive repetition, the gap between articulated demand and brute need, forever teasing with its *fort-da* of lack and plenitude, its crossing of drive and desire, it is the fetish (the Maid of Corinth is clearly in the grip of anticipatory fetishism, a form of anxiety in which one dreads in advance the loss of the love object, and creates a compensatory fantasy—*fort-da* before departure). Much of the reaction to 9/11 has been in the mode of classic fetishism, the flag-waving and profiling and endless hagiography of the victims. All this conducted with a kind of bellicose dogmatism, bordering on idolatry. It's as if we are being dared to disrespect the national fetishes, or (what is the same thing) forced to venerate them or pay the consequences.

Finally, there is friendship (which I take to include kinship), and its proper image type, the totem. Totemism is the image practice that signifies the clan, tribe, or family, and the word means, literally, "he is a relative of mine." Totemism takes us into the realm of what theorist René Girard called "mimetic desire," the tendency to want something because others want it.[26] It also evokes the sphere of what psychoanalyst D. W. Winnicott called the "transitional object," which is typically a plaything, learning/teaching machine, and an object of both love and abuse, affection and neglect. In contrast with the fetishistic object, the longed-for thing that is obsessively clung to, the transitional object (as its name suggests) is the focus of "letting go." When it is abandoned, as Winnicott says, it is "neither forgotten nor mourned."[27] I will have much more to say about this category, which I believe has been unjustly neglected in iconology and the theoretical discourse of psychoanalysis and anthropology as well. But for a proper treatment of this matter, we must proceed to the question of the value of images, both the processes by which we evaluate them and the values that inhere in them, that they bring into the world, teaching us how to desire, going before us.

26. René Girard, *Violence and the Sacred* (Baltimore: Johns Hopkins University Press, 1977), 145: "Rivalry does not arise because of the fortuitous convergence of two desires on a single object; rather *the subject desires the object because the rival desires it.*"

27. D. W. Winnicott, *Playing and Reality* (London: Routledge, 1971).

Up, make us gods, which shall go before us. EXODUS 32:1

Image is nothing. Thirst is everything. *Sprite commercial*

Everyone knows that images are, unfortunately, too valuable, and that is why they need to be put down. Mere images dominate the world. They seem to simulate everything, and therefore they must be exposed as mere nothings. How is this paradoxical magic/nonmagic of the image produced? What happens to an image when it is the focus of both over- and underestimation, when it has some form of "surplus value"? How do images accrue values that seem so out of proportion to their real importance? What kind of critical practice might produce a true estimation of images?

By invoking the concept of "surplus value" I am of course conjuring with the specter of the Marxist theory of value as the extraction of profit from labor by selling the products of the working classes "for more than they receive as wages."[1] As I did with Freudian theories of desire, however,

This chapter was first written as the keynote address for the 1999 meeting of the Association of Art Historians at the University of Southampton, England. I want to thank the association for their hospitality, and especially Brandon Taylor for his cordial and stimulating company. I also want to thank Arnold Davidson, Charles Harrison, Daniel Monk, Joel Snyder, Riccardo Marchi, and Candace Vogler for their very helpful comments on various drafts. A version of this chapter later appeared in *Mosaic*, a journal for the interdisciplinary study of literature, vol. 35, no. 3 (September 2002): 1–23. A very much shorter version appears in German in *Die Address des Mediens*, proceedings of the 1999 symposium inaugurating media studies at the University of Cologne.

1. See Tom Bottomore, ed., *A Dictionary of Marxist Thought* (Cambridge, MA: Harvard University Press, 1983), 474.

I want to delay the onset of the Marxian analysis and consider the question of value from the standpoint of the image and "image science."

The relation of images and value is among the central issues of contemporary criticism, in both the professional, academic study of culture and the sphere of public, journalistic criticism. One need only invoke the names of Walter Benjamin, Marshall McLuhan, Guy Debord, and Jean Baudrillard to get some sense of the totalizing theoretical ambitions of "image studies," iconologies, mediology, visual culture, New Art History, and so on. A critique of the image, a "pictorial turn," has occurred across an array of disciplines—psychoanalyis, semiotics, anthropology, film studies, gender studies, and of course, finally, cultural studies—and it has brought with it new problems and paradigms, much in the way that language did in the moment of what philosopher Richard Rorty calls a "linguistic turn."[2] On the side of public criticism, the rule of mass media makes the dominance of the image obvious. Images are all-powerful forces, to blame for everything from violence to moral decay—or they are denounced as mere "nothings," worthless, empty, and vain. This latter narrative of emptiness is encapsulated beautifully in "Moviemakers," a recent Sprite commercial. The scene is a brainstorming session of a team of "creative" advertising, media, marketing, and filmmaking professionals.[3] The producer marches into the meeting and says, "All right, people. What've you got?" The answer: "Death Slug. Big lizards are out." The birth of a new advertising image to replace the dinosaur icon of the early '90s is thus announced, with a ready-made campaign of commercial tie-ins: slug slippers, a slug rap video, slug tacos, slug-on-a-stick snacks. The material avatar of the Death Slug is a handful of green slime that can be thrown at a window, where (to the breathless admiration of the creatives and the audience) "it leaves a slime trail!" (figs. 26, 27) The gratified executive declares that all this is "nice, but what about the movie?" The answer: "Well, we haven't got a script yet, but we can bang one out by Friday." The moral of this commercial, if it isn't clear enough, is stated orally and spelled out typographically at the end. An authoritative voice-over concludes, "Don't buy the Hollywood hype. Buy what you want," followed by the texts: "Image is nothing. Thirst is everything. Obey your

2. See my discussion of Rorty and the linguistic turn in W. J. T. Mitchell, *Picture Theory* (Chicago: University of Chicago Press, 1994), chap. 1.

3. The commercial is entitled "Moviemakers," and was created for The Coca-Cola Company by Lowe & Partners/SMS, New York in 1998. It was shown extensively in movie theaters as well as on television.

thirst" (figs. 28, 29). The clincher: a bottle of Sprite (fig. 30) treated as an aesthetic object, rotating under the lights against a black background. This is staged as the Real Thing (Sprite is a subsidiary of Coca-Cola), the object of authentic desire, "what you want," not what the image-makers want you to want.

"Moviemakers" is a brilliant reflection on the surplus value of images in advertising, and their mobilization in the service of enhancing the image of a commodity. This commercial claims to be above all that, outside the sphere of commerce, hype, and phony image-making. Its concluding slogan, "Image is Nothing," is actually a rebuttal of sorts to an earlier series of commercials for Canon cameras featuring the tennis star Andre Agassi, that repeatedly assured us that "Image is Everything." Image may be everything when it comes to cameras and moviemaking, the Sprite commercial suggests, but it is nothing when it comes to *thirst*, a real, bodily need, not a false, fantasy-induced desire. The commercial addresses itself to the sophisticated viewer, perhaps one who has read Herbert Marcuse and the Frankfurt School on the creation of "false needs" by the culture industry.[4] More generally and accessibly, "Moviemakers" positions itself as an "anti-commercial commercial," flattering the good sense and skepticism of the viewer. If the general tendency of advertising is "to create positive evaluations of their product . . . through a process of *value transfer*" (to use the lingo of the training manuals) from generally positive cultural associations, this commercial uses a counterstrategy of *negative* value transfer.[5] It presents us with a window into the world of the image-makers, exposing to ridicule their cynical efforts to transfer value to an inherently disgusting product. Disgust is evoked most emphatically by the in-your-face gesture of the slug thrown against the "fourth wall," the movie/television screen and the window into the conference room.[6]

4. Or Wayne Booth's "The Company We Keep," *Daedalus* 3, no. 4 (1982): 52, with its vigorous denunciations of advertising as a kind of pornography that "rouses appetites and refuses to gratify them *within the form*," in the way that traditional forms of art do. The relegation of the script to an afterthought in the "Moviemakers" commercial ("we can bang one out by Friday") is also a wink at the sophisticated moviegoer who wants significant stories and literary values.

5. See John Corner's very useful discussion in *Television Form and Public Address* (London: Edward Arnold, 1995), 119.

6. From a semiotic standpoint, the commercial treats the *image* as an object of disgust in order to prop up its *words* (the verbally stated moral) as the voice of purity and truth. On cat-

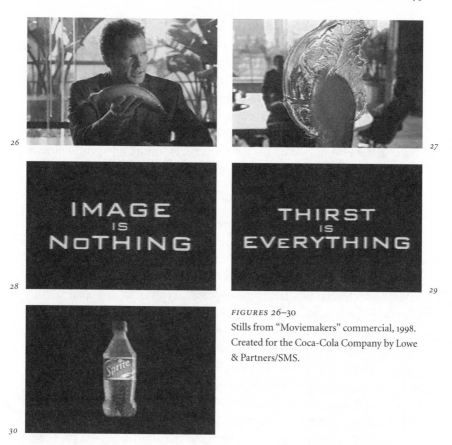

FIGURES 26–30
Stills from "Moviemakers" commercial, 1998.
Created for the Coca-Cola Company by Lowe
& Partners/SMS.

There is just one little problem with the straightforward moral of "Moviemakers"—or perhaps it is the ultimate touch of brilliance that puts the irony of the commercial over the top. I am not referring to the obvious fact that yes indeed, this is just a commercial after all, and it does not stand outside the world of advertising in using a familiar strategy of ironic, negative "value transfer." And it is not the obvious fact that the authentic object of desire, the Real Thing, the fetishized commodity, is itself nothing more than an image, one that is shown far less palpably than the "splat" of

egories of disgust as a means of establishing the (rather shaky) prohibitions that underwrite the symbolic order and social stability as such, see Julia Kristeva, *Powers of Horror* (orig. pub. 1980; New York: Columbia University Press, 1982), especially chap. 3, "From Filth to Defilement."

the slug in the viewer's face. No, it is a feature of the commercial that every class I have shown it to remarks on, and that may or may not be intentional: namely, its use of color. The green slime of the slug turns out to be exactly the same color as the green bottle of Sprite shown at the end. Could this be an inside joke, the ad agency cleverly smuggling in a secondary irony, one that undercuts its mission by transferring the negative value of disgust onto the commodity, rather than contrasting it? Or is this a kind of surplus value in the images mobilized by the commercial, an unintended consequence that takes its meanings into new territory—the green, slimy trail left by money itself as it traverses the images of desire and disgust, ultimate value and filthy lucre?

I will leave this determination to you. But I hope it goes without saying by this point that the observation of a "pictorial turn" in which image is everything—and nothing—is not strictly the province of sophisticated commentators or cultural critics but part of the everyday vernacular culture that makes a widely accessible language of advertising possible. The pictorial turn is such a commonplace that television commercials can rely on it. The deeper issue raised by this commercial, however, is its ingenious opposing of *image* and *thirst*, the visual and the oral—in Jacques Lacan's terms, the scopic and vocative drives. The relation of images and thirst is a promising entry into the question of images and value, particularly with reference to the way that images themselves are consumed or "drunk," and the way in which they are said to consume their beholders. From the kiss of the Byzantine icon (fig. 11; discussed in chapter 2) to the alluring mouth of *Videodrome*'s Nicki Brand (fig. 1; discussed in the preface), the surprising discovery is that images operate even more powerfully in the oral than the optical channel: that is to say, we do not merely "see" pictures, we "drink" in their images with our eyes (Shakespeare aptly called them "blind mouths"); and pictures in turn have a tendency to swallow us up, or (as the expression goes) "take us in." But images are also, notoriously, a drink that fails to satisfy our thirst. Their main function is to awaken desire; to create, not gratify thirst; to provoke a sense of lack and craving by giving us the apparent presence of something and taking it away in the same gesture. (Perhaps to the "Medusa," "Pygmalion," and "Narcissus" effects of images we should add the "Tantalus" effect, the way in which the image tantalizes its beholder.)[7] We might in-

7. Tantalus, son of Jupiter and Pluto, King of Lydia, was punished by "labouring under an insatiable thirst, and as having above his head a bough richly laden with delicious fruit,

terpolate in the Sprite slogan, then, a logical connective: "It is *because* image is nothing that thirst is everything."[8]

Between the all-or-nothing choice of images and thirst, there is a third possibility: the acknowledgment that images are not mere nothings, and thirst is not everything. This between has historically been occupied by that refinement of thirst known as taste. The application of "good taste" to images, the critical separation of true from false, baneful from beneficent, ugly from beautiful images, seems like one of the fundamental tasks of criticism. Insofar as the very word *criticism* implies a separation of good from bad, the problem of images seems immediately to settle on evaluation, and even more urgently, on a "crisis" of value that makes true criticism seem almost by default to present itself as a kind of iconoclasm, an effort to destroy or expose the false images that bedevil us. Gilles Deleuze argued that the very foundations of criticism as such reside in the Platonic effort to separate the false image or semblance from the true form, and that this means that "philosophy always pursues the same task, Iconology."[9] Most of the powerful critiques of images in our time, especially of visual images, have (as intellectual historian Martin Jay points out) been iconoclastic in character.[10] They approach images as subject to a discipline, an axiology or criteriology that would systematically regulate judgments of value. They think the key question about "images and value" is how to evaluate images and expose the false ones.

Unfortunately, I have neither a system nor a praxis to offer on this front. I generally leave the job of image evaluation to art critics or connoisseurs. When it comes to evaluation of new artworks, I console myself with critic Leo Steinberg's wise remarks on this issue:

which, as soon as he attempt to seize, is carried beyond his reach by a sudden blast of wind." See Homer, *Odyssey* 11.719–32 and *Classical Manual; or a Mythological . . . Commentary on Pope's Homer* (London: Longman et. al., 1827), 326.

8. The link between idolatry and gluttony, the lust of the eyes and the mouth, is made clear in the story in the book of Exodus of the festival of eating and drinking that accompanies the worship of the golden calf. See Pier Cesare Bori, *The Golden Calf* (Atlanta: Scholar's Press, 1990), 34.

9. Gilles Deleuze, "The Simulacrum and Ancient Philosophy," appendix to *The Logic of Sense*, trans. Mark Lester with Charles Stule (New York: Columbia University Press, 1990), 260.

10. Martin Jay, *Downcast Eyes* (Berkeley and Los Angeles: University of California Press, 1993). The title of Jean Baudrillard's *The Evil Demon of Images* (Sydney: Power Institute of Fine Arts, 1987) gives some sense of the currency of iconoclastic rhetoric in contemporary theory.

One way to cope with the provocations of novel art is to rest firm and maintain solid standards. . . . A second way is more yielding. The critic interested in a novel manifestation holds his criteria and taste in reserve. Since they were formed upon yesterday's art, he does not assume that they are ready-made for today . . . he suspends judgment until the work's intention has come into focus and his response to it is—in the literal sense of the word—sym-pathetic; not necessarily to approve, but to feel along with it as with a thing that is like no other.[11]

I take this "yielding" approach to evaluation as a cardinal principle. And I would just note two other features of Steinberg's criteria that will concern us here. The first is the claim that criteria are not arrived at independently, prior to the encounter with images, but "formed upon" yesterday's art. "Formed upon" is a very precise and delicate phrase, suggesting a mutual shaping of values in the encounter with works of art, as if artworks were the anvil on which one's values were tested and hammered out, or a mold in which they were cast. The second is the hint of animism in Steinberg's claim that we must "feel along with" the work of art.

What I am calling a "yielding" practice of evaluation was put in more militant terms in Northrop Frye's "Polemical Introduction" to *Anatomy of Criticism* some years ago.[12] Frye argued famously that "systematic" literary criticism had to renounce the temptation to engage in value judgments. "Value judgments," he said, "are founded on the study of literature; the study of literature can never be founded on value judgments." He believed that literary criticism could only attain the status of a science by adopting "the hypothesis that just as there is an order of nature behind the natural sciences, so literature is not a aggregate of 'works,' but an order of words" (17). "The history of taste," he continues, "is no more a part of the *structure* of criticism than the Huxley-Wilberforce debate is part of the structure of biological science" (18). Frye praises the practice of this kind of "systematic" criticism in the work of John Ruskin (ridiculing Matthew Arnold's provincial confidence in his evaluative powers). Ruskin, Frye notes, "learned his trade from the great iconological tradition which comes down through Classical and Biblical scholarship into Dante and Spenser . . . and which is incorporated in the medieval cathedrals he had pored over in such detail" (10).

Frye's suspicion of value judgments and his use of naturalistic and sci-

11. Leo Steinberg, *Other Criteria: Confrontations with Twentieth Century Art* (Oxford: Oxford University Press, 1972), 63.

12. Northrop Frye, *Anatomy of Criticism* (Princeton, NJ: Princeton University Press, 1957), 20.

entific analogies for criticism have themselves become the objects of suspicion in our age, with its emphasis on scholarly commitment to certain specific political and ethical values, and its ingrained suspicion of both nature and the images that are sometimes thought to imitate it. And we are surely right to be wary of naturalism at a time when Darwinism is once again the reigning ideology, and Freud and Marx are dismissed in middlebrow culture (that is, the *New Yorker* and the *New York Times*) as dinosaurs. Nevertheless, Frye's insistence on linking systematic criticism, and specifically *iconology*, to a rigorous suspension of value judgments is worth remembering, if only because it makes possible a critique of images as sources of value, rather than objects of evaluation. In a remarkable turn, Frye equates evaluative criticism with ideology, an imposition of a decorum, a hierarchy of taste, which is "suggested by the class structure of society" (22). But true criticism, Frye's "iconology," "has to look at art from the standpoint of an ideally classless society" (ibid.). This doesn't mean that all images become equal, or equally valuable, only that the point of criticism is not to rank them or to engage in iconoclastic exercises. Ranking and hierarchy (and episodes of image-smashing) take their place among the structures and historical events that differentiate the domains of art—images, texts, representations in all media.

I found a value-neutral strategy of this sort absolutely essential in *The Last Dinosaur Book*, my iconological study of "big lizards," dinosaur images from their first appearance in Victorian England in the 1840s to their present global circulation as the most highly publicized animal images on earth. First, the very choice of topic—the dinosaur—seemed to reveal a questionable taste in images. No art historian had ever taken up this topic, because it seems automatically to enmesh the critic in the worst kind of kitsch and popular culture. From the standpoint of paleontology, the only good dinosaur image is a true one, an image that has been verified as accurate by the most rigorous forensic disciplines. Obsolete, old-fashioned, and popular dinosaur images are at best amusing, at worst a serious distraction from the scientific search for truth. From an iconological standpoint, on the other hand, the scientific truth-value of a dinosaur image is simply another fact about it, not an exclusive basis for critical understanding. As the history of "the life and times of a cultural icon," *The Last Dinosaur Book* brings together a range of images whose registers of value are utterly disparate.[13]

13. W. J. T. Mitchell, *The Last Dinosaur Book: The Life and Times of a Cultural Icon* (Chicago: University of Chicago Press, 1998).

Some dinosaur images are valuable because they are impressive; others because they are cute or horrible; others still because they are accurate, or funny, or thought-provoking. It would seem that an image that finds a home in so many different places—television, toy stores, novels, cartoons, advertising—would have to possess some intrinsic value. But does it? Is it the image that has value or the concrete thing on or in which it appears? We buy a picture in a gallery; we don't buy the image in it. We can only borrow or rent or steal an image of the work (in reproduction) and we all know Walter Benjamin's argument that reproduction cheapens the work of art, draining value and "aura" from it. The image has value, but somehow it is slipperier than the value of the picture or statue, the physical monument that "incarnates" it in a specific place. The image cannot be destroyed. The golden calf of the Old Testament may be ground down to powder, but the image lives on—in works of art, in texts, in narrative and remembrance.

The longer one thinks about this topic (especially in the English language), the clearer it becomes that there is a vernacular distinction between images and pictures, images and concrete works of art, that comes to the surface in ordinary ways of speaking about graphic, iconic forms of representation.[14] As Wittgenstein puts it, "An image is not a picture, but a picture can correspond to it" [Eine Vorstellung ist kein Bild, aber ein Bild kann ihr entsprechen].[15] Ordinary, not philosophical, language leads us to think of images as a family of immaterial symbolic forms, ranging from well-defined geometrical shapes to shapeless masses and spaces, to recognizable figures and likenesses, to repeatable characters such as pictograms and alphabetic letters. Images are also, in common parlance, mental things, residing in the psychological media of dreams, memory, and fantasy; or they are linguistic expressions ("verbal images") that name concrete objects that may or may not be metaphoric or allegorical. They are, finally (and most abstractly), "likenesses" or "analogies" that invite more or less systematic correlations of resemblance in a variety of media and sensory

14. This distinction does not seem so readily available in French or German vernaculars. Horst Bredekamp points out that *Bild* does double duty for both *picture* and *image*, and argues that this is one reason that an image science, or *Bildwissenschaft*, is so readily conceivable in German. See his article, "A Neglected Tradition: Art History as *Bildwissenschaft*," *Critical Inquiry* 29, no. 3 (Spring 2003): 418–28.

15. Ludwig Wittgenstein, *Philosophical Investigations,* trans. G. E. M. Anscombe (Oxford: Basil Blackwell, 1953), 101.

channels.[16] C. S. Peirce's notion of the "icon," the "sign by resemblance," thus embraces everything from photographs to algebraic equations.[17]

What, then, is a picture? Let us start again from the vernacular. You can hang a picture, but you cannot hang an image. The image seems to float without any visible means of support, a phantasmatic, virtual, or spectral appearance. It is what can be lifted off the picture, transferred to another medium, translated into a verbal ekphrasis, or protected by copyright law.[18] The image is the "intellectual property" that escapes the materiality of the picture when it is copied. The picture is the image plus the support; it is the appearance of the immaterial image in a material medium. That is why we can speak of architectural, sculptural, cinematic, textual, and even mental images while understanding that the image in or on the thing is not all there is to it.

One could spend a long time debating whether talking about images in this way leads one to some sort of perverse Platonism, in which the concept of the image takes on the role of Plato's ideas or forms. Images would then subsist in some realm of archetypes, awaiting their concrete manifestation in concrete pictures and works of art. Probably Aristotle is a better guide to the question of the relation of images and pictures. From an Aristotelian standpoint, images are not, in Candace Vogler's words, "floating free like so many souls awaiting birth." Images are "kinds of pictures," classifications of pictures. Images are, then, like species, and pictures are like organisms whose kinds are given by the species. Platonism is more picturesque, materialistic, and vulgar about these "species," treating them as really existing entities rather than mere names or conceptual tools. Platonism gives us the

16. For a defense of the role of specifically *visual* analogy, see Barbara Stafford, *Visual Analogy: Consciousness as the Art of Connecting* (Cambridge, MA: MIT Press, 2001).

17. See C. S. Peirce's "Logic as Semiotic: The Theory of Signs," in *Philosophical Writings of Peirce,* ed. Justus Buchler (orig. pub. 1940; New York: Dover, 1955), 98–119. See especially pp. 104–8.

18. See Otto Pacht's classic essay, "The End of Image Theory" (1931), for an attack on the "unscientific" and poetic character of the image concept as such, precisely because it is what claims (wrongly) to be translated or reproduced in a verbal description of a work of art. In *The Vienna School Reader: Politics and Art Historical Method in the 1930s,* ed. Christopher S. Wood (New York: Zone Books, 2000), chap. 4. On ekphrasis, see Mitchell, *Picture Theory,* chap. 5. The reproduction of an image of a work is, of course, a critical distinction in copyright law. "Ownership of a copyright . . . is distinct from ownership of any material object in which the work is embodied" (The 1976 Copyright Act, S. 202 [Title 17 U.S.C. 90 Stat. 2541 et seq., Public Law 94-553]).

vernacular tradition of image theory, one constructed on a set of hyperval-
ued metapictures, most famously the allegory of the cave, which treats the
world of concrete sensations as a mere shadow world of insubstantial im-
ages, and the ideal sphere of forms as the realm of real substance.[19]

The task of an iconologist with respect to images and pictures is rather
like that of a natural historian with respect to species and specimens. (The
origin of the word *species* itself in the figure of the "specular" image helps to
motivate this analogy, as does the recurrent appeal to criteria of similarity,
recognizability, and reproductive lineage in both images and species.)[20]
While we can recognize beautiful, interesting, or novel specimens, our main
job is not to engage in value judgments but to try to explain why things are
the way they are, why species appear in the world, what they do and mean,
how they change over time. It makes sense to talk about a good specimen,
but it would seem very odd to engage in value judgments about species. A
species is neither good nor bad: it simply *is,* and the question of value only
arises when we are dealing with the individual specimen or the collection of
specimens.

Or perhaps this conclusion is too hasty. There may be a sense in which
we do evaluate images, or at least participate in a process of cultural selec-
tion that may look like a form of evaluation. Some biological species sur-
vive and flourish, become fruitful and multiply. Others remain marginal or
even die out. Can we apply this part of the analogy to images and pictures?
Can we speak of the origin of images, their evolution, mutation, and ex-
tinction? How do new images appear in the world? What makes them suc-
ceed or fail in the cultural ecology of symbolic forms? Whatever the hidden

19. I'm grateful to Candace Vogler of the Philosophy Department at University of
Chicago for her suggestions on the Plato-Aristotle choice in image theory. On the concept of
"metapictures," see my essay by that title in *Picture Theory.*

20. For discussion of the species concept in biology, see Peter F. Stevens, "Species: His-
torical Perspectives," and John Dupre, "Species: Theoretical Contexts," in *Keywords in Evo-
lutionary Biology,* ed. Evelyn Fox-Keller and Elisabeth A. Lloyd (Cambridge, MA: Harvard
University Press, 1992). If one expects the biologists to have a secure grasp of the species/
specimen distinction, however, one will be severely disappointed, and find that the same
nominalist/realist debate that enlivens "image science" is raging in the life sciences. Ernst
Mayr, for one, has even argued that the species concept, insofar as it presumes "reproductive
isolation" of one group of organisms for another, is actually confined to sexual organisms,
and does not apply to asexual organisms such as plants, which are referred to as "para-
species" or "pseudospecies." If images constitute a second nature within culture, we should
not expect their taxonomies or family groupings to be any simpler than first nature.

laws behind the life processes of images or species, it does seem clear that some of them are highly durable (like dinosaurs and cockroaches), and others (mutants and freaks of nature) scarcely last beyond the individual specimen. In between are species (like the one to which we ourselves belong) for which the jury still seems to be out. The human species is among the youngest and most fragile life-forms on the planet earth. Although it dominates the ecosystem for the moment, there is nothing to guarantee that this state of affairs will continue, and most of the images of man's future that have circulated in our global culture in the modern era have portrayed us as an endangered species.

Perhaps, then, there is a way in which we can speak of the value of images as evolutionary or at least coevolutionary entities, quasi life-forms (like viruses) that depend on a host organism (ourselves), and cannot reproduce themselves without human participation. And this framework might help us differentiate the kind of value we can attribute to images, as contrasted with evaluations we make of particular specimens, works of art, monuments, buildings, and so on. The difference is between a judgment of survivability and reproducibility, of evolutionary flourishing on the one hand, and the judgment of an individual as an example "of its kind." With a picture or specimen, we ask, Is this a good example of X? With an image, we ask, Does X go anywhere? Does it flourish, reproduce itself, thrive and circulate? Advertising executives appraise the images in ad campaigns with a simple question: Does it have legs? That is, does it seem to go somewhere, to "go on," as Wittgenstein puts it, leading into unforeseen associations?[21] When the Israelites request an image of God to "go before" them, they are hoping this image will "have legs," that it will lead somewhere, and replace their lost leader, the man Moses.[22]

Does an image "go on" or "go before" us? This is the question you might want to put to the image I have been constructing for you in the last few pages. This image has been verbal and discursive, an elaborate metaphor or

21. See Ludwig Wittgenstein's discussion of "going on" and "being guided" in *Philosophical Investigations*, trans. G. E. M. Anscombe (London: Basil Blackwell, 1958), pars. 151–54, 172–79.

22. Cf. the classical legend of "onolatry" (donkey worship): the Golden Ass in Plutarch and Tacitus. According to Bori, "the role of guide, in a moment of difficulty during the crossing of the desert, is attributed to the ass." "The idol is whoever 'brought the people out' and 'whoever will walk at the head of the people' in the absence of Moses" (*The Golden Calf*, 106–7).

analogy between the world of pictures and the world of living things, be-
tween iconology and natural history.[23] Is this a good image? Does it lead us
anywhere? Is it a freakish, monstrous analogy that can only lead to a cog-
nitive dead end? This question, you will notice, may be quite different from
the question of whether I am presenting it well in this chapter. If the basic
idea of comparing images to species, pictures to specimens, cultural sym-
bols to biological entities has any value, it will survive long after this par-
ticular text has been forgotten.

As it happens, I have some confidence in this analogy, and in its pros-
pects for survival, precisely because I did not invent it out of nothing. It is
an extraordinarily old idea about images, a metapicture which could easily
be traced through the history of human reflection on the very notion of
icons or signs by resemblance and mimesis. We might want to begin with
the peculiar place of images of animals in the earliest art forms, the impor-
tance of the natural world in the earliest religious images, and the emer-
gence of early forms of writing from "zoographic" images.[24] We would
ponder John Berger's reminder that "the first subject matter for painting
was animal. Probably the first paint was animal blood. Prior to that it is not
unreasonable to suppose that the first metaphor was animal."[25] Or Émile
Durkheim's more general argument that totemism, the transformation of
the natural world into sacred animated images, is the earliest, most funda-
mental form of religious life.[26] Or we might want to start from the human
image, and consider the creation myths that portray God as an artist, and
human beings as animated images, sculpted statues or vessels into which
life has been breathed. Or we might go to art historian Henri Focillon's de-
scription of artistic form as "a kind of fissure through which crowds of
images aspiring to birth" are coming into the world, or to the new world of

23. See Peirce on the question of iconic representation by resemblance, similarity, and
analogy in "Logic as Semiotic: The Theory of Signs," and Stafford's defense of analogical
thinking in *Visual Analogy*.

24. Jacques Derrida, *Of Grammatology*, trans. Gayatri Spivak (Baltimore: Johns Hopkins
University Press, 1976). See Derrida's reflections on "savage" writing/painting with figures of
animals (zoography), 292–93.

25. John Berger, "Why Look at Animals?" in *About Looking* (New York: Pantheon Books,
1980), 5. See also my discussion of animal images in "Looking at Animals Looking," *Picture
Theory*, chap. 10.

26. Émile Durkheim, *The Elementary Forms of Religious Life* [1912], trans. Karen Fields
(New York: The Free Press, 1995).

cyborgs and artificial life-forms conjured up in the work of science historian Donna Haraway and Bruno Latour.[27]

So the analogy between images and living organisms (a double connection, both metaphoric and metonymic) is not my original invention. It has already survived over several millennia of human history. My only contribution is to update it, to insert it into the new context of biological science and evolutionary thinking and propose a generalizing of the mutual mapping of iconology and natural history. No doubt this move will make you anxious. It certainly keeps me awake at night. The idea of images as living species is a very disturbing one for art historians, not to mention ordinary people whose anxieties about the way human creations take on "lives of their own" have become commonplaces of contemporary life. Art historians will worry that it reduces the role of artistic agency quite a bit. If images are like species, or (more generally) like coevolutionary life-forms on the order of viruses, then the artist or image-maker is merely a host carrying around a crowd of parasites that are merrily reproducing themselves, and occasionally manifesting themselves in those notable specimens we call "works of art." What happens to social history, to politics, to aesthetic value, to the artist's intention and creative will, to the spectator's act of reception if this model has any truth? My answer is: only time will tell. If this is a sterile, unproductive image, no eloquence of mine will make it come to life. If it "has legs," on the other hand, nothing can stop it.

Let's proceed, then, on the assumption that my picture of images as living things has some plausibility, at least as a thought experiment. What happens to the question of value? The obvious answer is that the question of value is transformed into a question of vitality, and that this question plays a role in value judgments on both sides of the image/picture distinction. With pictures, the question of vitality is generally posed in terms of

27. Henri Focillon, *The Life of Forms in Art* [1934], trans. Charles D. Hogan and George Kubler (New York: Zone Books, 1989); see also my discussion of Focillon in Mitchell, *The Last Dinosaur Book,* 54. See also Donna Haraway, "A Manifesto for Cyborgs," in *Simians, Cyborgs, and Women: The Reinvention of Nature* (New York: Routledge, 1991); Bruno Latour on the concept of the "factish" (the composite fact/fetish) in "Few Steps toward an Anthropology of the Iconoclastic Gesture," in *Science in Context* 10 (1997): 63–83. For a discussion of image proliferation in terms of biological metaphors, see Dan Sperber, "Anthropology and Psychology: Toward an Epidemiology of Representations," *Man* 20 (March 1985): 73–89; and Andrew Ross, "For an Ecology of Images," in *Visual Culture,* ed. Norman Bryson, Michael Ann Holly, and Keith Moxey (Middletown, CT: Wesleyan University Press, 1994).

liveliness or lifelikeness, a sense that the picture either "captures the life" of its model, or that it has in its own formal qualities an energetic, animated, or lively appearance. With images, the question of vitality has more to do with reproductive potency or fertility. We can ask if a picture is a good or bad, living or dead specimen, but with an image, the question is, Is it likely to go on and reproduce itself, increasing its population or evolving into surprising new forms? The life of images, therefore, is often connected with the life of a class or genre of representational practices—portraiture, landscape, still life, devotional icons—or with even larger classes such as media and cultural forms. This is why we have an incorrigible tendency to say things like "from this day, painting is dead," to lament the demise of the novel or poetry, or to celebrate the "birth" of new media like cinema, television, or the computer. The fastest-growing class of media in our time is perhaps the "dead media" (manual typewriters, Polaroid cameras, mimeograph machines, eight-track tape players), which proliferate exponentially in an era of constant innovation.[28]

It also seems that the vitality of an image and the value of a picture are independent variables. An image that has survived for centuries in millions of copies (the golden calf, for instance) can appear in a perfectly lifeless and worthless painting—stillborn, as it were. A dead or sterile image (a freak, mutant, or monster) may disappear for a while, but it is always capable of being revived. And some classes of pictures (still life or *nature mort,* most notably) are devoted to the task of providing lively representations of dead animals, withering flowers, and decaying fruits and vegetables. A dead picture usually disappears forever, languishing in the attic or the basement of a museum, or rotting on the trash heap. A fossil, on the other hand, is a natural image (both iconic and indexical) of a dead specimen and an extinct species which has miraculously survived physical disintegration to leave a trace that can be brought back to life in the human imagination—that is to say, in pictures, models, verbal descriptions, cinematic animations.[29]

The whole metapicture of images as life-forms, then, itself has a tendency to spawn a bewildering array of secondary images, a second nature as complex as the first nature of the biological sciences. Can images be created or destroyed? Is the notion of an "original image" a cultural version of

28. See *The Dead Media Project,* a Web site devoted to the archiving of these obsolete technologies and practices: http://www.deadmedia.org/.

29. See "On the Evolution of Images," in Mitchell, *The Last Dinosaur Book,* chap. 13.

creationist mythology, or of the biological principle of common ancestry? Do all images, like all life-forms, have a common ancestor? Can they become extinct? How do they evolve? Are the genres, forms, or media in which images appear best understood as habitats, environments, or ecosystems in which specimens can flourish and reproduce?[30] How is it that an environment or ecosystem itself can become imageable or iconic, so that images are nested inside one another in concentric formations, one species forming a habitat for another species in the way, for instance, that the human body is a host for millions of microorganisms, while itself inhabiting a larger social and natural environment? Consider, for instance, the hierarchy of entities that go by the name of *landscape:* first, a specimen (say, a specific painting by John Constable); second, a genre (the whole class of things called landscape painting, with its specific history in Western painting and beyond); third, landscape considered as a medium, the actual countryside or lived space of a people, including the specific concrete *place* in the Stour valley where Constable lived and painted. The dialectics of species and specimen, stereotype and individual, class and member, image and picture cut across all these levels of attention. That is why *landscape* itself is such an ambiguous term, referring at once to the represented motif in a painting, the painting itself, and the genre to which it belongs.[31]

I invoke the metapicture of images as living organisms, then, not to simplify or systematize the question of the value of images but to explode the question and let it proliferate a host of secondary metaphors. Biology is not being invoked here as if it were a master key or domain of certainty by means of which we might map the wilderness of images. If one turns to the biologists for certainty about things like the relation of species and specimens, one finds the same kinds of nominalist-realist debates. Are biological species really existing things? Or are they nominal entities, artificial creations of the human intellect—mere images that have been mistakenly reified and concretized into essences? What are the limits of the ocular/

30. I am echoing here some of the questions put by the movement known as "media ecology" at the Universities of Toronto and New York University which now has, of course, a professional association, an annual meeting, and a Web site: http://www.media–ecology.org/mecology/. See also the University of Chicago's home-grown student organization, The Chicago School of Media Theory (CSMT), at http://www.chicagoschoolmediatheory.net/.

31. For further elaboration of this point, see W. J. T. Mitchell, ed., *Landscape and Power* (Chicago: University of Chicago Press, 1994; 2nd ed., 2002), especially "Space, Place, and Landscape," the preface to the second edition, and the theses introducing "Imperial Landscape."

iconic models of biological species that begin with the principle (drawn from image-making) of "looking similar"?[32] What are we to make of the criteria of "reproductive isolation" and "mate recognition" that play a crucial role in contemporary theories of speciation, so that the ocular/iconic encounter with a member of one's own species, the recognition of a "conspecific" organism, replaces the godlike perspective of the objective Linnaean taxonomist looking down on clearly defined forms? Is biology itself moving from an encyclopedic iconology of species, with its table of likenesses, to an immersion in the "eye and the gaze," the encounter with the Other, as the mechanism by which species differentiate and reproduce themselves? What, then, are we iconologists to make of the asexual organisms (mainly plants) in which there are no species, only "paraspecies" (Ernst Mayr) or "pseudospecies" (M. Ghiselin), no "essential" form of the tulip or the daffodil but an endless proliferation of hybrids?[33] If images are like organisms, and organisms can only be recognized through those cognitive templates we call images, perhaps it is time for iconologists to once again consider the lilies of the field, how they grow.

But perhaps the most interesting consequence of seeing images as living things is that the question of their value (understood as vitality) is played out in a social context. We need to ponder that we don't just evaluate images; images introduce new forms of value into the world, contesting our criteria, forcing us to change our minds. Wittgenstein describes this moment of the birth or rebirth of an image as the "dawning of an aspect," a new way of seeing *this* as *that*.[34] Images are not just passive entities that coexist with their human hosts, any more than the microorganisms that dwell in our intestines. They change the way we think and see and dream. They refunction our memories and imaginations, bringing new criteria and new desires into the world. When God creates Adam as the first "living image," he knows that he is producing a creature who will be capable of the further creation of new images. This, in fact, is why the notion that the image is alive seems so disturbing and dangerous, and why God, having made Adam in his image, goes on later to issue a law prohibiting the further creation of images by human hands. If the value of an image is its vitality, that does not mean that the living image is necessarily a good thing. The man-

32. See Stevens, "Species: Historical Perspectives," 303, and note 17 above.

33. Dupre, "Species: Theoretical Contexts," 315.

34. Wittgenstein, *Philosophical Investigations*, par. 194. See also Stephen Muhall's *On Being in the World: Wittgenstein and Heidegger on Seeing Aspects* (New York: Routledge, 1990).

made image that comes alive is equally capable of being seen as an evil, corrupting, pathological life-form, one that threatens the life of its creator or host. The most eloquent testimony about the life of images comes from those who fear and loathe that life, regarding it as an invitation to moral degeneracy, perversity, and regression into savage superstition, infantilism, psychosis, or brutish forms of behavior. In acknowledging the life of images, we flirt with idolatry and fetishism, which makes us either fools or knaves, taken in by an illusion that we project onto things, or (even worse) perversely and cynically perpetrate on others. If we create images to "go before" us, they may be leading us down the primrose path to damnation.

Historically, then, the attribution of life to images is the occasion for deep ambivalence about value. The living image is not unequivocally a positive value, but (as we have seen) the object of both love and hate, affection and fear, forms of overestimation such as worship, adoration, and veneration, and of devaluation or underestimation—horror, disgust, abomination. The best evidence for the life of images is the passion with which we seek to destroy or kill them. Iconophilia and iconophobia only make sense to people who think images are alive.

Or, more precisely, we might say that iconophobia and iconophilia make sense primarily to people who think that *other people* think that images are alive. The life of images is not a private or individual matter. It is a *social* life. Images live in genealogical or genetic series, reproducing themselves over time, migrating from one culture to another. They also have a simultaneous collective existence in more or less distinct generations or periods, dominated by those very large image formations we call "world pictures."[35] That is why the value of images seems historically variable, why period styles always appeal to a new set of evaluative criteria, demoting some images and promoting others. Thus when we talk about images as pseudo–life-forms parasitical on human hosts, we are not merely portraying them as parasites on individual human beings. They form a social collective that has a parallel existence to the social life of their human hosts, and to the world of objects that they represent. That is why images constitute a "second nature." They are, in philosopher Nelson Goodman's words, "ways of worldmaking" that produce new arrangements and perceptions of the world.[36]

35. I echo Heidegger's use of this phrase, but not his confinement of it to modern, technical-scientific representations. See the preface.

36. Nelson Goodman, *Ways of Worldmaking* (Indianapolis: Hackett Publishing Co., 1978). Goodman continues the tradition of Kant and Cassirer, examining the way "worlds" are "made from nothing by use of symbols" (1).

The value and life of images becomes most interesting, then, when they appear as the center of a social crisis. Debates over the quality of this or that artwork are interesting, but they are merely minor skirmishes in a much larger theater of social conflict that seems invariably to be focused on the value of images as much as it is on "real" values such as food, territory, and shelter. The wars over "holy lands" like Palestine and Kosovo are, need we say it, really about images—idols of place, space, and landscape.[37] Use-values may keep us alive and nourished, but it is the surplus value of images that makes history, creates revolutions, migrations, and wars. And surplus value is, as Marx showed long ago, only explicable in terms of a logic of animated images. In order to explain the enigma of value in capitalist societies, Marx notes, it is not enough to measure the value of commodities in terms of their practical utility, or labor-time, or any other reasonable, pragmatic criterion. To understand commodities, "we must have recourse to the mist-enveloped regions of the religious world. In that world the productions of the human brain appear as independent beings endowed with life, and entering into relation both with one another and with the human race."[38] It is the fetishism of commodities, their transformation into living images, that makes them capable of reproducing themselves in ever-increasing spirals of surplus value, accompanied, Marx argues, by ever-increasing social contradictions—exploitation, misery, and inequality. It is also (as copyright law continually reminds us) the commodification of images that turns pictures into fetishes, adding to them a surplus that makes them bearers of ideological fantasy.[39]

But Marx doesn't simply write as an iconoclast who believes that the world must be purged of images in order to make a truly human society possible. To think that images are the real enemy would be to fall back into

37. See my essay, "Holy Landscape: Israel, Palestine, and the American Wilderness," *Critical Inquiry* 26, no. 2 (Winter 2000); reprinted in Mitchell, ed., *Landscape and Power*, 2nd ed. (Chicago: University of Chicago Press, 2002), 261–90.

38. Karl Marx, *Capital* [1867], trans. Samuel Moore and Edward Aveling (New York: International Publishers, 1967), 1:72. See my discussion of Marx's engagement with images and its legacy in "The Rhetoric of Iconoclasm: Marxism, Ideology, and Fetishism," in W. J. T. Mitchell, *Iconology: Image, Text, Ideology* (Chicago: University of Chicago Press, 1986), chap. 6.

39. On law and the commodification of the image (as distinct from the image of commodification), see Bernard Edelman, *The Ownership of the Image: Elements for a Marxist Theory of the Law,* trans. Elizabeth Kingdom (London: Routledge & Kegan Paul, 1979), and my discussion in *Iconology,* 184–85. See also Jane Gaines, *Contested Culture: The Image, The Voice, and The Law* (Chapel Hill: University of North Carolina Press, 1991).

the trap of the Young Hegelians, winning phantom wars against idols of the mind. It is the social order that must be changed, not images. Marx understands that images must be understood, not smashed. That is why he is so interesting as an iconologist. He is patient with his fetishes and idols, allows them to circulate in his text as concrete concepts that may be "sounded," as Nietzsche would have it, with the tuning fork of language.[40] He hints at a natural history of images, linked with modes of production and their ideological reflexes. Fetishes and idols, the superstitious and savage images, are not destroyed in Marx's writing. They are sounded, like dead metaphors brought back to life, retrieved from the archaic past into the modern present.

Recent studies of the image by David Freedberg and Hans Belting have made this transvaluation of fetishism and idolatry more thinkable by art historians than it would have been in a previous generation.[41] Freedberg's inquiry into the power of images and Belting's history of the image "before the era of art" both take us beyond the confines of art history into the more general field of visual culture. Both writers focus on the "superstitious" or "magical" image, an archaic figure to be sharply distinguished from modern images, and especially from the images of what we call art. After the onset of "the era of art," Belting argues, the artist and the beholder "seize power over the image" and make it an object for reflection.

Belting immediately admits that this division of the traditional from the modern image is an oversimplification, a historicist reduction necessary for focusing on a specific era. He notes that "humankind has never freed itself from the power of images."[42] Nevertheless, he sees the formations of artistic collections as evidence that agency has been transferred from the image to its enlightened, contemplative consumer, and that any "power" in the image is now a delicately adjusted "aesthetic response" that does not overwhelm the beholder in the way that traditional religious and magical icons did. Freedberg expresses a similar ambivalence: "paintings and sculp-

40. Friedrich Nietzsche, preface to *Twilight of the Idols, or How One Philosophizes with a Hammer* (1889), in *The Portable Nietzsche,* ed. Walter Kaufmann (New York: Penguin, 1954), 466.

41. David Freedberg, *The Power of Images: Studies in the History and Theory of Response* (Chicago: University of Chicago Press, 1989); and Hans Belting, *Likeness and Presence: A History of the Image before the Era of Art* (Chicago: University of Chicago Press, 1994); orig. pub. under the title *Bild und Kult* (Munich, 1990).

42. Belting, *Likeness and Presence,* 16.

ture do not and cannot do as much for us now" as they did in ages of faith and superstition. But immediately he hesitates: "Or can they? Perhaps we repress such things."[43]

Belting and Freedberg are right to be ambivalent about their own binary narratives of a nonmodern era of images to be opposed to a modern era of art. If there is a commonplace in contemporary image theory, in fact, it is that images (if not works of art) today are credited with a power undreamt of by the ancient idolaters and their iconoclastic opponents. One need only invoke the names of Baudrillard and Debord to remind ourselves that the image as a pseudoagency, a power in its own right, is alive and well. Martin Jay reminds us that the history of theories of visual images, indeed of vision itself, is largely a history of anxiety; and the theory of images, as I suggested in *Iconology*, is really about the fear of images. We live in the age of the cyborgs, cloning, and biogenetic engineering, when the ancient dream of creating a "living image" is becoming a commonplace. Benjamin's era of "mechanical reproduction," when the image was drained of its aura, magic, and cult value by mechanized rationality, has been displaced by an era of "biocybernetic reproduction," in which the assembly line is managed by computers, and the commodities coming off the line are living organisms. Even in Benjamin's moment, moreover, his account of the passing of cult value acknowledged new forms of "exhibition value" and spectacle that contained haunting premonitions of a new, uncontrollable power for images when mobilized by political cults and mass media, most notably in the culture industries of fascism and advanced capitalism.

Should we settle, then, for a kind of ongoing schism between the value of art and the value of images, seeing the latter as the trash heap of debased values, of commodity fetishism, mass hysteria, and primitive superstition, the former as the repository of civilized values, of the image redeemed for critical contemplation? This was the strategy of a number of powerful critics in the modernist era, most notably Clement Greenberg. And it is currently being updated in the recent attacks on image studies and visual culture in *October* magazine.[44] Visual culture, *October* declares, threatens the fundamental values of art history precisely because it turns our attention from art to images. It is time, we are told, to return to the material concrete-

43. Freedberg, *The Power of Images*, 10.

44. "Questionnaire on Visual Culture," *October* 77 (Summer 1997). I summarize here, of course, a wide variety of arguments.

ness and specificity of the work of art, and reject the new dematerialized notion of the image, a notion which serves only to blur the distinctions between art and images, art and literature; to eliminate history in favor of anthropological approaches to visual culture; and to prepare subjects for the next stage of global capitalism.

I don't find these ways of drawing the battle lines over value in contemporary studies of art history or visual culture especially productive. Is the concreteness of the artwork and the immateriality of the image really a political choice on which sides can be taken? Or is it more precisely a dialectical relationship without which neither art history nor iconology would be possible? The image has always been immaterial in one way or another. New media simply make the fundamental ontology of images evident in new ways. The warfare between elite and mass culture may make for easy moralizing polemics, but it does little to clarify the meaning or value of either to lob air strikes from on high to liberate those benighted masses. The study of images and visual culture is, in my view, precisely the vantage point from which these disputed borders might be mapped and explored, along with other borders such as the ones between the visual and verbal media. As for the supposedly ahistorical character of anthropology, no one who has read anything in the field itself in the last ten years could say something like this.[45]

That leaves, then, the question of what the value of images and the study of visual culture might be in the face of the next phase of global capitalism. If we are indeed "preparing subjects" for this brave new world, perhaps we are simply doing our job, especially if the preparation involves the development of new skills of critique, interpretation, and evaluation of images, based on a clearer sense of what they are and how they introduce new forms of value into the world. I'd like to make one conceptual suggestion about a way to rethink hypervalued, overestimated (and therefore despised and worthless) images. I will then conclude with a brief analysis of a pair of specific images at the moment of their birth or unveiling.

There are three names traditionally attached to the over/underestimation of images in Western critical discourse: idolatry, fetishism, and totemism. Of these three, idolatry has the longest history and discloses the greatest surplus of overestimation (as an image of God, the ultimate value). Fetishism comes in a close second to idolatry as an image of surplus, associated

45. For a more fully elaborated defense of visual culture, see chapter 16.

with greed, acquisitiveness, perverse desire, materialism, and a magical attitude toward objects. Totemism, by contrast, has not been widely employed in public (as opposed to professional) discussions of the value of images.

I propose that we reconsider the role of totemism alongside fetishism and idolatry as a distinct form of the surplus value of images. My aim in doing this is to flesh out the historical record of the overestimated image, and to offer a model that starts not with suspicious iconoclasm but with a certain curiosity about the way in which "primitive" forms of valuation might still speak to us "moderns." The introduction of totemism as a third term may also help to disrupt the binary model of art history that opposes an "age of images" to an "era of art," or (even worse) opposes "Western" art to "the rest." Totemism, in fact, is the historical successor to idolatry and fetishism as a way of naming the hypervalued image of the Other. It also names a revaluation of the fetish and idol. If the idol is or represents a god, and the fetish is a "made thing" with a spirit or demon in it, the totem is "a relative of mine," its literal meaning in the Ojibway language.[46] It's not that totems are essentially different from idols and fetishes; the distinctions are notoriously difficult to maintain (an idol, for instance, may also be a "relative," but it is usually a parental figure, a father or mother, whereas totemism seems more akin to brother- and sisterhood). The concept of totemism aims, in a sense, to incorporate the earlier ways in which the modern encountered the nonmodern image within a new and deeper structure.

Totemism was supposed to be the most elementary form of religious life, as Durkheim put it, deeper and more archaic than idolatry and fetishism.[47] Although idolatry comes first in the Judeo-Christian-Islamic tradition as the worst possible crime against an iconoclastic monotheism, it is a relatively late development from Durkheim's point of view. Idolatry turns the sacred totem, a symbol of the clan or tribe, into a god. Idols are just inflated totems, more powerful, valuable, and therefore more dangerous. Fetishism comes second in the historical sequence of image perversions. It emerges, as anthropologist William Pietz has shown, in seventeenth-century mercantilism, specifically the commerce between Africa and Portugal (which supplies the word, *feticho,* or "made thing").[48] It supplants

46. Claude Lévi-Strauss, *Totemism,* trans. Rodney Needham (Boston: Beacon Press, 1963), 18.

47. Durkheim, *The Elementary Forms of Religious Life.*

48. William Pietz, "The Problem of the Fetish," parts 1–3: *Res* 9 (Spring 1985), 13 (Spring 1987), and 16 (Autumn 1988).

idolatry as a name for the despised object of the Other. While idolatry was getting promoted in value, thanks to its association with Greek and Roman art, the fetish was consigned to the realm of materialism, filth, obscenity, phallic cults, magic, private interest, and contractual commodity exchange. The fetish might be thought of as a false, deflated little totem. To paraphrase anthropologist Andrew McLennan's famous formula, quoted by Claude Lévi-Strauss, "fetishism is totemism minus exogamy and matrilineal descent."[49] In short, the fetish is the totem without the communal investment. It is a fragment of the totem, a part object, often a body part, an isolated individual severed from the collective. The sexual practices associated with these hypervalued images put this point in the strongest relief. Idolatry is traditionally linked with adultery and promiscuity (whoring after strange gods),[50] fetishism with perversity and obscene phallic worship. Totemism, by contrast, is concerned with the regulation of legitimate sexual practices, prohibitions on incest, and the encouragement of proper intertribal marriages.

My point is not to idealize the totem but to locate its historical and iconological significance, and to bring it forward into the modern. It is significant that Freud begins *Totem and Taboo* by pointing out that while "taboos still exist among us . . . totemism, on the contrary, is something alien to our contemporary feelings."[51] The complexity of totemic rituals, the crazy quilt of social differentiations, the animism, naturism, ancestral piety all made it difficult to map totemism onto modern images. Even worse, totemism was pretty much useless as a weapon in the value wars of modernism. To call someone a totemist simply lacks polemical force; it's scarcely even grammatical. Totemism is primarily a technical term in the social sciences, virtually synonymous with the rise of anthropology as a discipline. Totemism signaled a shift from a rhetoric of iconoclasm to a rhetoric of scientific curiosity. If the idolater is an enemy who must be shunned or killed, and the fetishist is a savage with whom one wants to trade, the totemist is a member of a vanishing race left behind in an evolutionary pro-

49. Andrew McLennan, quoted in Lévi-Strauss, *Totemism*, 13.

50. See Moshe Halbertal and Avishai Margalit, *Idolatry,* trans. Naomi Goldblum (Cambridge, MA: Harvard University Press, 1992), chap. 1, "Idolatry and Betrayal." To see the default connection between fetishism and perverse sexuality, just try entering the word into a search engine in your Web browser.

51. Sigmund Freud, *Totem and Taboo,* trans. James Strachey (New York: W. W. Norton, 1950), x.

gression to modernity. The attitude toward the totem, therefore, is not iconoclastic hostility or moralism but curatorial solicitude. One might see the new art-historical revaluations of idols and fetishes as a kind of "totemizing" of them, an effort to understand the social-historical contexts, the ritual practices, the belief systems and psychological mechanisms that make these images possess so much surplus value.

As an analytic concept, totemism sheds the moralistic judgments pronounced on idolatry and fetishism, but at the expense of a benign and patronizing distancing of the totem into the "childhood" of the race. The totem becomes the figure of division between ancient and modern image cultures. It is thus automatically ruled out for the analysis of the modern image, which tends to be assigned to the realm of idolatry and fetishism on the one hand or to the sphere of the redeemed aesthetic object on the other. (There are numerous crossovers, of course: art historian Meyer Schapiro noted that the highest praise for modernist abstract painting seemed invariably to employ the language of fetishism, and both surrealism and forms of postmodern art directed at politics and gender have employed the language of fetishism extensively.)[52] Totemism, despite its explicit appearance in the sculpture of David Smith and the painting of Jackson Pollock (and, I have argued, in the aesthetics of minimalism and Robert Smithson's experiments in "paleoart") seems not to have established a foothold in the discourse of contemporary art.[53] Even more disabling for the concept of totemism was its abandonment as an analytic tool by cultural anthropology. While I cannot fully elaborate this story here, suffice it to say that Lévi-Strauss's dismissal of totemism as a phantom concept comparable to hysteria in psychoanalysis made it seem like an incoherent grab bag of images, beliefs, and ritual practices.

If the totem was useless even for the analysis of primitive images, then, it was difficult to see what role it could play in the analysis of modernity— at least, that is, until the present moment, when modernity itself has begun to recede in the rearview mirror of history, and a new synthesis of biological, ecological, and evolutionary thinking has made it possible to reconceive iconology as a natural history of images. Totemism is, before all else,

52. Meyer Schapiro, "Nature of Abstract Art" (1937), in *Modern Art: 19th and 20th Centuries* (New York: Georges Braziller, 1978), 200; and Hal Foster, "The Art of Fetishism: Notes on Dutch Still Life," in *Fetish, The Princeton Architectural Journal*, vol. 4 (1992): 6–19.

53. See my discussion of Robert Morris in *Picture Theory*, chap. 8; of Smithson in "Paleoart," *The Last Dinosaur Book*, 265–75.

grounded in images of the natural world, especially animals and plants. As Lévi-Strauss puts it: "the term totemism covers relations, posed ideologically, between two series, one *natural,* the other *cultural.*"[54] The totem, then, is the ideological image par excellence, because it is the instrument by which cultures and societies naturalize themselves. The nation becomes "natal," genetic, genealogical, and (of course) racial. It is rooted in a soil, a land, like a vegetative entity or a territorial animal.

The other features of totemism—its relation to ancestor worship, to the regulation of sexuality and reproduction (exogamy and matrilineal descent), its emphasis on sacrificial rituals centered on the communal meal or festival—are all ways of elaborating and ramifying the role of the over/ underestimated image. And the totem is, above all, an image, a collective representation in graphic or sculptural form, what Lévi-Strauss calls the "graphic 'instinct'" (71). As Durkheim notes, "the images of the totemic being are more sacred than the totemic being itself."[55] The birth of human society, for Durkheim, is therefore synonymous with the birth of images, specifically the image of the social totality projected onto a natural image. God does not create man in his image in the most elementary forms of religious life; man creates God in the image of the durable natural forms he encounters in daily life, as a way of signifying the ongoing life and identity of the clan.

I want to conclude now with a meditation on two scenes of what might be called the birth of an image, both of which exhibit an excess or surplus of value in a highly theatrical way and display many of the features of totemism, although neither has ever been given this name (figs. 31, 32). They are drastically remote from each other in historical-cultural location and pictorial style; at the level of iconography, however, one could go on forever noting the uncanny resemblances, which is why they make good examples for the comparative study of hypervalued imagery in ancient and modern settings. Both are scenes dominated by the image of a beast; both show a party of revelers engaged in a festive celebration of the birth of the image. Both images, needless to say, are regarded as highly valuable by their celebrants. The ancient image possesses the highest valuation to which an image can aspire. It quite literally *is* a god. That is, it doesn't merely resemble or represent a god that is elsewhere, but is itself a living deity. The

54. Lévi-Strauss, *Totemism,* 16; emphasis in the original.
55. Durkheim, *The Elementary Forms of Religious Life,* 133.

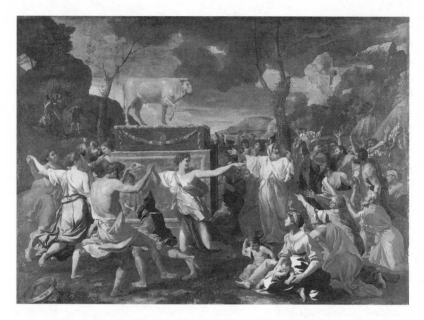

FIGURE 31 Nicolas Poussin, *The Adoration of the Golden Calf.* National Gallery, London. Copyright National Gallery, London.

Israelites do not ask Aaron to make them a symbol or likeness of a god, but a god—an *elohim*—itself.[56] And the most valuable materials are employed to this purpose. The gold jewelry that the Israelites have brought out of Egypt is melted down to make the calf.[57] For its part, the modern image of the dinosaur in "The Dinner in the Mould of the Iguanodon" has the value of a scientific miracle. It is not merely a replica or likeness of an extinct creature. In the words of Benjamin Waterhouse Hawkins, the sculptor who fashioned it, modern art and science have collaborated in this work to "revivify" the ancient world, to resurrect "dry bones" from the dead and reanimate them in a modern reenactment of Ezekiel's prophecy in the valley of dry bones.

But there are shadows of devaluation hovering over both images as well.

56. See Pier Cesare Bori, *The Golden Calf* (Atlanta: Scholar's Press, 1990), 15. On Nicolas Poussin's rendering, see Charles Dempsey, "Poussin and Egypt," *Art Bulletin* 45, no. 2 (June 1963): 109–19.

57. Dempsey ("Poussin and Egypt," 118) notes that Poussin was probably echoing the archaeology of his day by representing the golden calf as the Egyptian deity Apis, thus suggesting that the event is a backsliding into Egyptian idolatry.

FIGURE 32 "The Dinner in the Mould of the Iguanodon." *London Illustrated News,* January 7, 1854.

We know that the golden calf is an abomination before the Lord (no matter how attractive it may look to us), and it will be ground down to powder, burned and "strawed on water" for the sinful idolaters to drink. The dinosaur also will be condemned as an abomination by Christian fundamentalists, and its value will, in the century and a half after its first unveiling, continually fluctuate between sublimity and cuteness, between impressive monumentality and the aura of a silly, contemptible failure to which the spectator can condescend.

If the golden calf as depicted by Nicolas Poussin is at the center of a scene of sexual promiscuity and bacchanalian excess, the dinosaur frames a scene of male bonding, the appearance of a new class of modern professionals (what we now call "suits") in the belly of a beast whose symbolic life will go well beyond anything they could have imagined in 1854. The dinosaur will become, in fact, the totem animal of modernity. Its giantism will serve as a living image of modern technologies (especially the skyscraper); its overtones of violence and rapacious consumption will feed into neo-Darwinist

models of capitalism as the "natural" social order; its status as an extinct species will resonate with the emergence of mass death and genocide as a global reality in the twentieth century, and with the increasing pace of cycles of innovation and obsolescence. The dinosaur as a scientific and popular novelty is also a symbol of the archaic and outmoded, the fundamental dialectic of modernity.

Beyond these similarities of form and function, the contrasts between the two images are equally striking. Poussin's *The Adoration of the Golden Calf* is a scene of celebration around the sacred beast; "The Dinner in the Mould of the Iguanodon" stages its festival inside the belly of the beast, suggesting simultaneously a Jonah-like image of men being swallowed up by the animal, or of the animal being pregnant with the men. If this reading seems far-fetched, it is one that did not escape the notice of contemporary spectators. The *London Illustrated News* congratulated the gentlemen celebrating in the dinosaur for having been born in the modern age, for if they had been born in ancient times, they would have been the meal in the creature's belly. We also have the good fortune to know exactly what the modern gentlemen are doing as they raise their glasses in a toast. They are singing a song composed especially for the occasion:

A thousand ages underground
His skeleton had lain,
But now his body's big and round
And there's life in him again!

His bones like Adam's wrapped in clay
His ribs of iron stout
Where is the brute alive today
That dares to turn him out.

Beneath his hide he's got inside
The souls of living men,
Who dare our Saurian now deride
With life in him again?

Chorus: The jolly old beast
Is not deceased
There's life in him again.[58]

58. *London Illustrated News,* January 7, 1854.

It's not just that the animal image has performed a miraculous rebirth of an extinct creature, but that the creators of the image, the new breed of modern, scientific men, have somehow been begotten from the belly of this bestial image. Do we create images, or do they create us? The answer, from the standpoint of Durkheim's totemism, is perfectly equivocal. Totems are made things, artificial images. But they take on an independent life. They seem to create themselves, and to create the social formations that they signify.[59] The Israelites, and specifically Aaron, create the calf, but they create it to "go before them" as a leader, predecessor, and ancestor that has begotten them as a people. The golden calf and the dinosaur are animals that "go before" us in every sense of the word.[60]

Conclusion

We could go on at considerable length unpacking the meaning and value of these images, and I have scarcely scratched the surface in these remarks. My main point is simply to suggest that the question of images and value cannot be settled by arriving at a set of values and then proceeding to the evaluation of images. Images are active players in the game of establishing and changing values. They are capable of introducing new values into the world and thus of threatening old ones. For better and for worse, human beings establish their collective, historical identity by creating around them a second nature composed of images which do not merely reflect the values consciously intended by their makers, but radiate new forms of value formed in the collective, political unconscious of their beholders. As objects of surplus value, of simultaneous over- and underestimation, these stand at the interface of the most fundamental social conflicts. They are phantasmatic, immaterial entities that, when incarnated in the world, seem to possess agency, aura, a "mind of their own," which is a projection of a collective desire that is necessarily obscure to those who find them-

59. See Bori, *The Golden Calf,* 87, 97, on the supernatural and spontaneous making of the calf.

60. I recommend here Jacques Derrida's discussion of the role of animals in Western philosophy, "The Animal That Therefore I Am (More to Follow)," *Critical Inquiry* 28, no. 2 (Winter 2002): 369–418. See also Cary Nelson, *Animal Rites: American Culture, the Discourse of Species, and Posthumanist Theory* (Chicago: University of Chicago Press, 2003), and my preface, "The Rights of Things."

selves, like Hawkins's scientists or Poussin's revelers, celebrating around or inside an image. This is true no less for modern than for ancient images. When it comes to images, as Bruno Latour would put it, we have never been and probably never will be modern. I have suggested totemism as a critical framework for addressing these issues because it addresses the value of images "on the level," as it were, as a game between friends and relatives, not as a hierarchy in which the image must be adored or reviled, worshipped or smashed. Totemism allows the image to assume a social, conversational, and dialectical relationship with the beholder, the way a doll or a stuffed animal does with children. We adults could learn something from their example, and perhaps apply it to our relations with the images that seem, for often mysterious reasons, to matter so much to us.

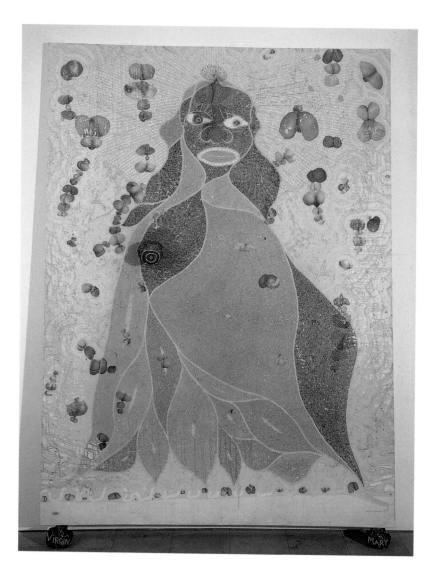

PLATE 1. Chris Ofili, *The Holy Virgin Mary*, 1995.
Acrylic paint, oil paint, polyester resin, paper col-
lage, glitter, map pins, and elephant dung on can-
vas, 8 × 6', with two elephant-dung supports.
Copyright Chris Ofili. Courtesy artist / Victoria
Miro Gallery, London.

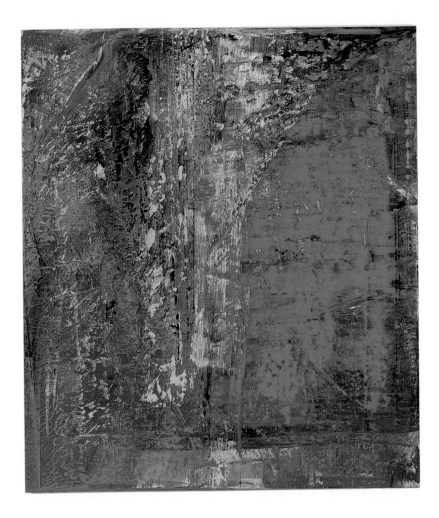

PLATE 2. Gerhard Richter, *Abstraketes Bild*, 1987. Courtesy of
the artist and Marian Goodman Gallery, New York.

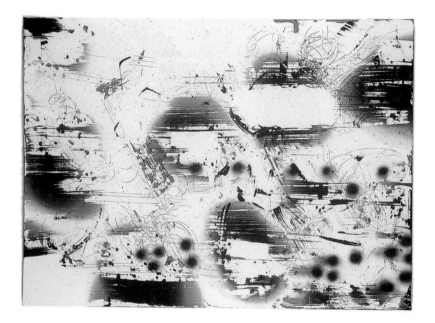

PLATE 3. Bill Kmoski, *Untitled*, 1995.
Courtesy Feature Inc.

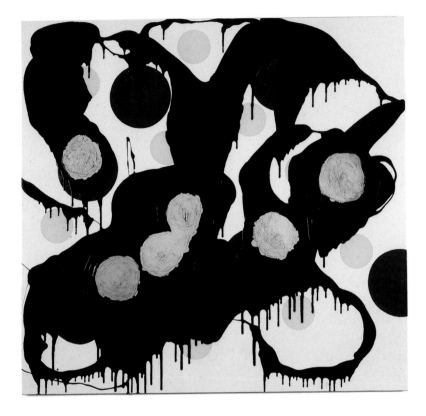

PLATE 4. Dona Nelson, *Moonglow,* 1993.
Courtesy of the artist.

PLATE 5. Polly Apfelbaum, *Honeycomb*, 1994.
Synthetic velvet, fabric dye, and fabric glue
on cotton sheeting, approx. 81 × 108″. Cour-
tesy of the artist and D'Amelio Terras
Gallery, New York.

PLATE 6. Richard Kalina, *Aemelia,* 1994.
Courtesy Lennon, Weinberg Gallery.

PLATE 7. Jonathan Lasker, *Medium Exaltation,* 1992. Oil on linen, 54 × 72" (137.2 × 182.9 cm).
Private collection. Courtesy Sperone Westwater, New York.

PLATE 8. Sven Dalsgaard, *Bagage,* ca. 1990. © 2003 Artists Rights Society
(ARS), New York / COPY-DAN, Copenhagen.

PLATE 9. Rochelle Feinstein, *Horizontal Hold,*
1994. Courtesy of the artist.

PLATE 10. Turkey Tolson Tjupurrula, *Straightening Spears at Ilyingaungau,* 1990, Kintore, Northern Territory. Synthetic polymer paint on canvas, 181.5 × 243.5 cm. Art Gallery of South Australia, Adelaide. Gift of the Friends of the Art Gallery of South Australia, 1990. Courtesy The Art Gallery Board of South Australia.

PLATE 11. Kathleen Petyarre, *Storm in Atnangker County II*, 1996. Acrylic on linen, 183 × 183 cm. Museum and Art Gallery of the Northern Territory, Darwin.

PLATE 12. Abie Kemarre Loy, *Titye/Awelye*
(Bush medicine/women's ceremony), 2001.
Photograph by Ted Lacey. Courtesy of the
artist and Gallerie Australis, Adelaide.

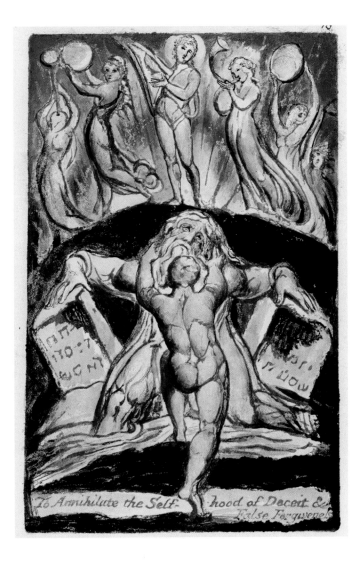

PLATE 13. William Blake, plate 17 in *Milton*
(ca. 1811), copy C: Los sculpting/pulling
down Urizen.

PLATE 14. Antony Gormley, *Field for the British Isles,* 1992. Courtesy of the artist.

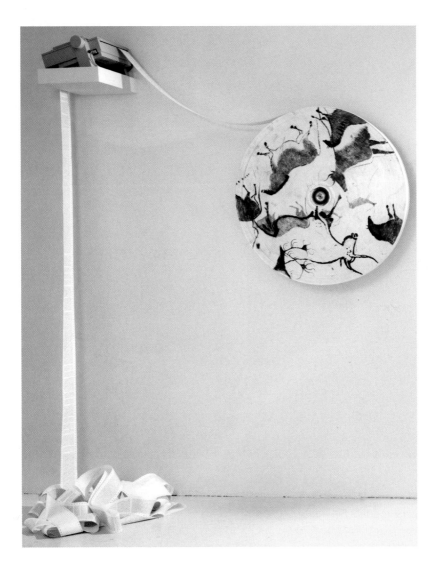

PLATE 15. Janet Zweig and Laura Bergman,
Abstraction Device, 2000. Courtesy of Janet
Zweig.

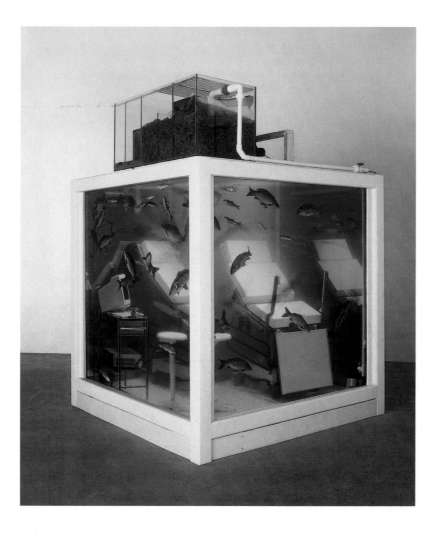

PLATE 16. Damien Hirst, *Love Lost*, 2000.
Courtesy of the artist and The Saatchi
Gallery, London.

Part Two

Objects

No ideas but in things.
William Carlos Williams

IMAGES MATTER in more than one sense. That is, they make a difference, are important, and make demands. But they are themselves matter, in the sense that they are always embodied in material objects, in things, whether stone, or metal, or canvas, or celluloid, or in the labyrinth of the lived body and its memories, fantasies, and experiences. In this section we turn from the phantasmatic, immaterial realm of the image to the domain of objects. Objects are, of course, many things. They are the targets of "objective" descriptions and representations, products of a discourse of objectivity. They are constituents of a world set over against "subjects," that is, persons, individuals, conscious beings. Objects can also (in the language of psychoanalysis) play the role of subjects, most notably in object-relations theory, where "object-choice" determines sexual orientation, and where "Good Objects" and "Bad Objects" can "*act* upon the subject" in a relationship of nourishing, persecuting, or (in the case of the "Split Object") both.[1]

It should be clear that if there are no images without objects (as material support or referential target), there are no objects without images. Melanie Klein notes that good and bad objects are really "imagos, which are a phantastically distorted picture of the real objects upon which they are based,"[2] but she could have said as well that "real objects" are also products of imagoes that are widely shared, practically useful, and publicly verifiable. The objects of our concern in the following section will be the sort that play across this boundary. That is, I am not principally concerned with the objects of individual psychology, neurotic or perverse behavior, but with objects that play a social role, and whose status (good/bad, normal/perverse, rational/irrational, objective/subjective) is precisely what is in dispute. We might think of these, then, as *objectionable* objects, object lessons, or even *abject* objects that have been disgraced, and discarded. This last category will be the subject of chapter 5, which looks at the theory of the "found object" in contemporary art. From these we will move (in chapter 6) to objects that are positively repugnant, the products of "offensive" imagoes. Chapter 7 will then return to the question of "objecthood" as such in aesthetics, tracing its roots in the imperial/colonial discourse on totemism, fetishism, and idolatry. Chapter 8 traces the emergence of a modern sense

1. See J. Laplanche and J.-B. Pontalis, *The Language of Psychoanalysis* (New York: Norton, 1973), 278–79.

2. Melanie Klein, "A Contribution to the Psychogenesis of Manic-Depressive States" (1934), in *Contributions to Psycho-Analysis* (London: Hogarth Press, 1950), 282.

of "the physical," and of animism and vitalism in the Romantic period, focusing on the new conceptual/scientific imagoes of the totem and fossil.

Anyone interested in seeing the whole triad of totemism, fetishism, and idolatry laid out in a schematic tableau should turn immediately to chapter 9, where the relations among these concepts are recapitulated.

"Things" have been in the news of late. The February 24, 2001, edition of the *New York Times* ran a feature in its Arts & Ideas section on the eruption of interest in material culture in academia. Trivial objects—slippers, pencils, gloves, teapots—no longer seem like innocent, passive entities, but have "lives of their own," with stories to tell, and voices to tell them; the venerable subdiscipline of "material culture" has news to report.[1] If Marx's ghost were to sit down at a table right now, no doubt he would remind us of his memorable words in *Capital*:

As soon as [the table] steps forth as a commodity, it is changed into something transcendent. It not only stands with its feet on the ground, but, in relation to all other commodities, it stands on its head, and evolves out of its wooden brain grotesque ideas, far more wonderful than "table-turning" ever was.[2]

But why should "things" suddenly seem so interesting? Is it a compensatory move for the sense of de-realization produced by cyberspace and virtual reality? A nostalgic gesture toward the revival of various forms of materialism, historical, dialectical, even empirical, at a time when Marxism seems as quaint as a Victorian séance and the most important commodities are virtual or intellectual properties such as images and ideas, genes and programs, not tables or bushels of wheat? Is it just another replaying of the "transgression" of the border between high and low art,

1. For one of the newest entries, see the *Journal of Material Culture* (London: SAGE Publications, 1995–), ed. Christopher Pinney and Mike Rowlands.

2. Karl Marx, *Capital*, vol. 1, trans. Samuel Moore and Edward Aveling (New York: International Publishers, 1967), 71.

which now has been crossed so often it scarcely seems to exist, and the display of junk, garbage, obsolete technologies, and other waste products has virtually become a genre in the exhibition spaces of contemporary art?

Whatever the causes, the consequences are manifest. We find ourselves talking about physical things today with a new tone of voice. "Things" are no longer passively waiting for a concept, theory, or sovereign subject to arrange them in ordered ranks of objecthood. "The Thing" rears its head—a rough beast or sci-fi monster, a repressed returnee, an obdurate materiality, a stumbling block, and an object lesson. Interdisciplinary discussion groups on material culture form at research universities, and *Critical Inquiry* produces a special issue entitled, simply, "Things."[3]

Amidst this ferment (which must not be exaggerated in its impact, if only because there is something deliberately muted and humble about the

3. Guest-edited by Bill Brown; *Critical Inquiry* 28, no. 1 (Fall 2001). "Things" was recognized as the Outstanding Special Issue of a Scholarly Journal for 2001 by the Conference of Editors of Learned Journals, and was published in book form in 2004.

very notion of objecthood), it seems like the right moment to revisit the traditional question of the found object in modern art. Yet when I recently sent around a brief questionnaire to knowledgeable scholars, I was surprised at the results. Everyone knows what a "found object" is, yet no one could think of a truly powerful and compelling theoretical account of the concept. The major exhibition on the subject, curator Diane Waldman's *Collage, Assemblage, and the Found Object,* is so comprehensive, inclusive, miscellaneous, and heterogeneous that, like things themselves, it overwhelms theoretical reflection.[4] And the best critical accounts of the subject, like art historian Hal Foster's discussion in *Compulsive Beauty,* tend to be focused on specific artistic movements. Foster isolates the surrealist use of the found object, linking it to the twin engines of object relations theory in psychoanalysis, and critical theory's critique of the commodity fetish. Foster's basic argument is that the found object is the critical weapon in the arsenal of the surrealist avant-garde, expressing a "return of the repressed" in psychic and social life, an eruption of the uncanny in the form of tribal, handicraft, and (above all) obsolete consumer objects.[5]

Yet Foster is the first to admit the limits of his own theory and of the surrealist deployment of the found object. He notes that the "shock of the found" object, especially of the detritus of the nineteenth-century bourgeoisie, has now been thoroughly co-opted and commodified by various "retro" fashions, and that surrealism has been exposed as "the critical double of fascism" in its flirtation with archaic, misogynistic fantasies of violence and death (189). Foster wants to take us "beyond the surrealism principle" toward some third return of the repressed. He reminds us of Marx's theory of historical repetition in *The Eighteenth Brumaire,* in which events occur first as tragedy, then as farce, by positing a third phase, which he calls "comedy"—"a comedic resolution that might somehow free the subject from delusion and death," or "at least . . . divert its forces in a critical intervention into the social and the political" (189). But at this point, such a third way seems like whistling in the dark. Foster's account of the found object, like most others I have encountered, seems locked in the fa-

4. Diane Waldman, *Collage, Assemblage, and the Found Object* (New York: Harry Abrams, 1992).

5. Hal Foster, *Compulsive Beauty* (Cambridge, MA: MIT Press, 1993). See especially pp. 44–48, where Foster associates the found object with "primal loss" (48), and chapter 6, in which he emphasizes the outmoded commodity.

miliar straitjacket of fetishism—whether the fetishism of psychic demand/ desire/need, with its predictable sadomasochistic rituals of mastery and enslavement, abjection and sacrifice, or the even more compulsive cycles of unending commodification. These objects are now no longer found but foundational for the familiar gestures of surrealism. The new-model found objects of our time don't even claim to have the uncanny frisson of the out-moded or obsolete commodity: they are the fresh new floor polishers of Jeff Koons (fig. 33), or "Lost Objects" like Allan McCollum's castings of dino-saur bones—so deeply archaic that they come from a time outside human history altogether. There is no "return of the repressed" with these objects. With Koons, there is no return;[6] with McCollum, no repression (indeed, what would it mean to think of dinosaur relics as repressed?)[7]

If found objects have not found themselves an adequate theory, then, it may be because they haven't felt the need for one. Everyone knows that there are just two criteria for a found object: (1) it must be ordinary, unim-portant, neglected, and (until its finding) overlooked; it cannot be beauti-ful, sublime, wonderful, astonishing, or remarkable in any obvious way, or it would have already been singled out, and therefore would not be a good candidate for "finding"; and (2) its finding must be accidental, not deliber-ate or planned. One doesn't seek the found object, as Picasso famously re-marked. One *finds* it. Even better: it finds you, looking back at you like La-can's sardine can or Marcel Broodthaers's *L'oeil* jar.[8] The secret of the found object is thus the most intractable kind: it is hidden in plain sight, like Poe's purloined letter. Once found, however, the found object should, as in sur-realist practices, become foundational. It may undergo an apotheosis, a transfiguration of the commonplace, a redemption by art. In the ready-made, it may take on a new name—the urinal becoming a "fountain." If it really works, however, we have a sneaking suspicion that the transfigura-tion was a trick, a comic ruse engineered by a deus ex machina; and the plain old thing with its homely, familiar name is still there, blushing and

6. Of course it could be argued (as Jeremy Gilbert-Rolfe has suggested to me) that Koons's vacuum cleaners are not really "found objects" at all but parodic exploitations of the cate-gory of the readymade which count on a well-rehearsed art-world "discourse" to lend them an air of hipness.

7. See my discussion of McCollum's *Lost Objects* in W. J. T. Mitchell, *The Last Dinosaur Book: The Life and Times of a Cultural Icon* (Chicago: University of Chicago Press, 1998), 114, 266–69.

8. For the episode of the sardine can which "looks back," see Jacques Lacan, *The Four Fun-damental Concepts of Psychoanalysis* (New York: Norton, 1978), 95–96.

smirking at us in the spotlight of aesthetic attention, or (better) ignoring us totally. An essential feature of the wit in Jeff Koons's reframing (inside a vitrine) of glossy new appliances is his conspicuous *refusal* to rename the objects, and his pedantic insistence on reciting their original proper names: *New Hoover Deluxe Shampoo Polishers, New Shelton Wet/Dry 10 Gallon Displaced Triple-Decker.*[9] The true found object never quite forgets where it came from, never quite believes in its elevation to spectacle and display. It remains humble to the end, a poor thing caught up in the push and pull of desire and demand.[10]

Perhaps the theory of the found object has not been found because, like its object, it is too obvious, too ubiquitous. This is the argument of Douglas Collins's account of the found object, the best that I have come across.[11] Collins's basic insight is simple: "since the found object is the entirety of modern philosophy, what is there that is not this?"[12] This may sound like a

9. Raimonda Modiano and Frances Ferguson connect the found object to an antitheatrical absorption and indifference to the beholder, reminiscent of Michael Fried's well-known concept, elaborated in his *Absorption and Theatricality: Painting and Beholder in the Age of Diderot* (Berkeley and Los Angeles: University of California Press, 1980). See Modiano's comments later in this chapter and Ferguson, *Solitude and the Sublime: Romanticism and the Aesthetics of Individuation* (New York: Routledge, 1992).

10. One wishes that Rosalind Krauss had not been so quick to dismiss the adhesion of the "proper name" to the found objects in Picasso's collages (Krauss, "In the Name of Picasso," in *The Originality of the Avant-Garde* [Cambridge, MA: MIT Press, 1985]) as if they were merely retrograde diversions from the freedom of the Saussurean signifier: "the mimetic image (or representation) is like the traditionally understood proper name. . . . It denotes the object. But it is without connotation or intension" (27). First, the proper name may not be quite as simple as Krauss thinks. More important, the function of the found object in the founding of identity may ultimately lead us back to another take on the proper name as something more than a symptom of "the inadequacy of classical mimetic theories" (27). For a sympathetic take on Koons's objects, see Alison Pearlman, *Unpackaging the Art of the Eighties* (Chicago: University of Chicago Press, 2003), 134–44.

11. I can't resist mentioning that I came across Professor Collins's work by accident while researching what I thought was a completely unrelated matter: the representation of the countryside in Romantic literature.

12. E-mail correspondence, February 12, 2001. Collins's articles appear in the online journal *Anthropoetics* (http://www.anthropoetics.ucla.edu). See, in particular, "L'Amour Intellectuel de Dieu: Lacan's Spinozism and Religious Revival in Recent French Thought, (Spring/Summer 1997) 3, no. 1; "From Myth to Market: Bataille's Americas Lost and Found," (Fall/Winter 1999–2000) 5:2; and "Justice of the Pieces: Deconstruction as a Social Psychology," (Spring/Summer 1998) 4:1. I am grateful to Collins for sharing with me his unpublished book manuscript, *The Prowess of Poverty: Miserable Objects and Redeemed Tradition in Modern French Philosophy.*

grandiose claim, but it is easy enough to make it good with a straightfor-
ward dialectical reflection, simply by asking, what is *not* the found object?
Answer: the *sought* object, the desired object, the sublime or beautiful ob-
ject, the valued object, the aesthetic object, the produced, consumed, or ex-
changed object, the given or taken object, the symbolic object, the feared
or hated object, the good or bad object, the lost or vanishing object. These
are the special objects singled out for theoretical attention by critical the-
ory and by psychoanalysis. They are the objects we care about in advance,
the objects we are looking for, the objects of theory. What constitutes all of
them, as their limit and antithesis, however, are the indifferent objects, the
"poor things" that are all around us, the objects that provoke "idle curios-
ity" at best. They are what theory overlooks in its drive for mastery over
things, its fantasy of a proper object for theorization. They are commodi-
ties prior to fetishization, prior even to commodification, languishing in a
zone of indistinction, beneath notice or contempt. This implies, of course,
that everything changes once they are found, at which point they will be
"discovered," "revealed," "reframed," and put on display, consequently be-
coming fetishes and (if their luck holds out) foundational for a whole se-
ries of new findings and appropriations. The temporality of the found ob-
ject is thus crucial, the sense that it has a kind of rags-to-riches biography
and that its humble origins are an essential part of its life cycle.

I cannot do justice here to the comprehensiveness of Professor Collins's
pursuit of this theme through modern French philosophy as centered in
Bataille, and beyond that in Spinoza, Kant, Hegel, Nietzsche, Marx, and
Freud. Let me just sketch out two regions of objecthood where his theory
has led me, or where it has confirmed findings that were, for me, only partly
crystallized. I'm thinking of the first emergence of the found object as an
aesthetic category in the Romantic craze for the picturesque, and its ethno-
graphic pedigree in the concept of totemism.

First, the picturesque. As Raimonda Modiano (also inspired by Collins)
has pointed out, the picturesque object is typically a "poor thing," a figure
of "destitution" like the gypsy, the beggar, the rustic, or the ruin.[13] She ar-
gues that "these destitutes function as narcissistic ego ideals, as figures of
undisturbed self-sufficiency and self-absorption" (196). They do not evoke

13. Raimonda Modiano, "The Legacy of the Picturesque: Landscape, Property, and the
Ruin," in *The Politics of the Picturesque*, ed. Stephen Copley and Peter Garside (New York:
Cambridge University Press, 1994), 196–219.

envy or love, but offer an image of unenviable freedom from property and social bonds. In their noblest form, they may suggest the "Resolution and Independence" of Wordsworth's Leech-Gatherer, a kind of dignified but wholly untheatrical and undemanding poverty. The objects of the picturesque, then, lie outside the erotics of the beautiful and the deadly abyss of the sublime sacrifice. As ruins, "they are already sacrificed, they cannot be sacrificed again and can thus constitute an ideal safe from the threat of violence" (196). As "attractive" objects, they do not invite (or threaten) possession, except in the picturesque sketch or photograph. They occupy the realm of denied or arrested desire, sufficiently gratified by the visual, picturesque experience. They thus play a crucial ideological role in late eighteenth-century aesthetics in mediating a double desire to own and renounce property, to possess the countryside without real ownership, to shape the landscape while preserving the illusion of wilderness. "Hence," Modiano concludes, "the objects typically featured in the Picturesque are not objects owned or acquired through gift transfers but those which fall under the category of 'the found object'" (197).

I won't bore you with a long concession speech about the blatantly ideological character of the picturesque tradition, or rehearse for you the way it has been drummed out of the aesthetics of High Romanticism in favor of the sublime and the beautiful.[14] Suffice it to say that the picturesque is the neglected key to Romantic aesthetics, with its emphasis on singling out the ordinary, the common, the trivial, the mean, and the destitute. From Blake's "The Fly" to Wordsworth's "meanest flower that blows," to Shelley's "Sensitive Plant," to Coleridge's fluttering ash on the hearth, the found object is the true Romantic Thing, much more surely than the summit of Mont Blanc, which notoriously disappoints.[15] When the found object reveals itself as a *subject*, however, as the beggar or gypsy, we suffer an aver-

14. See John Barrell, *The Dark Side of the Landscape* (New York: Cambridge University Press, 1980); Ann Bermingham, *The Ideology of Landscape* (Berkeley and Los Angeles: University of California Press, 1986); and my own essay, "Imperial Landscape," in *Landscape and Power*, ed. W. J. T. Mitchell, 2nd ed. (Chicago: University of Chicago Press, 2002), for a discussion of the aestheticization of poverty and the veiling of possession in the picturesque.

15. Even J. M. W. Turner's sublime landscapes are routinely disfigured by a kind of scumble of trash in the foreground, the flotsam and jetsam of beach scenes, or the working-class tourists cluttering the sublime vista. Ruskin, as Elizabeth Helsinger notes, found these figures "an unfortunate instance of Turner's vulgarity" (Helsinger, "Turner and the Representation of England," in Mitchell, ed., *Landscape and Power*, 110). See also Ronald Paulson's charac-

sive shock rather like that experienced by the early moderns when they found Victorian bric-a-brac showing up in the collages of Max Ernst. It is unpleasant to think that the found object might be a poor *person*, an orphaned, homeless beggar. We no longer know how to find these figures picturesque, which is to say, we no longer know how to find them at all.

The most salient example of the found object as "poor thing" is the figure of the old woman, preferably one in rags, as in Thomas Rowlandson's classic satire, *Dr. Syntax in Search of the Picturesque*. In a well-known imitation of Rowlandson by H. Merke, we see the picturesque artist *failing* at his mission. His easel is folded up, his umbrella open as he hurries past the classical objects of picturesque attention (fig. 34). But why is the old woman picturesque? Because she presents none of the sublime danger that a male gypsy might suggest (the brigands of Salvator Rosa), and none of the potential for erotic fixation that the peasant lass offers. Like Mother Nature herself, she is simply a singular object of curiosity, a time-roughened specimen of endurance and ruination. The old woman wards off the danger of Oedipal fixation. Instead of the nurturing mother whose breast is the object of desire, envy, and aggression, her withered frame suggests the mother-in-law whose visits are transitory—here today, gone tomorrow—as befits the temporality of the found object. The classic multistable image known as *My Wife and My Mother-in-Law* captures her peculiarity in a singular gestalt (fig. 35). Like its animal counterpart, the duck-rabbit, or its psychoanalytic substitute, the spool of the *fort-da* game, the found object can be lost or found without anxiety. Like D. W. Winnicott's transitional object, it is not a commodity, not a fetish, but a temporary plaything about which we can say, easy come, easy go.[16] Or perhaps we should amend this saying to "easy come, easy stay." For another key to the found object is its tendency, once found, to hang around, gathering value and meaning like a sort of semantic flypaper or photosensitive surface.

I appropriate the metaphor of the photographic surface from Rosalind Krauss's essay on Robert Rauschenberg's combines, which (as have often been observed) are collages or assemblages of found objects within a picture

terization of them as a form of "graffiti," a defacing of the pictures: Paulson, *Literary Landscape: Turner and Constable* (New Haven, CT: Yale University Press, 1982), pt. 2, "Turner's Graffiti: The Sun and Its Glosse," 63–103.

16. See D. W. Winnicott's *Playing and Reality* (New York: Basic Books, 1971), and my discussion of transitional objects in *The Last Dinosaur Book*.

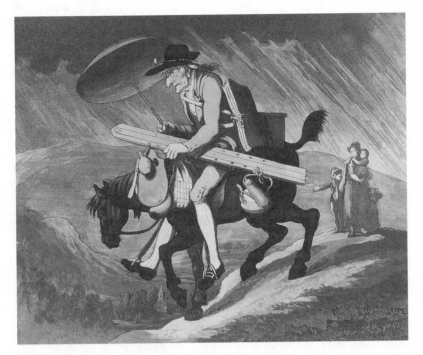

frame.[17] Krauss remarks on the way the Rauschenberg combine works "as a horizontal 'receptor surface' on which objects are scattered" and is then returned "to the frame, and hence to the window model of the picture plane . . . to arise from this flatbed."[18] Needless to say, this reframing of the found object within the pictorial is already a key feature of the picturesque, as well as of the photographic medium. What the picturesque wants, we might say, is to raise things up, to elevate them from their abject, supine condition and put them on display without forgetting where they came from. Koons's floor polishers accomplish both these tasks in one stroke, raising up the appliances from their humble condition in the department store or the commercial display into the aesthetic space of the museum and the vitrine, but (in the case of *New Hoover Deluxe Shampoo Polishers, New Shelton Wet/Dry 10 Gallon Displaced Triple-Decker* [fig. 33]) leaving the polishers in a supine, horizontal condition like corpses in a morgue or children in bunk beds, and elevating the Triple-Decker vacuum to the position of dominant overseer. Hal Foster dismisses this kind of work as a destruction of the "dialectic between modernism and mass culture," a forsaking of the productive "tension between art and commodity that the readymade once articulated," and thus an uncritical complicity with "the fetishism of the sign."[19] But Foster's initial take on these works is, I think, a bit less guarded and more perceptive. He sees the appliances displayed "like so many modern relics or totems," terms which might fruitfully be distinguished from fetishism, not just equated with it.

Art historian Alison Pearlman's brilliant readings of what I want to call Koons's "minor appliance" works help us to see why Relics or Totems may be more appropriate categories for these objects than fetishes.[20] Pearlman actually looks at these works with some care, going beyond the singular category of Commodity Fetish to note that they invariably display a collec-

17. See Rosalind Krauss's "Perpetual Inventory," her essay for the catalog of Robert Rauschenberg's Guggenheim retrospective, which traces Rauschenberg's reconciliation of the three-dimensionally literal found object with his faith in the integrity of the picture plane by way of the photographic process as index and inventory of findings: *Robert Rauschenberg: A Retrospective* (New York: Guggenheim Foundation, 1997), 206–23. Krauss evokes the relation of found and degraded materials to "picturesqueness" in "Warhol's Abstract Spectacle," in *Abstraction, Gesture, Ecriture: Paintings from the Daros Collection* (Zurich: Scalo, 1999), 130.

18. Krauss, "Perpetual Inventory," 216.

19. Hal Foster, "The Future of an Illusion, Or the Contemporary Artist as Cargo Cultist," in *Endgame: Reference and Simulation in Recent Painting and Sculpture,* ed. Yves-Alain Bois, David Joselit, and Elizabeth Sussman (Cambridge, MA: MIT Press, 1986), 96.

20. Pearlman, *Unpackaging the Art of the 1980s.*

tive array of objects, not singular entities, and that these displays do not mimic commercial fetishizing of the objects as lustrous commodities for private possession, but treat them as a kind of community of things. Pearlman notes that they play upon a "body language of product display" and of "model display" drawn from fashion (135). As such, they participate in a range of social relations—male/female, parent/child, alive/dead, awake/asleep, active/passive—that treats them as specimens of a form of life, rather than "lost objects" or "part objects" that we must fetishistically repossess to make ourselves whole. As productions in a series entitled *The New* (1980–87), they reverse the modernist imperative to "make it new" and treat the brand-new commodities as what they will inevitably become, relics of a civilization, and as what they will always be, members of a community—even a family—of objects.[21] This is accomplished by raising the objects up, framing them in a new way, just as Rauschenberg "lifts up" his found objects into the dignity of the picture plane or (in this case) the vitrine that protects the relic.

The picturesque is located, as theorists from William Gilpin to Robert Smithson have observed, in a dialectical space between the grand pretensions and death drives of the sublime, and the agonized longing for and enthrallment by the beautiful.[22] When an object becomes sublime, it is the all, the totality, the incomprehensible. In short, it becomes an idol. When the object is beautiful, we must have it, take possession of it, master it, and of course it inevitably enslaves us. In short, it becomes a fetish. What then of the picturesque object? The only thing left for it in my triad of sacred forerunners of the aesthetic object is the totem.

Totems, to remind you, are important things, but not quite so self-important as idols and fetishes. Émile Durkheim insists that while they are sacred objects, they are not gods, and they generally are not endowed with special powers of healing or magic the way fetishes are.[23] They are, rather,

21. This strategy of reframing the new was denounced by Kay Larson as "neoism," a label that misses the whole point of Koons's reversal of the "make it new" doctrine with the totemic reliquary framing. Larson, "Love or Money," *New York*, June 23, 1986. For discussion, see Pearlman, *Unpackaging the Art of the 1980s*, 22–23.

22. Robert Smithson, "Fredric Law Olmsted and the Dialectical Landscape," in *The Writings of Robert Smithson*, ed. Nancy Holt (New York: New York University Press, 1979).

23. See Émile Durkheim, *The Elementary Forms of Religious Life*, trans. Karen E. Fields (New York: Free Press, 1995): "we must be careful not to see totemism as a kind of zoolatry. [The] attitude toward the animals or plants whose name he bears is by no means the attitude a believer has toward his god" (139).

primarily objects of individual and collective identification. The totem may be a personal tutelary spirit or a clan emblem, the thing that gives a person or tribe its proper name. The naming of the object is also the naming of an individual or collective subject, as in the figure of the team mascot.[24] As material objects, totems are generally inferior things in the hierarchy of beings: animal, vegetable, or mineral, rarely human, they are things which are adopted as counterparts to people, a kind of society of things we can use to think through what a human society is. Totems are familiar, everyday items, usually from the natural world, that have been found—singled out—usually by what Durkheim calls "fortuitous circumstances," and have subsequently become foundational for identity.

In *Totem and Taboo*, Freud passes over Sir James Frazer's account of the accidental finding of the totem rather quickly: "At the moment at which a woman feels she is a mother, a spirit, which has been awaiting reincarnation in the nearest totem centre where the spirits of the dead collect has entered her body."[25] Freud dismisses this as an explanation because it already assumes the existence of totemism, and because it depends on ignorance about where babies come from. Worst of all, it makes totemism not (as Freud will have it) a masculine invention to resolve the sublime conflicts of the Oedipus complex, but "a creation of the feminine rather than of the masculine mind; its roots would lie in 'the sick fancies of pregnant women'" (118). What better place, though, to locate the roots of the found object than in the *foundling*, a poor, orphaned creature that might just amount to something. The moment of finding the found object is the moment when one feels oneself to be pregnant or about to adopt something (which comes

24. The idea of the mascot is worth pursuing here in more depth. The word itself comes from the same root as *mask* and *mascara*, and was associated with witchcraft and fetishism in the nineteenth century. The common practice of selecting colonized "others" as mascots—especially Native Americans in the United States—is an extension of a peculiar habit of selecting a figure that is seen as lower in some "natural" pecking order, and then adopting that figure as a clan or organizational emblem. A kind of limit case of this practice is the ritual of *blackface* (discussed in more detail in chapter 14 below), where the "adopted" mask expresses a complex of affection and outright racial hatred. The contrast with Native Americans is striking: sports teams have no problem naming themselves the "Redskins," but it would be very strange to see them adopting the name of "Blacks" or "Darkies," much less using the N-word. I am grateful to Laurel Harris, whose excellent paper for my seminar, "Totemism, Fetishism, Idolatry"(University of Chicago, spring 2003), investigates this topic thoroughly.

25. Sigmund Freud, *Totem and Taboo* [1913] (New York: Norton, 1950), 117. Freud is quoting Frazer's *The Golden Bough* here.

to the same thing).[26] This is, I think, quite distinct from the moment of finding the lost object (fetishism) or the sublime object of ideology (the idol), neither of which are capable of surprising anyone or of bringing newness into the world.

Totemism is also a productive framework for thinking about the relation of the found object to practices of image-making. Although the totem generally begins as an object (generally a class of things like Witchetty Grubs or Kangaroos), it only acquires totemic status in some form of representation. As Durkheim puts it,

In themselves, the churingas are merely objects of wood and stone like so many others; they are distinguished from profane things of the same kind by only one particularity: The totemic mark is drawn or engraved upon them. That mark, and only that mark, confers sacredness on them.[27]

Durkheim contrasts the graphic, pictorial character of the totem—usually a painted sculpture—with the fetish, in which the material object itself is the site of sacred or magical power (see 122).[28] The kangaroo, then, may be a tribal totem, but no particular kangaroo is as sacred as its representation. The golden calf is itself "a god to go before us": it is not sacred because it represents a calf, or because it is made of gold, but because it is an image. The "image sanctifies the object" (122), not vice versa. And "object" here, it should be noted, is *both* the object of depiction or reference and the object *on which* the depiction is engraved, painted, or inscribed. Rauschenberg's "lifting up" of the found objects into the vertical dignity of the picture frame and the picturesque elevation of the abject or impoverished figure are modern versions of the totemic ritual that operate not like the fetishistic return of the repressed but like the moment of conception, naming, and seeing-as.

26. Koons regards the vitrines that encase his vacuum cleaners and basketballs as "womb-like" enclosures. See Giancarlo Politi, "Luxury and Desire: An Interview with Jeff Koons," *Flash Art*, no. 132 (February-March, 1987): 73. The emergence of the vitrine as a major framing device in postmodern art production must have, as Koons remarks, "biological implications," in resonance with the image of *in vitro* fertilization.

27. Durkheim, *Elementary Forms of Religious Life*, 121.

28. A promising line of inquiry here would be the painted "totemic" sculptures of David Smith. In a well-known art world scandal, they had their paint removed in a vandalizing act of modernist "purification of the medium" by Clement Greenberg. I draw here on Kenneth Brummel's fine paper, written for my spring 2003 seminar at the University of Chicago, "Totemism, Fetishism, Idolatry."

Admittedly, I have weeded out a great many strands of totemism to find those which match up with my picture of the found object. There are, in fact, rituals of searching for the totem (the vision quest) which, like Rauschenberg's tour around the block to find junk to put in his combines, may seem too focused and willful and deliberate, lacking the contingency we want from the truly found object. But nothing is pure in this topic, and the "happy accident" is one that artists have always prepared themselves to recognize. The point remains, however. If we want to get past the tragic and farcical returns of the repressed to the comic scenario Foster hopes for, we will have to get over fetishistic and idolatrous attachments, both to objects and to our theoretical models for "mastering" them. If there are no ideas but those arising from things, the poor things and the poor, weak theories we devise to account for them, then perhaps the obsolete, fossilized, outmoded objects of our time are exactly the ones we now cannot bear to contemplate, namely ourselves and our most novel appliances and gadgets, from vacuum cleaners to computers. I take this as the real message of what is now widely heralded as the "posthuman" era, that the new form of the found object might be found in the relics of contemporary humanity, even (of all things) humanism, driven by an increasingly accelerated cycle of obsolescence. Perhaps this is why the current version of the found object (for example, Jeff Koons's vacuum cleaners and basketballs) is not archaic relics or fossils, but absolutely up-to-date, contemporary things. In contrast with surrealism, which fetishized the primitive and the outmoded, postmodernism (for lack of a better word) totemizes the novel and the innovative. If these objects are in any sense "fossils," they are framed within a *paleontology of the present*, a structure of representation that regards contemporaneity from the perspective of deep time and the possible obsolescence of the human species itself.[29]

29. See chapter 15 for further development of the concept of a "paleontology of the present."

This chapter could have been entitled "Objectionable Objects," because the images it discusses are so often treated as material objects and subjected to physical abuse. But as we have seen in the preceding chapter, objects—especially objectionable and sacred ones—are never merely material things. It is possible to imagine, I suppose, certain objects that would be seen as objectionable "on their own," without some form of representation or presentation to call attention to them. Excrement, garbage, genitals, corpses, monsters, and the like are often regarded as intrinsically disgusting or objectionable. What I am interested in, however (and what I suspect really interests most of us), is the moment when such objects are deliberately placed before us verbally or visually, represented or mediated in some way. This is the moment when objectionable (or inoffensive) objects are transfigured by depiction, reproduction, and inscription, by being raised up, staged, framed for display. So the question of the object always returns to the image, and we still have to ask what it is about images that gives them such remarkable power to offend people.

A better question might be, what is it about people that makes them so susceptible to being offended by images? And why is the response to the offensive image so often a reciprocal act of violence, an "offending of the

This chapter is a revised version of an essay by the same title that was presented at the School of the Art Institute of Chicago on February 12, 2000. The occasion was a conference organized by the Cultural Policy Program at the University of Chicago on the Brooklyn Museum's *Sensation* exhibition. A shorter version of the essay appears in Lawrence Rothfield, ed., *Unsettling "Sensation": Arts-Policy Lessons from the Brooklyn Museum of Art* (New Brunswick, NJ: Rutgers University Press, 2001), 115–33. Copyright © 2001 by Rutgers, The State University. Reprinted by permission of Rutgers University Press.

FIGURE 36
Dennis Heiner defacing Ofili's
Virgin at the Brooklyn Mu-
seum. Philip Jones Griffiths,
Magnum Photos.

image" by destroying, vandalizing, or banning it from view? Iconoclasm,
the defacement or destruction of images, is the best place to start in un-
derstanding the nature of offensive images.[1] The psychological forces that
lead people to be offended by an image are invisible and unpredictable. But
when people set out to offend an image, to censure, denounce, or punish
it, their behavior is out in the open where we can look at it. A kind of the-
atrical excess in the rituals of smashing, burning, mutilating, whitewash-
ing, egg- and excrement-throwing turns the punishment of images into a

1. See my essay, "The Rhetoric of Iconoclasm," in W. J. T. Mitchell, *Iconology: Image, Text,
Ideology* (Chicago: University of Chicago Press, 1986) for reflections and further references
on this matter. I have also found useful Bruno Latour's "Few Steps toward an Anthropology
of the Iconoclastic Gesture," in *Science in Context* 10 (1997): 63–83; David Freedberg's *The
Power of Images* (Chicago: University of Chicago Press, 1989); and Michael Taussig's *Deface-
ment* (Stanford, CA: Stanford University Press, 1999).

spectacular image in its own right (the destruction of the World Trade Center being the most horrific example in our time).[2] When the Soviet Union collapsed, the spectacle of what Laura Mulvey called "disgraced monuments" (in her film by this title), the toppling and humiliating of statues of Lenin and Stalin, made for wonderful cinema, just as the toppling of Saddam Hussein's statues after the fall of Baghdad in the spring of 2003 made for effective television. But exactly what sort of wonder, and what sort of effectiveness? What makes us think that "offending images" is a good way to deal with them? What assumptions make this kind of behavior intelligible at all?

Two beliefs seem to be in place when people offend images. The first is that the image is transparently and immediately linked to what it represents. Whatever is done to the image is somehow done to what it stands for. The second is that the image possesses a kind of vital, living character that makes it capable of feeling what is done to it. It is not merely a transparent medium for communicating a message but something like an animated, living thing, an object with feelings, intentions, desires, and agency.[3] Indeed, images are sometimes treated as pseudopersons—not merely as sentient creatures that can feel pain and pleasure but as responsible and responsive social beings.[4] Images of this sort seem to look back at us, to speak to us, even to be capable of suffering harm or of magically transmitting harm when violence is done to them.

As we have noted, this magical view of images is often described as if it were something we have grown out of—a premodern issue, a superstition found only in highly religious societies, or in the so-called primitive cultures studied by anthropology.[5] Or it is expressed as a "half-belief," simultaneously affirmed and disavowed. I hope it goes without saying by this

2. See the discussion in chapter 1 above.

3. For more on this subject see chapter 2 above.

4. On images as persons and as living things, see Hans Belting, *Likeness and Presence: A History of the Image before the Era of Art* (Chicago: University of Chicago Press, 1994), chaps. 13 and 14.

5. See Belting (*Likeness and Presence*, 16), who argues that the cultic "era of images" (from antiquity to the Middle Ages) has been replaced by an "era of art" in which "subjects seize power over the image" in collections and aesthetic experiences. A similar argument is made by Freedberg in *The Power of Images*, though Belting regards Freedberg's position as unhistorical (see xxi). My sense is that there can be no history of images without some notion of what is abiding about them. The question is not whether images "come alive" or not, but where, how, and what kind of life they take on, and how people respond to that life.

point that while there are important historical and cultural differences in the power attributed to images, the tendency to endow them with life and immediacy (and then to disavow that endowment or project it on someone else) is fundamental to the ontology of images as such, or to a form of life we might call "being with images." Modern, urban cultures may not have many cults of saints or holy icons, but they do have an ample supply of magical images—fetishes, idols, and totems of every description, brought to life in mass media and in a variety of subcultures. Supposedly obsolete or archaic superstitions about images, moreover, have a way of breaking out in thoroughly modern places like New York City and London. That is why people can still be hung in effigy, why we do not casually throw away or destroy photographs of our loved ones, why we still kiss a crucifix, why we kneel before an icon or deface it. And when images offend us, we still take revenge by offending them in turn. Far from being defanged in the modern era, images are one of the last bastions of magical thinking and therefore one of the most difficult things to regulate with laws and rationally constructed policies—so difficult, in fact, that the law seems to become infected by magical thinking as well, and behaves more like an irrational set of taboos than a set of well-reasoned regulations.[6]

In part, the intractability of offensive images stems from their tendency to take up residence on the frontlines of social and political conflicts, from the ancient quarrels of the iconoclasts, to the conflicts between Catholicism and Protestantism, to the art scandals of the modernist avant-garde, to the culture wars that have degraded American political discourse during the last fifteen years. They make their appearance in these conflicts not only as causes and provocations but as combatants, victims, and provocateurs.

6. Anthony Julius's interesting book, *Transgressions: The Offences of Art* (Chicago: University of Chicago Press, 2003), came to my attention too late to be reckoned with here. As his title suggests, Julius comes at the problem of the offensive image mainly from within the visual arts, not from standpoint of a more general iconology that would include vernacular and mass media images. He also focuses on the issue of transgression (and therefore laws, rules, and codes) rather than actions and beliefs. Transgression is, of course, not the same thing as offense. In the art world, as Julius notes, the offensive thing would be to produce a work of art that *fails* to be transgressive in any way, and is merely innocuous and safe. The line between "law" and "taboo" is another place where our arguments intersect. I would argue that the reason almost every interesting image turns out to be "transgressive" in Julius's sense is that there is something inherently transgressive (but perhaps not offensive) about every image. That is certainly what is stated, not merely implied, by the literal sense of the second commandment, which prohibits all image-making of any kind.

To remind you of some notorious offenders that have been centers of controversy and debates over censorship, I offer the following nearly random list of examples, both ancient and modern:

1. Richard Serra's *Tilted Arc,* which offended workers by disrupting the space of the Federal Plaza in New York City, was repeatedly vandalized, and finally removed.[7]

2. The Vietnam Veterans Memorial by Maya Lin, which was denounced as an antiwar countermonument that demeaned the memory of the heroism of American soldiers, but has since gone through a remarkable transformation into one of the most revered memorials in the United States.[8]

3. Robert Mapplethorpe's *Man in Polyester Suit* (1980), which offended conservative viewers, who found it obscene and pornographic, and was also seen as an offensive reinforcement of a racist stereotype about black men.[9]

4. Michelangelo's *David,* found offensive for its frank display of the penis, which has sometimes been covered with a fig leaf. So far as I know, it has never been denounced for reinforcing a stereotype about white men.[10]

5. A 120-foot-high portrait of the Roman emperor Nero on linen that so displeased the gods, according to Pliny the Elder, that they struck it down with lightning.[11]

6. The swastika, which after a long history as a religious symbol was appropriated as an insignia of National Socialism in Hitler's Germany, and now functions as an almost universal symbol of unredeemable evil.

7. The Confederate flag, which flies atop the South Carolina state capitol and has been the object of protests and legislative initiatives aimed at its removal.

7. See Serra's own defense of his work and other discussions of this controversy in *Art and the Public Sphere,* ed. W. J. T. Mitchell (Chicago: University of Chicago Press, 1993).

8. For an exhaustive discussion of the reception of the Vietnam Veterans Memorial, see Levi Smith, "Objects of Remembrance: The Vietnam Veterans Memorial and the Memory of the War" (Ph.D. diss., University of Chicago, 1997).

9. See Kobena Mercer, "Reading Racial Fetishism: The Photographs of Robert Mapplethorpe," in *Visual Culture: The Reader,* ed. Jessica Evans and Stuart Hall (London: Sage Publications, in association with the Open University, 1999), 435–47.

10. I could have included here the bare-breasted female statues at the U.S. Justice Department which have been veiled out of deference to the moral sensibilities of former Attorney General John Ashcroft.

11. Pliny, *Natural History,* 10 vols., trans. H. Rackham (Cambridge, MA: Harvard University Press, 1952), 9:277. See also the discussion in W. J. T. Mitchell, *Picture Theory* (Chicago: University of Chicago Press, 1994), 337–38.

8. Jasper Johns's *Flag* (1955), which caused a scandal in Cold War America as a degradation of the American flag, and is now regarded as one of the great masterpieces of modern painting.[12]

9. The painting *Myra* (1995), by British artist Marcus Harvey, a ten-foot-high portrait of Myra Hendin, a notorious accessory to serial child-murders. This painting, executed with imprints of a child's hand, was regarded as the most offensive image in the Sensation exhibition at the Royal Academy in 1995. It was excoriated in the popular press, led to the resignation of senior members of the Royal Academy, and was vandalized. When shown in the Brooklyn Museum in New York in 1999, it attracted relatively little notice, and was upstaged by Chris Ofili's painting of the Virgin Mary with dung.[13]

10. Chris Ofili's *The Holy Virgin Mary* (plate 1), which became the central focus of the controversy over the Brooklyn Museum's Sensation show, was condemned as obscene and sacrilegious by New York City mayor Rudolph Giuliani, who attempted to cut off the Brooklyn Museum's city funding. The painting was defaced by a pious Catholic who covered it with white paint (fig. 36).

11. Damien Hirst, *This Little Piggy Went to Market* (1996), which was expected to offend visitors to the Brooklyn Museum, but which failed to stir much outrage, even from proponents of animal rights.

12. *The Adoration of the Golden Calf* (see fig. 31), the biblical idol, as rendered by Nicolas Poussin in the early seventeenth century. The actual calf so offended God that he ordered Moses to melt it down and force the Israelites to drink it. Then he ordered the massacre of three thousand people, including women and children, for violating a law (the second commandment) that he had not yet delivered to them. Poussin's rendering of this scene, on the other hand, has never to my knowledge been accused of violating the second commandment, though it was the victim of a knife attack in the National Gallery in 1978.[14]

12. For further discussion, see Mitchell, *Picture Theory,* chapter 7, pp. 236–38.

13. It would be worth pondering the contrast between the Royal Academy and Brooklyn Museum scandals as a tale of two cities, and of two "moms." In London, the scandal was the elevation of an evil mother into a popular icon and a focus of liberal sympathy in the context of widespread hysteria about pederasty and child abuse. In New York, the scandal was the degradation of a good mother by an inappropriate pictorial rendering, and an offense to Christianity and organized religion more generally. Offending images are clearly not just individual matters but lightning rods for the energies of large social formations and local cultures.

14. Freedberg discusses this event in *The Power of Images,* 421ff., noting that the attacker never gave any reason for his actions.

I cite these images to provide a broad context for thinking about the nature of offending images in general, as well as in the specific case of the Brooklyn Museum's scandalous Sensation show. This context may help us to recall some obvious points about the complexity and variety of offense and transgression in images and to suggest some less obvious ways in which those images are treated as if they were persons or animated beings. Here are the obvious points:

1. Offending images are radically unstable entities whose capacity for harm depends on complex social contexts. Those contexts can change, sometimes as a result of the public debate around an image, more often because the initial shock wanes, to be replaced by familiarity and even affection. The offensive character of an image is not written in stone but arises out of social interaction between a specific thing and communities that may themselves have varied and divided responses to the object.

2. Offending images do not all offend in the same way. Some offend the beholder, others the object represented. Some offend because they degrade something valuable or desecrate something sacred, others because they glorify something hateful and despised. Some of them violate moral taboos and standards of decency, while some are politically offensive, insults to national honor or unwelcome reminders of an ignoble past. Some offend because of the manner of representation, so that a caricature or stereotype offends not because of *who* but *how* it represents. Like persons, images can be found "guilty by association" with the wrong kinds of people, values, or materials.

3. If an image offends very many people, sooner or later someone will invoke the law, and along with it judges, legislators, policymakers, and the police. The cry will go up that "there ought to be a law" about offensive images, and symposia will be convened to formulate policy guidelines. Like a person, the image may even become a "legal subject," a witness or defendant in a legal proceeding, as in cases such as *United States v. Thirty-Seven Photographs* or *United States v. 12 200-Ft. Reels of Super 8MM Film et al.*[15]

4. Finally, images are not all offended in the same way. Sometimes the effort is all-out annihilation (as in the melting down of the golden calf), to make the image disappear from the world forever, to render it extinct. Sometimes the iconoclastic gesture is only partially destructive, a defacement,

15. *United States Reports, Cases Adjudged in the Supreme Court, October Term, 1970 and 1972.* My thanks to Geoff Stone for calling these cases to my attention.

disfiguring, dismemberment, decapitation, or other mutilation that does not destroy the image but humiliates or "wounds" it in some way.[16] The effect of this tactic is quite different from that of annihilation. The object is not to make the image disappear but to keep it around and to render its appearance in a new way, one that is offensive to the image and what it represents. Caricature is, in this sense, a form of disfigurement and iconoclasm. Most curious of all is a strategy that neither disfigures nor destroys but attempts to "disappear" the image, to hide it away, cover it up, bury it, or conceal it from view. This strategy may or may not be a way of "offending" the image; it is compatible, as we shall see, with a respectful defense of the image against desecration. To summarize, then: there seem to be three basic strategies of iconoclasm: annihilation, disfigurement, and concealment.

Images have been offending people since the beginning, since (for instance) God created a human creature in his own "image and likeness," and that creature set about disobeying its Creator's orders. Images are not just "like" persons; the relation is much stronger than that.[17] It is common in creation myths for persons to be actually created *as* images (usually sculpted figures rendered in clay or stone).[18] And in most versions of this story, the (human) images "have minds of their own." In the biblical account, Adam and Eve (the images of God) are tempted by forbidden knowledge, and quickly get out of the control of their creator. Offended by the disobedience of his creatures, God expels Adam and Eve from paradise and sentences them to die. Their sin is, in effect, a kind of iconoclasm in that it has disfigured the image of God reflected in them. When God decides to give his chosen people a second chance, only if they will follow his laws, the first law he prescribes is one that forbids the making of images:[19]

Thou shalt not make unto thee any graven image, or any likeness of any thing that is in heaven above, or that is in the earth beneath, or that is in the water under the

16. Belting notes "'injured' images" react to desecration "like living people by weeping or bleeding" (*Likeness and Presence*, 1).

17. As Belting notes, "the image . . . not only represented a person but also was treated like a person" (ibid., xxi).

18. See chapter 12 for further discussion.

19. I call this the "first law," even though it is the second commandment, because the first commandment is not really a prohibition of any sort, merely a declaration by God that he is who he is, and no one else. This leads to the prohibition on worshiping other gods, especially in the form of images.

earth. Thou shalt not bow down thyself to them, nor serve them: for I the Lord thy God am a jealous God, visiting the iniquity of the fathers upon the children unto the third and fourth generation of them that hate me; And shewing mercy unto thousands of them that love me, and keep my commandments. (Exod. 20:4–6 [KJV])

This commandment, which, so far as I can tell, has never been very well understood, and certainly never obeyed literally, is clearly the most important law in the Decalogue. God spends more time explaining and defining it than all the other commandments put together. And it seems clear that this is the commandment he takes most seriously, the one that is really "written in stone." Commandments like "Thou shalt not kill" are not absolute, merely advisory.[20] They are suspended when the situation requires it. Most notably, the commandment against killing is suspended when the act is carried out as punishment for an act of idolatry. When the Israelites break the second commandment and erect a golden calf, God instructs Moses and the Levites to kill all their brethren who have been involved in this most hateful offense, the creation of an image that is offensive to God.

Why is God offended by the golden calf? The simplest answer is jealousy: the calf is a substitute for God, like a rival lover who moves in when the husband is away.[21] The Israelites are "whoring after strange gods," and idolatry is a form of adultery. So there is nothing special about the calf; it would have been just as bad to make an image of a lamb or an eagle or a man—even Moses himself. God would be equally upset at being replaced by any image. The second commandment therefore forbids making an image of *anything*. It does not say that only images of God, or of rival gods, are prohibited, but "any likeness"—presumably in any medium (gold, stone, paint, clay, even words)—of any thing on earth, in the sky, or in the sea.[22]

20. See Walter Benjamin on the contingent character of the commandment against murder in his "Critique of Violence," in *Reflections*, ed. Peter Demetz (New York: Harcourt, Brace, Jovanovich, 1978): "those who base a condemnation of all violent killing of one person by another on the commandment are therefore mistaken. It exists, not as a criterion of judgment, but as a guideline for the actions of persons or communities who have . . . to take on themselves the responsibility of ignoring it" (298).

21. See Jeremiah 3:1: "If a man divorces his wife, and she leaves him and marries another man, can he ever go back to her? Would not such a land be defiled? Now you have whored with many lovers: can you return to me?—says the Lord."

22. The commandment refers to the making of a *pesel*, an image carved from wood or stone, but it is generally agreed that the prohibition includes the making of metal figures as

Taken literally, the implication is that there is a "slippery slope" principle at work: if you start making images, it is inevitable that they will, as we say, "take on a life of their own," become idols, take the place of God, and thereby become offensive. The best policy, then, is to stamp out the potential for offense at its origin, and prohibit the making of any sort of images. Needless to say, this is an impossible commandment, and neither the Jews nor any other aniconic, monotheistic religion has ever followed it literally, but has always found ways of getting around it and explaining it away.[23] Periodically, American politicians propose the posting of the Ten Commandments in public schoolrooms (usually after some outbreak of violence). But none of them, to my knowledge, have noticed that if these commandments were followed, art classes would have to be prohibited and art teachers and students would have to be stoned to death.

But beyond its being an image at all, is there anything specific about the golden calf that is offensive to God? One common reading of the second commandment is that images make something material and visible that should be immaterial and invisible. Idolatry, according to this view, is "the worship of wood and stone,"[24] a fetishistic obsession with base matter. Even worse is the use of the specific materials of gold, suggesting earthly riches,

well. "To the prohibition of an image is attached a further specification [the ban on 'likeness'] which broadens the prohibition to include every representation. The term *temunah* designates the form or outward shape of an object" (Brevard Childs, *The Book of Exodus: A Critical, Theological Commentary* [Louisville: The Westminster Press, 1974], 404–5). The prohibition on images as likeness extends, in commentators like Maimonides, to figurative *language* and concrete descriptions or adjectives of any sort, so that ultimately, the language of scripture itself becomes a temptation to idolatry, and the worshipper is reduced to silence. See Moshe Halbertal and Avishai Margalit, *Idolatry* (Cambridge, MA: Harvard University Press, 1992), 56–57.

23. Even more striking is the tendency of commentators to ignore the literal meaning completely, and to assume that the offensiveness of images is not "built in" to them but must be added to them by wrong usage (adoration of the image), wrong representation (no image of any sort can represent the invisible Jehovah), or wrong referent (this image represents the wrong god, a "strange" god). See Kelman Bland, *The Artless Jew* (Princeton, NJ: Princeton University Press, 2000), for a decisive refutation of the characterization of Judaism as a culture of aniconism and iconoclasm, and a comprehensive inventory of ways that Jews have evaded any literal reading of the ban on images.

24. Halbertal and Margalit, *Idolatry*, 39. There could be other reasons for offense besides degraded materiality, of course. The offense could come from the use of the wrong image (a calf), which degrades God to the level of a brute; or it could derive from the adoration of any image at all, regardless of what it represents.

and even worse, the gold jewelry which the Israelites brought out of Egypt, and which therefore hearkens back to the Egyptian captivity and the idols of Egyptian religion. The image is offensive, then, both for what it seems to say ("I am god") and for what it is—the crass, vulgar materiality of Egyptian gold. The calf is made out of tainted money—filthy lucre, as it were.

What does this golden calf teach us about the scandal of the Brooklyn Museum's Sensation show? The offensiveness of Chris Ofili's Madonna seems, to begin with, to have almost nothing to do with idolatry as an adulterous "god-substitute" but everything to do with its use of materials, the notorious elephant dung (plate 1). Like the golden calf, Ofili's Madonna is (at least partly) composed of filthy lucre—filth because it is excrement, but "lucre" because (as Ofili argued) it has great symbolic value in African culture as a sign of fertility and the nurturing of Mother Earth. Ofili's declaration of intentions, however, was widely disregarded by commentators who were determined to be offended. The artist's respectful use of elephant dung was taken as an insult to the image of the Madonna.[25] The question arises, however: is it really the material that offends, or the interpretation of the material as making a statement or (worse) actually *doing* something to the image of the Madonna, defiling her "effigy" as it were? How do we decide whether elephant dung is a symbol of great value and reverence (as the artist insisted) or of filth and degradation? And how do we know what the Madonna does to dung, or dung to her? Does it degrade her, or does she elevate it, redeeming even the basest matter by the appearance of her image?

Ofili's Madonna helps us to see the complexly indirect and mediated character of offensiveness in images. One could argue, for instance, that it is not the image that offends us in this work of art. On the contrary, it is the image (of the Madonna) that is *being* offended by it. Pious Catholics are offended not by Ofili's image of the Madonna but by the way the image is presented, the materials in which it is rendered. This shows us how crucial it is to distinguish between the image or "motif" (the feature of this painting that links it to innumerable other pictures of the Madonna by Rubens, Raphael, Leonardo, and so on) and the concrete materiality of a specific picture. It is not the species that offends (the class that includes all Madonna

25. The question of whether elephant dung really *is* a sacred substance in African religions is somewhat in doubt. Ofili's use of the same substance in what seem unquestionably respectful paintings of African-American heroes, however, seems to support his declaration of intentions, no matter what the facts about African values turn out to be.

pictures) but the specimen, this particular "incarnation" of the species in a monstrous or disgusting version.[26] And the spectator's sense of offensiveness is not direct but vicarious. The logic goes like this: the Madonna's image is offended by being rendered in excremental materials; if her image is offended, then she herself must be offended. And if she is offended, then all who venerate her and her image must be offended as well. If the thing I respect or love is insulted, then I am insulted.

The outrage over Ofili's Madonna, then, is not just a matter of being offended by an image. It is outrage over an act of iconoclasm, or violence to an image, the painting itself seen as an act of desecration, disfigurement, and defacement. Language seems incapable of overcoming the imagined insult to the image. Ofili's protestations of benign, respectful intentions, and the obvious prettiness of his composition, were completely ineffectual in countering the outrage. And the most visible expression of this outrage, the defacement of the painting by Dennis Heiner (fig. 36), takes a very specific form that is worth pondering in its details. Heiner did not speak out against the painting or carry a sign in front of the Brooklyn Museum. He did not attack the painting, slashing it with a knife or throwing eggs or excrement at it. He very carefully and deliberately covered Ofili's composition with white paint. Instead of violent defacement or destruction, Heiner chose a strategy that might be called "veiling" or "effacement" of the image, a gesture of protection and modesty. The water-soluble paint was easily removed, and did no damage to the composition. Heiner's act, then, can be seen not so much an act of vandalism as a defense of the sacred image of the Madonna against its sacrilegious defacement by this painting.

It would be fascinating to ponder what the reaction to Ofili's painting would have been if the artist had declared that it *was* his intention to insult and degrade the Madonna, instead of denying it. One can imagine, for instance, a pious Muslim—or a Jew or Christian fundamentalist, for that matter—arguing that the second commandment makes it a sacred duty to offend or destroy all images, and especially one that depicts the Mother of God and thus is well on its way down the slippery slope to idolatry. One of the strangest moments in the whole scandal was the unwavering solidarity of Jewish organizations with the Roman Catholic Church against the offen-

26. For further discussion of this distinction between images and pictures as "species" and "specimens," see chapter 4. The concept of the image as "motif" comes from Erwin Panofsky, "Iconography and Iconology," in *Meaning in the Visual Arts* (Garden City, NY: Doubleday, 1955), 29.

sive Madonna. Has everyone forgotten that Mariolatry and the cult of images of the Virgin Mary violate the second commandment?[27]

It is somehow fitting that the moral objections to dung madonnas are paralleled by the hand-wringing over filthy lucre in its literal sense—that is, money. The "greater" scandal of the Sensation show was that it revealed (oh marvelous revelation!) that art museums are in competition with movies, shopping malls, and theme parks. Art, it turns out, has something to do with wealth and speculative capital. There is nothing so edifying as the moral shock of capitalist cultural institutions when they look at their own faces in the mirror. High-minded people in the museum world (Phillippe de Montebello, the director of the Metropolitan Museum of Art, for instance) were shocked by the corruption of aesthetic, curatorial, and institutional autonomy entailed in the relation of the Royal Academy and then the Brooklyn Museum to the Saatchi family.[28] Are they modern Medicis? Or hucksters of hype? Was the Brooklyn Museum really guilty of unethical and unprofessional conduct in its dealings with the Saatchis? Or was it merely guilty of being indiscreet, flaunting a bit too openly what is a common practice in art museums? Candor and openness about the financial underpinnings of contemporary art have never been very welcome in the art world. Hans Haacke managed to offend the Guggenheim Museum by displaying photographic images of the New York tenements owned by some of its principal trustees.[29] Haacke's strategy might be seen as the obverse of Ofili's. Instead of bringing a sacred image into too close of a contact with profane materials, Haacke brought images of profane realities into the sacred space of the museum. The ugly facades of slum properties make visible the filthy lucre that supports the sanitized realm of the aesthetic.

The role of excrement in the realm of offending images is not exhausted

27. It did occur to some commentators at the time that the real offense might have been the *blackness* of the Madonna, an affront to those who are accustomed to blonde, blue-eyed images of the Virgin. In this case, Heiner's whitening of the image takes on a racial overtone. So far as I know, no one had the effrontery to say this publicly. See Belting's excellent analysis of Mariolatry in *Likeness and Presence,* chap. 3, "Why Images?" 30–47.

28. See also the essay in Rothfield, ed., *Unsettling "Sensation"* by James Cuno of the Harvard Art Museums, who argues that there is a moral distinction to be made between respectable, clean money (the Mellons and the Astors?) and the contaminated money (earned in advertising?) of the Saatchis. In the same volume, Gilbert Edelson's essay on the actual financial arrangements that underlie museums' relations with wealthy collectors and the art market shed considerable light on this whole matter.

29. See Haacke's *Shapolsky et al Manhattan Real Estate Holdings, a Real-Time Social System, as of May 1, 1971;* first exhibited 1972.

by its role as an agent of symbolic desecration and disfigurement, or as a sign of the material and monetary foundations of artistic purity. There is also the key question of what is sometimes called bad art. I take it as a given that many people in and out of the art business think that a fair amount of contemporary art is a bunch of shit. Despite the art world's timorous and belated defense of the Brooklyn Museum, almost every defender of the Sensation show felt obliged to show his/her good taste by declaring that most of the work in that show was just plain "bad art." (There was the ritual exception made for Rachel Whiteread, a firmly canonized artist, whose tasteful castings seem incapable of offending anyone.) The mystery is why anyone should be offended for confirming what everyone already knows: 90 percent of artistic production is not likely to be remembered very long. This is hardly a scandalous revelation; it's just plain common sense. At least half the art made must be, as a matter of logic, "below average"; only in Garrison Keillor's Lake Wobegon can all the children be above average. And there is nothing deplorable or shocking about this fact—no scandal to be uncovered. Vast amounts of second-rate art have to be produced as a kind of mulch or fertilizer for the rare flowering of truly outstanding work. By now, one would think that a jaded, sophisticated crowd like the art world would have come to terms with this as a kind of natural law, and given up on the posturing and hand-wringing whenever a group show of new, young artists appears. The Sensation show, like most group offerings of this sort, was a mixed bag, with a few outstanding and promising works and a fair amount of competent but unmemorable efforts. My own sense of Sensation was that it was, as these things go, somewhat above average in matters like technical skill, wit, and professionalism of presentation.

As for the display of waste products as art objects, surely this was a moment for art connoisseurs to remind an outraged public that this sort of thing has been going on since the "dirt painters," or rhyparographers, were banned by the laws of Thebes.[30] Excrement, as Jacques Lacan (and every infant) reminds us, is the first medium of artistic expression.[31] For analogues in contemporary art, one should see, for instance, Robert Morris's "Scatter

30. See G. E. Lessing, *Laocoon: An Essay upon the Limits of Poetry and Painting*, trans. Ellen Frothingham (New York: Farrar, Straus and Giroux, 1969), 9; and Mitchell, *Iconology*, 108, on the control of the arts by civil law in antiquity.

31. Jacques Lacan, *The Four Fundamental Concepts of Psychoanalysis* (New York: Norton, 1981): "The authenticity of what emerges in painting is diminished in us human beings by the fact that we have to get our colours where they're to be found, that is to say, in the shit"

Pieces" or Joseph Beuys' corners stuffed with rotting fat. Ofili's tastefully lacquered dung piles are heirs to a long and distinguished art tradition: they are, more precisely, the symbolic pillars of material and spiritual wealth on which the work of art stands—filth and waste transformed to gold by the alchemy of art.[32] Like the Brooklyn Museum, Ofili is guilty only of candor. The great proponent of high modernist "purity," Clement Greenberg, remarked long ago that the avant-garde was linked to the ruling classes by an umbilical cord of gold.[33] Isn't it a bit late, then, to be outraged that museums cater to the rich, and must do so in order to survive?

Although the framework of freedom of speech is often invoked to ensure the utmost latitude for art museums in their exhibition policies, is it important to ponder the difference between speaking and image-making, a problem that usually comes up when conservative legal theorists are trying to deny artistic images any protection under the first amendment because they are not "speech" in any sense.[34] What is the difference between offensive images and offensive words? When modern secular law addresses images, it generally models them on speech—that is, on linguistic, discursive, and rhetorical models—in relation to the first amendment protections of freedom of speech. Laws regulating speech do not generally address the issue of poetics, that is, of language formally organized to create a mimetic representation or image, a verbal work of art, but deal with language as persuasion, argument, or performance (as in a "speech act" of promising, threatening, or insulting). Most of the attempts to define the offensive character of pornography are based on cases that involve photographic or cinematic images, but which treat the images then as if they were conveying speech acts that insult, degrade, and humiliate

(117). Lacan connects the thematic of feces with "the domain of oblativity, of the gift," which is the "drive" of the painter: "he gives something for the eye to feed on" (104, 111).

32. For a more general study of the relation between painting and alchemy, and the transmutations of "base materials" by painters, see James Elkins, *What Painting Is* (New York: Routledge, 1999).

33. Clement Greenberg, "Avant Garde and Kitsch," in *Clement Greenberg: The Collected Essays and Criticism*, ed. John O'Brian, 14 vols. (Chicago: University of Chicago Press, 1986), 1:11; this article first appeared in *Partisan Review* in Fall 1939.

34. It's also important to remember that free-speech defenses of offensive art risk "winning" hollow victories in court that translate into long-term defeat in the public sphere. See David A. Strauss, "The False Promise of the First Amendment," in Rothfield, ed., *Unsettling "Sensation,"* 44–51.

the (mostly female) subjects of representation and, by extension, all other women as well.

But images are not words. It is not clear that they actually "say" anything. They may show something, but the verbal message or speech act has to be brought to them by the spectator, who projects a voice into the image, reads a story into it, or deciphers a verbal message. Images are dense, iconic (usually) visual symbols that convey nondiscursive, nonverbal information that is often quite ambiguous with regard to any statement. Sometimes a picture of a pipe or a cigar is just saying something innocent and straightforward, like "This is a pipe." But it seems to be part of the nature of visual images that they are always saying (or showing) something more than any verbal message can capture—even something directly opposite to what they seem to "say" (for example, "This is not a pipe"). That is why a picture is said to be worth a thousand words—precisely because the exact words that can decode or summarize an image are so indeterminate and ambiguous.

A picture is less like a statement or speech act, then, than like a speaker capable of an infinite number of utterances. An image is not a text to be read but a ventriloquist's dummy into which we project our own voice. When we are offended by what an image "says," we are like the ventriloquist insulted by his own dummy. One could decode the dummy's rebellious voice as the discourse of the unconscious, a kind of Tourette's syndrome projected into a wooden object. Or we could simply acknowledge that this uncanniness of the dummy, its taking on a "life (and voice) of its own," is fundamental to the game of ventriloquism as such. The voice must not simply be "thrown" into the inanimate object; it must seem to make that object speak with its own voice. The really good ventriloquist doesn't simply impose his voice on the mute thing, but expresses in some way the autonomy and specificity of that thing. When Marx in *Capital* asks what commodities would say if they could speak, he understands that what they must say is not simply what he wants them to say. Their speech is not just arbitrary or forced upon them, but must seem to reflect their inner nature as modern fetish objects. When I claim, then, that the offensive statement made by the image is actually projected there by the spectator, I don't mean to say that the perception of this statement is merely a mistake or misinterpretation.

That is why it somehow feels both right and futile to punish images, to offend them for the offense that they do to us or "say" to us. Why should we be any smarter than the God who passed an anti-image law that no one

could understand, much less obey? We are always on the slippery slope that leads back from idolatry, offensive images, desecration, and iconoclasm to the mere fact that human beings seem to be inveterate makers of images— images which then seem to have "a mind of their own" and get out of control.

The confusion of images with speech acts is one reason people can be offended by images that they have never seen. Mayor Giuliani, and indeed a great many of the people who found Chris Ofili's Madonna to be offensive, never actually saw the painting. It was enough for them to hear about it, particularly to hear about its use of elephant dung as a material. Many of those who only heard about the image assumed (as legal scholar Stephen Presser does) that the elephant dung must have been smeared on or "flung at" the painting, rather than applied carefully, with meticulous ornamentation, as you can see for yourself.[35] The mere verbal report—"image of Madonna with elephant dung"—was enough to convict the image of being offensive. The actual sight of Ofili's Madonna, by contrast, was strangely inoffensive. The picture struck most viewers as sweet and innocuous. It is the verbal label, the naming of the dung, that provokes the perception of offensiveness and the conclusion that the painting must have been transmitting a disrespectful message. Like Andre Serrano's *Piss Christ*, it is the name and connotations of the material that offend, not the actual visual appearance; it is the imaginary, fantasized image provoked by the words, not the perceived visual image. Serrano's urine produces a golden glow around the crucified Christ which reminds one of the golden aureole or mandorla that is often associated with sacred images. If Serrano had called his image *Christ Bathed in Golden Light*, he might have gotten away with it until some wily critic exposed the connection with the "golden shower" as a perverse sexual practice.

What, then, are the implications of all this for art museums, cultural policy, and the law? My sense is that the Sensation scandal is mainly interesting as a relatively benign outbreak of a very old malady we might call the "iconophobia syndrome." People are afraid of images. Images make us anxious. We fight over them, destroy them, and blame them for our own bad behavior, as when we blame "the media" for encouraging moral decay

35. See Stephen Presser's remarks on the aesthetics of "flinging elephant dung" in his article, "Reasons We Shouldn't Be Here: Things We Cannot Say," in Rothfield, ed., *Unsettling "Sensation,"* 54.

and outbreaks of violence. I'm not saying that we are always wrong to blame or ban images, or that the law should take no interest in their control and prohibition. I find it disturbing, for instance, that a New York art gallery would display early twentieth-century American photographs of lynchings. What purpose, I want to know, is being served by putting these terrible, harrowing images of evil on display for the voyeuristic gratification of the gallery-going public?[36] Still, I would not censor them if I had the power—only protect and veil them from idle curiosity and disrespect. My sense is that the force of law ought to intervene with offensive images only when they are being forced upon the notice of an unwilling public. People have a right not to have offending images thrust in their faces. People also have a right to look at images that others might find offensive.

The questions about the freedom to show offending images are really, then, questions about context more than content—about where and when and to whom an image is displayed. The right of free speech, even political speech, does not allow me to blast you out of your house with a sound truck at four in the morning. A similar limitation on the display of images—perhaps we could call it the "'in your face' principle"—might be invoked to regulate the exhibition of images like the Confederate flag, the swastika, or graffiti when they are imposed on unwilling spectators in public spaces, especially spaces like the South Carolina statehouse that claim a publicly representative function. Art museums, on the other hand, are very special places that ought to enjoy the broadest protections from government interference in exhibitions. Their institutional autonomy needs to be safeguarded from transitory political pressures and the moral outrage of both vocal minorities and moral majorities. Demonstrations in front of museums are a sign of a healthy state of affairs, not a regrettable anomaly that should be averted by fine-tuned policies. Only by preserving a free space of artistic license where offending images are tolerated can we hope to understand what it is that gives images so much power over people, and what it is about people that brings this power into the world.

I conclude, therefore, with a proposal for a blockbuster exhibition called

36. Since writing these words I have seen this exhibition at the New York Historical Society, and I'm fully convinced that their presentation is anything but exploitative or voyeuristic. On the contrary, the exhibition is respectful and intelligent, with a quiet and modest presentation that encourages an intensity of attention that is almost devotional. I find nothing in this to offend, but a great to deal to mortify, astonish, and shame anyone who thinks America's race problem is behind us.

Offending Images, one that would gather all the most egregious offenders into one place.[37] This would be, first of all, an attempt to describe and analyze the multifarious modes of offensiveness, and to diagnose the social forces that give rise to them. It might aim at tracing the long history of offending images across many cultural boundaries, exploring the outbreaks of iconoclasm and iconophobia in the worlds of art and popular media. It would be an occasion for educating people about the histories of human degradation, exploitation, and dehumanization that are so often lurking in the background of the offending images. It would ask, who is offended? By whom, what, and how? It would explore the very nature of offensiveness, of the shock, trauma, or injury which images can produce, and try to identify the ways in which an image passes from being merely offensive to *harmful*, producing the graphic equivalent of yelling "Fire!" in a crowded theater. And it would, finally, include a special gallery of virtual simulations of all the offending images in the exhibition, in which visitors would be provided with all the materials necessary for offending the offenders. Stones, hammers, excrement, paint, blood, dirt, and eggs would be supplied, and visitors would be invited to hurl, smear, and smash away to their heart's content. This would provide a benign form of therapy, and allow lawyers and policymakers to focus their attention on more tractable issues. It might also have the effect of returning these things to their merely objectionable objecthood, and disenchant their status as offending images.

The story of objectionable objects and offending images clearly goes beyond the confines of the Brooklyn Museum controversy or the Chris Ofili Madonna. But this episode is symptomatic of the ways in which "bad objects" arise in borderline situations. In this case, the border was an exhibition in the United States of young British artists enthralled with the breakup of the British Empire, and a specific work by an African artist found offen-

37. Such an exhibition would be in the spirit of the Brooklyn Museum's own magnificent exhibition, The Play of the Unmentionable, installed by Joseph Kosuth in 1992. Kosuth's emphasis, however, was similar to that of Julius's *Transgressions*: the idea was to explore the ways in which art that violates common moral sensibilities subsequently becomes canonized and acceptable as tastes evolve. "Offending Images" would try to push this strategy one step further, and explore the possibility that there are images that can *never* be accepted, that do not offer provocative "transgressiveness" of the sort so highly valued in the art world, but remain eternally disgusting. Perhaps there is no such thing, and this exhibition would help to demonstrate that. I am grateful to Jessica Sack for reminding me of this exhibition, and sending me the catalog, *The Play of the Unmentionable* (New York: New Press, 1992).

sive to an image that supposedly "belongs" to the transatlantic First World nations. Like a deep undertone in a musical score, the question of imperialism and colonialism runs through this whole episode—the fate of older "fading" empires like Britain, the new hegemony of American imperialism known euphemistically as "globalization," and the arrival of an upstart artist from Africa who rubs the face of the art world in the materiality of the postcolonial. But to examine these issues in a larger framework, we need to turn directly to the question of art and imperialism.

Empire follows Art, and not vice versa as Englishmen suppose.

WILLIAM BLAKE, *annotations to* Sir Joshua Reynolds's Discourses *(ca. 1798–1809)*

If colonial imperialism made . . . primitive objects physically accessible, they could have little aesthetic interest until the new formal conceptions arose. But these formal conceptions could be relevant to primitive art only when charged with the new valuations of the instinctive, the natural, the mythical as the essentially human. . . . By a remarkable process the arts of subjugated backward peoples, discovered by Europeans in conquering the world, became aesthetic norms to those who renounced it.

MEYER SCHAPIRO, *"Nature of Abstract Art"* (1937)

What is the relation of art to empire? Was Sir Joshua Reynolds right in thinking that art follows empire, the way camp followers have always fawned upon the powerful? Or did Blake have it right when he wrote in the margins of Reynolds's *Discourses on Art* that art plays the leading role, and empire follows? Needless to say, I side with Blake, though I don't think that his view is necessarily a comforting one for artists. "Up, make us gods to go before us" is the call for an artist (Aaron) to lead the way into a Promised Land to be conquered and colonized. So if empire follows art, that does not guarantee that it leads in the right direction.

But in order to show why Blake is right about the priority of art to empire, we need to situate the matter of "art" within a general (that is, imperial) reflection on the problem of objecthood—including, but not exhausted by,

This chapter is a revised and expanded version of the keynote address to "Art and the British Empire," a conference convened at the Tate Britain in London, July 7, 2001.

art objects. What are the material and (if you will) nonmaterial "objects" of empire? What kinds of objects do empires produce, depend on, and desire? What kinds of objects do they abhor and attempt to destroy or neutralize? What happens to objects when they undergo a "worlding" in their circulation, moving across frontiers, flowing from one part of the globe to another? Does this produce, to use theorist Arjun Appadurai's phrase, a "social life of things,"[1] and are there other forms of animism in imperial objects? What would it mean to think of empire in terms of a broad range of objects and object types? What are the objectives of these objects, their role in constituting forms of objectivity and object lessons?[2]

Finally, I want to discuss three specific kinds of objects that we have encountered before, and that seem endemic to the discourses of imperialism and colonialism: totems, fetishes, and idols. These are, I will argue, productions of colonial discourse, and are often identified as the "bad objects" of empire, the things that produce ambivalence and need to be neutralized, merely tolerated, or destroyed. They are also things—often art objects—that seem (truly or falsely) to "come alive" in the colonial encounter, implying the animation of inanimate objects. One aim of this chapter, then, is to see how the history and logic of empire might be seen through, and beyond, these objects.

But I am equally interested in how the imperial construction of objects has produced concepts of objecthood that play a central role in aesthetics and particularly the concept of the *art object* as such—the process by which (as art historian Meyer Schapiro put it) "the arts of subjugated backward peoples . . . became aesthetic norms" for modern cultures.[3] The title of this chapter plays upon "Art and Objecthood," art critic Michael Fried's classic essay that defines in so many ways the transition from modernist to post-

1. See Arjun Appadurai, *The Social Life of Things: Commodities in Cultural Perspective* (New York: Cambridge University Press, 1986).

2. For more on these matters, see my essay, "Imperial Landscape," in *Landscape and Power*, ed. W. J. T. Mitchell, 2nd ed. (Chicago: University of Chicago Press, 2002), 5–34.

3. Perhaps the most famous instance of the "coming home" of the colonial categories of objecthood is the application of fetishism to modern art, first by Meyer Schapiro in his classic essay on abstraction, and later by the many theorists of postmodernism who have placed the critique, transvaluation, and appropriation of fetishism into an entire category of contemporary artistic practice (see discussion of Hal Foster in chapter 5 above). See Schapiro, "Nature of Abstract Art," in *Modern Art: 19th and 20th Centuries* (New York: Braziller, 1978), 185–211.

modernist art, especially in the United States.[4] I evoke Fried's essay in order to tap some of its dialectical and polemical dynamics, especially its effort to stage "objecthood" not merely as a general, neutral category into which all art objects may be placed as a subset, but as a category that *opposes* the art object with a new set of pseudoartistic objects (generally labeled as Minimalist or Literalist or Theatrical). Fried's essay, in short, could have been entitled "Art *versus* Objecthood." For Fried, art (especially modernist art) is precisely the kind of thing that "defeats" objecthood. "There is a war going on," he says, "between theater and modernist painting" (160), between the "literal object" of the minimalists and the "pictorial" aesthetics of the modernists. For Fried, modernist art is precisely the aesthetic that redeems the literal materiality of things, their mere "presence" as things ready to hand, and elevates them to a "presentness," an immanent, atemporal condition that is equivalent to a state of grace.

This division between art objects and mere, unredeemed objecthood, between art and nonart, has a deep connection, I want to argue, with the rhetoric of empire and colonization. It is not merely that notions of art arise spontaneously within a culture and then are tested or contested when that culture is involved in an imperial or colonial encounter. The very notion of art as a distinctive category of objects (and the category of objecthood more generally) is forged in the colonial encounter. To put the point in the most emphatic terms, my claim is that both art and objecthood are imperial (and imperious) categories, and that aesthetics as a quasi science of artistic judgment is a separation of the redeemed from the damned, the purified from the corrupt and the degraded object. As an imperial practice, aesthetics enlists all the rhetorics of religion, morality, and progressive modernity to pass judgment on the "bad objects" that inevitably come into view in a colonial encounter.[5] Although imperialism generally poses itself as a magisterial and objective viewpoint in which objects of all sorts are cat-

4. Michael Fried's "Art and Objecthood" first appeared in *Artforum* 5 (June 1967): 12–23, and has now been reprinted with extensive annotations, along with Fried's other essays from the sixties and seventies, in *Art and Objecthood* (Chicago: University of Chicago Press, 1998), 146–72.

5. By "bad object" I of course do not mean simply "bad" in a straightforward moral sense, but "bad" in the sense of producing a disturbance, uncertainty, and ambivalence in a subject. This term is borrowed from object-relations theory, especially as elaborated by Melanie Klein (see below). See also J. Laplanche and J.-B. Pontalis, *The Language of Psychoanalysis*, trans. Donald Nicholson-Smith (New York: Norton, 1973), 278–81.

alogued, preserved, and arranged in rational order, it is also centrally constituted by acts of judgment, dialectics of taste that separate the wheat from the chaff. This is why the phrase "primitive art" has never been easy to pronounce. Either it is an oxymoron, referring to a phase of object making that is "before the era of art" (as Hans Belting puts it), or it is offensive to a pluralist sensibility that wants to find art (understood as the nonprimitive) in every manifestation of human culture.

The most obvious symptom of imperial rhetoric in Fried's "Art and Objecthood" is the opening epigraph from Perry Miller which quotes seventeenth-century Puritan Jonathan Edwards on the perception of "a new world . . . freshly created" in every moment: "it is certain with me that the world exists anew every moment; that the existence of things every moment ceases and is every moment renewed. The abiding assurance is that 'we every moment see the same proof of a God as we should have seen if we had seen Him create the world at first.'"[6] This doctrine of the "new world" and perpetual re-creation is precisely the framework in which Fried wants to situate the redemptive experience of "presentness" and "grace" in the authentic work of art. But of course it is also a replaying of that moment in New England when the New World was (mis)perceived as an empty, virgin wilderness, as pure as the day it was created, ripe for colonization by the American Adam.[7]

This is not to be taken, however, as some kind of moralistic or political judgment on Fried's rhetoric, as if it were merely a repetition of nakedly imperialist gestures. My point is rather that the whole language of aesthetic judgment, especially of the distinction between art and objecthood, is already saturated with colonial discourse. This is not a fact to be lamented or overcome but to be understood. The clearest sign that the discourse is inevitable is the way the accusation of "anthropomorphism" comes up on both sides of the debate between Fried and the minimalists. Fried quotes Anthony Judd's critique of the gestural, "part by part" welded sculpture of David Smith and Anthony Caro: "a beam thrusts; a piece of iron follows a gesture; together they form a naturalistic and anthropomorphic image."[8] Against this, the minimalists argued for the values of "wholeness, single-

6. Perry Miller, quoted in Fried, *Art and Objecthood*, 148.

7. I echo here the title of R. W. B. Lewis's classic study, *The American Adam* (Chicago: University of Chicago Press, 1955).

8. Fried, *Art and Objecthood*, 150.

ness, and indivisibility," the aesthetic of the "Specific Object" that would renounce all the anthropomorphic gestures of modernist painting and sculpture. But when Fried turns to his attack on the minimalists, he turns the accusation of anthropomorphism against them: "a kind of latent or hidden . . . anthropomorphism, lies at the core of literalist theory and practice" (157). It is manifested by the sense that minimalist forms are like "surrogate person[s]," that the experience of their presence is "not . . . unlike being distanced, or crowded, by the silent presence of another *person*"; that the size of the works "compares fairly closely with the human body"; and that the "hollowness . . . of most literalist work—the quality of having an *inside*—is almost blatantly anthropomorphic" (156).

Both modernist art and minimalist objecthood, then, stand accused of anthropomorphism, the one for being gestural, the other for being hollow and theatrical. (Hollowness is, of course, one of the traditional indictments of idolatry, along with theatrical illusion, mere brute materiality, and false anthropomorphizing of inanimate objects.) The interesting thing about this debate now is not which side was right, but why the charge of anthropomorphism was so easily available to both sides. The personified (or merely animated) object is, as we have seen, the occasion of deep anxiety and disavowal in aesthetics. We want works of art to have "lives of their own," but we also want to contain and regulate that life, to avoid taking it literally, and to be sure that our own art objects are purified of the taint of superstition, animism, vitalism, anthropomorphism, and other premodern attitudes. The difficulty of containing the lives of images and the incorrigibility of the question, what do pictures want? are expressed in this ambivalence about anthropomorphism, the encounter with the object as Other. What follows is an effort to trace the evolution of the object-*as*-Other in the encounters with objects *of* the Other.

Empire and Objecthood

The age of imperialism is over, and therefore it is time to talk about empire. The age of disembodied, immaterial virtuality and cyberspace is upon us, and therefore we are compelled to think about material objects. The end of imperialism and the dematerialization of objects are not merely parallel or coincidental events but deeply implicated with one another. Perhaps they are even the same thing seen from two different angles. Imperialism, we are

told, has been replaced in our time by "globalization," a matrix of circulation and flows of information without a center, determinate location, or singular figurehead. (I always like to remind people, however, of Alan Sekula's cagey observation that the speed of actual commodity circulation on this planet is today almost exactly the same as it was in 1900.)[9] Globalization has no emperor, no capital, and no structure except for the endless labyrinths of corporate mergers, government bureaucracies, and the ever-proliferating nongovernmental organizations. It is a rhizome of networks, webs, and mediascapes where the buck never stops, the telephone trees never stop growing, and no one is in charge. A smiling pretender occupies the most powerful office in the world, a genial avatar of interlocking corporate interests such as weapons, biopower, and energy, and of a pervasive ideology of neoliberalism (also known as "compassionate conservatism") that installs "democracy" and "freedom" as the alibis for increasingly un-regulated capitalism and U.S. military adventurism. In this New World Order, freedom means the freedom of commodities (but not of human bodies) to circulate freely across borders, and democracy means an infinite proliferation of consumer choices accompanied by an increasingly narrow range of political choices. Before we celebrate the demise of imperialism, then, we had better reflect on the forms of empire that have replaced it. Before we sail off into the disembodied utopia of the World Wide Web, we had better ask ourselves what things we will have to leave behind, and what the consequences will be for the real bodies and physical objects that remain.

The end of imperialism and the dematerialization of the object have both generated compensatory forms of nostalgia for the good old days of colonialism. The British film industry provides a rose-tinted window into Victorian life at the apogee of the empire (a tactic it has resorted to since the 1930s, when it was seen as the only way to compete with Hollywood's cinematic imperialism; the theory was that the British film industry would have a world market waiting for its products, allowing it to compete with Hollywood's favorable home profit margins).[10] The National Trust provides the material settings: fashions, furniture, country houses and castles, gardens,

9. See Alan Sekula, *Fish Story* (Rotterdam: Witte de With, Center for Contemporary Art; Dusseldorf: Richter Verlag, 1995), 50, for Sekula's blistering critique of "the exaggerated importance attached to that largely metaphysical construct, 'cyberspace,' and the corollary myth of 'instantaneous' contact between distant spaces. . . . Large-scale material flows remain intractable."

10. My thanks to Tom Gunning for this information.

artifacts, obsolete scientific instruments, early photographs and bric-a-brac supply the Merchant-Ivory productions with lavishly detailed resources for periodizing nostalgia. American filmmakers compensate for the end of imperialism with fantasies of futuristic or archaic empires—the Evil Empire of *Star Wars*, the Roman revival of *Gladiator*, the cybernetic empire of *The Matrix*, or the lost empire of Disney's *Atlantis*—all featuring the latest in special effects and digital imaging. Like that period in popular culture after World War II when American cinema reflected the emergence of Pax Americana with spectacles of Egypt, Rome, and the golden age (in innumerable pirate movies) of the maritime empires, cinema at the turn of the twenty-first century replays the imperial spectacle in its heightened, virtual mode, with more garish violence and special effects than ever before.

Meanwhile, among scholars and intellectuals, the so-called postcolonial era has produced anything but a farewell to the imperial epoch. From Eric Hobsbawm's classic studies, to Giovanni Arrighi's *The Long Twentieth Century*, a magisterial survey of imperial dialectics from the early modern period to the present, to Edward Said's *Orientalism*, to Homi Bhabha's *The Location of Culture*, the New World Order of our time has reflected obsessively on the "old word order" of imperialism. Historical and theoretical study of imperialism has become a growth industry in the academy. Antonio Negri and Michael Hardt go so far as to argue that the demise of imperialism is also the birth of "empire" as a fully articulated concept and reality. "Our basic hypothesis," say Hardt and Negri,

is that sovereignty has taken a new form, composed of national and supranational organisms united under a single logic of rule. This new global form of sovereignty is what we call Empire. . . . In contrast to imperialism, Empire establishes no territorial center of power and does not rely on fixed boundaries or barriers. It is a decentered *and* deterritorializing *apparatus of rule that progressively incorporates the entire global realm within its open, expanding frontiers. Empire manages hybrid identities, flexible hierarchies, and plural exchanges through modulating networks of command. The distinct national colors of the imperialist map of the world have merged and blended in the imperial global rainbow.*[11]

I am not sure we should accept Hardt and Negri's rather utopian picture of the postmodern and postcolonial "Empire" with a capital *E*. What I find

11. Michael Hardt and Antonio Negri, *Empire* (Cambridge, MA: Harvard University Press, 2000), xii–xiii.

interesting about it is its insistence on the continued, in fact heightened, importance of empire as a contemporary concept, and its linkage of empire to the disappearance of the traditional imperialist objects—real territories, fixed locations of sovereignty, and (implicitly) the chief object of empire, the figure of the emperor as godlike ruler of the world. It is also critical to Hardt and Negri's picture of empire that the new objects of empire are described as "national and international organisms," a vitalist metaphor now extended to such objects as corporations, nongovernmental organizations, and nation-states.

If the passing of imperialism has spawned an obsession with empire, the triumph of virtuality and the dematerialized image is accompanied by an unprecedented fascination with material things. I'm thinking here not just of the rampant forms of materialism in contemporary consumer culture, the elephantine proportions of SUVs and suburban chateaux, but the ways in which the visceral reality of the body, the infinite archive of unrecyclable (but sometimes collectible) waste products, the plethora of obsolete gadgets, are filling up the world as if it were one giant junkyard. Contemporary art installations sometimes look as if they were sets for Bartertown in the *Road Warrior* trilogy, and the display of trash, of "formless" assemblages of materials, has become an aesthetic category in its own right.[12] The mixed-media collage, the found object, and the readymade occupy center stage in contemporary art production, while optically and pictorially oriented modes such as abstract painting have moved to a distinctly minor position.[13] Meanwhile, objecthood has also moved to the forefront of scholarly labor. "These days," as Bill Brown points out in his introduction to "Things," a special issue of *Critical Inquiry,* "you can read books on the pencil, the zipper, the toilet, the banana, the chair, the potato, the bowler hat. These days, history can unabashedly begin with things and with the senses by which we apprehend them; like a modernist poem, it begins in the street, with the smell of frying oil, shag tobacco and unwashed beer glasses."[14]

12. The College Art Association meeting of February 2001 included "Trash," a session organized by Lisa Wainwright, dealing with the theory of the Found Object. See chapter 5 of the present text. Also of interest is the Informe exhibition at the Beauborg Museum in Paris, curated by Yve-Alain Bois and Rosalind Krauss in 1996. See *L'informe: mode d'emploi* (Paris: Centre Pompidou, 1996), which traces the pedigree of this aesthetic in surrealism.

13. See chapters 5 and 11 for more on these matters.

14. Bill Brown, "Thing Theory," introduction to "Things," *Critical Inquiry* 28, no. 1 (Fall 2001): 2.

The new objecthood is not merely a woolgathering movement toward empiricism and materialism, or a spin-off of the new historicist love of detail and anecdote, but a return to fundamental theoretical reflection on the constitution of material objects, as if our virtual age were compelling us to start all over with the ontology of things, renewing Heidegger's obsessive questions about the Being of beings.[15] "Matter" seems to "matter" in a newly vivid and urgent way. Arjun Appadurai's *The Social Life of Things,* Hal Foster's *The Return of the Real,* Judith Butler's *Bodies that Matter* are among the more prominent contributions to this revival, and we could all enumerate, I'm sure, the ways in which material culture is reasserting itself as a discipline in new journals, conferences, and academic programs. Fried's "Art and Objecthood" returns, ironically enough, in a world where objecthood seems to have decisively triumphed over what Fried understood to be art— that is, abstract painting and sculpture, as epitomized by David Smith, Jackson Pollock, Morris Louis, and Frank Stella. Fried's major complaint about minimalist objecthood—aside from its anthropomorphism—was that it involved the display of merely literal, physical objects like cubes and slabs, unredeemed by any gestures of virtuality or figuration, any dematerialization by the work of fantasy or imagination. The imperative of the modernist art object, by contrast, was "that it defeat or suspend its own objecthood through the medium of shape."[16] It's as if the moment when the United States emerged as the dominant world power, and the moment when it appropriated the high modernist strategies of abstract art, is countered, dialectically, by an artistic movement that refuses virtuality and opticality and repudiates all the modernist strategies for redeeming the brute materiality of the art object, in favor of an affirmation of thingness and objecthood.[17]

The art of empire has to be seen, then, in its relations to a larger world of objects and objecthood. For one thing, the notion of art itself, in its traditional sense as comprising the "arts and sciences"—all the crafts, skills,

15. For Heidegger's taxonomy of things, see Martin Heidegger, "The Origin of the Work of Art," in *Poetry, Language, Thought* (New York: Harper & Row, 1971), 15–88. For an especially brilliant discussion of what might be called "the iconology of matter," see Daniel Tiffany, *Toy Medium* (Berkeley and Los Angeles: University of California Press, 2000).

16. Fried, *Art and Objecthood,* 153.

17. See Serge Guilbaut, *How New York Stole the Idea of Modern Art* (Chicago: University of Chicago Press, 1983), on the transfer of modernism from Europe to the United States after World War II.

and technologies that make imperialism possible—makes art a synecdoche for a much wider range of things—not just works of art proper but weapons, bodies, architecture, instruments, ships, commodities, raw materials, animals, monuments, mechanisms, paintings, statues, uniforms, fossils—the whole Borgesian archive of empire, which (as you will recall) begins with "things owned by the emperor"—that is to say, with absolutely *everything*. For that is what the concept of empire is really about. It is a name for the total domination of material things and people, linked (potentially) with totalitarianism, with "absolute dominion," the utopian unification of the human species and the world it inhabits; or the dystopian spectacle of total domination, the oppression and suffering of vast populations, the reduction of human life to a "bare life" for the great masses of people.[18] Empire is thus an object of radical ambivalence, perfecting the arts of mass death and destruction, conquest, and enslavement of whole populations while also producing the great monuments of civilization along with notions of universal law, human rights, and global harmony. Blake is not just a "prophet against empire" but a prophet of a positive ideal of "empery" figured by the lost civilization of Atlantis or the heavenly city of Jerusalem.[19] Hardt and Negri's *Empire* has been criticized from the left wing mainly because it paints too rosy a picture of the utopian possibilities lurking in the intricate webs of globalization.[20] Walter Benjamin's remark that "there is no document of civilization which is not at the same time a document of barbarism"[21] applies equally well to imperialism.

Objects arise as the figures in the landscape of empire; narratives and actions put them in motion. The caravels of Vasco da Gama, the triremes of Pericles, the Yankee clippers, Nelson's *Fighting Temeraire*, Darwin's *Beagle*, Cook's *Discovery*, along with all their cargoes (spices, sugar, breadfruit, tobacco, silver, porcelain, gold, maps, sextants, cutlasses, cannons, coins, jewelry, works of art), flow through the spectacle of empire in the rearview

18. On "bare life," see Giorgio Agamben, *Homo Sacer* (Stanford, CA: Stanford University Press, 1998).

19. Blake refers to "the Golden world / An ancient palace, archetype of mighty Emperies, / . . . built in the forest of God," in "America: A Prophecy" (1793). In *The Poetry and Prose of William Blake*, ed. David Erdman (Garden City, NY: Doubleday, 1965), 54.

20. See Timothy Brennan, "The Empire's New Clothes," *Critical Inquiry* 29 (Winter 2003): 337–67.

21. Walter Benjamin, "Theses on the Philosophy of History," in *Illuminations*, ed. Hannah Arendt (New York: Schocken Books, 1969), 256.

mirror of history. We differentiate these formations, of course. We insist that "empire proper" is a relatively recent historical formation, probably a modern one, and probably best exemplified by Great Britain. Rome, Athens, Holland, and China are radically different forms of empire, so different that we probably need to put the word in quotation marks for some of them. But the thing that unites (while differentiating) all forms of empire is the brute necessity of objects, the multitude of things that need to be in place for an empire to even be conceivable—tools, instruments, machines, commodities.

That is why an empire requires not just a lot of stuff, but what Michel Foucault called an "order of things," an epistemic field that produces a sense of the kinds of objects, the logic of their speciation, their taxonomy. Empire requires and produces, in a word, objecthood, and along with it a discourse of objectivity. All these it then mobilizes around an ideal object, an objective or goal, which motivates the imperial quest, gives it a purpose and life of its own. Men did not (usually) make empires for the sake of empire. They have always had clear (if somewhat contradictory) objectives in mind. As the Earl of Arundel put it when he floated the fantasy of colonizing Madagascar in the seventeenth century, our objectives are the "propagation of the Christian Religion, and the prosecution of the Eastern Traffique."[22] Globalization does not usually announce its objectives as the maximization of profit and the exploitation of an increasingly oppressed working class, but as the spread of prosperity and democracy, by way of what Noam Chomsky calls "a religious faith in the infallibility of the unregulated market."[23] We may think that the religious objective is merely ideology or propaganda, but that makes it no less powerful and determinative in the course of empire. God and money, the ultimate "Big Object" and the many little objects of desire, coalesce to form the object choice of empire. And when the empire declines and falls, as it inevitably must, it leaves behind nothing but objects—relics and ruins, inscriptions and monuments—which are invariably interpreted as ironic "object lessons" for succeeding empires. "Look on ye mighty and despair" is the inscription

22. Ernest Gilman, "Madagascar on My Mind: The Earl of Arundel and the Arts of Colonization," in *Early Modern Visual Culture: Representation, Race, Empire in Renaissance England,* by Peter Erickson and Clark Hulse (Philadelphia: University of Pennsylvania Press, 2000), 284–314.

23. Noam Chomsky, *Profit Over People* (New York: Seven Stories Press, 1999), p. 8.

Shelley reads on the colossal ruined statue of Ozymandias, king of kings. In the golden era of the British Empire, Volney's *Ruins of Empire* and Gibbon's *Decline and Fall of the Roman Empire* were familiar classics as Britons pondered their own place in the *translatio empirii*, the transfer of empire from East to West, and meditated on the object lessons left by their predecessors.

Objects and Things

Objects, objectives, object lessons, and objecthood put things into circulation within a total system. "Things" themselves, on the other hand, have a habit of breaking out of the circuit, shattering the matrix of virtual objects and imaginary objectives. I invoke here a dialectical concept (which is also a familiar, vernacular distinction) between the *object* and the *thing*.[24] Objects are the way things appear to a subject—that is, with a name, an identity, a gestalt or stereotypical template, a description, a use or function, a history, a science. Things, on the other hand, are simultaneously nebulous and obdurate, sensuously concrete and vague. A thing appears as a stand-in when you have forgotten the name of an object. As Bill Brown reminds us, we say "Hand me that thing over there, the one next to that green thing" when we are suffering cognitive object loss. So things play the role of a raw material, an amorphous, shapeless, brute materiality awaiting organization by a system of objects. Or they figure the excess, the detritus and waste when an object becomes useless, obsolete, extinct, or (conversely) when it takes on the surplus of aesthetic or spiritual value, the *je ne sais quois* of beauty, the fetishism that animates the commodity, the "wild thing" or "sweet thang" or "Black Thing" that you wouldn't understand. The thing appears as the nameless figure of the Real that cannot be perceived or represented. When it takes on a single, recognizable face, a stable image, it becomes an object; when it destabilizes, or flickers in the dialectics of the multistable image, it becomes a hybrid thing (like the duck-rabbit) that requires more than one name, more than one identity. The thing is invisible, blurry, or illegible to the subject. It signals the moment when the object becomes the Other, when the sardine can looks back, when the mute idol speaks, when the subject experiences the object as uncanny and feels the need for what Foucault calls "a metaphysics of the object, or, more exactly,

24. See Brown, "Thing Theory," for an especially subtle analysis of this distinction.

a metaphysics of that never objectifiable depth from which objects rise up toward our superficial knowledge."[25]

I want to draw a distinction here between objectivity, understood as the somewhat detached, skeptical attitude associated with scientific research, and "objectivism," the conviction that we do possess, or will in due course, a complete and total account of objects, an exhaustive, eternally comprehensive description of the "given."[26] Both objectivity and objectivism are protoimperialist formations. Objectivity is an essential component of that open, curious, and unresolved frame of mind that makes the encounter with novel, alien realities possible and desirable—surely a requirement of any successful colonial venture. Objectivism is the ideological parody of objectivity, and tends toward self-assurance and certainty about the sovereign subject's grip on the real. Objectivism is the fantasy of what Rousseau called the "sovereign subject," a picture of the beholder as imperial, imperious consciousness, capable of surveying and ordering the entire object world. The gap between objectivism and objectivity might be thought of, then, as the moment when the "thing" makes its appearance. It is the moment of uncertainty and liminality where ambivalence about objects arises.

I want to make this distinction in order to head off any notion that objectivity can or should be abandoned in favor of some form of subjective relativism. Objectivity is one of the most important and durable achievements of imperial civilizations (along with notions of universality and the species being of the human race) and will survive no matter how firmly we might reject the more odious features of imperialism. Notions of subjectivity and relativism, in fact, are part of the discourse of imperial objectiv-

25. Michel Foucault, *The Order of Things: An Archaeology of the Human Sciences* (New York: Random House, 1970), 245. The sardine can makes its appearance in Jacques Lacan's *Four Fundamental Concepts of Psychoanalysis* (New York: Norton, 1981), 95.

26. See Pierre Bourdieu, *Outline of a Theory of Practice* (Cambridge: Cambridge University Press, 1977): "Objectivism constitutes the social world as a spectacle presented to an observer who takes up a point of view on the action, who stands back so as to observe it and, transferring into the object the principles of his relation to the object, conceives of it as a totality intended for cognition alone, in which all interactions are reduced to symbolic exchanges. The point of view is the one afforded by high positions in the social structure, from which the social world appears as a representation . . ." (96). See Robert Nelson's application of this concept to art history in "The Map of Art History," *Art Bulletin* 79 (1997): 37; also Stephen Shapin's *A Social History of Truth* (Chicago: University of Chicago Press, 1994) on the "Christian gentleman" as the figure of objectivity, and the implicit exclusion of savages, women, and the "lower orders" from the discourse of truth.

ity, not antithetical to it. Relativism only makes sense to someone who understands that there are radically different forms of subjectivity in the world, and this understanding can only come to someone who knows that there are other cultures, other societies and polities, and other kinds of objects in the world.

Idol/Fetish/Totem

Among the many kinds of objects that come within the purview of imperial objectivity are some that we might call bad objects, or objects of the Other. I'm loosely adapting psychoanalyst Melanie Klein's notion of the split "part-object," more precisely, "imagos, which are a phantastically distorted picture of the real objects upon which they are based."[27] Bad objects, then, are not simply bad in some straightforward moral sense. They are objects of ambivalence and anxiety that can be associated with fascination as easily as with aversion.

Bad objects are not, at least to start with, the commodities (spices, gold, sugar, tobacco) that lure colonial expeditions, nor the symbolic gifts that are exchanged between emperors[28] to impress the recipient with the donor's wealth and refinement. Instead, these are objects generally seen as worthless or disgusting from the imperial perspective, but which are understood to be of great and no doubt excessive value to the colonial Other.[29] These objects usually have some kind of religious or magical aura and a living, animated character, which is seen from the objective imperial perspective as the product of merely subjective and superstitious beliefs. Although these objects are given many different names in the languages of colonized peoples, I want to focus on three categories of objects that have had a remarkably durable life in the history of European imperialism, and that have a further life in imperialism's picture of its own "proper" objects, especially its works of art. The names of these objects are fetishes, idols, and totems, terms which are often confused with one another or given very special meanings

27. Melanie Klein, quoted in Laplanche and Pontalis, *The Language of Psychoanalysis*, 188.

28. Tony Cutler's "The Empire of Things" is an unpublished book manuscript about the symbolic objects that passed between Byzantine and Islamic emperors, but some of the essential points are made in Cutler's article "Gifts and Gift Exchange as Aspects of the Byzantine, Arab, and Related Economies," *Dumbarton Oaks Papers* 55 (2001): 247–78.

29. See chapter 4 for more on the over- and underestimation of the image of the Other.

in technical discussions—theology, anthropology, economic theory, and psychoanalysis immediately come to mind—but have never, to my knowledge, been subjected to systematic comparison and differentiation.

These three objects are also exactly the sort of things that tend to throw the distinction between objectivity and objectivism into crisis. They are uncanny things that we should be able to dismiss as naive, superstitious objects of primitive subjectivities, but which at the same time awaken a certain suspicion or doubt about the reliability of our own categories. We know that the voodoo doll impaled with pins cannot really hurt us; its power is totally psychological and depends on the gullibility of a believer, not on any real forces in the real, objective world. And yet we hesitate to dismiss it outright.[30] The statue of the Virgin Mary does not really weep, but the staunchest unbeliever will hesitate to desecrate her image. The child's doll cannot really feel pain, but the wise parent will refrain from abusing or destroying this object out of respect for the child's feelings. One rather benign construction of the bad object, then, would be to call it the "transitional object" of the Other, in D. W. Winnicott's sense of the object of imaginative play that helps to unfold cognitive and moral sentiments.[31]

Both the history and logic of empire can be, in a sense, "told" by the triad of the idol, fetish, and totem. Idols correspond to the old territorial form of imperialism that moves by conquest and colonization, physically occupying someone else's lands and either enslaving or displacing the inhabitants. The idol has two functions in this process: on the one hand, it is a territorial marker to be erected or destroyed, as with the Baalim of nomadic tribes, a god of the place.[32] On the other hand, it is the figurehead or image that "goes before" the conquering colonizers. When the emperor himself plays the role of a god, and his image is circulated in statues and coins, becoming the center of a cult, then imperial idolatry in its classic, Roman form is achieved.[33] As symbols or actual incarnations of a god, idols are the most powerful of imperial objects, presenting the greatest dangers

30. See Bruno Latour, "Notes Toward an Anthropology of the Iconoclastic Gesture," *Science in Context* 10 (1997): 63–83, for an excellent account of iconoclastic hesitation in the face of the sacred object.

31. D. W. Winnicott, *Playing and Reality* (London: Routledge, 1971).

32. See my discussion of the Baalim as gods of the place or *genius loci* in "Holy Landscape," in Mitchell, ed., *Landscape and Power*, 2nd ed., 277.

33. I'm grateful to my colleague Richard Neer for his help with questions about the cult of the Roman emperor.

and making the greatest demands. Idols characteristically want a human sacrifice, and the punishment for idolatry is death. Not every idolatrous people is, of course, imperialist. In principle, a tiny tribal unit could worship idols. The consolidation of idolatry into an imperial imaginary comes, I suspect, with the rise of monotheism, coupled with sufficient technical resources to give it military force. Either the empire is ruled by a god, a living idol, or the empire sets its face against idolatry in all its local forms and makes iconoclasm a central feature of colonial conquest. The book of Numbers puts this doctrine in the most emphatic terms: "When you cross the Jordan into Canaan, drive out all the inhabitants of the land before you. Destroy all their carved images and their cast idols, and demolish all their high places" (33:52–53). Ironically enough, this phase of imperialism corresponds to what economist Joseph Schumpeter calls "an *objectless* disposition on the part of a state to unlimited forcible expansion" (emphasis mine). A warrior culture plus an infinitely voracious and bloodthirsty deity who will tolerate no other gods before him and demand destruction of all idols is the formula for empire without limits, empire for the hell of it, a variation that Schumpeter traces from the Assyrians and Egyptians right down to Louis XIV.[34]

Fetishism, as anthropologist William Pietz has shown, is a much later development, emerging in early modern Europe as a buzzword among the mercantilist, seafaring empires of Holland, Portugal, Genoa, and the seventeenth-century phase of the British Empire. The word *fetish* comes from the Portuguese, and means simply a "made thing" (compare with *facture*).[35] The typical European attitude toward fetishes is a complex mixture of aversion and fascination. Sometimes they were regarded as native deities

34. See Joseph Schumpeter, *Imperialism and Social Classes* (New York: A. M. Kelley 1951), 7.

35. William Pietz, "The Problem of the Fetish," pts. 1–3: *Res* 9 (Spring 1985): 5–17; 13 (Spring 1987): 23–45; and 16 (Autumn 1988): 105–23. In contrast with the all-powerful image of the idol, fetishism (or "making fetish") treats the object as a prop in a ritual performance rather than a free-standing, self-authorizing thing. Cf. David Simpson's *Fetishism and Imagination* (Baltimore: Johns Hopkins Press, 1982), on Herman Melville's descriptions of the fragility and ephemerality of sacred objects in Polynesia—holy one minute, on the trash heap the next. Fetishism, Pietz argues, refers originally to the sacred objects and rituals of West Africa encountered by Portuguese sailors, and fetish objects were used by Africans in a variety of ways: as power objects, talismans, medicinal charms, and commemoration devices to record important events such as marriages, deaths, and contractual agreements. Fetishism rapidly became a term of art in the African trade, and the trinkets and gadgets that the Europeans brought to Africa also took on the name of fetishes.

and equated with idols, but more often they were regarded as less important and powerful than idols, and were seen as connected to the private interests of individuals. Fetishes were almost invariably regarded with contempt as crude, inert, smelly, obscene, basely material objects that could only acquire magical power in an incredibly backward, primitive, and savage mind. A contrast is sometimes made between the idol, which is a relatively refined iconic symbol of a deity, and the fetish, regarded not as symbolic but as the place of the real presence of the animating spirit; hence fetishism has often been equated with crude materialism, in contrast with the relative refinement and sophistication of idolatry.[36] For the Protestant empires, the idolatry of the savages was readily associated with the Roman Catholic empires, so fetishism immediately became associated with idolatry and the holy crusade against popery, right alongside the missionary effort to stamp out heathen idolatry all over the world. Nevertheless, European traders to Africa found it necessary to tolerate the fetishes, and even to accept their social and cultural currency among the tribes they encountered. Swearing an oath on a fetish object, driving a nail into a power figure in order to commemorate an agreement, was often the only way to secure a bargain. Given this background in commerce, it seems only appropriate that when Marx looked about for a figure to define the magical character of Western, capitalist commodities, he adopted the fetish character as the appropriate figure for our rationalized and objective measures of exchange value.

Totems, finally, are the latest in the sequence of objects of the Other, emerging in the nineteenth century, mainly in the writings of anthropologists about North America and the South Pacific. Less threatening than idols, less offensive than fetishes, totems are generally natural objects or their representations, and they rarely have been seen as possessing godlike powers. They are, rather, "identity" objects associated with tribes or clans, and individual tribal members occasionally serve as tutelary or guardian spirits. The word *totem* comes, as Claude Lévi-Strauss notes, "from the Ojibwa, an Algonquin language of the region to the north of the Great Lakes of North America,"[37] and it is usually translated as equivalent to the expression, "He is a relative of mine." Of all the imperial objects, totems are

36. See my essay, "The Rhetoric of Iconoclasm," in W. J. T. Mitchell, *Iconology: Image, Text, Ideology* (Chicago: University of Chicago Press, 1986), for more on this distinction.

37. Claude Lévi-Strauss, *Totemism*, trans. Rodney Needham (Boston: Beacon Press, 1963), 18.

the most benign. While idolatry and fetishism were generally condemned as obscene, perverse, demonic belief systems to be stamped out, totemism usually has been characterized as a kind of childish naiveté, based on an innocent oneness with nature. Hegel's discussion of the "flower" and "animal" religions in *Phenomenology of Spirit* stresses the harmless, benign character of these early intuitions of spirit in nature. Totem objects, therefore, rarely have been the target of iconoclastic fervor. On the contrary, the characteristic imperial attitude toward totems was one of curiosity and curatorial solicitude. Totemism represents what anthropologist Sir James Frazer and others regarded as "the childhood of the human species," and thus it has been treated with tolerance and condescension. Frazer, in fact, sent out questionnaires to missionaries, doctors, and government administrators throughout the British Empire in order to gather the information for his first book, *Totemism* (1887).[38]

It is crucial to remind ourselves at this point of what is probably obvious: these objects—totems, fetishes, and idols—are anything but objective. They are really objectiv*ist* projections of a kind of collective imperial subject, fantasies about other people, specifically other people's beliefs about certain kinds of objects. Totemism, fetishism, and idolatry are thus "secondary beliefs,"[39] beliefs about the beliefs of other people, and thus inseparable from (in fact, constitutive of) systems of racial or collective prejudice. They involve quite general notions about the operations of the "savage" or "primitive" mentality—that the natives are invariably gullible and superstitious; that they live in a world of fear and ignorance where these objects compensate for their weakness; that they lack the ability to make distinctions between animate and inanimate objects. These objects are, moreover, firmly held collective and official imperial belief systems, axioms within scientific discourses of ethnography and comparative religion, not just private opinions. Beliefs about idolaters—for instance, that they believe the idol hears their prayers and that it will intercede on their behalf and be pleased with their sacrifices—are articles of faith for the iconoclast, held so firmly that they justify the extermination of idolaters as subhuman creatures. The Portuguese trader had to believe that his African trading partner sincerely believed that an oath sworn on a fetish object was binding,

38. Sir James Frazer, *Totemism* (Edinburgh, A. & C. Black, 1887); for an account of Frazer's methods, see "A Chronology of Sir James George Frazer," xlvii, in Sir James Frazer, *The Golden Bough*, A New Abridgement from the Second and Third Editions, ed. Robert Fraser (New York: Oxford University Press, 1994).

39. Cf. the discussion of secondary beliefs in chapter 4.

even if he himself shared no such belief. (An idolater, by contrast, can never be believed: "they will respect not in you the ties either of kinship" according to the Qur'an, 9:8—though the Qur'an is realistic about the need to make compromises on this point.)[40] The British anthropologist has to believe that the native informant is telling him the truth when he explains the magical beliefs surrounding a specific totem ritual. The natives have to really believe that their souls are deposited in a totem object for safekeeping during the ritual death of initiation ceremonies, even though the natives may seem at times fully aware of the play-acting character of the ritual. Wittgenstein noted that the literalness of Frazer's beliefs in natives' beliefs prevented him from entertaining more complex notions of ritual and religion that might involve a complex combination of play and seriousness.[41]

It is tempting to summarize the history of imperialism as the sequence from idolatry (empires of conquest and colonization of territory) to fetishism (mercantilist, seafaring empires) to totemism (the mature, that is to say, British, form of empire, combining mercantilism and territorial expansion, the spread of trading monopolies and religious missions). Imperial theory in general is fond of triadic narratives—sociologist Giovanni Arrighi's Genoese/Dutch/British dialectic of "accumulation" and "territorialism" is a classic instance.[42] And there is a sense in which the concepts of idolatry, fetishism, and totemism adumbrate a historical sequence in terms of the history of words and their application. Idolatry clearly comes first, dating to the ancient Greek and Hebrew texts as a discourse on iconoclasm and iconophilia, law, morality, national identity, and imperial destiny (the figure of Zion and the Promised Land later become the central ideology of the modern, especially Protestant, empires). Fetishism and totemism, by contrast, are modern words, arising as a kind of colonial pidgin language (along with words like *taboo, mana, nabob, bamboozled,* and *loot*). The fe-

40. See the Qur'an, chap. 9 (Repentance), verse 8 on the inability to establish kinship or covenants with idolaters (in contrast with the contractual function of fetishism, and the centrality of kinship to totemism). The realism of the Qur'an on this matter is notable also: idolaters may be slain, but they may also be forgiven and spared if they repent (9:5); if they come to you for asylum, you may grant it; and if you make a treaty with them "near the sacred mosque" (9:7), then you should honor it as long as the idolaters do not violate it. See the University of Southern California's online edition of the Qur'an: http://www.usc.edu/dept/MSA/quran/.

41. Ludwig Wittgenstein, *Remarks on Frazer's Golden Bough,* trans. A. C. Miles (Atlantic Highlands, NJ: Humanities Press, 1979), 1–18.

42. See Giovanni Arrighi, *The Long Twentieth Century* (New York: Verso, 1994).

tish, as I have said, is a seventeenth-century "discovery" or "invention"—a new word, concept, and image in the world. Similarly, totemism springs up in nineteenth-century North America on the "wilderness" frontier (Canada during the American Revolution), and enters the English language through the memoirs of an English fur trader named John Long.[43]

So the sequence of idol/fetish/totem hints at a historical unfolding of the bad objects of empire, a progression from bad to tolerated to curated and collected. Perhaps this is just a measure of the increasing power and invincibility of modern imperialism. The extirpation of idolatry only makes sense to an empire that is insecure about its grip on the colonial territory, or utterly fanatical about its religious mission or its love of war. Fetishism, by contrast, is the merchant's religion. It's about making deals with the devil. And totemism is—well, that's the question, isn't it? This term tends to differentiate itself from the other two in a variety of ways. Perhaps its most notable differences are (1) its adoption as a technical term in anthropology and comparative religion as an imperial universal that is supposed to provide the key to primitive religions and mentalities, and (2) its vernacular usage in a weakened and vague sense of the "symbolic," along with the all-purpose pop icon of the "totem pole" and the "totem animal" as prototypes for public monuments, corporate logos, and the mascots of teams and men's clubs (Elks, Moose, Eagles, Raptors, and so on). Perhaps the most conspicuous thing about "totemism" as a catchphrase is its lack of polemical force: idolatry and fetishism are accusations; totemism is a fairly neutral classification of objects and object choices.

Any historical account of the idol/fetish/totem triad has to recognize that the story could go just the other way as well, as it does in the writing of Durkheim, where totemism is installed as the earliest phenomenon, and fetishism and idolatry are treated as later developments.[44] This is a different kind of history, of course: sociology and anthropology, not philology. Durkheim doesn't care about the modern provenance of the word *totem*. He is concerned with its applicability as a concept to explain the elementary forms of religious life. So despite the hints of a historical progression in this trio of terms, I would urge caution and flexibility on this front. The meanings of the three terms shift in various contexts. Their real interest is

43. See chapter 8 for a discussion of John Long.

44. Émile Durkheim, *The Elementary Forms of Religious Life* [1912], trans. Karen E. Fields (New York: Free Press, 1995).

as much a matter of structural logic as of historical progression, which is why they can coexist as a highly adaptable discourse of bad objecthood in the same historical moment, and why the same object could, from various angles, receive all three names. Fetishism is often contrasted to idolatry as the cruder, more materialistic variation on the investment of life and value in worthless objects. Totemism can be defined, as it was by its theoretical inventor, anthropologist Andrew McLennan, as "fetishism plus exogamy and matrilineal descent."[45] The three kinds of objects can be differentiated quite strictly in relation to categories such as gods (idols), natural forces (totems), and artifacts (fetishes). In the family romance framework of psychoanalysis, the idol is the father, or Big Other; the fetish is the Mother's Breast, or Little Other; and the totem is the natural kind as sister, brother, or kinfolk. Or the three objects can be placed in a sliding scale, differentiated by degree, in which case the fetish is just a deflated, miniaturized version of the totem (lacking the communal investment), and the idol is just an inflated, gigantic version (insisting on its supreme importance and imperial ambitions).

The British Empire's most conspicuous use of these bad objects was to differentiate themselves from the bad, old idolatrous empires and their modern Catholic rivals. Milton's Paradise sets the stage for this contrast. The Garden of Eden is a colonial "plantation" in which the innocent, childlike natives are given light agricultural work ("Sweet gardening labor" [bk. 4, line 328]) under the benign supervision of Raphael. The natives are instructed to be patient and loyal, not to seek to learn forbidden knowledge that is beyond their station, and especially not to be misled by "Some specious object by the foe suborned" [bk. 9, line 361]).[46] Ultimately, then, they are to be emancipated as equal citizens in the heavenly empire along with the angels. Meanwhile, Satan is portrayed as an imperial seafarer sailing "Beyond the Cape of Hope," past Mozambique,[47] smelling the spices and sweet perfume of paradise (bk. 4, line 160). He declares his motives to be the acquisition of new slaves, and "Honor and empire with revenge enlarged, / By conquering this new world" (bk. 4, lines 390–91), but his quest has a religious dimension as well. He is the Antichrist ruling over an empire of

45. Andrew McLennan, "The Worship of Animals and Plants," *Fortnightly Review*, vols. 6 and 7, 1869–70; quoted in Lévi-Strauss, *Totemism*, 13.

46. John Milton, *Paradise Lost* [1667], ed. William G. Madsen (New York: Modern Library, 1969). Note that Satan addresses Eve as "Empress" in order to flatter her (bk. 6, line 626).

47. See Gilman, "Madagascar on My Mind."

devils who will play their historical role as pagan idols (Baal, Beelzebub, Ashtoreth, Moloch, Mammon, Belial, and so on; see book 1). Satan himself is "the first grand thief" who has climbed into God's fold, as "into his Church lewd hirelings climb" (bk. 4, line 193). In short, Satan is the spiritual leader of the rival Catholic empires who enslave their colonial subjects, and maintain them in a state of brute savagery by encouraging their idolatrous religions. As Willem Bosman put it in his *Discription of Guinea* (1704), "If it was possible to convert the Negroes to the Christian Religion, the Roman-Catholicks would succeed better than we should because they already agree in several particulars, especially in their ridiculous ceremonies."[48] Needless to say, the ceremonies were, from the Protestant standpoint, virtually indistinguishable from pagan idolatry.

Totemism might be seen in this light as an imperial compromise formation, dictated by the exigencies of colonial warfare and the fur trade. John Long, who brought the word and concept of totemism back to England in 1791, had spent twenty years fighting alongside the Chippewa Indians against the American colonists. He had "gone native," been initiated as a totem brother with the figure of his totem animal inscribed on his chest. As a fur trader, he was interested in the preservation of a Canadian wilderness for continued trapping, as opposed to the breakaway settler colonists of America with their Jeffersonian agrarianism and their policy of Indian removal.[49] Totemism marks the point when the bad object of the Other is adopted by the imperial conqueror, when the possibility—indeed, the imperative—of exogamy, intermarriage, and colonial exchange at the level of the body becomes imaginable. It also marks the moment when the bad object of the Other, and the whole culture that supports it, has become so precarious and weak that it is transformed from an object of iconoclastic aversion to one of curatorial solicitude and sentimentality.

Fossils

If idols, fetishes, and totems were the bad objects of imperialism, we need to ask ourselves what is the bad object of *empire*, of the dematerialized, virtual world of globalization we now inhabit. My answer is simple: it is the

48. Excerpts from Bosman's *Discription* are collected in *Modern Mythology: 1680–1860*, ed. Burton Feldman and Robert D. Richardson (Bloomington: Indiana University Press, 1972), 46.
49. For more on John Long and the emergence of totemism, see chapter 8.

fossil, understood as the material image of extinct life. Unlike idols, fetishes, and totems, fossils are seen as purely objective, purely natural objects, uncontaminated by human artifice or fantasy. Fossils are thus even more radically "other" than fetishes, idols, or totems, because they signify the lost, nonhuman worlds of natural history and deep, geological time. They also signify a radical form of death that goes beyond any of the mass exterminations carried out by imperial conquerors. They signify species death, the utter vanishing of an entire class of living things.

Fossils are, at the same time, not Other at all, but creations of modern science and objective rationality. Fossils are *our* thing. Primitive societies never understand what fossils "really" mean as scientific objects; they regard them as taboo objects or freaks of nature. And in this case, primitive society continues right up to the European Enlightenment, because it was not until the 1790s, as Cuvier sorted through the imperial collections of fossils coming to Paris as a result of the conquest of Belgium, that the modern meaning of the fossil was uncovered. And it was not French Catholic idolatry that conceived of the fossil, but Cartesian rationality and a mechanistic notion of living organisms. Mature nineteenth-century imperialism, with its global reach and archives of living organisms, was a precondition for discovering the true nature of fossils as the relics of extinct life-forms.

Like all bad objects, fossils produce ambivalent reactions. Their rarity makes them objects of fascination. Their association with extinction inevitably makes them solemn, even melancholy figures, rather like those mournful object lessons provided by the relics of imperial civilizations. This is especially noticeable in the cult of the dinosaur, which dominates the natural history museums of the great imperial cities, and which is routinely characterized as an "imperial" animal group that once ruled the entire world.[50] The object lesson of the dinosaur, moreover, has become the regnant cliché of our time. The cycles of innovation and obsolescence that are endemic to technical progress and capital growth, the emergence of gigantic new corporate bodies locked in a Darwinian struggle for survival, the inability to imagine, as theorist Fred Jameson puts it, the end of capitalism as a more plausible outcome than the death of the human species—all this adds up to an ideological complex that makes the fossil the bad ob-

50. See W. J. T. Mitchell, *The Last Dinosaur Book: The Life and Times of a Cultural Icon* (Chicago: University of Chicago Press, 1998), for a fuller discussion of the dinosaur as imperial icon and modern totem.

ject of our time. We now stand at the threshold of a world order that may well threaten the existence of everyone, as if we had created a Moloch-like Matrix that demanded the sacrifice of the human species itself. If Joshua Reynolds is right, the arts can do nothing but follow in the train of empire, adorning the palaces of the new emperors. If Blake is right, the arts and the sciences are in a much more complex position. On the one hand, they are making possible all the techniques of domination and exploitation on which the new form of empire depends, and providing the ideological fantasies that make this process seem natural and inevitable. On the other hand, they provide the prophetic visions that let us see where we are going before we get there: like the idols of old, they "go before us" into possible and probable futures. How to disentangle these objectives, how to transform our objects and ourselves, is the great task of art—and empire—in our time.

But what is "our time"? Is it the post-9/11 world of terrorism and incipient forms of neofascism, from the Taliban to the new American imperialism? Is it the era of postmodernism, or of a modernism (as philosopher-anthropologist Bruno Latour argues) that may never have existed? Is it a time defined by new media and new technologies, an era of "biocybernetic reproduction" to succeed Walter Benjamin's "mechanical reproduction," Marshall McLuhan's "wired world" displacing the time when one could tell the difference between a machine and an organism? Is it a moment when new objects in the world produce new philosophies of objectivism, and old theories of vitalism and animism seem (like fossil formations) to take on new lives?

In the next chapter, I want to continue our pursuit of the animated image-object in an expanded historical perspective that goes back into the eighteenth and nineteenth centuries, the periods known as Enlightenment and Romanticism, the eras that precede a modernism that now seems, as art historian T. J. Clark has argued, so remote as to require an archaeology to recover it. My primary aim is not, however, to provide a panoramic survey but to take a snapshot of a specific historical moment, the 1790s in Europe, when two new objects entered that world, altering its entire picture of physical reality in the process.

The following chapter was originally written as the keynote address to the annual meeting of the North American Society for the Study of Romanticism in September 2000.[1] *The topic for that year was "Romanticism and the Physical," a signal that the current interest in questions of material culture, objecthood and thingness, were (as always) percolating down through the canonical periods of literary and cultural history. Romanticism, however, has been a period under siege in recent reformulations of English literary history. Crowded on the one side by an expanding "long eighteenth century" and on the other by the Victorian and ever-voracious modernist periods, it has begun to look like an endangered species in the sequence of historical literary specialties, especially as measured by the Modern Language Association's annual lists of job openings.*[2] *This historical squeeze is compounded by the continuing habit among cultural critics and historians of referring unreflectively to tendencies such as emotionalism, sentimentality, and idealism as "merely Romantic" phenomena that have been superseded by tough-minded modernism or even more wised-up postmodernism. My essay, then, was a double effort to link Romanticism to the new interest in "things" across a number of disciplines, and to trace the genealogy of that very interest to the historic discovery of some*

This chapter originally appeared in "Things," ed. Bill Brown, special issue, *Critical Inquiry* 27, no. 1 (Fall 2001): 167–84. Copyright © 2001 by The University of Chicago. All rights reserved.

1. Special thanks are due to Mark Lussier, the organizer of this event. I want to acknowledge also Bill Brown, James Chandler, Arnold Davidson, Marilyn Gaull, and Françoise Meltzer, who made numerous excellent suggestions about the issues raised in this chapter.

2. See William Galperin and Susan Wolfson, "The Romantic Century," *Romantic Circles,* April 30, 2000, http:/www.rc.umd.edu/features/crisis/crisisa.html.

very specific and rather momentous concepts and images of "thinghood" in the heart of the Romantic movement.

At the same time, I conceived this essay as part of the inquiry of the present book into the question of the "animated" object/image/thing, especially those forms of animation rooted in desire and longing. The argument may be seen, then, as an attempt to pursue the question—what do pictures want?—into a historical period when, by all accounts, modernity and the Enlightenment first encountered the revolution in the life sciences that has reached a crisis point in our time. Romanticism is not only the age of desire (sentiment, feeling, and passion) but also the age when vitalism, organicism, and animism first posed a powerful challenge to mechanistic models of the physical world. It is also the historic moment when the problem of the image, the imagination, and the Imaginary looms as an inescapable issue in epistemology and aesthetics. It therefore seems an unavoidable stopping place for any historical inquiry into the lives of images, and the desires of pictures.

Getting Physical with Romanticism

Romantic studies have always been a weathervane for contemporary issues in cultural theory, partly because all the roads to modernity seem to lead back to the Romantic period, and partly because Romanticism has always seemed to be something more than a period of cultural history in its tendency to elicit passionate commitments and continued debates about its nature and importance. To "be" a Romanticist, to profess Romantic literature or culture, has always seemed to entail something more than "being" a scholar of the eighteenth century, or even being a professional literary historian more generally.

The conversation in cultural studies has turned, in recent years, toward material culture, objecthood, and physical things. It is not surprising, then, that these issues have percolated down to the early nineteenth century, and that the relationship of "Romanticism and the Physical" is now on the agenda. In the old days, of course, it would have been "Romanticism and the Spiritual" (or the mental, the psychological, the ideal, the immaterial, the metaphysical). We would have been quoting Blake's "Mental Things are alone real" and Wordsworth's vaporous raptures over the mind and the spirit. But if all roads lead to Romanticism, they inevitably bring along with them the baggage of our present concerns—postcoloniality, gender, race, technology, and now "the physical."

What exactly is "the physical"? Is it the physical body? Or the physical, material world more generally, the object of the physical sciences, especially physics (and not biology)? Is it the domain of nature, the nonhuman realm of what Wordsworth called "rocks and stones and trees," and all the rest—the earth, the oceans, the atmosphere, the planets and stars in their courses? And what is the rhetorical or theoretical force of invoking "the physical" as a thematic within Romanticism? Is this a signal of a new materialism, another overturning of Hegel and idealism? Is it a reflex of the fashion for "bodily matters" in contemporary criticism, and if so, is this a natural body or a cultural body? A virtual techno-body, a gendered, racialized, erotic body, or a body without organs? Where does the invocation of the physical locate us in the endless debate of nature and culture, the natural and the human sciences? Is it a replaying of the old Romantic division between the *physical,* understood as the organic, living substance, and the *material,* understood as the inert, dead, or mechanical?

The great temptation for Romanticists is to think that our gesture of "getting physical with Romanticism" is an accomplishment in itself. We are in danger of supposing that somehow the turn to the physical is a tough-minded and realistic gesture, a politically progressive act of getting down to the concrete, hard facts, the obdurate stuff of things in themselves, an escape from old-fashioned "Romantic idealism." And of course the more closely we look at both Romanticism and at the physical world, the more difficult it becomes to sustain any such illusion. The physical is a thoroughly metaphysical concept; the concrete is (as Hegel points out) the most abstract concept we have; bodies are spiritual entities, constructions of fantasy; objects only make sense in relation to thinking, speaking subjects; things are evanescent, multistable appearances; and matter, as we have known since the ancient materialists, is a "lyric substance" more akin to comets, meteors, and electrical storms than to some hard, uniform mass.[3]

The Life of Things

"Getting physical with Romanticism," then, will get us absolutely nowhere if we do not get metaphysical at the same time. We can see this most clearly

3. See Daniel Tiffany's *Toy Medium* (Berkeley and Los Angeles: University of California Press, 1999) for a brilliantly detailed exploration of "poetic substances" and iconologies of matter.

if we look at the status of the physical in our own time. We live at a strange moment in cultural history, when the most extreme forms of material physicality and real violence are exerted by virtual, disembodied actors. As Katherine Hayles has demonstrated, there are more things, especially more living things, in heaven and on earth today than were ever dreamt of by physicotheology, natural philosophy, or Romantic idealism.[4] I like to call this the age of "biocybernetic reproduction" to name the conjunction of biological engineering and information science that has made it possible to produce physical organisms in the real world out of bits of data and inert substances.[5] Walter Benjamin's "mechanical reproduction," a paradigm of cultural and technical production based in the assembly line and such exemplary figures as the robot, the photograph, and the cinematic sequence, has now been replaced by the figures of the clone and the cyborg, the unpredictable, adaptable mechanism. The old opposition between the mechanical and the organic makes no sense, or is restaged in films like *Terminator 2* as the difference between the rods, gears, pulleys and servo-motors of the "old" Terminator and the new model composed of living, liquid metal.

The slogan for our times, then, is not "things fall apart" but "things come alive." The modernist anxiety over the collapse of structure is replaced by the panic over uncontrolled growth of structures that have lives of their own—cancers, viruses, and worms that can afflict electronic networks and power grids as well as physical bodies.[6] The premonition of an imminent decoding of the riddle of life repeats a familiar trope of Romanticism, as we see in the resonance between the Frankenstein narrative and its contemporary descendant, *Jurassic Park*. Both stories revolve around the hubristic conquest of death and the production of new living things that threaten to destroy their creators. The difference is that Frankenstein's monster is human and is composed of recently dead matter, corpses fresh from the graveyard. Our contemporary monster, the dinosaur, is nonhuman, a giant beast driven solely by appetite, and it is resurrected from material that is not just long-dead, but absolutely inert, petrified, and fossilized. No phys-

4. See Katherine Hayles, "Simulating Narratives: What Virtual Creatures Can Teach Us," *Critical Inquiry* 26, no. 1 (Autumn 1999): 1–26.

5. See chapter 15 below.

6. The great North American blackout of August 15, 2003, might be most aptly described not as a mechanical power failure but as a breakdown and overreaction of the power grid's "immune system." See Steven Strogatz, "How the Blackout Came to Life," *New York Times*, August 25, 2003, A21.

ical remains of the original organic tissues survive in a fossil, only the image or impression, a purely formal trace in which every atom and molecule of the original has been turned to stone. While this may seem like a narrative that depends for its plausibility on contemporary biocybernetics, it is, I will argue, a tale whose foundations were laid in the Romantic period.

"The life of things" in Romantic literature is sometimes mischaracterized as a matter for unmixed celebration, as when Wordsworth praises "that blessed mood" in which "an eye made quiet by the deep power of harmony and joy" sees "into the life of things."[7] But closer readings of this celebrated passage note that something very like the death of the physical body is entailed in this perception:

the breath of this corporeal frame
And even the motion of our human blood
Almost suspended, we are laid asleep
In body, and become a living soul.

When Blake raises the question, "what is the material world, and is it dead?" his answer comes from a Fairy who promises (when tipsy) to show him "all alive / The world, where every particle of dust breathes forth its joy."[8] Yet the life of matter the fairy goes on to describe is a storm of "snaky thunder," pestilence, and howling terrors animating the "devoured and devouring" elements, while human history, the "1800 years" of *Europe*, passes as a dream in the mind of a ravished Nameless Shadowy Female. Romantic animism and vitalism are not unmixed affirmations but complex, ambivalent weavings of fairy lore and irony, mystical trances and anxiety, joy and sorrow. The stony, petrified sleep of Urizen may be preferable to— equivalent to!—the pain and terror of living forms. What consolation is it to know that Wordsworth's dead Lucy is "rolled round in earth's diurnal course with rocks and stones and trees"? Or that his complacent assurance of her vitality was expressible only in terms of a "slumber" that "sealed" the poet's spirit like a gravestone, and made him perceive her as "a thing that could not feel / The touch of earthly years"?[9]

7. William Wordsworth, "Lines Composed a Few Miles above Tintern Abbey," in *Selected Poems and Prefaces*, ed. Jack Stillinger (Boston: Houghton Mifflin, 1965), ll. 47–49, 43–46, p. 109.

8. William Blake, *Europe: A Prophecy* (1794), plate iii, in *The Poetry and Prose of William Blake*, ed. David Erdman (Garden City, N.Y.: Doubleday, 1965), 59.

9. William Wordsworth, "A Slumber Did My Spirit Seal," in *Selected Poems and Prefaces*, ll. 7–8, 3–4, p. 115.

What is this new, heightened perception of "thingness"—of materiality, physicality, objecthood—really all about? Foucault suggests an answer in *The Order of Things*. If "things" are taking on a new life in the Romantic period, if biology is replacing physics as the frontier of science, if new forms of archaic and modern animism and vitalism seem to be springing up on every side, it is because history itself is abandoning "man" and moving into the nonhuman world, the world of physical things. We usually suppose exactly the opposite to be the case. As Foucault puts it,

We are usually inclined to believe that the nineteenth century, largely for political and social reasons, paid closer attention to human history. . . . According to this point of view, the study of economies, the history of literatures and grammars, and even the evolution of living beings are merely the effects of the diffusion . . . of a historicity first revealed in man. In reality, it was the opposite that happened. Things first of all received a historicity proper to them, which freed them from the continuous space that imposed the same chronology upon them as upon men. So that man found himself dispossessed of what constituted the most manifest contents of his history. . . . The human being no longer has any history.[10]

The age of the greatest historical upheavals, of massive political, social, and cultural revolutions, of the invention of "history" itself, is also, as Hegel insisted, the age of "the end of history," a Romantic slogan that has been echoed in our own time in reflections on the end of the Cold War.[11]

Once again biology is at the frontier of science, new nonhuman lifeforms are everywhere, and a new history of physical objects seems to be rearing its head. Cloned sheep, self-reproducing robots, and the frozen DNA of a Siberian mammoth are front-page news, and images of extinct monsters revived from the dead dominate the world of cinematic spectacle. How can the "life of things" in the Romantic period help to illuminate these images?

Beaver and Mammoth

Consider two physical things—two animals, in fact—that arrive in Europe in the 1790s. One is a mammoth, reconstructed in Paris by Georges Cuvier

10. Michel Foucault, *The Order of Things: An Archaeology of Human Knowledge* (New York: Vintage Books, 1973), 368.

11. Cf. Francis Fukuyama, *The End of History and the Last Man* (New York: Free Press, 1992).

in 1795 to demonstrate his new theory of fossils, which transforms them from freaks of nature or mere curiosities into traces of extinct life, and evidence for a series of catastrophic revolutions in the history of the earth.[12] The other is a beaver, and it arrives in London in 1790 tattooed on the chest of an Englishman named John Long, who worked as a fur trader among five nations of Canadian Indians. Long had been initiated as a Chippewa warrior while working as what we would now call a military advisor to Indian tribes who were fighting as allies of the British against the American colonies. The scant biographical studies of Long invariably raise the question of whether he scalped or killed American civilians or soldiers while participating in raids.[13] But Long himself is silent about his participation in violence. He is at his most eloquent in describing the exquisite torture of the three-day initiation ceremony.

He undergoes the following operation. Being extended on his back, the chief draws the figure he intends to make with a pointed stick, dipped in water in which gunpowder has been dissolved; after which, with ten needles dipped vermilion, and fixed in a small wooden frame, he pricks the delineated parts, and where the bolder outlines occur he incises the flesh with a gun flint. The vacant spaces, or those not marked with vermillion, are rubbed in with gunpowder, which produces the variety of red and blue; the wounds are then seared with punk-wood to keep them from festering.[14]

Long's name for the animal inscribed on his body is *totem*, a word from the Ojibwa language usually translated as "he is a relative of mine" and associated with ideas of animal, vegetable, and sometimes mineral "tutelary spirits," and thus with destiny, identity, and community.

The mammoth on display in Paris and the beaver on John Long's chest are "forms of animal visibility," to borrow Foucault's expression. They are

12. See Martin J. S. Rudwick, *Georges Cuvier, Fossil Bones, and Geological Catastrophe* (Chicago: University of Chicago Press, 1997).

13. A copy of Long's memoir in the John Carter Brown Library, Providence, R.I., contains handwritten notes by George Coleman, Sr., complaining that "this book had better never been published for it adds fresh disgrace to the English nation, and hurts our character, as it shews that we neither act like Christians or men of common honesty in Canada" (*A Catalogue of Books Relating to North and South America in the Library of John Carter Brown* [Providence, 1871], vol. 2, pt. 2).

14. *John Long's Voyages and Travels in the Years 1768–1788*, ed. Milo Milton Quaife (Chicago: Lakeside Press, 1922), 64.

real objects in the world, but they are also images and verbal expressions. Long's "totem" is a new word in the English language that quickly circulates in French and German translations of Long's memoir.[15] Of course the longer range fortunes of this word are legendary. By the midnineteenth century it had become a staple of early anthropology and comparative religion. It travels to Australia and the South Pacific, where "totemism" is discovered in its purest form in aboriginal societies. In the work of Durkheim and Freud it becomes a key to explaining not just primitive religions but the foundations of sociology and psychology; it is the object of obsessively thorough critique by Lévi-Strauss, and enters popular consciousness in its linkage with the so-called totem poles of the Pacific Northwest Coast Indians. In common usage it is often confused with fetishism and idolatry, or equated with animism and nature worship.[16]

If Long brings a new object into the world with a new word from the New World, Cuvier takes an old word-image-idea complex, the fossil, and gives it a revolutionary new meaning. Foucault could not be more emphatic: "One day, towards the end of the eighteenth century, Cuvier was to topple the glass jars of the Museum, smash them open and dissect all the forms of animal visibility that the Classical age had preserved in them."[17] In this epistemic revolution, natural history becomes truly historical for the first time, opening up what Wordsworth would call an "abyss of time" un-

15. While no sales figures for Long's memoir are traceable, it seems to have achieved fairly wide circulation. Joseph Banks, the president of the Royal Society, headed the list of subscribers. It was favorably reviewed in the *Monthly Review* (June 1792): 129–137, and was translated into French (1794, 1810) and German (1791, 1792). See Quaife, "Historical Introduction," *John Long's Voyages and Travels,* xvii–xviii. The fortunes of this word and concept between the 1790s and the 1850s remain a missing chapter in intellectual history that would be fascinating to explore. It would involve, among other things, finding out how this North American Indian word is merged with the Polynesian vocabulary of *mana* and *tapu* by Andrew McLennan and E. B. Tylor to become a fixture of comparative religion and ethnography in the second half of the nineteenth century. I'm grateful here for the help of Raymond Fogelson of the Anthropology Department, University of Chicago, for sharing with me his unpublished manuscript on Long's memoir.

16. See Émile Durkheim, *The Elementary Forms of Religious Life* [1912], trans. Karen Fields (New York: Free Press, 1995); Freud, *Totem and Taboo,* in *The Standard Edition of the Complete Psychological Works of Sigmund Freud,* trans. James Strachey, 24 vols. (London: Hogarth Press, 1953–74), 13:1–162; and Claude Lévi-Strauss, *Totemism,* trans. Rodney Needham (Boston: Beacon Press, 1963).

17. Foucault, *The Order of Things,* 137–38.

imaginably greater than human history. We could debate endlessly whether Cuvier's theory of the fossil as a trace of a life-form wiped out by geological revolutions was an echo of the French Revolution, or whether the understanding of that revolution is itself a product of the new sense of natural history.[18] In any event, the new meaning of fossils quickly becomes a metaphor for human as well as natural history, and specifically for the human relics left behind by the French Revolution. British novelist Edward Bulwer-Lytton finds "fossilized remains of the old regime" in certain districts of Paris, and describes an aging English baronet as "a fossil witness of the wonders of England, before the deluge of French manners swept away ancient customs."[19] In short, "fossilism" is a way of revolutionizing natural history and naturalizing revolutionary human history. Under the spell of this metaphor, political revolution comes to be seen less as a matter of human agency and control than as a product of inhuman, impersonal forces, the life of physical things going out of control in catastrophic upheavals.

Forms of Animal Visibility

The simultaneity of two events is no less a historical fact than their succession.

FOUCAULT[20]

What is the relation between the appearance of the fossil and the totem? Foucault makes the fossil the centerpiece of his history of epistemic transformations in *The Order of Things*. The fossil is the principal example of this new "historicity of things" that is independent of human affairs and

18. Exposing the futility of this debate is, I take it, one of Foucault's key contributions to historical study. My aim here is to describe, not explain, the transformation that made the fossil central to a new system of cognitive and intellectual relations. For more on this non-causal theory of historical change, see Arnold Davidson's "Structures and Strategies of Discourse: Remarks Towards a History of Foucault's Philosophy of Language," introduction to Davidson, ed., *Foucault and His Interlocutors* (Chicago: University of Chicago Press, 1997), 1–17; and Paul Veyne's crucial essay in that volume, "Foucault Revolutionizes History," 146–82.

19. Edward Bulwer-Lytton, *Pelham; Or, the Adventures of a Gentleman* (London, 1828), 186, 273.

20. Michel Foucault, "Sur les façons d'écrire l'histoire," in *Dits et écrits*, 1:586–87; quoted in *Foucault and His Interlocutors*, ed. Arnold Davidson (Chicago: University of Chicago Press, 1997), 10.

human history. But he is silent on the other new natural object, the totem. This is surely because totemism arrives unobtrusively, in the memoirs of an obscure Englishman whose name survives only as a footnote in the writings of anthropologists. Cuvier's notion of the fossil, by contrast, was a revolutionary breakthrough, and an international sensation in learned circles.

Nevertheless, there is something uncannily fitting about the emergence of these two concepts in the 1790s, something that resonates between them both in their internal logics and in their subsequent careers in intellectual history. Fossils and totems are both "forms of animal visibility," images of natural objects, residing on the border between artifice and nature. The fossil is the "natural sign" par excellence, an imprint in stone sculpted by petrifaction. Seeing the fossil as a picture or symbol of any kind, however, requires human eyes to pick out the image/organism in the stony matrix. Even a devout antievolutionist like Hegel had to account for fossils as readable images. His strategy was to deny that fossils *ever*

actually lived and then died; on the contrary, they are still-born. . . . It is organo-plastic Nature which generates the organic . . . as a dead shape, crystallized through and through, like the artist who represents human forms in stone or on flat canvas. He does not kill people, dry them out and pour stony material into them, or press them into stone . . .; what he does is to produce in accordance with his idea and by means of tools, forms which represent life but are not themselves living: Nature, however, does this directly, without needing such mediation.[21]

The totem also occupies the nature/culture frontier: it is traditionally a handmade image, in wood, stone, or skin, of an animal; less often it is a vegetable or mineral object. The animal itself is also the totem (though Durkheim will insist that the image is always more sacred than what it represents).[22] Natural organisms are not just entities in themselves but a system of natural signs, living images, a natural language of *zoographia,* or "animal writing" that, from ancient bestiaries to DNA and the new Book of Life,

21. *Hegel's Philosophy of Nature* (pt. 2 of *Encyclopedia of the Philosophical Sciences,* 1830), ed. A. V. Miller (Oxford: Clarendon Press, 1970), 293. I'm grateful to Robert Pippin for helping me find my way through Hegel and natural history.

22. "We arrive at the remarkable result that *the images of the totemic being are more sacred than the totemic being itself*" (Durkheim, *Elementary Forms of Religious Life,* 133; Durkheim's emphasis). This is surely because the image of the totem animal, like that of the fossilized specimen, is the site where the species-being of the individual is "crystallized," as it were, and rendered as a kind of concrete universal.

continually reintroduces religion—and animation—into things and their images.[23]

The central physical objects of paleontology and anthropology, the twin sciences of ancient life, are conceived in the same decade: modern (as distinct from traditional, Kantian) anthropology, understood as the science of the savage, of the primitive ancestor living in a "state of nature"; paleontology, the science of successive "states of nature" that existed long before the emergence of human life, long before the forms of natural life that we see around us. By the end of the nineteenth century, fossils and totems will serve as the principal display objects of museums of natural history, especially in North America. The relics of ancient life and of so-called primitive life will anchor the biological and cultural wings of these institutions.

Fossil and totem are windows into deep time and dream time respectively, into the childhood of the human race and the earliest stages of the planet on which this race lives. Fossilism is modernized natural history, based in comparative anatomy, systematic notions of species identity, and a mechanistic model of animal physiology.[24] Totemism is *primitive* natural history, what anthropologists now call ethnozoology and ethnobotany, a combination of magical lore and empirical folk wisdom.[25] The fossil is the trace of a vanished life-form and a lost world; the totem is the image of a vanishing, endangered life, the trace of a world disappearing before the advance of exactly that modern civilization that has invented the concept of fossils as a trace of extinct life. If fossils are the evidence for a "first nature" totally alien to human culture, totems are evidence for what we might call a "first second nature," a state of culture that is much closer to nature than

23. The DNA revolution has not, as one might suppose, utterly secularized the concept of the living organism. Robert Pollack, a collaborator of James Watson's, finds the image of the holy city with the sacred text at its center the ideal metaphor for the cell: "A cell is not just a chemical soup but a molecular city with a center from which critical information flows, a molecular version of King David's Jerusalem. That walled city . . . had a great temple at the center and a book at the very center of the temple" (Robert Pollack, *Signs of Life: The Language and Meanings of DNA* [Boston: Houghton Mifflin, 1994], 18).

24. See Rudwick, *Georges Cuvier, Fossil Bones, and Geological Catastrophe*, on Cuvier's insistence on a mechanical model for anatomy: "He put his science firmly on the map, by explaining his conception of organisms . . . as functionally integrated 'animal machines'" (15).

25. See Scott Atran, *The Cognitive Foundations of Natural History* (Cambridge: Cambridge University Press, 1992), and my discussion in W. J. T. Mitchell, *The Last Dinosaur Book: The Life and Times of a Cultural Icon* (Chicago: University of Chicago Press, 1998), for an account of folk taxonomy and ethnobiology.

our modern world. Both fossils and totems are images of nature expressing a relationship between human beings and the nonhuman physical world of "animal, vegetable, and mineral" objects. There are no human fossils, according to Cuvier, and totems are almost never human images, but are invariably drawn from the natural world, a feature that distinguishes them from the tendency to anthropomorphism in idols and fetishes.

Totems as Fossils, and Vice Versa

In a very real (if metaphoric) sense, then, totems are fossils, and fossils have the potential to become totems. The first possibility is illustrated by Freud when he opens *Totem and Taboo* by noting that, while "taboos still exist among us," and "do not differ in their psychological nature from Kant's 'categorical imperative,' which operates in a compulsive fashion and rejects any conscious motives . . . totemism, on the contrary, is something alien to our contemporary feelings—a religio-social institution which has been long abandoned as an actuality and replaced by newer forms. It has left only the slightest traces behind it in the religions, manners, and customs of the civilized peoples of to-day."[26] Freud goes on to note the parallel between natural and cultural history that obtains in the one place on earth where totemism seems to survive: "the tribes which have been described by anthropologists as the most backward and miserable of savages, the aborigines of Australia, the youngest continent, in whose fauna, too, we can still observe much that is archaic and that has perished elsewhere" (1). Australia is the land of living fossils, where both totemism and "archaic" life-forms survive together. E. B. Tylor, the founding father of modern anthropology, laid the groundwork for theories of "social evolution" in his "doctrine of survivals," the preservation of what *The Dictionary of Anthropology* calls "obsolete or archaic aspects of culture" as "living cultural fossils."[27]

Fossils become totemic, on the other hand, when they escape (as they inevitably do) from the grip of scientific classification and become objects of public display and popular mythology. I have traced some of this process in *The Last Dinosaur Book*, exploring the transformation of the American

26. Sigmund Freud, *Totem and Taboo* [1913], trans. James Strachey (New York: W. W. Norton, 1950), x.

27. Thomas Barfield, "Edward Burnett Tylor," in *The Dictionary of Anthropology*, ed. Barfield (Oxford: Blackwell, 1997), 478.

mammoth or mastodon into a national icon during the Jeffersonian period, and the emergence of the dinosaur as a totem figure of the British Empire in the midnineteenth century and of American modernity in the twentieth.[28] The fossil, with its connotations of catastrophic extinction, obsolescence, and technical modernity, is the characteristic "bad object" of modern imperialism.[29]

Given the numerous parallels and analogies between totems and fossils, one might ask why they have never been brought into a metaphorical, much less historical relationship. This is principally a result of the disciplinary divisions between biology and anthropology, between the "natural" wing of the natural history museum and its "cultural" wing. Fossils and totems cannot be compared with one another within these disciplinary frameworks; they are discursively incommensurate. The one is the trace of an extinct animal, an image reconstructed by the methods of modern science. The other is the image of a living animal, as constructed within a premodern set of religious or magical rituals. To compare fossils and totems is to undermine the difference between science and superstition, to violate a taboo against mixing distinct kinds of objects and genres of discourse.

Nevertheless the very proximity of fossil and totem images in public displays, especially in the natural history museums of North America in New York, Washington, D.C., Pittsburgh, Chicago, and Toronto, makes the metonymic if not metaphoric relations of these images unavoidable. Perhaps most dramatic is the central hall of the Field Museum in Chicago, in which the most prominent objects of display are the Kwakiutl totem poles from the Pacific Northwest and the T. Rex named Sue.[30] Fossils and totems coexist and greet each other in the natural history museums of North America, even if they have not yet acknowledged their kinship. The Romantic and the North American genealogies of these institutions made it all the

28. Clearly, fossil bones were already filled with totemic potential for premodern and ancient cultures. Jefferson gathered Delaware Indian legends about the mastodon, and later ethnographers noted Sioux legends of subterranean monsters that were probably based on large fossil bones. Adrienne Mayor's recent book, *First Fossil Hunters* (Princeton, NJ: Princeton University Press, 2000), points out that Greek and Roman images of the griffin as well as legendary wars of primeval giants and monsters were very likely based on the large fossil bones to be found in Turkey and Asia Minor.

29. See discussion in chapter 7.

30. Before Sue became the main attraction in the Field Museum's great hall, "she" was preceded by an impressively tall brachiosaurus, which now scrapes the ceiling of the United Airlines terminal at O'Hare Airport.

more appropriate to stage their first encounter at a meeting of the North American Society for the Study of Romanticism.

The Romantic Image and the Dialectical Object

What does all this add up to for the study of Romanticism and its legacy? In one sense, of course, I am simply revisiting very old and familiar territory in Romantic studies, the regions that intellectual historian Arthur Lovejoy long ago designated by the names of "organicism" and "primitivism."[31] Both fossils and totems are concrete instances, physical, minute particulars that instantiate these very broad conceptions. Each is both "organic" and "primitive" in its way, providing a glimpse into the deep past and the deep present of physical things from the different angles of nature and culture. So you might well ask, what is gained by focusing so minutely on these exemplary objects?

One hopes, of course, that concreteness and specificity will be sources of added value in themselves. Marx's key contribution to the history of ideas, in my view, was his insistence on tracing what he called the "concreteness of concepts" to their origins in practical, historical circumstances (a matter I discuss at some length in *Iconology*).[32] But he did not perform this maneuver with the notion of fixing a metaphysical origin in material things, but rather to trace the dialectics of the object, its shifting placement and significance in human history. The theory of the commodity fetish proceeds by refusing to reduce either the commodity or its anthropological analogue, the fetish, with an iconoclastic critique that denies or destroys the "life of things." Like Nietzsche, Marx refuses the strategy of straightforwardly smashing the idols of the mind, the tribe, or the marketplace. Instead, he "sounds" the idols with the tuning fork of his own critical language, makes them speak and resonate to divulge their hollowness, as when he invites the commodity to talk about its own life.[33]

31. See Arthur Lovejoy's classic essay, "On the Discrimination of Romanticisms," in *PMLA* 39, no. 2 (1924): 229–53.

32. See W. J. T. Mitchell, *Iconology: Image, Text, Ideology* (Chicago: University of Chicago Press, 1986), chap. 6.

33. Friedrich Nietzsche, *The Twilight of the Idols* (1888; London: Penguin Books, 1990): "and as regards the sounding-out of idols, this time they are not idols of the age but *eternal* idols which are here touched with the hammer as with a tuning fork" (32).

The concreteness of the totem and fossil as physical objects, then, is only half the story. The other half is the abstract, metaphysical, and imaginary character of these objects, their lives not only as real objects but as words circulating in the new discourses of paleontology and anthropology and (beyond that) in new commonplaces and poetic tropes. But to call them tropes is already to associate them with that strange attractor, the image, that has always bedeviled Romantic poetics. Romanticism has circulated obsessively around the notion of the image, understood as both the origin and destination of literary expression, from Coleridge's "living educts of poetic imagination" to Blake's graphic images, whose bosoms we are encouraged to enter as "friends and companions."

In his classic essay, "The Intentional Structure of the Romantic Image," Paul de Man begins with the thoroughly uncontroversial claim that imagery and imagination (along with metaphor and figuration) take on an unprecedented centrality in Romantic poetics, and that this is coupled with a new concentration on nature: "An abundant imagery coinciding with an equally abundant quantity of natural objects, the theme of imagination linked loosely to the theme of nature, such is the fundamental ambiguity that characterizes the poetics of romanticism."[34] But why is this an ambiguity? Why does it constitute, in de Man's words, a "tension between two polarities" rather than a natural fit between two domains, the mind and the world, the image and the natural object? De Man's answer is that language itself is what makes the "natural image" impossible for poetry, or even for imagination, and condemns Romantic poetry to expressions of "nostalgia for the object." "Critics who speak of a 'happy relationship' between matter and consciousness," he argues, "fail to realize that the very fact that the relationship has to be established within the medium of language indicates that it does not exist in actuality" (8).

The problem I have always had with this explanation is that language is given too much blame and too much credit for the unhappy consciousness of Romanticism. If language as such were the culprit, then the strange ambivalence de Man describes would be the condition of all poetry and not distinctive to the late eighteenth and early nineteenth centuries in Europe and England. "The word," de Man insists, "is always a free presence to the mind, the means by which the permanence of natural entities can be put

34. Paul de Man, *The Rhetoric of Romanticism* (New York: Columbia University Press, 1984), 2.

into question and thus negated, time and again, in the endlessly widening spiral of the dialectic" (6).

But suppose natural, physical objects were already caught up in the dialectic before being put into question by "the word"? Suppose the image was not, as de Man seems to think, merely an emphatic expression of language's desire to draw closer to the natural object but a visible and material entity, a representation in a physical medium like stone or human flesh? Suppose further that these sorts of representations were appearing for the first time in Europe in concrete, public manifestations that resonate deeply with the great historical events of the time? Cuvier's fossil mastodon and Long's beaver totem are, of course, new words, or new meanings for old words. But they are also physical manifestations, a reconstructed assembly of petrified bone fragments and a figure carved and burned on the chest of a veteran of the Indian wars. Language is important, but it is not everything. And poetic language is the place where the world beyond language comes home to roost, at least temporarily.

I propose, then, a revision of de Man's theory of the Romantic image, one that preserves its dialectical character and its combination of irony and sentimentality toward the concrete things of the natural world. The Romantic image becomes a composite of two concrete concepts, the fossil and the totem. Totemism is the figure of the longing for an intimate relationship with nature, and the greeting of natural objects as "friends and companions"—the entire panoply of tutelary spirits from Wordsworth's daffodils to Coleridge's Albatross to Shelley's West Wind. It is also, as these examples should remind us, the figure of the kind of guilt, loss, and tragic transgression that only becomes imaginable when natural objects enter into a family romance with human consciousness. The totem animal must not be killed; the Nightingale was not born for death, and so of course the Albatross is killed, and everything that lives must die, even the Nightingale.

This is the point where the figure of the fossil enters the picture, bringing with it the specter not just of individual death but of species extinction. If totemism adumbrates the Romantic longing for a reunification with nature, akin to Hegel's notion of the "flower and brute religions" that lie at the origins of spirit's encounter with nature,[35] fossilism expresses the ironic

35. See Georg Hegel, *The Phenomenology of Spirit*, trans. A. V. Miller (Oxford: Oxford University Press, 1977), section 7, "Religion," pt. A, "Natural Religion," the discussion of "Plant and Animal," pars. 689–90.

and catastrophic consciousness of modernity and revolution. As a petrified imprint, both icon and index, of a lost form of life, the fossil is already an image, and a "natural image," in the most literal sense we can give these words. As a verbal figure, moreover, the fossil is an image of the very process that de Man associates with "the medium of language." Emerson is perhaps the first to say this explicitly when he declares that

[l]anguage is fossil poetry. As the limestone of the continent consists of infinite masses of the shells of animalcules, so language is made up of images, or tropes, which now, in their secondary use, have long ceased to remind us of their poetic origin. But the poet names the thing because he sees it, or comes one step nearer to it than any other. This expression, or naming, is not art, but a second nature, grown out of the first, as a leaf out of a tree.[36]

If the Romantic desire for an image to secure an intimate communion with nature is itself a form of totemism, the inevitable defeat of this desire is named by the fossil, which turns out to be a name for the dead images that make up language as such. The living origin of language is in metaphor. And the first metaphors, as commentators from Jean-Jacques Rousseau to John Berger have remarked, were animals. As Berger puts it (writing as confidently as if he were Rousseau), "The first subject matter for painting was animal. Probably the first paint was animal blood. Prior to that, it is not unreasonable to suppose that the first metaphor was animal."[37] Totems and fossils are both animal images, one living, organic, and cultural, the other dead, mechanical, and natural.

When Theodor Adorno comes to his critique of "World Spirit and Natural History" in *Negative Dialectics,* his aim is not just to overturn Hegel's thoroughly ahistorical and mythic notion of nature, the "organoplastic" artist of fossil images. He is also, like Walter Benjamin, aiming at the formulation of dialectical and critical images, which would capture "the objectivity of historic life" as a form of "natural history." Marx, Adorno reminds us, "was a Social Darwinist" who recognized that no amount of critique would allow the "natural evolutionary phases" of "modern society's

36. Ralph Waldo Emerson, "The Poet" [1884], in *The Selected Writings of Ralph Waldo Emerson,* ed. Brooks Atkinson (New York: Modern Library, 1950), 329–30.

37. John Berger, "Why Look at Animals?" in *About Looking* (New York: Pantheon, 1980), p. 5. See also my essay, "Looking at Animals Looking," in W. J. T. Mitchell, *Picture Theory* (Chicago: University of Chicago Press, 1994), chap. 10.

economic motion" to be "skipped or decreed out of existence."[38] This dynamic and evolutionary notion of natural history can, of course, become as rigid an ideology in its lockstep sequence of "phases" as the timeless order of "ideological" nature that it opposes. Among the many lessons we might learn from the simultaneous onset of fossilism and totemism in the Romantic era is that when new objects appear in the world, they also bring with them new orders of temporality, new dialectical images that interfere with and complicate one another. Dream time and deep time, modern anthropology and geology together weave a spell of natural imagery in the poetry of the Romantic era, an imagery that continues to haunt critical theory today.

It is perhaps not so surprising that the Romantic image should turn out to be a combination of fossilism and totemism, a dialectical figure of animation and petrification, a ruinous trace of catastrophe, and a "vital sign." After all, Romanticism itself plays something like this double role in our sense of cultural and literary history. Why does the professional formation known as "Romantic Studies" have such a peculiar and persistent life in the academic study of cultural history? Is it not because we take a more than professional interest in this period and its ideologies? Not content with "historicizing" Romanticism, we seem to want it to do more for us, to revive and renovate our own time. Is not Romanticism itself a fossil formation in the history of culture, not only because of its obsession with lost worlds, ruins, archaism, childhood, and idealistic notions of feeling and imagination, but because it is itself a lost world, swept away by the floods of modernity it attempted to criticize? And is not Romanticism therefore itself a totem object, a figure of collective identification for a tribe of cultural historians called Romanticists, and beyond that, for a structure of feeling more generally available to anyone who identifies himself as a "romantic"? The survival of this structure of feeling, and the poetic and critical resources it makes available, is a story that goes beyond my limits here. Suffice it to say that the critique of modernity that runs through Marx, Nietzsche, and Freud to Benjamin and Adorno would be unthinkable with-

38. Theodor Adorno, *Negative Dialectics*, trans. E. B. Ashton (New York: Continuum, 1973), 354–55. For a discussion of Adorno's and Benjamin's deployment of natural history, and especially of figures of petrification and fossilization in their theories of allegory and imagery, see Beatrice Hanssen, *Walter Benjamin's Other History: Of Stones, Animals, Human Beings, and Angels* (Berkeley and Los Angeles: University of California Press, 1998).

out the special form of natural history bequeathed to us by the Romantics, captured in its particularity by the figures of the fossil and the totem. Bruno Latour has assured us that, in reality, "we have never been modern,"[39] and I would only add that this must mean we have always been Romantic. Romanticism may just be a historicizing label for the juncture of mechanism and vitalism, inanimate objects and organic bodies, obdurate matter and spectral imagoes in pictures laden with conflicting desire.

39. Bruno Latour, *We Have Never Been Modern* (Cambridge, MA: Harvard University Press, 1993).

Our survey of Romantic things, offending images, and imperial and founding objects has returned repeatedly to the fundamental categories of "bad objecthood" endemic to Western critiques of religion, anthropology, psychology, aesthetics, and political economy. This seems like the right moment to pause for reflection on the categories of totemism, fetishism, and idolatry, and to attempt a preliminary overview of their conceptual and historical relations.

First, just to reinforce a few key claims: totemism, fetishism, and idolatry are not to be regarded as discrete, essential categories of objects, as if one could provide a description that would allow one to sort images and works of art into three different bins on the basis of their visual, semiotic, or material features. They are rather to be understood as the names of three different *relations* to things, three forms of "object relations,"[1] if you will, that we can form with an infinite variety of concrete entities (including words and concepts) in our experience. It is therefore important to stress that one and the same object (a golden calf, for instance) could function as a totem, fetish, or idol depending on the social practices and narratives that surround it. Thus, when the calf is seen as a miraculous image of God, it is

1. Jean Laplanche and J.-B. Pontalis, in *The Language of Psychoanalysis* (New York: Norton, 1973), remark that the term *object relationship* may be misleading in its implication that the "object" is not really a subject, a human being or living thing that can "*act* upon the subject" (278). From the standpoint of the idol/fetish/totem concept, however, the object may well be an inanimate thing that cannot act upon a subject without the cooperation of the subject's fantasies about the object. The strategy here, then, is to reliteralize the concept of "object relations" and to take the misleading implication of "objects" as exactly what needs exploring.

an idol; when it is seen as a self-consciously produced image of the tribe or nation ("society," in Durkheim's terms), it is a totem; when its materiality is stressed, and it is seen as a molten conglomerate of private "part-objects," the earrings and gold jewelry that the Israelites brought out of Egypt, it becomes a collective fetish. The biblical references to the golden calf as a "*molten* calf" reflect this sense that it is a fluid, multistable image, a highly charged duck-rabbit. The object relations into which this image enters, then, are like Wittgenstein's "seeing-as" or "aspect seeing"; the calf is a shape-shifting chimera that changes with the subject's perceptual schematism. Unlike Wittgenstein's multistable images, however, it is not the cognitive or perceptual features of the image that shift (no one claims to see the calf as a camel) but its value, status, power, and vitality. The totem-fetish-idol distinction, then, is not necessarily a *visible* difference, but can only be apprehended through a *sounding* of the image, an inquiry into what it says and does, what rituals and myths circulate around it. Poussin's marvelous rendering of the golden calf (fig. 31) is perhaps best seen as a liberation or transvaluation that links the image to a classical antiquity self-consciously resurrected for the purposes of a modern aesthetic and a modern civilization. It is staged as the center of a community festival that upstages, in its attractive neopaganism, the dark, solitary figure of Moses coming down the mountain to deliver the word of God. From a Durkheimean perspective, the scene is one of totemism *avant le lettre*, or perhaps of modern art at its conception.

Totems, fetishes, and idols need not be works of art, or even visible images. Francis Bacon argued famously that there are four kinds of "idols of the mind" that must be eliminated by science: "Idols of the Tribe" are the collectively shared errors that stem from the natural limits of the human sensorium; "Idols of the Cave" are those of individuals, the result of their own natural limitations and experiences; "Idols of the Marketplace" are those of language, the medium of "discourse" and "the intercourse and association of men with each other"; and "Idols of the Theater" are what we would now call "world pictures," the "received systems" of philosophy, like "so many stage plays, representing worlds of their own creation after an unreal and scenic fashion."[2] Bacon's metaphoric extension of idolatry to con-

2. Francis Bacon, *The New Organon* [1620], ed. Fulton H. Anderson (Indianapolis: Bobbs Merrill, 1960), 48–49. See Moshe Halbertal and Avishai Margalit, *Idolatry* (Cambridge, MA: Harvard University Press, 1992), 242–43, for a discussion Bacon's idols of the mind.

ceptual, perceptual, and verbal images is a foundational trope for subsequent attempts to stage criticism itself as an iconoclastic practice. The "eternal idols" that are sounded in Nietzsche's *Twilight of the Idols*, and Marx's even more outrageous double indictment of capitalism and the Judeo-Christian tradition ("Money is the Jealous God of Israel before whom no other god may exist")[3] both extend the concept of idolatry well beyond its application to religious images. Idols are no longer necessarily visible or graven or sculpted images but words, ideas, opinions, concepts, and clichés.

If we follow Bacon's logic, then, we must ask whether there are also fetishes and totems of the mind, mental "objects" coupled with imagoes that endow them with special value, power, and "lives of their own." Marx and Freud clearly led the way with the extension of fetishism to commodities and obsessive symptoms. It has been suggested that DNA is the fetish concept of our moment, and the concept has a remarkable currency in aesthetics and ordinary language. Terrorism, both the spectacle and the word, seems to have emerged as the idol of our time, demanding the "ultimate sacrifice" both from the terrorists and from those who mobilize the world to stamp it out.

Are there, then, "totems of the mind," self-consciously articulated "collective representations" (to use Durkheim's phrase) of ideas, communities, and objects? My sense is that there are, and that they are not so different from Bacon's idols, which are all (except for idols of the cave) collectively produced. The tribe, the market, and the theater are exactly the sites of the totemic image, the representation that unites a social species with a sense of its natural identity (tribe), its exchanges and "intercourse" (market), and its theatrical "world pictures." (The cave is, perhaps, the proper location for fetishism.) The difference between Bacon's idols and totemism is not in the images as such but in the critical strategy they invite. Bacon believes that science, a method that works exclusively by experiment, renouncing speculation and reining in all flights of the imagination, is the true iconoclastic technique that will sweep all the idols away. He believes that this is not just his private discovery but a production of time itself, which has graced him with the benefit of being born in a modern, enlightened world that will eliminate idols once and for all.[4] Aristotle, Plato, and

3. Karl Marx, "The Jewish Question," in *Writings of the Young Marx on Philosophy and Society*, ed. Loyd Easton and Kurt Guddat (Garden City, NY: Doubleday, 1967), 245.

4. "I myself esteem [this insight] as the result of some happy accident, rather than of any excellence of faculty in me—a birth of Time rather than a birth of Wit" (Bacon, *New Organon*, 75).

"the wastes and deserts" of "the Arabians" and "the Schoolmen" are to be left behind (75). All the idols "must be renounced and put away with a solemn and fixed determination, and the understanding thoroughly freed and cleansed: the entrance into the kingdom of man, founded on the sciences, being not much other than the entrance into the kingdom of heaven, whereinto none may enter except as a little child" (66).

As this last sentence indicates, however, Bacon's own language, his own education as a Christian gentleman, and his own world picture have led him back into the very realm of mental idolatry that he wants to renounce. Science, even modernity itself, not just a fetish concept like DNA, is clearly capable of becoming an "idol of the mind," just as potent as the archaic and medieval superstitions Bacon decries. A *historical* science, in fact, would reverse his view of Plato and Aristotle (not to mention "the Arabians" and "the Schoolmen") and renounce the fantasies of mental cleansing, second childhoods, and kingdoms of heaven to come. It would urge a continuous preservation and reinterpretation of ancient wisdom and a respect for sources of knowledge outside the "nations of Western Europe" (75), whom Bacon sees as uniquely capable of renouncing idolatry.[5] Totemism offers a different strategy with idols, a certain tactical hesitation in the impulse to critical iconoclasm, a curatorial and hermeneutic reflex,[6] a sounding rather than a smashing of the offending image.

It is important to stress as well that the insight offered here is on the order of a triangulation of concepts that have formerly been thought of mainly in dualistic, binary terms. Fetishes have often been both contrasted with and equated with idols;[7] totems are often confused with fetishes. The importance of triangulating the terms is not to provide absolute positionality but a sense of their relations—*objective* object relations, as it were. One might compare this to the rough triangulating of shirt sizes as "small, medium, and large," which are clearly relative to some norm of the human body. Intuition tells us immediately that fetishes are small, totems are medium, and idols are large, in a number of senses yet to be specified. When

5. It is probably worth mentioning that Bacon's "Western Europe" means primarily the northern Protestant countries, and especially England, as the places that are capable of renouncing idolatry in favor of science. Bacon has little patience with the Roman Catholic defense of images. See *The Advancement of Learning* [1605], ed. G. W. Kitchin (London: J. M. Dent & Sons, 1973), 120, on the "Roman church" and devotional images.

6. See "secular divination" in chapter 1 above.

7. Halbertal and Margalit, for instance, regularly treat the moment when the *materiality* of the idol (as stone or wood) is emphasized as a transition into fetishism. See *Idolatry,* 39.

painter Claude Lorrain represents the golden calf as a tiny figure atop a classical pillar, the contrast with Poussin's massive sculpture on its marble base is impossible to overlook. The shock of diminution is reminiscent of the moment when one sees the actual model of the great ape, King Kong, that was employed in the movie bearing his name. The giant ape, we are told, "was a god in his own country," but is reduced to a mere theatrical spectacle in New York City, his diminutive stature cinematically exposed when he finds himself trapped on top of the Empire State Building. Queen Victoria, a tiny woman in physical reality, was inflated into a grandiose figure by the words and images of British propaganda during her reign. The implicit "size" standard, then, is clearly not just physical or visible but metaphoric and metonymic. It may measure the relative social importance of the objects: hence Andrew McLennan's definition of fetishism as totemism *minus* exogamy and matrilineal descent, or the commonplace notion that idols are, insofar as they represent deities that demand great sacrifices, the *most* important and dangerous objects that human beings can create. Among the many stunning features of the *Planet of the Apes* cycle is the elevation of the atomic bomb into an idol by the ape civilization. In Billy Wilder's *Sunset Boulevard*, the washed-up director, Max von Meyerling (played by Erich von Stroheim) proudly informs the young screenwriter, Joe Gillis, that Norma Desmond was the greatest of the screen idols, and that one of her disappointed suitors, having received a gift of one of Norma's stockings, later used it to strangle himself. The suggestion is that Norma's idolatrous cult is so powerful that a mere part-object, a fetish such as one of her stockings, becomes the instrument of human sacrifice.

It might also be useful to register some of the resonances between the triad of totem, fetish, and idol and similar triads such as Lacan's Symbolic, Real, and Imaginary, or Peirce's symbol/index/icon. Totemism, as the use of an object to prohibit incest and to regulate marriage, social identities, and proper names, seems closely tied to the Symbolic, in both Lacan's and Peirce's sense, as a figure of the Law (Peirce called the symbol the "legisign," a sign constituted by *rule*, and Lacan associates it with prohibitions and the law). Fetishism, by contrast, seems deeply linked with trauma, and therefore with the Real, and with what Peirce called the "index," the sign by cause and effect, the trace or mark. The very name of idolatry (from the Greek *eidolon*, an "image in water or a mirror, mental image, fancy, material image or statue" [*OED*]), finally, suggests a primary identification with what Peirce called the "icon," that is, with *imagery* and the Imaginary, the graven image or likeness that takes on supreme importance as a representation of

a god or a god in itself. None of these associations is hard and fast, however, and one can imagine one person's fetish being treated as an idol by someone else, a totem by yet another. Fetishes can have iconic features, and insofar as there are prohibitions, conventions, and rules surrounding all these objects, all of them play the totemic, symbolic role of social bonding. All these disclaimers will, I hope, prevent anyone from making a fetish object out of my table of distinctions among them (see below).

The totem/fetish/idol triad also has a historical and empirical relation to certain times and places that seems much more stable and secure than these conceptual differentiations. Totemism, as has been noted, is the most recent term—a nineteenth-century concept in anthropology and comparative religion. Fetishism, to remind us once again of William Pietz's classic study, is an early modern concept associated with mercantile colonialism, the Portuguese in Africa.[8] Idolatry is a creation of monotheism and iconoclasm, the ancient religions of the Book.

We find, then, both analytic and narrative, synchronic and diachronic relations among the concepts of totemism, fetishism, and idolatry. One can tell stories about their relations, or one can think them as triangulating a kind of symbolic space in their own right, as if our relations with object-image assemblages—with "pictures," as I have been calling them, or "things," as Bill Brown would insist—had certain limited logical possibilities that are named by these categories of "special" object relations.[9] For that is what totems, fetishes, and idols are: *special* things. They can range, therefore, from what we might call rather ordinary, secular, and modern "special things" like commodities, souvenirs, family photos, and collections, to sacred, magical, uncanny things, symbolic things, associated with ritual and narrative, prophecies and divinations. These objects are also "special" in the sense that they are "specieslike," comprising families of image and ritual practices (everything from mobility and circulation to unique habitats and highly charged practices like human sacrifice, mutilation, and festival)— what theorist Arjun Appadurai calls a "social life of things"—and they are often specular or spectacular—that is, associated with image-making, ornamentation, painting, and sculpture.[10] As such, they are associated with

8. William Pietz, "The Problem of the Fetish," pts. 1–3: *Res* 9 (Spring 1985), 13 (Spring 1987), and 16 (Autumn 1988).

9. See the special issue edited by Bill Brown, "Things," *Critical Inquiry* 28, no. 1 (Fall 2001).

10. See Arjun Appadurai, *The Social Life of Things: Commodities in Cultural Perspective* (New York: Cambridge University Press, 1988).

familiar aesthetic categories—idols (especially those hidden in darkness) are linked through their negation or prohibition to the Kantian sublime;[11] fetishes are characteristically linked with beauty and attractiveness, as opposed to the dangerous, forbidding aspect of the idol. And totems, as we have seen, may have a historical connection with the picturesque, and specifically with the notion of the "found object" that comes to the beholder by chance.

Totems, fetishes, and idols are, finally, things that *want* things, that demand, desire, even require things—food, money, blood, respect. It goes without saying that they have "lives of their own" as animated, vital objects. What do they want from us? Idols make the greatest demands: they characteristically want human sacrifice (or at least, this is the Hollywood fantasy of what they require). Fetishes, as I've suggested, characteristically want to be beheld—to "be held" close by, or even reattached to, the body of the fetishist. Totems want to be your friend and companion. In *The Wizard of Oz*, the ruby slippers are Dorothy's fetish objects; Toto (as his name suggests) is her totem animal—her companion and helper; and the Wizard himself is the (obviously false, hollow) idol, as we learn when the Wizard tells Dorothy and her friends to "Pay no attention to that man behind the curtain."

It is with some trepidation that I offer the following table of distinctions as an aid to thinking about the historical and synchronic relations among totemism, fetishism, and idolatry. The table should be thought of as being "in quotation marks," as a tableau of associations, some of which come from highly vulgar and vernacular sources like Hollywood movies, where certain stereotypes of idolatry and fetishism, especially, have been circulated as popular images. It also seems useful to sketch out the disciplinary locations (psychoanalysis, anthropology, historical materialism, comparative religion, art history) where these concepts have been elaborated. I offer this table, then, as a way of laying my cards on the table. But I fully expect that the cards will be reshuffled, and that new cards will be played that I have not considered. The important thing is the framework provided by the triangulation of these concepts. To my knowledge, no one has tried to

11. "Perhaps there is no sublimer passage in the Jewish law than the command, 'Thou shalt not make to thyself any graven image, nor the likeness of anything which is in heaven or in the earth or under the earth'" (Immanuel Kant, *Critique of Judgment*, trans. J. H. Bernard [New York: Hafner Press, 1951], bk. 2, par. 29, p. 115).

Type of Animated Icon	IDOL	FETISH	TOTEM
Language	Hebrew, Greek, Latin	Portuguese	Ojibway
Period	Ancient, classical	Early modern	Modern
Ritual practice	Worship	Obsession	Festival, Sacrifice
Theology	God of Monotheism	God of Polytheism	Ancestor worship
Spectator	Mass public: politics	Private: sex	Tribal identity
Type of Art	Religious figure	Private adornment	Public monument
Body type	Corporate, collective body	Body part, member	Animal, Plant
Biblical idolatry	Golden Calf as idol	Gold Earrings made into calf	Calf as totem
Place, site, landscape	Egypt, Israel	Africa, Greece	America, Australia
Drive	Scopic	Phallic	Vocative
Sign-type	Icon	Index	Symbol
Register	Imaginary	Real	Symbolic
Ritual Roles	Sacrificer, Priest	Wound	Substitute Victim
Discourse	Theology	Marxism, psychoanalysis	Anthropology
Perversion	Adultery	Sado-masochism	Incest
Economic dimension	Production	Commodity	Consumption
Literary source	Bible	Folklore	Mythology
Philosophical position	Idealism	Materialism	Animism/Vitalism
Ritual Violence	Human sacrifice	Mutilation	Animal, vegetable offering
Relation to individual	God of nation	Private possession	Friend, companion, kin
Epistemological status	Object	Thing	Other

put these three ideas together in historical-conceptual structure, and this is nothing more than an invitation to try it out for yourself.

But where to begin? One could imagine a purely semiotic discussion of fetishism and idolatry in relation to distinctions such as metonymy and indexicality (the fetish), metaphor and iconicity (the idol), symbol and allegory (the totem). Alternatively, one could start from disciplinary orientations with a comparative account of fetishism in Marxism and psychoanalysis, or an examination of idolatry within the history of religion, theology, and philosophy. The principal location of totemism, then, would seem to be anthropology and sociology. And then of course there are the vernacular uses of these words as terms of (usually) abuse and polemic, their metaphoric extension (Francis Bacon's "idols of the mind"), and their elevation at various moments into "critical" concepts in the discourses of art history and criticism, as well as in political and religious rhetoric.

My starting point with these concepts has been rather different. I have wanted to use them to diagnose the ways in which objects and images are fused together to produce those things I have been calling "pictures" in an expanded field. Totems, fetishes, and idols are not just objects, images, or even uncanny "things" that defy our modes of objectivity. They are also condensed world pictures, synecdoches of social totalities ranging from bodies to families to tribes to nations to monotheistic notions of metaphysical universality. But if they are, to use philosopher Nelson Goodman's terms, "ways of worldmaking," they are also ways of *unmaking* the various worlds in which they circulate. They are not simply manifestations of coherent world pictures or cosmologies whose myths and sacred geographies might be securely mapped and narrated, but sites of struggle over stories and territories. They are the situations in which we find ourselves asking: do we get the picture, or does it get us?

Part Three

Media

There is no such thing
as a happy medium.
Anonymous

IF IMAGES ARE LIFE-FORMS, and objects are the bodies they animate, then media are the habitats or ecosystems in which pictures come alive.

It goes without saying that all the images and objects we have discussed so far exist in some medium or other. In fact, the conjunction of image and object, of a virtual appearance or illusion and a material support, is our usual way of specifying what a medium is. An image of Winston Churchill appears somewhere, *in* or *on* something—a coin, a marble bust, a photograph, a painting. But there are good reasons for resisting the temptation to say that the medium is just the object or material thing in which the image makes its appearance. Media are not just materials, but (as Raymond Williams once observed) material *practices* that involve technologies, skills, traditions, and habits.[1] The medium is more than the material and (pace McLuhan) more than the message, more than simply the image plus the support—unless we understand the "support" to be a support *system*—the entire range of practices that make it possible for images to be embodied in the world as pictures—not just the canvas and the paint, in other words, but the stretcher and the studio, the gallery, the museum, the collector, and the dealer-critic system. To quote the preface to this volume: "By 'medium' I mean the whole set of material practices that brings an image together with an object to produce a picture."

So the moment has come to put together images and objects in those peculiar cultural formations we call media. As a glance ahead will suggest, I am less interested in producing a grand systematic theory of all media than in constructing *pictures* of media, ones that will allow the specificity of materials, practices, and institutions to manifest itself; at the same time they will put into question the received idea that a medium has something called "specificity." (The notions of "mixed media" and "specificity," along with the peculiar singularity/plurality of the very concept of "media" would seem to be on a collision course of some kind.) I also want to swerve from the McLuhanesque model of "understanding media" to a posture that emphasizes "addressing media" and being addressed by them. This is, in short, less an attempt to construct a general theory of media than it is to explore something that might be called "medium theory," a middle-level, immanent approach that works mainly by cases. The cases will include both old and new media, artistic and mass media, and manual, mechanical, and

1. Raymond Williams, "From Medium to Social Practice," in *Marxism and Literature* (New York: Oxford University Press, 1977), 158–64.

electronic modes of reproduction: the fortunes of painting, especially abstract painting, at the present time; the place of sculpture in the present system of the arts and in the public sphere; the vocation of photography and the photographer in producing an image of a nation; the mediation of racial stereotypes in cinema, television, and their nineteenth-century predecessor, the blackface minstrel show; and the emergence of new media in the age of high-speed computing and biological science. I conclude, finally, with a meditation on a "natural" medium, the process of visual perception as such (and the field of "visual culture" that it has spawned), to examine its role in making us creatures who create pictures that make demands on us.

You mean my whole fallacy is wrong. MARSHALL MCLUHAN, *in* Annie Hall

I don't know if I mean what I say. And if I knew, I would have to keep it to myself.
 NIKLAS LUHMANN, *"How Can the Mind Participate in Communication?"*[1]

In *Annie Hall,* there is a famous scene in which Woody Allen is stuck on a movie line next to an obnoxious media studies professor from Columbia University who insists on broadcasting his stupid opinions about cinema. When the professor starts to hold forth on Marshall McLuhan's theories of media, Woody can stand it no longer. He steps out of the line and addresses the camera directly, complaining about being trapped next to this boor (fig. 37). The professor then steps toward the camera as well and responds: "Hey, it's a free country. Don't I have a right to my opinions too?" When he goes on to defend his own credentials for explaining McLuhan, Woody has his moment of triumph. He says, "Oh yeah, well I have Marshall McLuhan right here" (fig. 38). McLuhan steps into view and squelches the obnoxious

The phrase "Addressing Media" was the title of a symposium held at the University of Cologne to inaugurate their new program in Media and Cultural Communication in December of 1999. This chapter originated as the keynote address for that symposium, and I am grateful to the organizers, Eckhard Schumacher, Stefan Andriopoulos, and Gabriele Schabacher, for their wonderful hospitality. A brief sketch of this essay appears (in German translation by Gabriele Schabacher) in the conference volume as the preface to "Der Mehrwert von Bildern" [The surplus value of images] in *Die Addresse des Mediums,* ed. Stefan Andriopoulos, Gabriele Schabacher, and Eckhard Schumacher (Cologne: Dumont, 2001), 158–84.
 1. In *The Materialities of Communication,* ed. Hans Ulrich Gumbrecht and Ludwig Pfeiffer (Stanford, CA: Stanford University Press, 1994), 387.

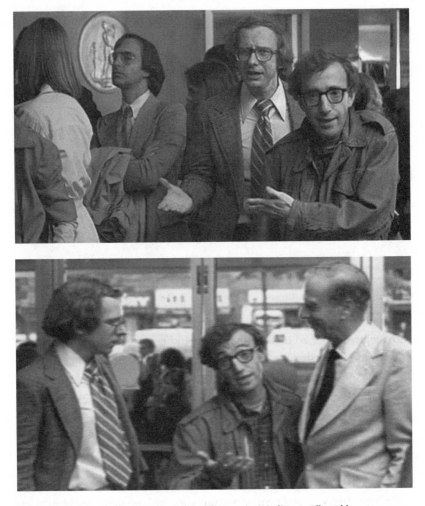

FIGURE 37 Still from *Annie Hall* (dir. Woody Allen, 1977): an indignant Allen addresses audience, gestures at professor.

FIGURE 38 *Annie Hall* still: Woody brings out Marshall McLuhan.

professor with the decisive putdown: "I heard what you were saying. You know nothing about my theories." Woody smiles at the camera and sighs, "If only life were like that."

The only problem with this moment of at least negative clarity and insight in the welter of media theories is that someone (Woody Allen? McLuhan himself?) has inserted a tiny glitch into the intervention of the authority

figure, the media guru, the One Who Is Supposed to Know. Generally over-looked (or unheard) is a quiet little remark nested inside McLuhan's asser-tion of authority over his own theories: "You know nothing about my the-ories. You mean my whole fallacy is wrong."

One wants to play this scene over and over again to be sure one has heard the words correctly. What nonsense! There must be some mistake in the script, or in McLuhan's delivery of his lines. Of course his *fallacy* is wrong. That is what it means to be a fallacy. But why should McLuhan, as he steps forward to declare his authority as the oracle of media theory—a kind of meta-medium in his own right—subvert his authority by calling his theory a fallacy?[2] At the very least it suggests that one had better approach the ques-tion of media somewhat cautiously. If even the inventor of media studies, the great avatar of media theory who became a media star in his own right, is capable of slipping on a figurative banana peel, what lies in wait for the rest of us who think we have a right to our opinions about media? How can we hope, as McLuhan promised, to "understand media," much less become experts about them? Perhaps we need a less ambitious model than under-standing. That is what I propose to explore by "addressing" media: not as if they were logical systems or structures but as if they were environments where images live, or personas and avatars that address us and can be ad-dressed in turn.

The lives and loves of images, it seems clear, cannot be assessed without some reckoning with the media in which they appear. The difference be-tween an image and a picture, for instance, is precisely a question of the medium. An image only appears in some medium or other—in paint, stone, words, or numbers. But what about media? How do they appear, make themselves manifest and understandable? It is tempting to settle on a rigorously materialist answer to this question, and to identify the medium as simply the material support in or on which the image appears. But this answer seems unsatisfactory on the face of it. A medium is more than the materials of which it is composed. It is, as Raymond Williams wisely in-sisted, a material *social practice*, a set of skills, habits, techniques, tools, codes, and conventions.[3] Unfortunately, Williams wanted to push this in-

2. This line does appear in the script as reproduced on the *Annie Hall* Web site, http://www.un-official.com/anniehall.txt (August 29, 2003). What Allen intended by it one can only guess.

3. Raymond Williams, *Marxism and Literature* (New York: Oxford University Press, 1977), 158–64.

sight to the point of jettisoning the whole idea of the medium as an un-
necessary reification. The title of his essay on this subject, "From Medium
to Social Practice," suggests as much. The idea is to release the study of me-
dia from a misplaced emphasis on the material support (as when we call
paint, or stone, or words, or numbers by the name of media) and move it
toward a description of the social practices that constitute it. But perhaps
this gesture of de-reification goes too far. Is every social practice a medium?
This is not the same as asking whether every social practice is mediated. Is
a tea party, a union walkout, an election, a bowling league, a playground
game, a war, or a negotiated settlement a medium? Surely these are all so-
cial practices, but it would seem odd to call them media, no matter how
much they might depend on media of various sorts—on material supports,
representation, representatives, codes, conventions, and even mediators.
The concept of a medium, if it is worth preserving at all, seems (unsurpris-
ingly) to occupy some sort of vague middle ground between materials and
the things people do with them. Williams's compromising phrase, "*mate-
rial* social practice," is clearly an attempt to sketch this middle ground, in
contrast with his title, and the thrust of this argument, which wants to move
us from one side (materials) to the other (social practice).

Perhaps this is the fundamental paradox built into the concept of media
as such. A medium just is a "middle," an in-between or go-between, a space
or pathway or messenger that connects two things—a sender to a receiver,
a writer to a reader, an artist to a beholder, or (in the case of the spiritualist
medium) this world to the next. The problem arises when we try to deter-
mine the boundaries of the medium. Defined narrowly, confined to the
space or figure of mediation, we are returned to the reified picture of mate-
rials, tools, supports, and so forth. Defined more broadly, as a social prac-
tice, the medium of writing clearly includes the writer and the reader, the
medium of painting includes the painter and beholder—and perhaps the
gallery, the collector, and the museum as well. If media are middles, they
are ever-elastic middles that expand to include what look at first like their
outer boundaries. The medium does not lie *between* sender and receiver; it
includes and constitutes them. Are we left with a version of the Derridean
maxim about texts—that is, "there is nothing outside the medium"? What
does it mean to *go to* the movies? When are we inside or outside the
medium? When we are in the theater, or like Woody Allen in *Annie Hall*,
standing on line in the lobby?

The vagueness built into the concept of media is one of the main stum-

bling blocks in the way of a systematic discipline of "media studies," which seems today to occupy a rather peculiar position in the humanities. One of the youngest emergent disciplines in the study of culture and society, it exists in a parasitical relationship to departments of rhetoric and communication and to film studies, cultural studies, literature, and the visual arts. The common rubrics these days are "cinema and media studies," as if the general idea of media were merely a supplement to the centrally located medium of film; or "communication and media studies," as if media were merely instrumental technologies in the master domain of communicating messages. In the field of art history, with its obsessive concern for the materiality and "specificity" of media, the supposedly "dematerialized" realm of virtual and digital media, as well as the whole sphere of mass media, are commonly seen either as beyond the pale or as a threatening invader, gathering at the gates of the aesthetic and artistic citadel.[4] A symptom of art history's ambivalent relation to media is the way it marginalizes architecture as (at best) the third most important medium in its purview, well down the standard hierarchy that places painting at the top, sculpture a distant second, while the oldest, most pervasive medium human beings have devised, the art of constructing spaces, languishes at the bottom. In the study of literature, the medium of language, and the specific technologies of writing, from the invention of the printing press to the typewriter to the computer, are relatively minor issues compared to questions of genre, form, and style, which are generally studied independently of the specific material vehicle through which literary works are transmitted.[5] Cultural studies, meanwhile, is such an amorphous formation that it may well be synonymous

4. The hostile reception to the emphasis on new media art at the 2002 Documenta exhibition in Kassel, Germany, is symptomatic of this continued resistance to moving, virtual, and dematerialized images in the art world. Of course, like everything else in the art world, the new media are contested zones, and there are many who regard them as the frontier of artistic experimentation and research. The other notable "invaders" of the media territory of art history are, of course, the verbal disciplines—literary theory and history, rhetoric, linguistics, and semiotics.

5. This claim might seem counterintuitive, given the importance of structural linguistics in the study of poetry and literary narrative. But these studies (along with their poststructural and deconstructive descendants) tend to focus on tropes and structural elements that are quite independent of the technical media in which a "text" makes its appearance. Thus, Friedrich Kittler's arguments about the importance of the typewriter to the gendering of literature in the late nineteenth century have fallen, so far as I can see, on deaf ears among students of literature.

with media studies, or vice versa, with a bit of emphasis on technologies of communication and archiving.

Thirty years after the death of Marshall McLuhan, the great pioneer of media studies, the field still does not have its own identity. Symptomatic of this is the need to constantly overturn McLuhan, to recite all his mistakes and bemoan his naive predictions of the end of labor, the emergence of a peaceful "global village," and the development of a new planetary consciousness, a kind of wired "world spirit." Contemporary media theory, as if in reaction against McLuhan's optimism, is driven by an obsession with war machines (Friedrich Kittler, Paul Virilio) and traces every technical innovation to the arts of coercion, aggression, destruction, surveillance, and propaganda spectacle.[6] Or it is enveloped in a presentist rhetoric that takes the Internet and the age of digital information as the horizon of its interests (Peter Lunenfeld, Lev Manovich).[7] Or it focuses exclusively on the so-called mass media (television and print journalism) as a uniquely modern invention that can be rigorously distinguished from more traditional media.[8]

Perhaps the most interesting symptom in the current discussion is the recurrent theme of the end of media and the death of media studies, a claim which, if true, would make this one of the shortest-lived concepts in the history of human thought. Just thirty years ago, in the wake of McLuhan's meteoric career and burnout as a has-been media star in his own right, Jean Baudrillard penned a "Requiem for the Media," in which he denounced Hans Magnus Enzenberger's hopeful attempts to sketch out a socialist theory of media in terms of productive forces and a "consciousness industry."[9] "There is no theory of the media," declared Baudrillard, except "empiricism and mysticism"; and the idea that socialism could somehow harness

6. Friedrich Kittler, *Gramaphone, Film, Typewriter,* trans. Geoffrey Winthrop-Young and Michael Wutz (first pub. 1986; Stanford, CA: Stanford University Press, 1999); Paul Virilio, *War and Cinema: The Logistics of Perception,* trans. Patrick Camiller (New York: Verso, 1989).

7. Peter Lunenfeld, *Snap to Grid: A User's Guide to Digital Arts, Media, and Cultures* (Cambridge, MA: MIT Press, 2000); Lev Manovich, *The Language of the New Media* (Cambridge, MA: MIT Press, 2001).

8. See Niklas Luhmann, *The Reality of the Mass Media* (Stanford, CA: Stanford University Press, 2000). By "mass media" Luhmann means "those institutions which make use of copying technologies to disseminate communication" (2).

9. Hans Enzensberger's "Constitutents of a Theory of the Media" appears in Timothy Druckrey's important anthology, *Electronic Culture: Technology and Visual Representation* (New York: Aperture, 1996), 62–85. Jean Baudrillard replied in "Requiem for the Media," in *For a Critique of the Political Economy of the Sign* (St. Louis: Telos Press, 1981), 164.

the productive forces of the intransitive, nonreciprocal structures of mass media was dismissed as a pipe dream harnessed to an illusion. Even Friedrich Kittler, who opens *Gramaphone, Film, Typewriter* by declaring that "[m]edia determine our situation," within a few pages is hinting that the age of media, the era of the great media inventions (cinema, sound recording, the keyboard interface), may now be over. The invention of the computer promises "a total media link on a digital base" that will "erase the very concept of medium. Instead of wiring people and technologies, absolute knowledge will run in an endless loop." All that is left for the present, according to Kittler, is "entertainment" as we wait for the arrival of the endless loop that will not include any human component in its circuits.[10]

What does it mean to "address" media today, at the threshold of the twenty-first century? I want to raise the question this way in contrast with McLuhan's notion of "understanding" media in order to foreground the way media address or "call out" to us, and the ways in which we imagine ourselves talking back to or addressing media.[11] The primal scene of this address might be the moment when we find ourselves shouting at the television set, or putting our hands on the radio and sending in five dollars in response to an evangelical preacher. How are the media addressing us, who is the "us" they are addressing, and what is the "address" of media, in the sense of their location or place in social and mental life? How, in particular, can we address the totality of media—not just mass or technical media, not just television and print media, but obsolete and archaic media, and media in McLuhan's expanded field—money, exchange, housing, clothing, the arts, communication systems, transportation, ideology, fantasy, and political institutions? One avenue is offered by systems theory, which provides models of media as autopoetic system-environment dialectics. Every entity in the world, from the single-celled organism to the multinational corporation to the global economy, turns out to be a system that inhabits an "environment" which is nothing more than the negative of the system—an "unmarked space" that contrasts with "marked space" of the system. Persons and minds are also systems, and they are "isolated monads" that can never communicate with one another.

Systems theory, especially as developed by its principal exponent, Niklas

10. Kittler, *Gramaphone, Film, Typewriter*, 1–2.

11. Marshall McLuhan, *Understanding Media: The Extensions of Man* (first pub. 1964; Cambridge, MA: MIT Press, 1994).

Luhmann, tends to be very abstract and paradoxical.[12] It can be rendered concrete, if no less paradoxical, by picturing its logic with the aid of those ambiguous figure-ground diagrams that are the icons of cognitive science. The system-environment relation turns out to be a nest of Chinese boxes in which systems (such as minds) never communicate with one another, but do manage to observe their own observing (fig. 39). The ultimate result of systems theory seems finally to be a rather dry mystical empiricism (in contrast with the messy, metaphorical, and associative logic of McLuhan's dazzling puns and alliterations). Luhmann's own system is worked out with impeccable and impersonal logic. It finds that systems are something like living organisms, while environments, seen from a high enough level, can begin to look like systems (that is, organisms) in their own right. Media can fit on both sides of the system/environment divide: they are a system for transmitting messages through a material vehicle to a receiver; or they are a space in which forms can thrive, and Luhmann's "form/medium" division recapitulates his foundational move of "drawing a distinction" (between inside and outside, object and space, observer and observed) in a rather graphic way. In vernacular reflections on media, we describe this as the difference between a medium *through which* messages are transmitted, and a medium *in which* forms and images appear. These two fundamental models of media (as transmitter and habitat) may be visualized with Umberto Eco's familiar linear diagram of the sender-receiver circuit (fig. 40) and with my own diagram of Luhmann's system/environment and form/medium distinctions (fig. 39).

If we are stuck with mystical empiricism, I would prefer mine to be as concrete as possible, and so I suggest that instead of using system/environment as the master terms, we think of media in terms of faces and places, figures and spaces. If we are going to "address" media, not just study or reflect on them, we need to transform them into something that can be addressed, that can be hailed, greeted, and challenged. If we are going to "address media" in the other sense, that is, locate them, give them an address, then the challenge is to place them, and to see them as landscapes or spaces. This may all correspond to the distinction between system (organism,

12. See Niklas Luhmann, *The Reality of the Mass Media,* trans. Kathleen Cross (Stanford, CA: Stanford University Press, 2000). Also crucial are "Medium and Form," in *Art as a Social System* (Stanford, CA: Stanford University Press, 2000), and "How Can the Mind Participate in Communication?" [the answer is, it cannot] in *The Materialities of Communication,* ed. Hans-Ulrich Gumbrecht (Stanford, CA: Stanford University Press, 1994).

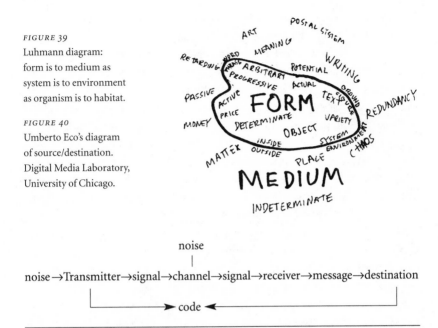

FIGURE 39
Luhmann diagram:
form is to medium as
system is to environment
as organism is to habitat.

FIGURE 40
Umberto Eco's diagram
of source/destination.
Digital Media Laboratory,
University of Chicago.

body, face) and environment (place, space), but it will have the advantage of being more picturesque. The methodological strategy here is what I have called "picturing theory," that is, treating theory as an embodied discourse, one that is constructed around critical metaphors, analogies, models, figures, cases, and scenes. A theory of media that follows this path has to ask not only what media are, what they do; it has to raise the question of what the medium of theory itself might be. We tend to assume, of course, that some form of critical or philosophical language, the metalanguage of systems theory or semiotics, for instance, might lift us out of the welter of media and give us a neutral scientific perspective on the totality of media.[13]

13. Luhmann, for instance, imagines that systems theory can replace traditional "utopian" ethical/political concepts of social theory (e.g., democratization, dialectics, inequality, and struggle) and traditional concepts of media aesthetics (e.g., mimesis, expression, representation) with an Olympian survey of "*the emergence of comparable conditions* in systems as diverse as religion or the monetary economy, science or art, intimate relationships or politics—despite extreme differences between the functions and the operational modes of these systems"(*Art as a Social System*, 2; emphasis Luhmann's). I disagree. See my essay, "Why Comparisons Are Odious," *World Literature Today* 70, no. 2 (Spring 1996): 321–24, for a critique of comparatism in literature and the arts.

My approach is just the opposite. It assumes that no theory of media can rise above the media themselves, and that what is required are forms of vernacular theory, embedded in media practices. These will turn out to be what I have called "metapictures," media objects that reflect on their own constitution, or (to recall artist Robert Morris's wonderful object of minimalist Dadaism), boxes with the sound of their own making.[14]

A useful metapicture of media is provided by the classic multistable image of the one vase/two faces (fig. 41).[15] If we begin with the vase, we see a useful illustration of Luhmann's distinction between the "marked" system (the vase), and the "unmarked" environment, or empty space around it. It also illustrates the distinction between form (the drawn outline that distinguishes the vase) and the medium (the blank paper on which it is inscribed). But a second glance precisely reverses these readings: the vase turns from a system into an environment between two systems that face each other, and the empty space or environment around the vase turns into the two facing systems. But the most stunning reversal in this image is the transformation of the ornamental markings on the vase into conduits of communication between the eyes and mouths of the faces. The invisible media of seeing and speaking are depicted here as channels of intersubjectivity, a kind of emblem of the very process of "addressing media." Not only do the two faces address each other simultaneously in what Jacques Lacan would call the "scopic" and "vocative" registers, the image as a whole addresses us, the beholders, staging for us our own relation to the picture as something we speak of and to at the same time we see it and find ourselves shown by it. As we "face" this image, in other words, we face our own interpolation as seeing/speaking subjects in face-to-face communication. This picture wants to address us, to be addressed, and to differentiate sensory modes of address. The unmarked ribbon of the oral medium is contrasted to the punctuated, subdivided channel of the visual, perhaps to sug-

14. See my discussion of Morris in W. J. T. Mitchell, *Picture Theory* (Chicago: University of Chicago Press, 1994), chapter 8. Metapictures are similar to Luhmann's concept of the "'playful' doubling of reality" in works of art, but Luhmann assumes that this is a distinctive feature of the modernist "art system," rather than an essential property of representation and mimesis as such. My notion of the metapicture is not limited to works of art, modern or otherwise.

15. In a simpler, unornamented form, this figure is known as Rubin's Vase, first presented by the Danish psychologist Edgar Rubin in 1921. See J. Richard Block, *Seeing Double* (New York: Routledge, 2002), 8.

FIGURE 41 One vase/two faces: figure-ground ambiguity. Digital Media Laboratory, University of Chicago.

gest a qualitative difference between the scopic and vocative, the pulsations and nervous glances of the optical process as contrasted with the fluidity of the smooth talker.

In the following chapters, as promised, I will look at a variety of meta-pictures of media—painting, sculpture, photography, film, a hybrid medium I call "biocybernetics," and finally, vision itself—in moments of self-referentiality. It may be useful at this point, however, to spell out some conclusions that may be drawn from the preceding reflections on theories of media, and to make explicit the assumptions about media that underlie this series of case studies. The following "ten theses on media" provide a summary of these conclusions, followed by a more leisurely elaboration.

1. Media are a modern invention that has been around since the beginning.
2. The shock of new media is as old as the hills.
3. A medium is both a system and an environment.
4. There is always something outside a medium.
5. All media are mixed media.
6. Minds are media, and vice versa.
7. Images are the principal currency of media.
8. Images reside within media the way organisms reside in a habitat.
9. The media have no address and cannot be addressed.
10. We address and are addressed by images of media.

1. *Media are a modern invention that has been around since the beginning.* When I address the question of media, I do not confine myself exclusively

or even primarily to the modern sphere of "mass" media or technical, mechanical, or electronic media. I prefer to see modern and traditional and so-called primitive media as dialectically and historically linked. Ancient and archaic media such as painting, sculpture, and architecture provide a framework for the understanding of television, cinema, and the Internet, at the same time that our view of these early media (even our modern understanding of them as "media" in the first place) depends on the invention of new means of communication, simulation, and representation. Ancient practices such as body painting, scarification, and gesture language, archaic cultural formations like totemism, fetishism, and idolatry survive (albeit in new forms) in contemporary media, and many of the anxieties surrounding traditional media involved questions of technical innovation, from the proliferation of "graven images" to the invention of writing.

2. *The shock of new media is as old as the hills.* Insofar as there is a history of media, it is not usefully bifurcated between modern and traditional forms. A dialectical account of media involves the recognition of uneven development, of the survival of traditional media in the modern world, and anticipations of new media in ancient practices. For instance, the "first" medium, architecture, has, as Walter Benjamin noted, always been a mass medium in the sense that is consumed in a state of distraction.[16] Outdoor sculpture has addressed mass collectivities since time immemorial. Television may be a mass medium, but its point of address is generally in the private, domestic space, not a mass gathering.[17] And technology has always played a role in the production of works of art and the communication of messages over distance, from the invention of fire to the drum, to tools and metallurgy, to the printing press. The notion of "new media" (the Internet, the computer, video, virtual reality) must be tempered, then, by the recognition that media are always new, and have always been sites of technical innovation and technophobia. Plato regarded writing as a dangerous innovation that would destroy human memory and the dialectical resources of face-to-face conversation. Baudelaire thought the invention of photography would destroy painting. The printing press has been blamed for revolution, and youthful violence has been attributed to everything

16. Walter Benjamin, "The Work of Art in the Age of Mechanical Reproduction," trans. Harry Zohn, in *Illuminations*, ed. Hannah Arendt (New York: Shocken Books, 1969), 240.

17. This is not, of course, a fixed condition of the television medium. In South African shantytowns, for instance, one television set may provide mass entertainment for several hundred people at the same time.

from video games to comic books to television. When it comes to media, then, the "shock of the new" is as old as the hills, and needs to be kept in perspective. There has always been a shock of the new with media; they have always been associated with divine invention, with double-edged gifts from the gods, and with legendary creators and messengers (Theuth, the inventor of writing; Moses, the bringer of the phonetic alphabet from Sinai; Edison and the phonograph; Prometheus and the fire; and McLuhan, the Promethean inventor of media studies as such). That doesn't mean that these innovations are not really new, or make no difference; only that the difference they make cannot be settled by labeling them "new" and treating all of the past as "old."[18]

3. *A medium is both a system and an environment.* The notion of media is derivative of a more embracing concept of "mediation"[19] that goes well beyond the materials and technologies of art and mass media to include such arenas as political mediations (representative institutions such as legislatures and sovereigns), logical media (the middle term in a syllogism), economic mediations (money, commodities), biological "media" (as in a biotic "culture" or habitat), and spiritual mediations (the medium as the go-between at a séance; the idol as symbol of an invisible god). A medium, in short, is not just a set of materials, an apparatus, or a code that "mediates" between individuals. It is a complex social institution that contains individuals within it, and is constituted by a history of practices, rituals, and habits, skills and techniques, as well as by a set of material objects and spaces (stages, studios, easel paintings, television sets, laptop computers). A medium is as much a guild, a profession, a craft, a conglomerate, a corporate entity as it is a material means for communicating. This proposition leads us back, however, to the Pandora's Box opened by Raymond Williams's concept of "social practice," threatening to unleash a boundless concept of the media. Therefore we need to supplement this concept with another maxim, in this case, illustrated by the following cartoon by Alex Gregory (fig. 42):

18. An instructive example here is Lev Manovich's tendency to equate "New Media" with computerization (numeric coding, modularity, automation, variability, transcoding), and to treat photography and cinema as "traditional media," with "old media" identified as "manually assembled" (*The Language of New Media*, 36). The line between old and new, however, is continuously redrawn, and needs clearer specification.

19. Here I agree with the basic position of Régis Debray, *Media Manifestos*, trans. Eric Rauth (New York: Verso, 1996).

FIGURE 42 "It's not high-definition anything. It's a window." Cartoon by Alex Gregory, *The New Yorker.* © The New Yorker Collection 2001 Alex Gregory from cartoonbank.com. All Rights Reserved.

4. *There is always something outside a medium.*[20] Every medium constructs a corresponding zone of immediacy, of the unmediated and transparent, which stands in contrast with the medium itself. The window was, of course, a medium in its own right, dependent on the emergence of suitable technologies of glass rolling. Windows are perhaps one of the most important inventions in the history of visual culture, opening architecture to new relations of inner and outer, and remapping the human body by analogy into inner and outer spaces, so that the eyes are the windows of the soul, the ears are porches, and the mouth is adorned with pearly gates. From the grillwork of Islamic ornament to the stained glass windows of medieval Europe, to the show windows and arcades of modern shopping and flâneurie, to the Windows of the Microsoft user interface, the window is anything but a transparent, self-evident, or unmediated entity. But this cartoon also reminds us that the new medium is, paradoxically, often asso-

20. As Luhmann argues, this is simply a formal condition of any system, including media: "the mass media, as observing systems, are forced to distinguish between self-reference and other-reference. They cannot do otherwise . . . they must construct reality—another reality, different from their own" (Niklas Luhmann, *The Reality of Mass Media* [Stanford, CA: Stanford University Press, 2000], 5).

ciated with immediacy and the unmediated, so that high-definition, high-speed computing makes it possible to simulate the older medium of the window perfectly. In this sense, new media do not remap our senses so much as they analyze the operations of the senses as they are already constructed by nature and habit and previous media, and try to make them look just like the older media.[21]

5. *All media are mixed media.* There are no "pure" media (for example, "pure" painting, sculpture, architecture, poetry, television), though the search for the essence of a medium, what critic Clement Greenberg saw as the task of the modernist avant-garde, is a utopian gesture that seems inseparable from the artistic deployment of any medium. The issue of media purity arises when a medium becomes self-referential and renounces its function as a means of communication or representation. At this point, certain exemplary images of the medium become canonized (abstract painting, pure music) as embodying the inner essence of the medium as such.[22]

6. *Minds are media, and vice versa.* Mental life (memory, imagination, fantasy, dreaming, perception, cognition) is mediated, and is embodied in the whole range of material media.[23] Thinking does not, as Wittgenstein put it, reside in some "queer medium" inside the head. We think out loud, at the keyboard, with tools and images and sounds. This process is thoroughly reciprocal. Artist Saul Steinberg called drawing "thinking on paper."[24] But thinking can also be a kind of drawing, a mental sketching, tracing, delineating, and (in my own case) aimless scribbling. We not only think *about* media, we think *in* them, which is why they give us the headache endemic to recursive thinking. There is no privileged metalanguage of media in semiotics, linguistics, or discourse analysis. Our relation to media is one of mutual and reciprocal constitution: we create them, and they create us. That is why so many creation myths describe God as an artificer working in various media to make an ensemble of creations (the architecture of the universe, the sculpted forms of animals and human beings).

7. *Images are the principal currency of media.* If we wish to "address me-

21. This is one of Kittler's major arguments in *Gramaphone, Film, Typewriter,* and it needs to be kept in mind when we too easily fall into the notion that media reconfigure or reprogram the senses.

22. For more on the issue of purity in media, see my essay, "Ut Pictura Theoria: Abstract Painting and Language," in *Picture Theory.*

23. See Stephen Pinker on the concept of "mentalese" as a mixed medium in *The Language Instinct* (New York: HarperPerennial, 1995).

24. See my discussion of Steinberg in my essay, "Metapictures," in *Picture Theory.*

dia" as such, we must recognize that images, not language, are their main currency. Speech and writing are of course crucial to articulating and deciphering the messages conveyed by media, but the medium itself is the embodied messenger, not the message.[25] McLuhan had it half right: the medium is "the massage," not the message. Speech and writing, moreover, are themselves simply two kinds of media, the one embodied in acoustic images, the other in graphic images.

8. *Images reside within media the way organisms reside in a habitat.* Like organisms, they can move from one media environment to another, so that a verbal image can be reborn in a painting or photograph, and a sculpted image can be rendered in cinema or virtual reality. This is why one medium can seem to be "nested" inside another, and why a medium can seem to become visible in a canonical exemplar, as when a Rembrandt comes to stand for oil painting, or oil painting comes to stand for painting, or painting comes to stand for fine art. It is also why the notion of a "life of images" is so inevitable. Images need a place to live, and that is what a medium provides. McLuhan argued, famously, that "the content of a medium is always another medium." Where he went wrong was in assuming that the "other" medium has to be an *earlier* medium (novels and plays as the content of film; film as the content of video). The fact is that a newer and even a nonexistent medium may be "nested" inside of an older medium, most notably in those science fiction films that predict technical breakthroughs in imaging and communication, in virtual reality environments, in teleportation devices, or in brain implants that have yet to be invented. New media inventions invariably produce a set of hypothetical futures, both utopian and dystopian, as Plato saw when he predicted that writing would destroy human memory.

9. *The media have no address and cannot be addressed.* The notion of "addressing media" (all of them, as a general field) is a thoroughly mythical and paradoxical concept. The media have no address and cannot be addressed. Like the god of monotheism, like the "Matrix" of modern sci-fi, the media are everywhere and nowhere, singular and plural. They are that in which "we live and move and have our being." They are not located in a particular place or thing, but are themselves the space in which messages and representations thrive and circulate. Asking for the address of a medium is like asking for the address of the postal system. There may be specific post of-

25. See Debray, *Media Manifestos*, p. 5.

fices, but the medium known as the postal service does not have an address. It contains all addresses within itself; it is what makes addresses possible.[26]

10. *We address and are addressed by images of media.* Therefore, we cannot "address media" or be addressed by media as such. We address and are addressed by *images* of media, stereotypes of specific mediascapes, or personifying figures (media stars, moguls, gurus, spokespeople). When we speak of being "hailed" or "interpellated" by media, we are projecting a personification of the media, addressing it as a speaker for whom we are the addressee. The "address of media" takes two distinct forms, one figural, the other spatial: (1) the "address" as that of a speaking subject to an addressee, in which case the medium is given a face and body, represented in an avatar (as when the Matrix speaks through its "Agents" and the hackers respond, or when McLuhan or Baudrillard utters gnomic statements that speak "for" as well as "about" media, as if the media expert were a "medium" in his own right); or (2) the "address" as a location, a place, space, or site of enunciation, in which case the important thing is *where* the address is "coming from," as we say.

Given that media address us with and as images of spaces or bodies, landscapes or figures, they produce in us all the ambivalence we associate with images. They are the invisible Matrix or the hypervisible spectacle, the hidden God or his incarnate living Word. They are mere instruments of our will, increasingly perfect means of communicative action or out-of-control machines that are leading us to slavery and extinction. I conclude, therefore, that a reasonable place to start "addressing media" is by addressing images of media, the forms that they bring to life and that bring them to light. To illustrate this point, I want to end with a meditation on a scene from David Cronenberg's horror classic, *Videodrome*, in which a trio of "media avatars" are brought together in the same space, and the whole distinction between the medium as body and as space is deconstructed.

Max Wren (played by James Woods) is the first avatar, a television producer who has been searching for a new "tough" form of pornography to raise the ratings on his struggling Toronto channel. He has been given a videocassette of a lecture by a media expert, Dr. Brian O'Blivion (a clear reference to Marshall McLuhan), whom we have already met in this film as an enigmatic, oracular figure who declines all invitations to appear in person

26. I believe Wolfgang Schaffner made this observation at the Cologne Symposium, "Addressing Media."

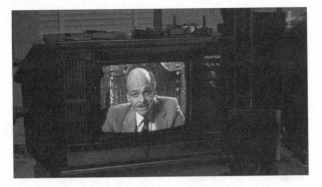

FIGURE 43 In this still from David Cronenberg's *Videodrome* (1983), Dr. Brian O'Blivion recites his McLuhanesque mantra: "The battle for the mind of North America . . ."

on live television, insisting that he "only appears on television *on television*," in the form of prerecorded videotapes. The third avatar is a gorgeous television personality named Nicki Brand, who has been having an affair with Max Wren. Max has been having strange hallucinatory experiences, and is hoping that Dr. Oblivion will be able to explain what is going on.

As the tape begins to play, Brian O'Blivion recites what we know as his familiar McLuhanesque mantra about the new age of the video medium (fig. 43):

The battle for the mind of North America will be fought in the video arena. The Videodrome. The television screen is the retina of the mind's eye. Therefore, whatever is seen on television emerges as raw experience. Therefore, television is reality, and reality is less than television.

Max, who has heard this all before and is watching in a state of distraction, scratching himself and fidgeting, snorts disdainfully as if to say, "Oh, sure." At this point, the voice of Dr. O'Blivion then changes drastically and begins to address Max directly, as if in real time—no longer an archived recording:

Max! I'm so glad you came to me. I've been through it all myself you see. Your reality is already half video hallucination. If you're not careful, it will become all hallucination.

At this point, Brian O'Blivion has Max's total attention, and continues thus:

I had a brain tumor. I thought the visions caused the brain tumor, and not the reverse. But when they removed the tumor, it was called Videodrome.

As O'Blivion tells his story, we see the figure of a hooded executioner in a chain-mail tunic entering the room behind him. As O'Blivion continues, the hooded figure straps his arms to the chair and takes out a length of rope. Just as O'Blivion reaches the end of his story, revealing that he was "Videodrome's first victim," the executioner strangles him in midsentence. Max leaps from his chair and demands, "But who's behind it? What do they want?" The executioner removes the hood, revealing herself to be Max's lover, Nicki Brand (fig. 44). She says, "I want you, Max," and proceeds to insist in tones that are alternately commanding and pleading, "Come to Nicki. Come to me now. Don't make me wait," as her lips grow to fill the entire picture tube (fig. 45). Next, the tube bulges out from the television set while the set itself comes alive, panting and purring with desire, veins dilating under its plastic skin. The scene ends as Max (fig. 46) obeys her demands, inserting his head into the mouth of Nicki Brand (fig. 47).

The three media avatars in this scene personify the four crucial components of all media systems: the sender or "producer" of messages, the code that makes it possible to understand messages, the receiver or "consumer" who takes in the message; and the embodied message in the form of an image. But these are immediately scrambled in the staging of this scene: Max, the producer, is put in the role of spectator; Dr. Brian O'Blivion, the master of the code, the media theorist who holds the key to all messages whatsoever, is portrayed as the "first victim" of the medium; and while Nicki Brand plays the role of cannibalistic receiver-consumer, prepared to devour the producer, she has also become the avatar of the medium as her mouth merges with the screen and the body of the television set merges with her physical, sexually excited body. All the supposedly stable components of the medium—sender, receiver, code, and embodied message— are rewired in this brilliant scene to make clear the radical instability of the very concept of the medium. The producer is consumed; the embodied image that should be the consumed object of visual pleasure turns out to be the consumer; and the media theorist, the oracle of the code who should stand outside the media in Olympian serenity, is its first victim.

We can read this, of course, as an allegory of the death of McLuhan himself, the great avatar of media theory brought down by the curse of his own media celebrity. As McLuhan became a bigger media star, appearing on the TV programs *The Dick Cavett Show* and *Laugh-In* and in the film *Annie Hall* and consulting with American corporations about new product lines, his academic reputation hit the skids. He was quickly supplanted by a new

FIGURE 44
Executioner unmasked: "I want you, Max." Still from *Videodrome*.

FIGURE 45
Nicki Brand: "I want you, Max." Still from *Videodrome*.

FIGURE 46
Max approaches the TV. Still from *Videodrome*.

FIGURE 47
Max's head in the TV. Still from *Videodrome*.

media oracle in the early eighties, the rising star of the more politically correct and safely posthumous Walter Benjamin.[27]

But there is a more fundamental lesson to be learned from this scene, and that is the presence of media theory in the midst of the media themselves. Of course these theories need to be greeted and transcoded with all the tools of semiotics, systems theory, phenomenology, and hermeneutics. But this cannot happen as long as we imagine that the media are somehow an "object" for scrutiny by the master discourses of theory. Perhaps we need a new label for this pursuit, a "medium theory" that would acknowledge its middling, muddling location in the midst of media.[28] This would be the location of theory as an immanent vernacular, closely tied to practice while reflecting on it from within. It would ask the question of media, "Who's behind it? What do they want?" without expecting the answer to be as simple as "Rupert Murdoch, dummy!" or as indeterminate as a mystical notion of the mass media system as a massive, living totality, the paranoid scenario of the Matrix, or the autopoetic system-environment shuffle of Niklas Luhmann. The answer to "Who's behind it?" may also be "Ourselves," and our obscure objects of desire, the fantasy of fatal pleasure promised by Nicki Brand. As for what the media want, that much is clear: they want you.

27. The fall of McLuhan and the rise of Benjamin is a story that remains to be told in the history of media studies. McLuhan's cheery "global village" optimism and his mystical visions of a group mind did not play well in the era of poststructuralist suspicion and a predominantly Left-oriented media studies. My confidence in the importance of this story has been bolstered by conversations with Horst Bredekamp. See his article, "Der simulierte Benjamin. Mittelalterliche Bemerkungen zu seiner Aktualität," in *Frankfurter Schule und Kunstgeschichte*, ed. Andreas Berndt, Peter Kaiser, Angela Rosenberg, and Diana Trinkner (Berlin: Reimer Verlag: 1992), 116–40, which argues that Benjamin's article, "The Work of Art in the Age of Mechanical Reproduction," was celebrated since the sixties as an antidote against McLuhan, at least in Germany.

28. See my essay "Medium Theory," *Critical Inquiry* 30, no. 2 (Winter 2004): 324–35.

Painting has always been the fetish medium of art history, as poetry is of literary history, and cinema of media studies. And modern *abstract* painting has been the fetish object of painting's history, the specific style, genre, or tradition (the difficulty of naming it is part of the point)[1] in which painting is supposed to find its essential nature.[2] Clement Greenberg put this most eloquently when he declared that the abstract artist is "engrossed in the problems of his medium"[3] to the exclusion of every other consideration. Greenberg regarded representational modes of painting, whether genre, history, allegory, surrealism, portraiture, or landscape, as regrettable deviations from the true essence of painting, which is contained in the materiality of the medium itself. In a curious way, Greenberg agrees with Marshall McLuhan (whose ideas must have appalled him in every other way) that "the medium is the message" of modern art.[4] The great accomplish-

1. Stanley Cavell argues that abstract painting is not a "style" or "genre" in the usual sense of the word (like the Baroque, mannerism, Romanticism, or classicism) but a crisis in the identity of the medium as such. See *The World Viewed* (Cambridge, MA: Harvard University Press, 1979), 106.

2. "Abstract painting," argues Yves-Alain Bois, "can be taken as [the] emblem" of "the whole enterprise of modernism." See "Painting: The Task of Mourning," in *Painting as Model* (Cambridge, MA: MIT Press, 1993), 230.

3. Clement Greenberg, "Towards a Newer Laocoon" (1940), in *Clement Greenberg: The Collected Essays and Criticism*, 4 vols. (Chicago: University of Chicago Press, 1986), 1:23.

4. Yves-Alain Bois argues that the modernist insistence on the "materiality" and "integrity" of the medium was "a deliberate attempt to free art from its contamination by the forms of exchange produced by capitalism. Art had to be ontologically split not only from the mechanical, but also from the realm of information" (Bois, "Painting: The Task of Mourn-

ments of abstract art were, for Greenberg, the "acceptance of the limitations of the medium of the specific art"[5] and the renunciation of mixed media, hybrids, literary painting, and (above all) kitsch, with its sentimental and facile appeals to familiar subject matter.[6] He celebrated the accomplishments of the purists in the following words:

[T]he avant garde arts have in the last fifty years achieved a purity and a radical delimitation of their fields of activity for which there is no previous example in the history of culture. The arts lie safe now, each within its "legitimate" boundaries, and free trade has been replaced by autarchy. . . . The arts . . . have been hunted back to their mediums, and there they have been isolated, concentrated and defined. It is by virtue of its medium that each art is unique and strictly itself.[7]

And this "hunting back to the medium" is most vividly realized in painting, in which the fundamental elements are simplified "in instinctive accommodation to the medium":

The picture plane itself grows shallower and shallower, flattening out and pressing together the fictive planes of depth until they meet as one upon the real and material plane which is the actual surface of the canvas. . . . Realistic space cracks and splinters into flat planes which come forward, parallel to the plane surface. . . . As we gaze at a cubist painting of the last phase we witness the birth and death of three-dimensional pictorial space. (1:35)

I have discussed elsewhere the curious combination of elements that make up the master narrative of modernist abstraction: part religious quest, with overtones of iconoclasm (the destruction of mimesis and representation); part scientific revolution (the claim to be opening up a new field of perception and representation of a deeper reality than mimesis could offer); and part political revolution (shocking the bourgeois beholder with the

ing," 235). Cf. McLuhan's insistence that the informational content of a medium is not to be confused with its "message," the alteration of sensory ratios produced by the medium.

5. Greenberg, "Towards a Newer Laocoon," 1:32.

6. Michael Fried's declaration that "*what lies* between *the arts is theater*" (emphasis Fried's) expresses similar reservations about mixed media. "Art and Objecthood," first pub. *Artforum* 5 (June 1967): 12–23; reference here to reprint in Michael Fried, *Art and Objecthood* (Chicago: University of Chicago Press, 1998), 164.

7. Greenberg, "Towards a Newer Laocoon," 1:32.

militant gestures of the avant-garde).[8] This heroic picture of abstract paint-ing has remained the canonical narrative of art history for the last forty years, even while it was being dethroned as the master medium by the mul-timedia experiments of postmodernism. By the 1980s it had become fash-ionable to declare that abstract painting was dead or moribund: "the new quasi-abstract painters," declared art critic Hal Foster, "either simulate ab-straction, recycle it in a campy way or reduce it to a set of conventions. Far from critical . . . this conventionalist attitude complies with our economy of signs and simulations."[9] Foster regards the attempts to revive abstract paint-ing in an age of simulation as more or less opportunistic efforts to mimic "the abstractive processes of capital."[10] Paintings are thus capable of little more than a complicitous irony, but fall far short of the magical operation known as "critique," which would position painting in an authentic relation to the great abstract work of the past (Robert Ryman, Kenneth Noland, Brice Marden) while disrupting the regime of capitalist simulation. "The posture of the artist remains the dandyism of Dali rather than the radical-ism of Duchamp, and the logic of the art follows the given dynamic of the market/history system" (84).

The heroic role of critical abstract painter, capable of opposing the market/history system and subverting the regime of capitalist simulation, has gen-

8. See my "Ut Pictura Theoria: Abstract Painting and Language," in W. J. T. Mitchell, *Pic-ture Theory* (Chicago: University of Chicago Press, 1994), chap. 7. On abstraction and icono-clasm, see Maurice Besancon, *The Forbidden Image* (Chicago: University of Chicago Press, 2000). On the claim to a new epistemology in which "changes . . . in physics or philosophy" are registered in painting, see T. J. Clark's skeptical critique in "Cubism and Collectivity," in *Farewell to an Idea* (New Haven, CT: Yale University Press, 1999), 214–15. Clark argues that cubism is a "counterfeit" of "a new description of the world," one that has little to do with scientific paradigm shifts—a charge that he recognizes will be taken as "an insult" that robs "the founding monuments of modern art of one kind of authority" (215).

9. Hal Foster, "Signs Taken for Wonders," *Art in America* (June 1986): 80. See also Douglas Crimp, "The End of Painting," *October* 16 (Spring 1981); reprinted in *On the Museum's Ruins* (Cambridge, MA: MIT Press, 1993), 84–106. Crimp denounces the "resurrection of painting" as "almost entirely reactionary" (90), with "all the hallmarks of bourgeois ideology" (92). Only paintings that find ways to represent the death of the medium (Robert Ryman), its des-peration (Frank Stella), or the death of the art institution as such (Daniel Buren) are to be taken seriously.

10. Foster, "Signs Taken for Wonders," 139. A longer view of the matter is provided by Yves-Alain Bois in "Painting: The Task of Mourning," where the "end" or "death" of painting as a release from capitalism is seen as inscribed in the project of abstract painting from the very beginning (230–32).

erally been reserved for Gerhard Richter, an artist of undeniably major ambitions whose work has consistently explored the boundaries between media such as photography and painting (plate 2). Richter is singled out by art historian Benjamin Buchloh as the heir to the avant-garde ambition of "liquidating [the] false bourgeois cultural inheritance" and refusing to indulge itself in "lyric poetry after Auschwitz." Buchloh thinks that what makes Richter authentic and "attractive to many viewers" is that his work "looks like a survey of the whole universe of twentieth-century painting, presented in one vast, cynical retrospective."[11] Buchloch wants to see Richter as involved in a heroic struggle with contradictions, "trying to pursue both a rhetoric of painting and a simultaneous analysis of that rhetoric".[12] When Richter paints his "big pictures not with an artist's brush but with a decorator's brush," Buchloh sees this as a critical act, reflecting on "the anonymization and objectivization of the painting process" (161).

The only problem with Buchloh's reading of Richter is that the artist himself has repudiated it in the most emphatic terms. Richter insists that there *is* lyric poetry after Auschwitz, refuses to see his project as a "vast, cynical retrospective," and denies that "a stupid demonstration of brushwork or of the rhetoric of painting . . . could ever achieve anything, say anything, express any longing" (156). As for the decorator's brush, he simply maintains that "a brush is a brush, whether it's five millimetres wide or fifty centimetres" (162). Far from "liquidating [the] false bourgeois cultural inheritance," Richter dismisses this is as agitprop rhetoric, "like someone saying that language is no longer usable, because it is a bourgeois inheritance, or that we mustn't print texts in books any more, but on cups or chair legs. I am bourgeois enough to go on eating with a knife and fork, just as I paint in oil on canvas" (151–52). Richter insists that his art is not out to destroy anything or produce a break with the past. "In every respect," he says, "my work has more to do with traditional art than with anything else" (23). He

11. Gerhard Richter, "Interview with Benjamin H. D. Buchloh, 1986," reprinted in Richter, *The Daily Practice of Painting: Writings and Interviews, 1962–1993*, ed. Hans-Ulrich Obrist (Cambridge, MA: MIT Press, 1995), 146. Crimp also makes considerable use of an unguarded remark by Gerhard Richter to the effect that "painting is pure idiocy" unless one is passionately engaged with it ("The End of Painting," 88). It doesn't occur to Crimp that Richter could have been joking, and also that he could still have been passionately engaged, committed to the "idiocy" built into a utopian notion of painting—"where one thinks that humanity could be changed by painting" (ibid.).

12. Richter, "Interview with Benjamin H. D. Buchloh, 1986," 156.

characterizes his pictures in terms that sound dangerously close to traditional notions of aesthetic autonomy and existential authenticity. When working on a picture, he feels that "something is going to come, which I do not know, which I have been unable to plan, which is better and wiser than I am" (155). He even flirts with kitsch values in suggesting that his painting "tells a story" and "sets up moods" (156). If his painting is an assault on anything, it is not, as Buchloh thinks, "on the history of abstraction in Europe," but "on the falsity and religiosity of the way people glorified abstraction, with such phoney reverence" (141). Richter consistently refuses the heroic, critical, transgressive role of the avant-gardist that Buchloh wants to give him. He insists on the mundane nature of the "daily practice of painting," questions whether any painting can have a serious political impact, and declares that "politics don't suit me" (153).[13]

Richter's refusal of the heroic mantle of the abstract painter may help us to answer some questions about the possibilities of abstract painting more generally at a time when painting has been demoted from its major, dominant position to a relatively minor status. What are the current possibilities for abstract painting at the end of the postmodern era? Can abstract art recover any of the utopian, revolutionary, and spiritually transcendent ambitions it was associated with in the early modernist era, the heroic age of Kandinsky, Malevich, and the historical avant-garde? Can (or should) it try to replay the second historic wave of abstraction that occurred with the rise of abstract expressionism and color field painting after World War II? What can abstraction aim for in the wake of the postmodern return to figuration, pictorialism, and the oft-noted "eruption of language into the aesthetic field"? Should it seek moments of continuity in the persistence of a tendency to abstraction in the work of the minimalists, the neoexpressionists? Who are the continuators of abstraction in the last twenty-five years? Do they add up to a sustaining alternative tradition, or are the contradictions among them so fundamental that their common "look" of abstraction is quite misleading?

13. It is worth noting that the abstract paintings have generally been treated as a relatively minor aspect of Richter's work by curators. The fetish objects of his oeuvre are the Baader-Meinhof compositions and the photo-based pictures, both resolutely nonabstract and linked directly with mass media. As for his abstract paintings, Jeremy Gilbert-Rolfe's remark about them (they "seem to exist to be photographed. . . . Concentrated into the intimate space of the page. . . . one sees the point") suggests their minor status as relatively nonfetishistic works. See Rolfe, *Beauty and the Contemporary Sublime* (New York: Allworth Press, 1999), 98.

These are the sorts of questions that a critic can pose, but only artists can answer. And it may well be that the work of minor artists would provide more illuminating answers than that of the major figures who have been selected by the vagaries of the market and critical taste to stand for the forward movement of art history. Minor artists working in what Raymond Williams would have called a "residual" tradition (in contrast with the "emergent" or "dominant" tendencies of the period) may help us to see how a conversation around an artistic tradition might be sustained at the level of ordinary language, free of the hyperbolic pressures to demonstrate genius or world-historical significance.

It was in this spirit that I accepted an invitation in the mid-1990s to respond to a show entitled Re: Fab, mounted at the Art Gallery of the University of South Florida. This show invited beholders to inspect a range of recent work by new and established artists working in recognizably abstract modes. It did not constitute an "artistic statement" or manifesto by a coherent group of working collaborators. It was, rather, a kind of borderline project produced by a cooperative effort of artists, curators, and critics, an attempt to assemble a range of work that might enable us to answer the critical questions about the present state of abstraction in a relatively empirical fashion without very many explicit preconceptions. Of course the sample was inevitably biased: it excluded hard-edged and magical fetishist abstraction; it was oriented toward New York. It seemed to be in league, above all, with the pleasure principle, willing to risk ornamentality, prettiness, or mere "interest" for the sake of an openness to the question of abstraction. It was not overly eager to declare its own importance or meaning, but seemed willing to invite viewers into a game for which the moves and the rules were not stipulated in advance.

I show you here, pretty much at random, a sampling of works from the show. Bill Kmoski's Untitled, a coloristic dialogue between spraying and scratching, acrylic and modeling clay (plate 3); Elliot Puckette's elegantly virtuosic scribble in ink, gesso, and kaolin on wood, a fantasy in black porcelain (fig. 48); Dona Nelson's Moonglow, staging a conversation between dripping and dropping, biomorphic figures and fluids (plate 4); Polly Apfelbaum's Honeycomb, which wants its beholder to suck the dye from its cotton and nestle with the black velvet bodies interspersed among its cells (plate 5); Richard Kalina's Aemilia, which collages biomorphic shapes on a rectangular ground plan (plate 6). Finally, Jonathan Lasker's Medium Exaltation, which combines three modes of graphic abstraction from the

FIGURE 48 Elliott Puckette, *Hang the Dog and Shoot the Cat*, 1994. Courtesy of Paul Kasmin Gallery and the artist.

pictorial-representational code: writing, geometry, and color (plate 7). The painting's title is either a pun or an oxymoron, depending on whether the word *medium* is read as a noun or an adjective. Is this an exaltation of the medium, showing us the elements of pure abstraction—writing reduced to a trace of hand gestures in a calligraphic scribble, color reduced to an undifferentiated field (except for the white space hollowed out for writing), and geometry reduced to the fundamentals of triangulation and surveying of a space? Or is it a "medium exaltation," a sort of middling, unpretentious elevation of familiar graphic conventions? Not a revolutionary statement or a negation of anything, but a reminder of the humblest ele-

ments of the graphic arts? Either way, the painting is neither beautiful nor sublime. In fact, in its choice of dominant color, a kind of synthetic, seasick green, coupled with its scribble and its disorienting use of tricky geometry from Gestalt diagrams, it seems to want to disorient the viewer, leaving us queasy and uncertain.[14]

It seems to me that all this work is competent at the very least. It shows thorough professionalism, mastery of techniques and materials, elegance of execution, and interesting ideas. I'm not prepared to claim world-historical status for any of them, but then I'm skeptical of any art history that trots out a Hegelian narrative of great geniuses on their mountaintops calling to each other and "abolishing the code that . . . has made art what it is."[15] These artists all know how to paint. They know what painting has been, where abstraction has gone, how its codes have been manipulated. The technical dialectics in the paintings, their clever playing on the connotations and properties of materials, are addressed to a patient, sympathetic viewing.

The worst you could say, then, is that this show was an attempt to run up the flag of abstraction once more to see if anybody is still willing to salute. And yet flag-waving was exactly counter to its spirit, which was more like an invitation into the intimacy of the studio—a diverse range of studios, in fact—to see what is happening at the present time. Perhaps this intimacy itself could provide a key to the present possibilities of abstraction.

In linking abstraction and intimacy, I'm thinking of course of Wilhelm Worringer's influential argument in *Abstraction and Empathy* (1906), that abstract art in both its primitive and modern phases obeys an impulse of "self-alienation," expressing a "dread of space" and a negation of all forms of empathy. Much of the rhetoric of negation in modernist abstraction, from its refusal of language, representation, and narrative to its courting of fetishism and primitivism, to its ambivalence about the bourgeois beholder (who had to be simultaneously seduced and abandoned), could be traced to Worringer's case against "empathic" art, against the art of pleasure, beauty, (self-) enjoyment, projection, and identification.

14. See Enrique Juncosa, "Index and Metaphor: Jonathan Lasker, David Reed, Philip Taaffe," in *Abstraction, Gesture, Ecriture: Paintings from the Daros Collection* (Zurich: Scalo, 1999), 135–55. Juncosa comments on the undogmatic, nonutopian mood of the "New Abstraction" in the nineties.

15. Daniel Buren, *Reboundings*, quoted in Crimp, "The End of Painting," 103.

I don't think, however, that the new possibilities for abstraction reside simply in a revival of the rejected aesthetics of empathy. Intimacy is not the same as empathy. The empathic relationship is caught up (along with abstraction) in the idealist "philosophy of the subject," in which the relation of painting and beholder is to be understood as the dyadic relation of subject and object or (if one is really good) subject and subject. Jonathan Borofsky's *Green Space Painting with Chattering Man at 2,841,787* (fig. 49) might be seen as emblematic of this empathic model. The beholder and the work of art address each other in a dyadic relationship: a vortex of colors on the one side, a fixated, mechanical spectator on the other who is endlessly talking to compensate for the silence and the refusal of speech, narrative, figuration, and legibility from the painting.

Empathy is both a mimetic and compensatory relation between the beholder and the object. Mimetic in that the beholder, as William Blake would have put it, "becomes what he beholds," his language—a meaningless, repetitive "chattering," just as abstract, nonreferential, and autofigurative with respect to language as the painting is with respect to paint. Compensatory in that the beholder makes up for the silence of the image by supplying what it lacks, what it seems to need or demand, a voice adequate to its visual purity. An aesthetics of empathy, then, is a kind of negation of a negation when it encounters abstraction—the negation of a visual alienation associated with voyeurism and "seeing without being seen," a scenario in which the work of art does not need the spectator, even "turns away" from the spectator (to echo art historian and critic Michael Fried's account of "absorption").

Intimacy, by contrast, implies collectivity, a circle of acknowledgment and recognition. If the game of intimacy is played by two, it requires a third as witness or participant—sometimes even an unwitting witness, as in the phenomenon of "passing," or the joke that is shared in the presence of someone who doesn't get it. Borofsky's composition, a multimedia installation portraying the relation of a perfectly attentive beholder to a perfectly nondescript, even generic abstract painting, stages the dialectic of abstraction and empathy for us. But in doing so it of course makes fun of this relationship, staging it as a kind of metapicture of a familiar and conventional painting-beholder encounter, and thus creating a new space for us to reflect on this relationship. We come to this scene as a third party. We interrupt the empathic monologue-dialogue and transform it into a scene of intimacy. The dialectic, the dialogism of alienation and empathy, is transformed into a "trialogue," a three-way encounter—perhaps even a missed encounter.

FIGURE 49 Jonathan Borofsky, *Green Space Painting with Chattering Man at 2,841,787,* 1983. Acrylic on canvas, two floodlights, primed aluminum, wood, Bondo, electric motor, and speaker; canvas, 112 × 72"; chattering man, 82½ × 23 × 13". Collection of the artist. Photograph by eeva-inkeri. Courtesy of the Paula Cooper Gallery, New York.

What does this have to do with abstract art? Simply this: that the historical moment when abstraction could alienate anyone by virtue of being abstract is long past. Abstract painting is familiar, classical, standard, even official. Works of abstract art no longer stand out as polarities in the dialectic of subject and object. They are more like members of a brother- or sisterhood of objects than Oedipal spectacles, more like totems, toys, or transitional objects than fetishes. They promise, not transcendence or purification of the singular beholder, but a *conversazione* (to recall the eighteenth-century pictorial genre) among beholders.

I could illustrate this point with the trompe l'oeil abstractions of David Reed, who simulates and parodies the painterly brushstroke in a thoroughly deceptive tour de force. But let me go to a work not by any artist in this show but by a Danish artist who, at the age of eighty, has lived through the long goodbye of modernism in all its permutations, and who reflects on the "defacement" of the image. Sven Dalsgaard's *Bagage* (plate 8) presents us with an abstract yellow color field in broad, translucent brushstrokes that leave

the blue undersurface "peeking out" in the lower right corner of the canvas. The purity of this abstract surface is immediately violated, however, by two features: a melancholy pair of geometrical lozenge- or diamond-shaped eyes that compel us to read the yellow surface as a "face," and a label with "I love you" inscribed in Danish located in the position we now have to recognize as the mouth. The other notable feature of the picture is the handle attached to the top of the frame, presumably literalizing the title and linking the painting to a whole series of works presented by Dalsgaard as "luggage" or "baggage" that can be handled, carried, and transported.

I transport this baggage into this context to make two points. First, abstraction in the twentieth and twenty-first centuries has been international, migratory, and universal, but far from homogeneous or unidirectional. Abstraction, from Australian Aboriginal painting to the work of the KOBRA Group (Copenhagen, Brussels, Amsterdam), has flowed outward not just from cosmopolitan centers like New York or Paris, or between imperial "centers" and primitive or colonial "margins," but across many borders in a lateral traffic, like a battered suitcase covered with the labels of numerous destinations.

Second, a work like Dalsgaard's *Bagage* betrays an awareness of the myths of heroic, antiempathic abstraction. It knows that the marks of a *face* effectively deface the purity of the faceless, alienated surface of abstraction as surely as Duchamp's moustache defaces the Mona Lisa. It knows that the signs of language (orality, writing) transgress abstraction's code of ineffable silence and unreadability, and that the sentiments expressed by this face are precisely that demand for empathy which modernist abstraction had to renounce. The expression "I love you," as Lacan notes, is never just a statement about the speaker; it is a demand addressed to the listener/beholder for a reciprocal declaration, "I love you too." That this label is screwed onto the painting, not *painted* on or in it, allows it to be read not as a "mouth" expressing what we all want to hear, but a *gag* that covers the mouth, silencing it so that the beholder's desire can be projected onto the face, leading us, for instance, to read the eyes as beseeching and melancholy. How would we read the expression of the eyes if the label said "I hate you"? And how do we nonreaders of Danish take it?

Bagage, in short, is a "gag," a travesty of abstract painting, a metapicture of the present state of abstraction.[16] It shows us the face of abstraction not

16. I'm told that the pun on "gag" does work in Danish.

as heroic, sublime, antitheatrical, or transcendent of objecthood. The object, as Robert Morris once put it, is still important, but perhaps not quite so self-important. It presents itself with wistful humor as a companionable, useful form. Like a faithful spouse one has lived with for a half a century, it has earned only the title of "baggage" and a certain familiarity and intimacy. Like the abstract tradition itself, we continue to carry it with us; it is handy, ready to hand. We can't abandon it, yet we don't quite know what to do with it aside from ritual declarations of love and confessions of infidelity. Who, aside from Michael Fried, has remained faithful to the pure promises of abstraction?

Perhaps Dalsgaard's composition can help us glimpse some of the new possibilities for abstraction in an era of modern maturity (was the Florida location of the Re: Fab show selected with this in mind?). Adolescent, juvenile, heroic modernism may have asked abstraction to do too much, demanding that it play a world-historical role as political, spiritual, and cognitive vanguard, an artistic negation of the negation. Can there still be "pure" abstraction? Perhaps, but the *stains* and impurities may be more interesting. Can it transcend its commodity status? Only if we recognize, as art critic Dave Hickey has put it, that commerce and capitalism are not the same thing. Abstract painting predates both modernism and capitalism, and it will outlive museums, curators, critics, and dealers. Can it participate in a politics? Yes, but perhaps not a straightforwardly polemical politics of propaganda but a more subtle politics of intimacy that works across the boundaries between the public and private and opens new conversations within the fellowship of artists, objects, beholders.

An exhibition entitled Disappeared, mounted by John Ricco at Chicago's Randolph Street Gallery in November and December of 1996, seems to me exemplary of this sort of politics. As an assemblage of recent work by a group of gay artists in Europe and the United States, it was notable for the absence of militant or aggressive imagery and the presence of relatively abstract works that seemed to invite new relations between beholders and objects. Derek Jarman's film *Blue*, for instance, was being run continuously, presenting a pure blue field on a movie screen in front of a row of old-fashioned movie theater seats, backed by a shoulder-high wall to screen off the viewers in an evocation of the intimate viewing space of a theater, and a nonnarrative soundtrack combining singing and ambient noises of speech and movement. The play on the connotations of pornographic "blue" movies and what Ricco calls the "minor architecture" of the blue movie

house seemed somehow to capture perfectly the lowered gallery temperature and heightened viewer attentiveness and intimacy offered by the exhibition. Similarly, a series of square color fields painted directly on the walls in temperature-sensitive paint by Berlin artist Jurgen Mayer invited attention to the subtly changing hues of the squares as the room heated up with breath of the crowd, as well as to the more dramatic impressions left on the paintings when spectators accepted the invitation to touch them, leaving hand-, cheek, and fingerprints to slowly fade out and disappear.

The effect of this show was to defuse some of the erotic anxiety that seemed paradigmatic for the era of high abstraction, the feeling that the painting was what Jean Laplanche has called an "enigmatic signifier," withholding its mystery from the lonesome, isolated beholder, who is reduced to respectful silence or formulaic chatter. Instead of the muttering one sometimes hears in front of artworks or the noisy obliviousness usually associated with a gallery opening (in which the works remain largely unnoticed, while people greet each other), this show seemingly provoked a kind of conversational playfulness and whimsical improvisation on the part of the beholders.

Who can participate in these conversations, and where might they lead? One feature of the old revolutionary abstraction that survives in recent work is a kind of demotic invitation to a (relatively) innocent eye to play the game of Seeing As. I don't mean, though, Clement Greenberg's innocent eye as "a machine unaided by the mind" (another possible target of Borofsky's parody). I mean, rather, an eye capable of laying down the gaze, capable of relaxing the demand for importance, meaning, value, and truth and letting the picture look back at us, speak to us; an eye that refuses to be shamed by its temptations to projection, identification, and empathy. "After great pain," says Emily Dickinson, "a formal feeling comes." The long goodbye of heroic modernism has been a great pain—and not just in the neck, as art historian T. J. Clark's *Farewell to an Idea* makes clear.

So contemporary abstraction may require something like a new aestheticism, a renewal of formalism, but we mustn't forget that formalism has always been associated with a democratization of art, an enlarging of the conversational circle. (The American New Criticism in literary studies played a similar role in releasing poetry from the grip of learned elites.) The nonvanguard position of abstraction at the present time may open it to a similar kind of playful, vernacular analysis of pictures "without authors"— without the weight of history and borrowed authority. Certainly, abstract

paintings can play at least one powerful role as a training ground in the practice of prolonged visual concentration on singular, determinate complexes of visual imagery, discursive association, and concrete objecthood. In this role, abstraction (especially when displayed outside the context of the blockbuster show) continues to be an absolutely necessary antidote or counterspell to the aesthetics of distraction, the visual noise offered by mass media and everyday life.

Consider, for instance, Rochelle Feinstein's composition, *Horizontal Hold* (plate 9), which was among the paintings in the University of South Florida show I mentioned earlier. When I showed a slide of this painting as a long session with a single image to a group of art history students a few years ago, the first response was fatigue and frustration, leading to a debate over which diagonals provide the quickest and easiest path across the picture: left to right or right to left. To some students, the picture seemed to invite the beholder to rush past it, even to stage the beholder as someone who is moving horizontally, in imitation of the artist's own gesture of laying down streaks, swipes, and stripes. This effect is reinforced by the instantaneously readable crosshatch pattern, with its recollection of tile floors seen in perspective, and the composition title's linkage of the image with televisual distortion, specifically the failure of the "horizontal hold" function, and the collapse of the TV image into a chaos of anamorphic distortions. This is exactly the sort of image that would make us go past a TV set on display in a showroom. The only thing worse would be the "white noise" associated with the complete absence of a signal.

By this point in the discussion, however, the students began to notice that their temptation to pass by the picture was exactly what the picture is about. The "horizontal hold" button is one that every picture wants to push in its beholder, to "arrest" the beholder before the composition and stop the distracted, out-of-focus rush through the sequence of an exhibition. At this point, at any rate, we were ready to stop and take a look, ready to question the function of what might be called the "hooks" and "eyes" in the weave of the picture—the three red lozenges that seem to be floating in or on the surface of transparent streaks that wash across the diagonal grid, and the one blank, black-outlined lozenge that seems to penetrate however many "levels" we would wish to read in the image, all the way down to the naked, unpainted surface.

I can't say that the conversation produced a deep interpretation of these lozenges; it succeeded only in elaborating a collective description of these

figures as secondary abstractions, signifiers of the basic spatial unit in the overall composition, extracted and subtracted as distinct elements: the red patches as positive "attachments," the white as an absence or blank. If we had gone on, we would certainly have discussed the painting's play on the "grids" of both perspective and modernism, its ability to let contrary readings (clarity/obscurity, stationary pattern/transverse movement) wash over the image. As art-historical initiates, we might eventually have gotten around to potential references in the canon of high modernism, seeing the picture as a recollection of Malevich's *Red and Black Squares* in the age of video. As theorists of art and visuality, we might have questioned a mere "coincidence" in the presence of the diamond-shaped lozenge as an abstract token of elemental structure in the Feinstein and as an abstract icon of the eye in Sven Dalsgaard's *Bagage*. This *losange* (fig. 50), as Lacan terms it, is a basic topological figure in the dialectic of vision and desire. It is a linear, geometrical reduction of the "rim" of the orifice, the gateway of the organ, the opening between the organism and the world, through which the drives, or "pulsions" (oral, anal, genital, scopic), ebb and flow. In the scopic drive, the losange is the threshold across which light and vision cross and circulate, a reminder not only of the perspectival rendering of tiled surfaces, but of diamond-paned windows and the visual pleasures they provide. It is the *punctum*, or wound, in both compositions: the hook that arrests the beholder, activates the picture, and allows it to look back.

The sort of contemplative, concentrated seeing demanded by abstraction needn't be associated with a regression to empathy, sentimentality, and (heaven forbid) private, bourgeois subjectivity. The democratizing of abstraction, its availability as a vernacular artistic tradition, offers access to a space of intimacy in which new collective and public subjectivities might be nurtured. This intimacy isn't in itself a politics. It won't save the NEA, much less bring down the New Right or stop the killing in Israel/Palestine. Its operations and aspirations will have to be quiet, modest, and patient. Its apologists will have be willing to listen to the uninitiated, not just lecture them. If the picture speaks Danish, someone will have to translate for us; if it depends on ironic, knowing allusions to special knowledges, they will have to be explained. Abstraction will serve us best, in other words, if it takes Milton's advice to himself, resigning itself to "stand and wait," not for an artistic messiah, but for a new community of beholders and new forms of intimacy made possible by a very old artistic tradition. There might even be new occasions for transcendence and utopia in such experiences, and

FIGURE 50 Lacan's *Losange,* a basic topological figure in the dialectic of vision and desire. Digital Media Laboratory, University of Chicago.

they might take us back, as Charles Altieri has suggested to me, with a new eye for the intimacy of Malevich, and the compatibility of intimacy and heroism more generally.[17]

Now, it has been pointed out to me that this entire theory of abstraction and intimacy may actually be based on nothing more than my own personal limitations. That is, it is just because I am so poor at immediate, unmediated intimacy that I need an object, an image, a plaything to establish social relationships. If so, this is a lack I no doubt share with many other people, and in any case, theories are always based on a lack or deficiency of some sort. We theorize in order to fill a void in thought, we speculate because we don't have an explanation or narrative; and so we cast a hypothetical net into the sea and see what swims into it.

And it is true that I see best with four eyes on the object, my own and someone else's. I see best with a voice by my side, and I confess to being one of those people who dutifully take audio tours at museums. Imagine my delight at the MoMA show The Museum as Muse to find the audio tour itself turned into a work of art by Canadian artist Janet Cardiff (complete with the rustle of background noise, fading sounds of docents conducting live tours, the echo of footsteps—a whole second sound world, with all its distractions, to overlay the actual sound world of the social space in which art appears),[18] made especially for MoMA and this exhibition.

But perhaps the most literal presentation of the contemporary link between abstraction and intimacy has appeared not in the museum but on

17. E-mail letter, May 19, 1997. We would also want to revisit Vuillard and the intimists, not only for their practice as painters but their sense of audience.

18. Janet Cardiff is a Canadian artist who resides in Lethbridge, Alberta.

the stage. I'm thinking of *Art*, a play by Yazmina Reza that treats an abstract painting as the central focus of dialogue and dramatic action.[19] This play brings abstract painting out of the gallery and the museum and into the private sphere as an object of private ownership and the subject of a crisis in the relations among three old friends. In the process, it explores the three ways of addressing abstraction I have been invoking: (1) a fetishistic, eroticized relation, filled with obsession and anxiety; (2) a heroic, utopian, and transcendental relation, verging on idolatry; and (3) an intimate relation, one of friendship or kinship—what I want to call "totemic," an understanding of the work of art as what Coleridge called a "companionable form," a kind of silent-witness figure.[20]

As the play opens, three old friends, Serge, Mark, and Ivan, convene to celebrate Serge's purchase of an all-white painting for 200,000 francs. Serge is the complete aesthete, seemingly confident of the value of this work by a fashionable artist, and ready to discuss it in relation to art theory, even deconstruction. Mark is his (former) mentor and father figure, who calls the painting "shit" when he first sees it, and provokes a heated argument. Ivan is the ambivalent middleman in the triangle. At his first sight of the painting he expresses cautious approval, but withholds comment until Serge breaks into uproarious, self-doubting laughter at the fact that he has spent so much money on this piece. Each man also has his own painting: Mark has a classical landscape in his apartment; Ivan has a kitsch still-life "motel painting" that was painted by his father, so the triangle is further elaborated as the modernist vs. the classicist vs. the sentimental souvenir collector. The three friends pair up in various combinations to discuss the object, and as the anger escalates it appears that their friendship is in danger of breaking up. Finally, Serge offers to let Mark disfigure the painting with a blue Magic Marker as a tacit way of indicating that his friend is worth more to him than the painting. Mark draws a corner-to-corner diagonal and a stick figure of a skier racing downhill (at the performance I attended, the audience burst into gasps of horror at this vandalism). In the final scene,

19. *Art* received the 1998 Tony Award for Best Play. Other plays by Reza include *A Strong Blood, Death of Gaspard Hauser, The Year 1000, The Trap of the Jellyfish,* and *The Nightwatchman.*

20. I borrow this concept from Jonathan Bordo. See his "Picture and Witness at the Site of Wilderness," in *Landscape and Power,* ed. W. J. T. Mitchell, 2nd ed. (Chicago: University of Chicago Press, 2002), 291–315.

the friends have gathered for a meal in front of the painting and are washing off the (fortunately washable) Magic Marker. They hang up the canvas, and the play concludes with a soliloquy from Mark, a lyrical comment on the painting as a landscape that has been traversed by a skier who has disappeared.

Art is a wonderful treatment of the notion of an artwork as a social, dialogical object. It moves through the three forms of hypervalued object relations I have described, beginning as a fetish object (specifically a commodity fetish, with its inflated exchange value) and thus, conversely, as a despised obscenity, a filthy waste product (Mark's assessment of it as "shit"). It then evolves into an idol (Mark explicitly calls it this when he complains that the painting has replaced him as Serge's father figure), and finally into a totem (when it becomes a sacrificial object, disfigured and repurified as the focus of a communal feast). The picture is also a stand-in for the absent women in the play: like a woman, it plays the silent mediator "between men," a medium of exchange that provokes and finally settles a crisis in their relationship. As a white, blank tabula rasa, it plays the role of empty signifier, self-referential "Thing," and "hollow" icon, waiting to be filled with narrative, discourse, open to activation by description and ekphrasis. As a companionable form, it provokes a crisis within an intimate brotherhood of beholders, and finally becomes the occasion and witness to the restoration of amity and intimacy.

The magic of Reza's play is, I think, its successful negotiation of the radically disparate valuations available to abstract painting at the present time. The occasion of contempt, studied indifference, and a longing for utopian transcendence, the painting finally emerges as the quiet hero—or, perhaps, the heroine—of *Art*. It testifies in silent eloquence to the continued viability of one of the oldest art forms in the world in a time of reduced expectations.

The antiquity of abstraction takes us back to what is perhaps the most notable example of an "emergent" school of abstract painting in our time, namely, the work of the Australian aborigines. Of course, to call this sort of painting "abstract" is immediately to invite the rejoinder that this is an inappropriate term for painting that is highly figurative, narrative, and filled with references to real or imaginary places and persons. If abstract painting means "pure painting," referring only to the medium, then Aboriginal painting is decidedly impure and unabstract. Nevertheless, there is no denying what art historian Terry Smith has pointed out about this work: its in-

ternational circulation and commodification beyond the tourist trade and into the art world is largely due to its visual resemblance to abstract painting. Aboriginal painting appeals to Western eyes trained on geometrical and painterly abstraction, not to mention (out of embarrassment) various forms of what Europeans used to call "primitivism." Aboriginal painting offers a range of pure optical pleasures—complex patterning, vivid color, virtuosic brushwork—with the added value of mystique, authenticity, and the aura not just of the "original" but of the "aboriginal." Every purchaser of an Aboriginal painting becomes an initiate in a story specific to that painting—even if it had to be fabricated on the spot.

It is possible, then, to be ironic about the cult of Aboriginal painting, the hushed tones of sacredness that surround it. The spilt religiosity, the strangeness of buying other people's religious images and using them as decorations for bourgeois interiors, is too evident to require belaboring. I bring this up not to debunk Aboriginal painting but to remain mindful of the potential for corruption in an art that is so entangled with questions of politics, identity, the marketplace, the dealer-critic system, and the tourist trade. Aboriginal painting is not exactly commodity fetishism; a better term would be "commodity totemism," because what it offers is not a lost body part but a lost community and a loss of locatedness. Aboriginal painting expresses a remarkably stubborn resistance to the disappearance of these things in its fixation on place and identity. This feels like a value beyond the pictures, but one which is manifested by their disproportionate importance in Australian culture. Aborigines are, after all, less than 2 percent of the population of Australia. But their cultural presence, their visibility on the international stage, especially as manifested by their art, exerts a kind of dominance over Australia's self-image in the postcolonial era. The most abused, disrespected, and systematically despised of the British Empire's "lower peoples" turns out to play a critical international role in the late twentieth and early twenty-first centuries' annals of artistic style, fashion, and taste. What is going on here?

Well, perhaps lots of fraud, bad faith, and chicanery. But also some fabulous achievements in the art of painting, as measured by the most demanding standards. A substantial number of major Aboriginal artists in recent decades—Rover Thomas, Kathleen Petyarre, Turkey Tolson (recently deceased), to name a few—have managed to produce remarkable works that fit recognizably within what is arguably the oldest unbroken painting tradition on the planet while producing innovations and technical surprises

within that tradition.[21] Rover Thomas's black-on-brown abstractions with white dot outlines, for instance, use natural pigments that have been employed for thousands of years to create striking figures whose inner space vibrates between readability as body and void. Mawalan Marika (with help from his friends and relatives) transfers the patterns of body-painting rituals (fig. 51) to bark to map his plane flight from the Central Desert region to Sydney. Turkey Tolson (plate 10) produces shimmering horizontal linear abstractions from the ritual of spear-sharpening in preparation for battle (according to the legendary basis of this painting, the two tribes became so interested in sharpening their spears that they forgot to go to war). Paddy Tjapaltjarri's *Witchetty Grub Dreaming at Kunajarrayi* overlays the spatial configurations of mapping, tracking, and hunting-gathering with vividly colored narrative tracks that document an entire region's collective life. Kathleen Petyarre's *Storm in Atnangker Country II* (plate 11) maps a region, a convergence, an event, and the oceanic sense of the vast desert marked only by the repetition of dune ridges and hollows. Emily Kame Kngwarreye (fig. 52) transforms the familiar dot technique of delineation into a thicket of expressive motions and flashing lights. In short, what we are dealing with here is a painting style thoroughly imbued with virtuosity, but demonstrating almost nothing in the way of iconoclasm. Aboriginal artists have no interest, so far as I can tell, in smashing images or overcoming them. The point is repetition and variation, ritual performance and improvisation.

Looking at Aboriginal painting, then, is like watching basketball in the United States. It ranges all the way from the competent average to the brilliant playground performance to the highest feats of professional virtuosity. This is the advantage of having established an immemorial vocabulary of forms, all highly ambiguous in significance, that can be pursued through an infinite variety of modulations and innovations—sometimes subtle, sometimes startling and dramatic. The basic pattern of much Central Desert painting, for instance, is the familiar "path and site" format—lines and circles that can designate song lines, storylines, pathways, geographical features, and animal trails between such sites as waterholes, canyons,

21. An exemplary critique of the special values embedded in Aboriginal painting is provided by Terry Smith in his discussion of Emily Kame Kngwarreye, "Kngwarreye Woman Abstract Painter," in *Emily Kame Kngwarreye*, ed. Jennifer Isaacs (Sydney: Craftsman House, 1998), 24–42. Smith traces the complex negotiations between tradition and modernity, the colonized and the colonizer, local gifts and international markets that make Aboriginal painting—especially abstract painting—such a fraught business.

FIGURE 51

Mawalan Marika, Wandjuk Marika, Mathaman Marika, and Woreimo (language group: Rir-ratjingu; community center: Yirrkala, NT), *Djan'kawu Creation Story* (other title *Djan'kawu Myth no. 1*), 1959. Natural pigments on bark, 191.8 × 69.8 cm (irreg.). Art Gallery of New South Wales, Sydney, gift of Dr. Stuart Scougall, 1959, acc. #P64.1959. © 2003 Artists Rights Society (ARS), New York / VISCOPY, Australia. Photograph by Christopher Snee for AGNSW.

FIGURE 52

Emily Kame Kngwarreye, single panel from the 22-panel *Alhalkere Suite*, 1993. National Gallery of Australia, Canberra. © 2003 Artists Rights Society (ARS), New York / VISCOPY, Australia.

caves, sacred ritual spots, secret places, and landmarks. These forms can be elaborated in abstract figures and patterns executed in a wide variety of materials.

This format is given a startlingly novel elaboration in a painting (plate 12) by a young artist named Abie Kemarre Loy from the Desert town auspiciously known as Utopia. The composition, based on traditions of

women's body painting, references a variety of vegetative and geographic forms and is executed with a sense of touch and color that is, to my jaundiced eye, fresh and vibrant. The painting, in short, is alive, comes alive as it is beheld. It vibrates with shimmering, sliding strata of color that pull past one another like a geological fault, folding inward and circling off to infinity. It is incredibly simple and striking in its basic formal organization, absolutely ambiguous as to its scale as a leaf pattern or a canyon.

And then there is, up close and at a distance, the dance of the brushstrokes themselves. We can almost see them being made as the 6-by-4-foot surface is stretched on the ground and the painter moves across it in long, sure gestures, punctuated by a kind of pulsing line that threatens to become a series of dots. We also notice that at somewhat regular intervals the brush has started to go dry, thinning the texture of the paint, setting up a secondary pulsation in each line, which is then echoed in the adjacent cluster of lines. The effect of this from a distance is the appearance of a ghostly landscape of rolling contours, wavy and hilly, appearing through a mist which somehow floats behind the surface grid of strongly colored lines; and bands of lines grouped, intermingled at intervals that invite a sense of regularity and defy it at the same time. This artist has something to say about op, and about formal and coloristic effects.

All in all, a fabulous painting. But it does not stand alone on a mountaintop. It grows out of a deep tradition that is, in principle, bottomless and yet right there to be seen by the non-Aboriginal beholder (if such a category makes any sense). The painting's form comes from Abie Loy's father, who has instructed her in the obligations that go with it. She is the granddaughter of Kathleen Petyarre, one of the most brilliant of the Utopian Women painters. You don't produce this kind of painting by negating some previous kind of painting. It grows out of women's batik painting, and an (often desperate) sense of place, community, and necessity. The painting tradition, after all, was rooted in a relation to the Australian desert that required every single living thing to be identified, described, and understood, simply as a way to stay alive in the hostile environment. When there was no water, you had to know where to dig up hibernating frogs and suck the water out of their bodies; which berries to eat when; and what those berries mean to the kangaroo.

Now the painting is once again a critical survival strategy for Aboriginal communities. It goes from mapping the local place to entering into the international art market, traveling beyond tourist art to join the company of

masterpieces of the medium, especially in its tendency toward abstraction. There is something fitting about the commodification of Aboriginal art. It testifies to the enduring power of a traditional medium, its ability to find new vocations, new modes of survival. It's no wonder that Western eyes, trained on the iconoclastic gestures of high modernist abstraction, find something comforting, intimate, and even necessary about this painting. Iconoclastic abstraction is dead. Long live abstract painting.

What Sculpture Wants
Placing Antony Gormley

The continuation into the twentieth century of a traditional treatment of the human figure is not given a place in these pages.

ROSALIND KRAUSS, Passages in Modern Sculpture *(1977)*

Sculpture: the embodiment of the truth of Being in its work of instituting places.

MARTIN HEIDEGGER, *"Art and Space" (1969)*

It is undeniable that from man, as from a perfect model, statues and pieces of sculpture . . . were first derived. GIORGIO VASARI, Lives of the Artists *(1568)*

After architecture, sculpture is the most ancient, conservative, and intractable of the media. "The material in which God worked to fashion the first man was a lump of clay," notes Vasari, and the result was a kind of defiant self-portrait, since God took himself as the model and formed Adam (or Adam and Eve together) "in his image" (fig. 53). You know the rest of the story. God breathes life into the clay figures. They have minds of their own, rebel against their Creator, and are punished for it by being condemned to leave their paradisal home and work all their lives, only to die and return to the shapeless matter from which they emerged. Variations of this myth appear in many cultures and materials: Prometheus's creation of man from clay; the Jewish Golem; the clay statuettes animated by the Great Spirit in Hopi legend; Pygmalion falling in love with his own statue; "the modern Prometheus," Dr. Frankenstein, who uses dead bodies as material for his re-

bellious creatures; the metallic humanoids of contemporary science fiction, the "posthuman" creatures known as robots and cyborgs (fig. 54).

There is a kind of circular process at work here. Man is both the sculpted object and the sculpting agent, both created as and creator of sculpted images. God introduces man and other creatures into the world by means of the art of sculpture. Then man brings sculpture (and gods) into the world by creating material images of himself and other creatures. The dangerous moment, of course, is always the moment of animation, when the sculpted object takes on "a life of its own." The God of monotheism, the deity of Judaism, Christianity, and Islam, understands that image-making as such is a dangerous business, and establishes an absolute prohibition on it. Let me quote once again the words of the second commandment:

Thou shalt not make unto thee any graven image, or any likeness of any thing that is in heaven above, or that is in the earth beneath, or that is in the water under the earth. Thou shalt not bow down thyself to them, nor serve them: for I the Lord thy God am a jealous God, visiting the iniquity of the fathers upon the children unto the third and fourth generation of them that hate me; And shewing mercy unto thousands of them that love me, and keep my commandments. (Exod. 20:4–6 [KJV])

This is not some minor prohibition. It is the absolutely foundational commandment, the one that marks the boundary between the faithful and the pagans, the chosen people and the gentiles. Its violation (which seems all but inevitable) is the occasion for terrible punishment, as the episode of the golden calf suggests. When Aaron, the Hebrews' master sculptor, sets up the calf as a god to "go before" the Israelites in place of their lost leader, Moses, God commands the destruction of the statue and the massacre of some three thousand of his people. Idolatry is the one sin that God cannot forgive, since it is a direct threat to his status as the one and only god, and therefore the one and only being capable of creating living images. Man is prohibited from making images just as surely as he was prohibited from eating from the tree of knowledge, and for the same reason. Image-making, like thinking for yourself, is a dangerously godlike activity.

Vasari understood that this story spelled trouble for the arts, and especially the art of sculpture. So he resorts to a familiar distinction: "it was the worship given to statues, not the making of them, which was wickedly sinful."[1] Vasari then cites the usual precedents: "the art of design and of

1. Giorgio Vasari, *Lives of the Artists* [1568], vol. 1, trans. George Bull (London: Penguin Books, 1965), 25.

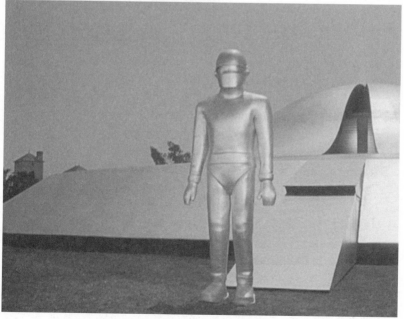

sculpture, in all kinds of metal as well as marble, was taught by God. . . . They made the two golden cherubim, the candlesticks, and the veil, and the hems of the sacerdotal vestments, all the beautiful casts for the Tabernacle" (1:26–27). He finesses the question of images of the human form, and ignores (as he must) the clear language of the second commandment, which prohibits "the making" of statues as such, not just the worship of them. I have remarked previously on the slippery-slope principle at work: if one allows human beings to make statues or images of any kind, the images will sooner or later take on a life of their own, and ultimately become objects of worship. Better to stop the whole process at its origin, or insist on arts that refuse all image-making, figuration, or representation, arts of pure ornamentation or abstraction. Sculpture, especially that modeled on the human body, is not only the first but also the most dangerous of the arts. It impiously elevates the human image to the status of a god, reifies mortal men into immortal idols, and degrades spirit into dead matter. Sometimes it seems as if sculpture achieves its truest vocation not when it is erected but when it is pulled down (plate 13).

Let us fast-forward now to the present day, when these archaic and mythical taboos on sculpture seem at best a faint and distant memory. What place does sculpture have in the contemporary system of the arts? Has it been swallowed up, along with photography, painting, collage, and technical media, into an overarching art of spectacle, display, installation, and environmental design, a mediascape of infinitely malleable and dematerialized images? Or does it have a distinctive role to play as a specific medium linked with its immeasurably long and deep history? What role, more specifically, does sculpture oriented toward the human body have to play in our time?

Certainly sculpture played a key role in the unfolding of artistic modernism and postmodernism. Every abstract movement in modern painting had its sculptural counterpart. Minimalist sculpture and the readymade even dared to challenge painting in its quest for supremacy in the negation of figuration and representation. Sculpture in the sixties expressed concerns, as sculptor Robert Morris put it, "not only distinct but hostile to those of painting."[2] Paintings, as Michael Fried laments, began to take on "objecthood," asserting their three-dimensional physical presence in real

2. Quoted in W. J. T. Mitchell, *Picture Theory* (Chicago: University of Chicago Press, 1994), 243.

space, or becoming themselves something like cabinets for the storage of more objects of three-dimensional manipulation.

But sculpture, whether it obeyed Fried's modernist imperative (exemplified by David Smith and Anthony Caro) of virtuality, opticality, gestural significance, and antitheatrical autonomy or asserted itself in what Rosalind Krauss called its "expanded field," has still seemed to many a kind of homeless art. Does it belong in a sculpture garden? A special wing of the museum? Next to an architectural monument, like the parsley garnish next to a roast? An ornament to the public plaza as an invisible prop, like the typical work of "public art"? An obtrusive barrier, like Richard Serra's *Tilted Arc* (fig. 55)? Or off in the wilderness, a disappeared monument, like Robert Smithson's *Spiral Jetty* (fig. 56)?

The question of place, site, or location has always been a central issue for sculpture. Unlike painting, it normally does not carry its frame with it, and is thus much more sensitive to issues of placement. It does not project a virtual space, opening a window into immensity as, say, landscape painting does; it *takes up* space, moves in and occupies a site, obtruding on it or changing it. It risks failure on two fronts, by being too obtrusive (Serra) or too passive (the statue as perch for pigeons). There seems to be an ideal middle place, a utopia for sculpture, hinted at in the notion of genius loci, the spirit of the place embodied in some sculptural figure[3] that seems to belong to the place, express its inner being, and "activate" the place by incarnating its special character.

But this notion of sculpture as rooted in a specific place, organically connected with its site, seems like an archaic and nostalgic residue, perhaps appropriate for a primitive sedentary society deeply connected to the land. It reeks of Heideggerian mysticism, of clearings in the wilderness, "the release of places at which a god appears."[4] What possible application could it have for modern cultures caught up in vortices of mobility, flow, and instantaneous global communication?

Antony Gormley's sculpture strikes me as important for our moment and his medium precisely because it constitutes a profound reflection on the *place* of and as sculpture—not only its physical and institutional sites,

3. "Sculpture would not deal with space. . . . Sculpture would be the embodiment of places." Martin Heidegger, "Die Kunst und der Raum" (St. Gallen: Erker Verlag, 1969), trans. Charles Seibert as "Art and Space," *Man and World* 1 (1973): 3–7.

4. Martin Heidegger, "Art and Space," 7.

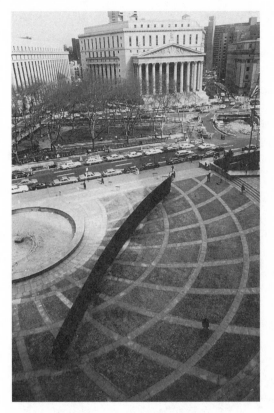

FIGURE 55
Richard Serra, *Tilted Arc*, 1981;
overhead view of installation,
Federal Plaza, New York City.
© 2003 Richard Serra. Photo-
graph courtesy Richard Serra.

its location among the arts and media, but also the sculptural work as itself
a place or space as well as an object in space. As Heidegger puts it, "things
themselves are places and do not merely belong to a place" (6). This is es-
pecially true when the *thing* is a human body or a sculptural representation
of it. The human body is the most highly charged place in our experience.
It is at once an inescapable prison and the portal to every conceivable flight
of fantasy. Like sculpture itself, it is ancient, intractable, and conservative,
yet capable of being refashioned, altered, and sculpted.

 Gormley's work gives profound expression to the question of what
sculpture wants—that is, both what it desires or longs for, and what it
lacks—in our time and (as I shall argue) in any time whatsoever. What
sculpture wants is a place, a site, a location both literally and figuratively,
and Gormley's work provides a profound expression of this longing for
space. Like the naked human body which is its first model, it is both a

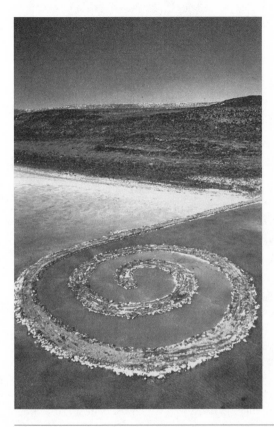

FIGURE 56
Robert Smithson, *Spiral Jetty,*
1970; aerial view of installation,
Great Salt Lake, Utah. Black
rock, salt crystals, earth, and
red water (algae), 3½ × 15 ×
1,500'. Estate of Robert Smith-
son, courtesy James Cohan
Gallery, New York. Collection:
DIA Center for the Arts, New
York. Photograph by Gian-
franco Gorgoni. Art © Estate
of Robert Smithson/Licensed
by VAGA, New York, NY.

homeless wanderer, an exile from the Edenic utopia where it was the genius
of the place, and itself the home that it can never completely abandon.
Sculpture wants a place to be *and* to be a place.

I know that these remarks convict me on at least two fronts of being out
of step with contemporary thinking about the arts and many other matters.
First, by attributing desires to sculpture, to a medium and to the specific
images that appear within it, I seem to be flirting with a form of animism
or totemism, personifying inanimate objects as well as the entire set of
practices (the medium) in which those objects are produced.[5] Second, by
suggesting that there is a transcendental or at least abiding set of problems
associated with the medium of sculpture, I may seem to be lapsing into an

5. See my essay, "What Do Pictures *Really* Want?" in *October* 77 (Summer 1996): 71–82 for
further reflections on the question of desire and lack in representational forms.

ahistorical formalism. The reader will have to trust me for the moment that my position is not quite that simple. My real conviction is that it is only by risking the exploration of the deeply abiding conditions of an artistic medium that we can hope to specify its historical modulations with any precision.[6] And only by exploring the human attribution of agency, aura, personhood, and animacy to artificial objects can we hope to understand those objects, the media in which they appear, and the effects they have on beholders.

Statues: Sculpture as Place

Statue n. L. statua, *f.* sta-, *root of* stare *to stand. . . . 1. A representation in the round of a living being, sculptured, moulded, or cast in marble, metal, plaster or the like materials; esp. a figure of a deity, allegorical personage, or eminent person, usually of life-size proportions. Also transf. and* similitave, *as a type of silence or absence of movement or feeling. (OED)*

Gormley's importance begins with his insistence on taking the human body—specifically, his own body—as his principal subject matter. This may seem so obvious as to require no notice. But it is, from the standpoint of advanced, sophisticated thinking in the art world in the twenty-first century, something like a polemical gesture. For an entire century, the most important sculpture had been more or less abstract, rendering the human body as an object to be deformed, extruded, deconstructed, fragmented, or mutilated. There is no "human" body anymore: there is the gendered body, the desiring body, the racialized body, the medical body, the sculpted body, the techno-body, the body in pain or pleasure. The human body has come to seem like an infinitely malleable assemblage of prostheses and spare parts, an expression of a "posthuman" sensibility and a "cyborg" consciousness.[7] The ideal form of the integral body—especially of the white,

6. I am especially concerned to avoid the kind of historicism (marked by the "post-" and the "pre-") that reduces the history of an art or medium to two phases separated by a "rupture," which is located in the period that just happens to correspond to the historian's field of specialization. For more on this, see "The Pictorial Turn," in Mitchell, *Picture Theory,* especially pp. 22–23.

7. See Katherine Hayles, *How We Became Posthuman: Virtual Bodies in Cybernetics, Literature, and Informatics* (Chicago: University of Chicago Press, 1999); and Donna Haraway, "Manifesto for Cyborgs," in *Simians, Cyborgs, and Women* (Routledge, 1991).

male body—as expressed in all those familiar diagrams of Renaissance and Romantic humanism (figs. 57, 58) has seemed like an archaism or an exploded ideology to be surpassed or, even worse, a reminder of patriarchal idols and fascist monumentalism that we can do without. A casual encounter with Gormley's work, especially with the castings of his own body for which he is best known, is likely to provoke a snap judgment that his project is retrograde, redundant, a step backward into figurative sculpture, and an outmoded humanism, masculinism, and egotism. An early admirer "didn't dare tell anybody" how much he liked Gormley's statues, because he "thought they were very unfashionable."[8] And indeed, they were and are. How dare a contemporary sculptor, in full knowledge of a century of sculptural experimentation which from constructivism to minimalism has renounced the "statue," simply turn back to the human body, much less *his own* body, as subject, model, and content of his art? Antony Gormley has taken this dare. The results are worth looking at and thinking about.

The first dare is the risk of what Judith Butler calls "gender trouble." How can we "place" the sexual identity of Gormley's statues? Gormley makes castings of his own unambiguously male body. They are sites of male identification, with phallic marks sometimes accentuated (fig. 59). Gormley also has the good (or bad) fortune to possess a rather beautiful, "sculpturesque" body that inevitably reminds a beholder of the male body as the archaic figure of the idealized, normative human form—the very image that allows us to say "man" or "mankind" when we really mean "human." The primal scene of sculpture in the book of Genesis reinforces this sort of association: the creation of "man" as the original creative act of the divine artist, the creation of woman as a kind of surgical dismemberment of the male body. The female body is not, in the first instance, sculpted but encased inside the male, to be delivered from the male "womb" by a kind of Caesarean section. Adam is the first sculptural production; Eve, the first reproduction. Man is made, woman is born.

Gormley's work complicates these stereotypes by activating the distinction between sex and gender at both the level of visual appearance (as in the figure with the erect penis) and in the productive processes that "engender" the sculpted object. It is a standard doctrine of feminist theory, notes Judith Butler, that "whatever biological intractability sex appears to have, gender is culturally constructed. *Man* and *masculine* might just as easily

8. Quoted in Antony Gormley, *Critical Mass* (Vienna: Verein Stadtraum Remise, 1995), 7.

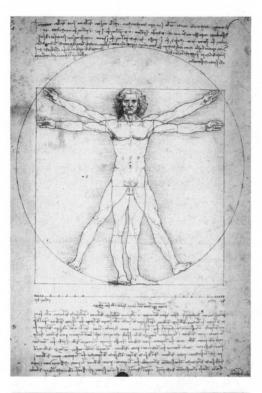

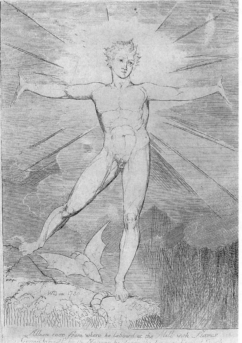

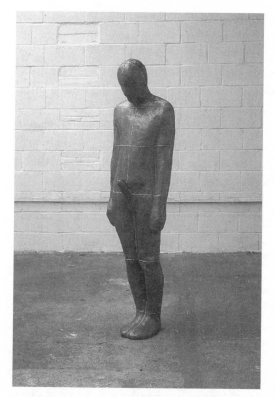

FIGURE 59 Antony Gormley, *Peer*, 1984. Courtesy of the artist.

signify a female body as a male one, and *woman* and *feminine* a male body as easily as a female one."[9] If Gormley's sculpted figures are "intractably" coded as biologically male, their postures evoke the feminine codes of passivity, vulnerability, abjection, and receptivity. One might say that Gormley has a male body but uses it to express feminine (not to mention feminist) attitudes. Or that his figures express mixed messages about the relation of sex and gender, the "intractable" facts of the material, biological body and its "constructed" cultural form. More fundamentally, I think his work deconstructs (while evoking) the differences between sex and gender, nature and culture. How, after all, do we know that the penis "belongs to" the male of the species? Is the possession of a penis necessary or sufficient for "manhood" or masculinity? Once the dialectic of sex and gender has been un-

9. Judith Butler, *Bodies That Matter* (New York: Routledge, 1993), 6.

leashed, as it is in Gormley's body sculptures, it is not so easily stabilized. "As a result," Butler argues, "gender is not to culture as sex is to nature; gender is also the discursive/cultural means by which 'sexed nature' or 'a natural sex' is produced and established as 'prediscursive'" (67). Gormley makes visible the way the murmur of discourse is woven into the natural materiality of the human body and its sculptural traces.

An even more fundamental issue is the distinction between the gendering and *engendering* of human bodies. Real human bodies are both gendered and engendered. They are marked and re-marked by sexual difference and gender identity. But they are produced and reproduced by the interplay of bodies, even by a kind of autopoiesis in the case of cloning or parthenogenesis. What about the engendering of sculpture, the processes of its production and reproduction?

There are two traditional ways[10] of making sculpture: carving or molding from the outside (as in the creation of Adam), and casting from the inside out (as in the birth of Eve).[11] Gormley's "corpographs" work in the second mode, casting himself in a full-body life mask of plaster (fig. 60). The resulting "negative" can then be used to cast a positive image in molten metal. The shaping tool is not the hand but the artist's entire body, and it works from within matter, holding open a space within it rather than sculpting away material from outside. He produces a kind of three-dimensional photographic impression—a corpograph is the artist's preferred term—that necessarily (while the plaster is drying) catches the body in a moment of stasis. Gormley affirms and redoubles this stasis by placing his body in resolutely static positions, enduring the entombment in plaster by using Buddhist techniques of breathing and meditation. The resulting figures are steadfastly motionless. They are holding a pose, seated, crouched, supine, spread-eagled, or standing erect, suspended in meditative stillness.

10. I put to the side for the moment a "third way" that works by assembly and construction.

11. If we locate the Adam and Eve analogy at the intersection of gender and engendering, we would have to say that while Adam is the first man from the standpoint of gender, he is also mother of Eve from the standpoint of engendering. These ambiguities of gender and reproduction are made marvelously complex in films like the *Alien* trilogy, which render the alien as an egg-laying dragon queen who implants her hatchlings to "gestate" in the bodies of men and women; or *Invasion of the Body Snatchers*, in which zombielike "pod people" are engendered by a process of vegetative transfer of vital fluids through vines and tendrils. See Klaus Theweleit on the uncanny resemblance between some of Gormley's sculpture and the deadly pods in *Gormley Theweleit* (Schleswig: Holsteinschen Kunstverein, 1997), 59, 113.

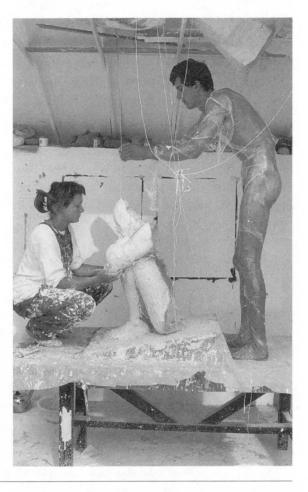

Like the minimalist objects which are among their sculptural ancestors, they refuse all gesture or narrative syntax, forcing the spectator's attention back onto a specific object, this body, understood as a place, a space where someone has lived.[12]

This procedure is so simple and obvious that it seems a wonder that no one had ever quite thought of doing it before. Casting the whole body as a

12. One reason the tradition of assembled or constructed sculpture (David Smith, Anthony Caro, cubist and surrealist sculpture) seems antithetical to Gormley's practice is that it almost inevitably produces a sense of gesture and syntax in the figure, making it a body that *acts* in space rather than simply "being there," which is, I take it, Gormley's aim, and one of

life (or death) mask, the self-portrait, the monumentalizing of the human form in the static, standing figure—literally, the statue—all these resources had been available to sculpture, but never combined in quite this way. Why not? Perhaps because the results are visually subtle, even misleading: the casual observer may not know that these are casts of the artist's body, and take them simply as generic figurative representations that seem "old-fashioned" in their archaism and simplicity. Perhaps also because sophisticated viewers dismiss the product for presenting the "wrong look," no matter how original the process might be. This may be why Gormley often seems to be in the position of denying what seems like a self-evident appearance of his work. He claims that he "was never really interested in figurative sculpture per se"[13] or even in "representation" or copying more generally. My own view is that his work is thoroughly mimetic and representational, but not of the human body as a narrative agent or actor; instead, the body is portrayed as a purely contemplative figure of witnessing and enduring in poses of suspended animation. Gormley subjects the processes of sculptural representation to a critical reshaping, so that the apparently familiar, recognizable results (life-size anthropomorphic statues, most notably) radiate a strange sense of inward animation and sentient presence that is the abiding goal of (and phobia about) sculpture. Gormley's figurative statues are "uncanny" in Freud's sense of the word. That is, they are not visibly weird or grotesque but "strangely familiar," both masculine and feminine, *heimlich* and *unheimlich*, homely and homeless. We have always known sculpture could do and has been doing this. Why did it wait till this moment to make its appearance?

There is a systematic doubleness, a perceptual double-take, then, that accompanies the experience of Gormley's statues. They are what Walter Benjamin called "dialectical images," deeply ambiguous figures that fuse contrary forms of affect and interpretation, risking misapprehension so thoroughly that the artist may even seem to be "in denial" about what is most manifest and obvious about them. There is nothing wrong with this. Artists' intentions never fully determine the meaning of a work, any more than critical interpretations do. If they did, we could dispense with the

the features of his work that most firmly links him to minimalism. One thinks here of Robert Morris's "I-Box," depicting the naked body of the artist in a sculpted metal box with the letter *I* as a door.

13. Gormley, *Critical Mass*, 164.

work and just listen to what the artist has to say. Interviews could take the place of sculpture.

But Gormley is quite aware that his own work is no mere communication of messages he might want to send. He stresses, in fact, that the process involves a necessary descent into blindness and unknowing. Unlike a sculptor who steps back and looks at his work from outside as he carves it from stone, Gormley immerses himself in the material, encases himself, buries himself alive. He only sees what he has produced after the fact, at which point he has the option of going on with it, casting it further, or casting it aside.

What Gormley shows us, then, is that the body is a place, and that sculpture reveals the shape of that place, the invisible interior space where someone lives or has lived. That place is represented as a positive form, a "statue" that has to be seen as embodied darkness (hence, I think, the frequent use of lead as material).[14] The place of the body is also indicated as an absence, a negative impression or void, as in *Bed* (fig. 61), or the implied interior of an architectural or biomorphic "case," as in *Sense, Flesh,* or *Fruit.* In these latter "cases," the sculptural object may remind us of a tomb or a womb, a casket or a seed pod in which the body is gestating. In either case, there is a sense of an impassive, almost featureless exterior hiding an explosive interior, much like the structure of a bomb.[15]

Inert or explosive objects, dead or living things, industrial relics or paleontological fossils, individual or generic bodies, gendered or engendered identities, persons or places, archaic or contemporary works of art: the strange power of what I have called Gormley's "statues" resides in the irresolvable tensions they activate among these alternative ways of "seeing as." But this is still only half (at most) of the story. Sculpture wants to be a place, wants to offer us a space for thought and feeling. It provides this place out of its own lack, its abject status or "place" in the hierarchy of the arts as the medium of brute materiality—iron, lead, cement, mud—or (conversely) in its impression of serene detachment in a meditative space beyond desire. But sculpture also wants a place to be, a location or station or site where it can be seen, encountered by other bodies. At this point all the dialectics of

14. I'm reminded here of Marc Quinn's *Self* (1991), a sculptural self-portrait carved in the frozen blood of the artist, shown at the Sensation exhibition at the Royal Academy and the Brooklyn Museum of Art.

15. "The perfect form of sculpture is a bomb," Gormley notes in *Critical Mass,* 162. Cf. my discussion of Robert Morris's "Bomb Sculpture Proposal" in *Picture Theory.*

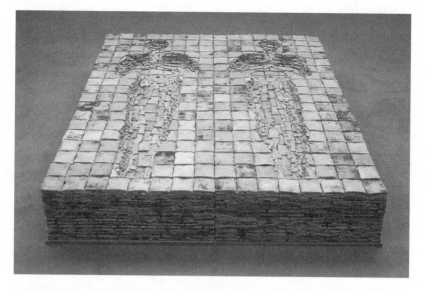

FIGURE 61 Antony Gormley, *Bed*, 1981. Bread and wax sculpture. Courtesy of the artist.

inner and outer form that have been activated in the shaping of a sculptural object are redoubled in the act of its placement in a setting or landscape. The statue has to find a place to stand. This longing for a place is as crucial to what sculpture wants as the desire that haunts the object itself.

Sites: Place as Sculpture

ANECDOTE OF THE JAR

I placed a jar in Tennessee
And round it was, upon a hill.
It made the slovenly wilderness
Surround that hill.

The wilderness rose up to it,
And sprawled around, no longer wild.
The jar was round upon the ground
And tall and of a port in air.
It took dominion everywhere.

The jar was gray and bare.
It did not give of bird or bush,
Like nothing else in Tennessee.

WALLACE STEVENS[16]

If Gormley's sculpted objects are best seen as sites, they are also what Robert Smithson called "non-sites," or displaced places. Like many artists of the sixties, Smithson sought a way of moving out of the space of the gallery into other places—the "wilderness" of the American West, the postindustrial wastelands of New Jersey. He brought back from these places material samples, geological maps, and photographic documentation which reconstituted the gallery or space of exhibition as a non-site, a place defined by its reference to another place. Gormley does something similar, only in reverse. His corpographs are already non-sites in themselves, three-dimensional photographs that refer to the absent space of a body. These non-sites are then transported to a wide variety of places, some traditional locations for sculpture (plazas, squares, architectural settings, museums, galleries) and others in natural settings, most notably the magnificent blankness and expansiveness of the Australian Desert and the tidal mudflats of Cuxhaven, Germany.

Wallace Stevens gives us a sense of the impact of the singular artifact on a place. The lone figure, especially one stationed as a witness or monitory presence, changes the whole sense of a place. As Heidegger suggested, the sculpted object "institutes" the place as a human location, a site of gathering, rather than a mere location. The eloquence and power of the figure seems, moreover, inversely proportional to its dramatic or gestural insistence. It is as if the more passive, noncommittal, and self-absorbed the figure, the more "dominion" it exerts over the space around it.[17] Another way to see this is to ponder the scale of the human figure against the vastness of space. *Another Place* (fig. 62), which places Gormley's figures on the tidal flats of Cuxhaven, clearly evokes the pictorial precedent of Caspar

16. From *The Collected Poems of Wallace Stevens* (New York: Knopf, 1964), 76.

17. I'm reminded here of the contrast between Bob Dylan's and Bruce Springsteen's ways of relating to an audience. Springsteen is a constant whirlwind of energy, passion, and insistence, reaching out directly to the audience. Dylan (far more effectively, in my view) almost seems indifferent to the presence of the audience, focused on some incommunicable relation to his own words and music. Perhaps this is what Michael Fried's categories of "absorption" and "theatricality" really come down to.

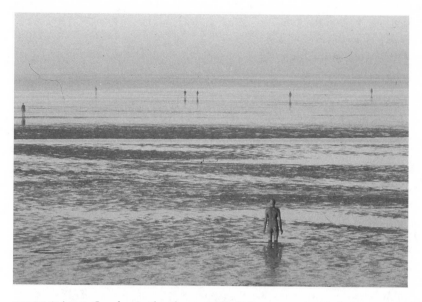

FIGURE 62 Antony Gormley, *Another Place*, 1997; installation over 3 sq. km, Cuxhaven, Germany. Photograph © Helmut Kunde. Courtesy of the artist.

David Friedrich's *Monk by the Sea*. The tiny figure of the monk against the vastness of the beach, sea, and sky may seem at first to declare the insignificance of the figure. But a blink of the eye (or a moment's thought) reverses this impression, turning the landscape into what Gaston Bachelard called an "intimate immensity."[18] The landscape becomes an inscape, an interior space all the more evocative for its blankness.[19]

Another Place is notable, moreover, for the way it complicates the Romantic image of the lone, singular figure contemplating the vast, sublime landscape. In this work, Gormley multiplies the figures (as many as a dozen of them may be seen in a single panoramic photograph), dispersing them at intervals of several hundred yards, all facing out to sea. The effect is of a stately procession into oblivion, as if a platoon of sentinels were pausing on their death march for a final look. The advancing and receding tide must enhance this sense that as the sea rises and falls, the figures are descending

18. Gaston Bachelard, *The Poetics of Space* (1958; Boston: Beacon Press, 1994), chap. 8.

19. See Stephen Bann's evocation of Friedrich's *Monk by the Sea* in "The Raising of Lazarus," in *Antony Gormley* (Malmo-Liverpool-Dublin, 1993), 71.

into or emerging from the sea. Figure and ground each "give away" their motion and stillness to the other.

So while the image of the sculpted figure that, like Stevens's Jar or Friedrich's *Monk*, "[takes] dominion everywhere," dominating and organizing the wilderness, is evoked by Gormley's emplacements, it is not quite what they are after. The effect, I think, is more dialectical and interactive, a mutual dislocation. This is most evident, perhaps, in Gormley's gallery installations, which sometimes recall Robert Morris's technique of reorienting a single minimal object in a variety of positions within the exhibition space, so that a horizontal "slab" becomes a vertical monolith, which in turn becomes a "cloud" suspended from the ceiling (figs. 63, 64).

Although Gormley's work has always been highly sensitive to issues of placement, it does seem as if his site installations in the last decade have been increasingly concerned with addressing the problem of the isolated and monumentalized singular figure. This concern is expressed, I think, in several ways: by a multiplication of figures; by an increasing tendency to breach the boundaries of the integral body; by an enhancement of the sense of "alienness" and homelessness surrounding the figures, an expression of longing for place that remains rigorously and on principle unsatisfied by any particular location. This last effect is perhaps most noticeable in the "street" installations (fig. 65) that station Gormley's figures as if they were vagrants peering into shop windows, or drunks sleeping off the night's excess in the lee of a building. The photographs of interactions of passersby with these figures are most telling; they suggest a kind of intimacy and familiarity coupled with strangeness and dislocation. In contrast with the assertively central placement of the typical public monument (which is, as a consequence, usually ignored), Gormley's "marginal" placements of figures where we would least expect them have the effect of producing a double take, not unlike the shock one sometimes feels on encountering some George Segal figures in a park, or a hyper-realist Bruce Naumann figure or installation. The difference is that Segal depends on gestures of action, and Naumann on a trompe-l'oeil effect, a literal shock at taking something as alive that turns out to be a simulacrum. With Gormley, there is no simulation of the visual appearance of life. They assert their status as statues, affirming the muteness and stillness of sculpture. If his figures "simulate" anything like life, it is a transitional zone of sentience between consciousness and unconsciousness.

Gormley's most dramatic departure from the almost solipsistic focus on

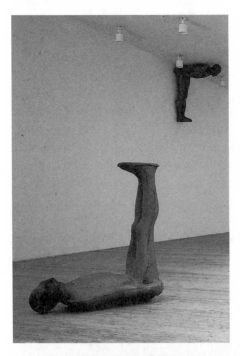

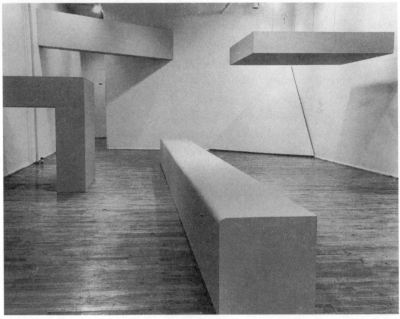

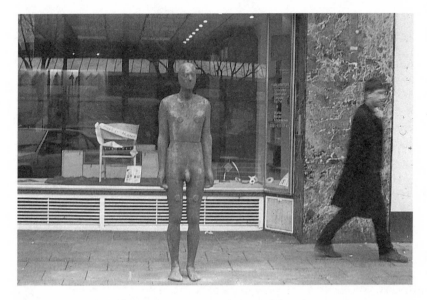

FIGURE 65 Antony Gormley, *Total Strangers*, 1999. Courtesy of the artist.

his own figure isolated in a space has been the series of works known as *Field for the British Isles,* realized in Europe, the United Kingdom, the United States, and Australia (plate 14). This project constitutes a dialectical inversion of emphasis in several respects. First, it almost completely eliminates the sculptor's own hands or body in favor of a collective process that produces not just a multiple set of figures but a massive crowd of figures, so closely packed into the space of exhibition that they occupy every inch of floor space and leave no room for a spectator to enter. (If Gormley had been an abstract painter, one might be tempted to see a reference to "all-over" and "color-field" composition, an effect enhanced by the untouchable framing of this collective object in the space of exhibition. This is not a piece that can move outdoors.) Second, the figures are tiny, precisely the size that makes them potentially handheld objects and reflects their insistently manual production. Third, the figures are molded, not cast. Fourth, the relation of figure and ground, the sculptural body and the place it activates, is completely collapsed in *Field:* the figure is quite literally the ground, and vice versa. And fifth, in contrast with the internal, meditative absorption signaled by the closed or blank eyes of most of Gormley's figures, the tiny Golem-like terra-cotta figures all have dark eye sockets, which collectively

form the impression of a mass of beseeching faces, all gazing at the specta-
tor. If sculpture really "wants" something, *Field* is a work that gives full ex-
pression to that desire while rigorously withholding the answer.

This "withholding" (a link with the mysterious inwardness of Gormley's
cast sculptographs) casts the desire for an answer onto the spectator, tempt-
ing us into narratives that can account for the disconcerting and fascinating
effect of this image of mass spectatorship. With its waves of varying earth/
skin tones, *Field* recalls, first, Vasari's primal scene of sculpture, the shap-
ing of a "lump of clay" into a man—not, however, into a singular male an-
cestor, an "Adam," but an infinitely differentiated collectivity united by
proximity and similitude. The signs of gender differentiation are com-
pletely eliminated in the engendering of these figures. We are left only with
what Emmanuel Levinas called the naked, unconditional appeal of the hu-
man face, an appeal that transcends sexual difference, and perhaps even
species difference, since the faces of some animals (especially our mam-
malian cousins) seem to present a similar claim on our attention.

No single story is capable of stabilizing this work and rendering its desire
nameable. *Field* evokes a whole range of precedents in minimalist sculp-
ture, recalling a variety of earthworks and non-sites, especially Walter de
Maria's "earth rooms," and the emphasis on seriality, the body, and space.[20]
It has been read as a host of lost (or saved?) souls assembling for the Last
Judgment; as the spirits of unborn fetuses yearning for incarnation; as the
resurrected victims of the Holocaust demanding justice; as a parable of the
specific sites from which these figures emerge as a local "earthwork"; or as
a global allegory of displacement and diaspora, as if the "huddled masses"
of immigrants, exiles, homeless, and refugees were all assembled in a single
space. Each of these interpretive frameworks casts the spectator in a differ-
ent role as well, inviting us to bask in the glow of mass attention or recoil
from the sense of accusation and impossible demand. The "double takes"
elicited by Gormley's singular figures are vastly multiplied with this work
and have an effect (which art critic Johann Winckelmann observed in the
highest achievements of classical sculpture) of fascination and astonish-
ment—quite literally, a momentary turning of the spectator into some-
thing like a statue, stunned into contemplative stillness.

The notion of "collective representation," the condensation of a social

20. Cf. Gormley's *Host*, a room flooded with mud in the old City Hall Jail, Charleston,
South Carolina.

totality into a single gestalt, is central to what Émile Durkheim called "totem-ism."[21] The totem is, literally (in its origin in the Ojibway language), "a rel-ative of mine," a figure that mediates social difference (exogamous sexual relations, tribal distinctions) with a sense of social solidarity and collective identity.[22] (William Blake's figure of the giant Albion, who contains the whole universe in his body, is an important English precedent.) Gormley's rendering of the "body of the multitude" (a "host" in another sense) is an-other of his forays into the most archaic sculptural traditions.[23] This figure receives its most ominous (early) modern rendering in the frontispiece of Hobbes's *Leviathan,* where the social totality is "personated" and embodied in the figure of a giant man, the sovereign who contains a multitude inside his body (fig. 66). Hobbes's collective figure, like Gormley's, seems to rise out of the earth; but *Field* has no unitary, integral, sovereign shape—ex-cept, of course, for the one that is given to it by the beholder. The spectator's body plays the role of Hobbes's Leviathan, insofar as the spectator frames the mass assembly in some subjective gestalt (a narrative or way of "seeing as"). The closest Gormley comes, I think, to flirting with the totalitarian overtones of Leviathan as collective giant is his *Brick Man* (fig. 67), which resonates both with the signs of collectivity (the bricks as the individuals in the social body) and the aura of the monolithic idol. As it happens, the brick makers, from Istock Building Products, supplied the prepared clay used in *Field for the British Isles* and fired the figures in their kilns.

If *Field* marked Gormley's "moving out" from his own body to that of others, and from art spaces into a more public sphere, it also heralded a cer-tain popularity and populism that comes with the territory of sculpture that looks figurative and "humanistic." *Field* was an unqualified popular success, drawing "a passionate response from people who saw it in Liver-pool and Dublin," according to art critic Lewis Biggs.[24] The combination of

21. Émile Durkheim, *The Elementary Forms of Religious Life* [1912], trans. Karen E. Fields (New York: Free Press, 1995). For a discussion of some of the genealogies of the concept of totemism in its relations to idolatry and fetishism, see chapters 7–9 above.

22. For more on totemism, see section 2 above.

23. Comparisons have been drawn with the terra-cotta army of Xian, China; the thou-sand bodhisattvas in Kyoto, Japan; and (in a contemporary context) with the mass-produced "surrogates" of Allan McCollum and the "ranks of humanoid shells" of Magdalena Abakan-ovics. See Caoimhin Mac Giolla Leith, "A Place Where Thought Might Grow," in *Antony Gormley: Field for the British Isles* (Llandudno, Wales: Oriel Mostyn, 1994), 24–26.

24. Lewis Biggs, introduction to *Antony Gormley: Field for the British Isles.*

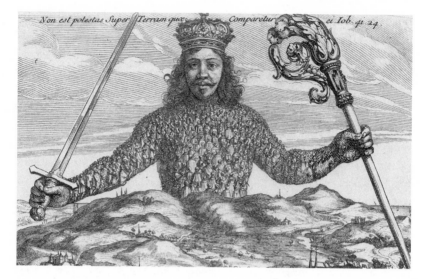

FIGURE 66 Thomas Hobbes, *Leviathan* frontispiece, detail. Photograph courtesy of Department of Special Collections, The Joseph Regenstein Library, University of Chicago. Reprinted with permission of the University of Chicago Library.

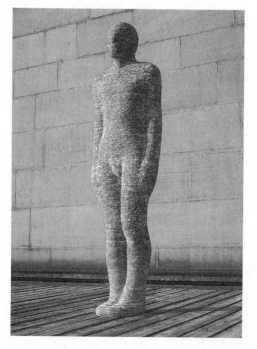

FIGURE 67
Antony Gormley, *Brick Man*, 1987.
Courtesy of the artist.

collective, local authorship-involvement and the sheer visual power of the work, its rather demotic accessibility to many kinds of beholders and interpretations, make *Field* into one of the most successful public art projects of its time. This can be a mixed blessing, of course. There is nothing like popularity and public approval to earn the scorn of an art world elite that thinks no serious artist can make serious work for the masses. But *Field* is not only for but in a certain sense *of* and *by* the masses, asserting the democracy of artistic imagination and the possibility that the sculptural "genius of the place" might be formed by its own inhabitants. Gormley serves, in that case, more like a *Gastarbeiter* than a visiting "art star," a guest worker who assists in the process of instituting a place.

His most recent large public works, *Angel of the North* (fig. 68) and *Quantum Cloud* (fig. 69), continue this process of what we Americans call "outreach" beyond the boundaries of the cast body and the conventional spaces of artistic exhibition. *Angel* literally spreads its wings in the highly traditional gesture of welcoming and opening, combining what are by now the familiar polarities of Gormley's work. The angel opens its wings for flight, yet it stands firmly anchored to resist winds of up to 100 miles per hour. It combines an archaic rendering of the human form with the modern, technical prostheses of airplane wings. It expresses both the earthbound, gravitational pull of sculpture and its transcendental, aerial, utopian idealism. Of all Gormley's public works it is the one that has sparked the most violent controversy, a target for the usual battles over the waste of public money on the arts. Vilified for its size (63 feet high, 169-foot wingspan, 100 tons of reinforced steel), its monumentality (some critics associated it with Albert Speer and fascist monuments), its expense, its danger as a distraction to the 90,000 motorists who pass it every day on the A-1, its propensity for attracting lightning, and even a pornographic image (one critic saw in it a flasher opening his trench coat), *Angel* has nonetheless rapidly achieved acceptance and a landmark status of sorts. Other works of public art seem destined to undergo this ritual of humiliation and sanctification. Maya Lin's Vietnam Veterans Memorial is perhaps the most notable and moving example of this transformation from reviled to revered monument. Already it seems that the question about *Angel* is not, what does it mean? but, how did it become a totem of this place? Beyond the obvious resonance with the spread-eagled figure of the thunderbird often found on Native American totem poles, the Angel resonates somehow with its abandoned, postindustrial, wasteland site, thereby helping to institute and resurrect it as place.

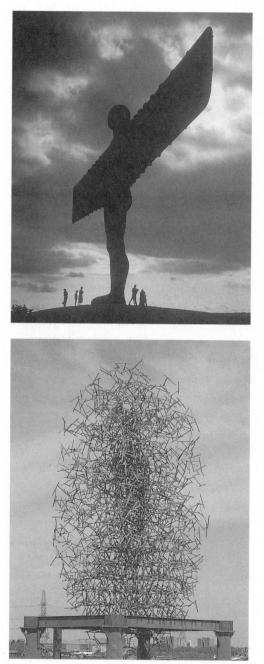

What will be the fate of *Quantum Cloud*, Gormley's latest project? The site and scale will put it in competition with Nelson's column, Westminster Bridge, Big Ben, and other London landmarks. Will this be taken as an image of the digitized, cybernetic body, abstracted into a cloud of "quanta" or bits of materialized information? Will it be taken as a figure of what critic Tom Nairn called "the break-up of Britain"[25]—Albion deconstructed? If it is like Gormley's other public pieces, it will both invite and frustrate allegories of this kind, serving as a demotic invitation to enter a place for contemplation in the heart of urban commotion. As a continuation of Gormley's effort to "think with materials" and with the sculpted body, it surely expresses his current tendency to move beyond his own body. The visual impression, in fact, is that of the body breaking up and dispersing in a cloud of steel segments (one could also read this, of course, as an image of convergence, as if the segments were like giant iron filings coalescing around the magnetic field left by an absent, almost invisible body). Once again, the body is a place, but this time a place whose boundaries are indeterminate, exploding or imploding, expanding or contracting. Perhaps that perfect shape for sculpture, the bomb, has "gone off" in this work.

If I believed in linear, progressive narratives of artistic careers, I might conclude that *Quantum Cloud* signals the end of Gormley's entrapment in his own body, and the beginning of a new phase in which the body, the human figure, and the traditional sculptural choices of casting and carving have been replaced by or refunctioned as construction and assembly. The welded totems of David Smith and the entire constructivist tradition in sculpture might be hovering about this cluster of I-beams. But I don't believe in these sorts of narratives. Gormley has already been "out of his body" for over a decade, and construction has always been an important feature of his work. More important, the story to be told about his work is not so much a matter of what he wants, but what sculpture seems to want from him. The general answer seems clear: Gormley's sculpture wants a place to be and to be a place. Where and in what form this desire will be gratified remains to be seen.

25. Tom Nairn, *The Break-Up of Britain: Crisis and Neo-Nationalism* (London: New Left Books, 1977).

The Ends of American Photography
Robert Frank as National Medium

For Joel Snyder

If, as Roland Barthes has suggested, "all the world's photographs formed a Labyrinth,"[1] surely the central region of that labyrinth would be occupied by American photography. Photographic historian Joel Snyder has made it clear that this isn't just because more photographs have been made in the United States than any other country, but because more has been made *of* them. Snyder notes specifically that the opening in 1937 of a department of photography at the Museum of Modern Art signaled the first real canonization of photography as a modernist or (what comes to the same thing) artistic medium.

"American photography" is not merely a phrase denoting the photographs made in or about the United States, or by its citizens. The phrase now has the same ring of inevitability that we associate with "French painting," "Greek sculpture," "Dutch landscape," and "Egyptian hieroglyphics," and the same potential for reduction to a self-evident cliché, the automatic linkage of a nation and a medium. The connotations of photography—its technical, scientific, progressive modernity, its cheapness and democratic availability, its middle-brow, petit-bourgeois social position, its mythic status as a natural and universal language—all commend themselves to American national ideology.[2] American photography may be thought of,

1. Roland Barthes, *Camera Lucida: Reflections on Photography,* trans. Richard Howard (New York: Hill & Wang, 1981), 73.
2. The title of Pierre Bourdieu's *Photography: A Middle-Brow Art* [1965], trans. Shaun Whiteside (Stanford, CA: Stanford University Press, 1990), tells all. See also Alan Sekula's discussion of the way photography interpellates, "in classic terms, a characteristically 'petit-

then, as a "naturalized" and "nationalized" immigrant European medium that has been given American citizenship. Invented in France and England almost simultaneously in the 1840s, it migrates to the United States in the nineteenth century, where it seems to find its most ambitious vocation. When it returns to Paris and the Centre Pompidou (as it did for an exhibition in 1996), it does so with its passport in hand, a *carte de visite* inscribed with the signature American Photography.

The very concept of American photography implies a set of prior questions about the relations of nations and media. Contemporary discussions of nationalism stress its mediated character. The nation, as political theorist Benedict Anderson has argued, is an "imagined community," a cultural construction made up of images and discourses, the seeable and the sayable.[3] A modern nation is not a natural fact: its origin, history, and destiny are the stuff of myth, made and not given. At the same time, however, nations always disavow their artificial, constructed character; they insist on representing themselves as natural, as grounded in immemorial traditions and essential characteristics, rooted in a territorial soil like a native plant. The nation, then, is a thoroughly ambivalent, conflicted entity, a complex of utopian fantasy and everyday reality, official slogans and actual practices, idealized narratives of manifest destinies and counternarratives of resistance and struggle.

Similarly, contemporary discussions of media argue that a medium also has no essence, no specific "nature." Like the nation, a medium is a cultural

bourgeois' subject": "The Body and the Archive," in *The Contest of Meaning: Critical Histories of Photography*, ed. Richard Bolton (Cambridge, MA: MIT Press, 1989), 347.

3. Benedict Anderson, *Imagined Communities* (London: Verso, 1983). Anderson specifies "print-as-commodity" (41) as the key medium that makes possible universal literacy, a middle-class readership, and a sense of "homogeneous empty time" in which the nation can thrive. He contrasts the print media with the "ideograms" of the "sacred silent languages" (20) of the dynastic empires (especially China) that were understood only by an elite priesthood and bureaucracy of scribes. "The great global communities of the past," argues Anderson, "depended on an idea largely foreign to the contemporary Western mind: the non-arbitrariness of the sign. The ideograms of Chinese, Latin, or Arabic were emanations of reality, not randomly fabricated representations of it" (21). If Anderson is correct, then photography's peculiar status as a print medium predicated on a mechanically constructed "homogeneous empty space" is the perfect pictorial counterpart to the homogeneous empty time he sees in printed texts. Yet photography's status as the "natural" and "non-arbitrary" medium suggests that it might have a crucial vocation in the evolution of modern (as opposed to dynastic) empires, and (in its digital form) of the postcolonial form of imperialism known as globalization. The concept of a photographic "family of man" is discussed further below.

institution, an artifact or technology. But also like the nation, accounts of media tend to disavow their constructed character, presenting the medium as possessed of essential characteristics and a certain natural destiny. This is especially true of photography, which seems to license every commentator to make pronouncements on its essential character, even when their aim is to deny any essentialism.[4] Thus, the very theorists of photography who have done the most to open up the limitless variety and complexity of photographic images invariably wind up at some point declaring an essential teleology, a fixed center to the labyrinth. Photography's true nature is found in its automatic realism and naturalism, or in its tendency to aestheticize and idealize by rendering things pictorial. It is praised for its incapacity for abstraction, or condemned for its fatal tendency to produce abstractions from human reality. It is declared to be independent of language, or riddled with language. Photography is a record of what we see, or a revelation of what we cannot see, a glimpse of what was previously invisible. Photographs are things we look at, and yet, as Barthes also insists, "a photograph is always invisible: it is not what we see."[5]

The two pathways into the labyrinth of American photography, the nation and the medium, cannot, then, simply be followed as parallel tracks that lead to the same goal, much less as a single track in which the history of the medium "reflects," reveals, or converges with the history of the nation. What we have to confront here are the irregular, erratic intersections of two ambivalent and conflicted histories, each constituted by official narratives and dissenting counternarratives, standard and deviant practices, clear-sighted views of the "ends" of America and of photography, and impasses or confusions that seem to offer no way out.[6]

4. André Bazin, for instance, sees "the essential factor" in photography as "satisfying our appetite for illusion by a mechanical reproduction in the making of which man plays no part" (*What Is Cinema?* [Berkeley and Los Angeles: University of California Press, 1967], 12). Stanley Cavell similarly argues that photography "does not so much defeat the act of painting as escape it altogether: by *automatism*, by removing the human agent from the act of reproduction" (*The World Viewed: Reflections on the Ontology of Film* [Cambridge, MA: Harvard University Press, 1979], 21, 23). For a classic discussion of the "ontology of photography," see Joel Snyder and Neil Walsh Allen, "Photography, Vision, and Representation," *Critical Inquiry* 2, no. 1 (Autumn 1975): 143–69.

5. Barthes, *Camera Lucida*, 6.

6. On the conflicted histories of the photographic medium, see Bolton, ed., *The Contest of Meaning*, especially the essays by Alan Sekula, Christopher Philips, Rosalind Krauss, and Abigail Solomon-Godeau.

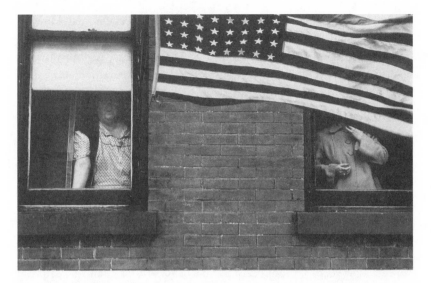

FIGURE 70 Robert Frank, *Parade—Hoboken, New Jersey* [AM 1]. From *The Americans* (New York: Aperture, 1959). Copyright Robert Frank, courtesy Pace/MacGill Gallery, New York. Photograph: Museum of Fine Arts, Houston.

In 1969, the American photographer Robert Frank made a short film entitled *Conversations in Vermont,*[7] documenting a series of conversations with his children about his early work. As Frank leafs through a stack of photographs, he comes to the first image in his famous photo-essay, *The Americans* (fig. 70), and lingers on it for a moment, muttering, "That's where the photographs end." Frank is famous, of course, for his endings. Like the family legends that surround a private photo album, a whole set of "insider" narratives surround Frank's *The Americans*: the shock and scandal of its initial reception; the sense that it was a photographic breakthrough that brilliantly synthesized and transcended the styles of two great predecessors, Walker Evans and Bill Brandt; the revelation of American ennui and alienation in the Eisenhower years, an era generally characterized as a high point of American complacency, hypocrisy, and superficiality; the feeling, in Jack Kerouac's words, that Frank had done even more than "expose" American culture to a photographic critique—he had actually

7. Made in 1969 for PBS station KQED in San Francisco, funded by the Dilexi Foundation; 16 millimeter, black and white, 26 minutes.

created a "tragic poem" that sucked out the "pink juice of human kind" in American civilization, a civilization that (as Frank noted) is "spreading all over the world."[8] In short, any viewing of The Americans is almost invariably accompanied by a ritual recitation of its legendary status as a classic, a high point in the art of photography, and a moment of special intensity in the photographic revelation of "the truth" about the American nation. In the small family of professional photographic insiders, The Americans is regarded by some as "the most important single effort in photography in this century."[9]

The hypercanonization of The Americans is accompanied by a similar canonization of Robert Frank himself. If ever a Vasari writes the "Lives of American Photographers," Frank would play the role of Michelangelo— but a very odd and tragic Michelangelo, one whose career is characterized by a radical break, a renunciation, and an extended tragic denouement. Within a few years of the appearance of The Americans, Frank gave up still photography and pursued a career of relative obscurity as an independent filmmaker.[10] In 1958 he declared that he had produced "his last project in photography. . . . I knew and I felt that I had come to the end of a chapter."[11]

8. Jack Kerouac, introduction to The Americans, by Robert Frank (1st English ed., 1959; New York: Aperture, 1969), iii.

9. Jno Cook, "Robert Frank's America," AfterImage 9, no. 8 (March 1982): 9–14; Frank's remark about the global spreading of photography and American civilization appears in "A Statement," in U.S. Camera 1958, ed. Tom Maloney (New York: U.S. Camera, 1957). See also, among numerous other remarks, Bill Jay's comment that "The Americans . . . must be the most famous photo-essay ever produced": "Robert Frank: The Americans," in Creative Camera, no. 58 (January 1969): 22–31; quotation on p. 23. See also Tod Papageorge, Walker Evans and Robert Frank: An Essay on Influence (New Haven, CT: Yale University Art Gallery, 1981), and John Brumfield, "'The Americans' and the Americans," Afterimage 8, no. 1/2 (Summer 1980): 8–15.

10. See Stuart Alexander, Robert Frank: A Bibliography, Filmography, and Exhibition Chronology 1946–1985 (Tucson, AZ: Center for Creative Photography, University of Arizona, 1986), vii: "Frank's films attracted relatively little attention in the literature of the seventies and eighties." Also, Michael Mitchell notes that "[a]lthough his films are far from being without interest," they fail "to convince one the way The Americans always has. . . . In Frank's films, the medium and the maker were never entirely well met" ("Commentaries/Reviews," Parachute [Summer 1980]: 46–47, quoted in Alexander, Robert Frank, 123).

11. See "Walker Evans on Robert Frank/Robert Frank on Walker Evans," Still/3 (New Haven, CT: Yale University Press, 1971), 2–6. Frank continues: "I did not want to go out and do still photography again. . . . I think my book was a little bit at the end of some period. . . . I always feel like ripping them [the photographs] up." Quoted in Alexander, Robert Frank, 69.

Jno Cook remarks that "Frank's abandonment of still photography *sancti-fied* the project of *The Americans*,"[12] as if this renunciation were an act of almost religious asceticism. After the early sixties, Frank's only works in still photography were commercial projects to make money, "private" documentation of his retreat in Nova Scotia, or collages in which still photographs are often disfigured and mutilated. Frank's abandonment of still photography as he had practiced it was clearly more than a simple "moving on" to new interests. In an NPR radio interview in December 1974, Frank told about driving a nail through a stack of valuable prints from *The Americans* and writing across them, "The end of photography." In 1989 he made an untitled work by driving four nails through a stack of his early photographs, the top image showing a bull with a banderilla stuck in its back, as if he saw in the earlier image of piercing and wounding a prefiguration of the destiny of the photographs themselves. It was not enough for Frank to put photography behind him: he seemed compelled to destroy it, to subject it to a violent "cancellation" and nullification.

Frank has been asked why he gave up photography so many times that I'm sure he is heartily sick of the question,[13] and his famous "renunciation" of still photography is now part of his mythical status (actually, he has continued to produce new photographs on a highly selective range of subjects, the most recent being his photographs of Beirut). The real question, in my view, is why this question should be so obsessively repeated, why so many commentators on American photography think that the answer is important, as if it contained a lesson for all other American photographers. It is like the question, Why is this night different from every other night? the opening move in the recitation of the legends circulating around a body of remarkable images that have achieved the status of an unofficial national monument. If *The Americans* is the great tragic poem of American photography, Frank seems to play the role of its tragic hero, a kind of Oedipus who "had eyes"[14] that saw something so terrible and shocking that he felt compelled to put them out, to put his camera in a closet.

The whole "case" of Frank's *The Americans* is a classic instance of over-

12. Cook, "Robert Frank's America," 9; emphasis mine.

13. The first question in the first interview Frank published was, "Why did you give up still photography?" and it is repeated in almost every interview Frank gave for the next twenty years. See Alexander, *Robert Frank*, 54, 182.

14. I am echoing Jack Kerouac's conclusion, "To Robert Frank I now give this message: You got eyes" (introduction to Frank, *The Americans*, vi).

determination: it is a constitutive myth in the construction of American photography and the evolution of American national identity. Time, place, individual talent, tradition, luck, intuition, ambition all converged in the Robert Frank of the 1950s, leaving behind a photographic record that, as he predicted, "will nullify explanation" even as it seems to demand it. If the photographs were received as a traumatic shock within the family of American professional photographers,[15] they are also the record of Frank's own trauma as a naturalized American citizen, experiencing his newly adopted homeland as an alien civilization. The "alienation" he saw and felt was not, I think, just the European variety that Frank brought with his reading of Sartre. It is a highly traditional American emotion, specific to a nation of immigrants, expressed most eloquently by Nathaniel Hawthorne in his preface to *The Scarlet Letter*: "I am a citizen of somewhere else."

The Americans must be seen, then, as a labyrinth of contradiction and ambivalence which by fate or design seemingly nullifies any single thread of explanation. It is certainly an ironic social critique, revealing a smug, proto-fascist patriarchy in images such as *City Fathers—Hoboken, New Jersey* (AM 2),[16] *Political Rally—Chicago* (AM 58; fig. 71), and *Convention Hall—Chicago* (AM 51);[17] grimy urban landscapes in unexpected places like *Butte, Montana* (AM 15), alienated labor in expected places like *Assembly Line—Detroit* (AM 50) and in places never seen before in photography, such as the lovely, lonely face of the elevator operator in *Elevator—Miami Beach* (AM 44). Equally alienated consumption is exposed in the industrial heartland (*Drug Store—Detroit* [AM 69]) and in the Western land of opportunity (*Cafeteria—San Francisco* [AM 68]). But *The Americans* is also an acknowledgment of a distinctively American sublimity: the baroque radiance of the jukeboxes (see especially *Candy Store—New York City, Cafe—Beaufort, South Carolina* [AM 22], and *Bar—Las Vegas, Nevada* [AM 24]) weaves a music into these photographs that may have been mere noise to the refined European ear of Theodor Adorno, but is the focus of ecstasy and absorption

15. See Kelly Wise, "An Interview with John Szarkowski," *Views* 3, no. 4 (Summer 1982): 11–14, for testimony on the shock felt by the curator of photography at the Museum of Modern Art.

16. I use the abbreviation *AM* to designate Frank's *The Americans,* followed by the numerical positioning of the photograph in this text, an order which remains consistent through all editions of this work.

17. I have been limited to reproducing only six of Frank's photographs in this chapter. I recommend reading it with a copy of *The Americans* close at hand.

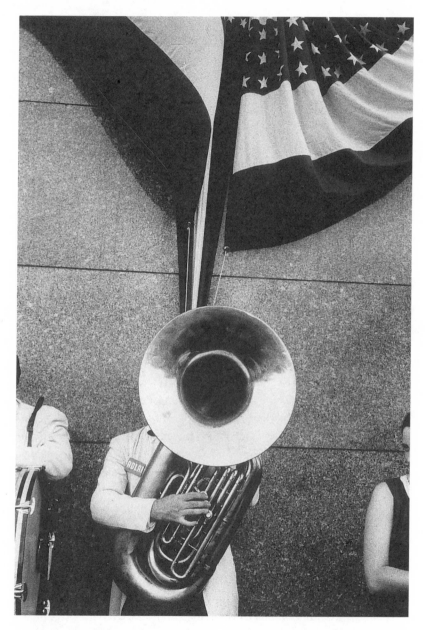

FIGURE 71 Robert Frank, *Political Rally—Chicago (Man with Sousaphone)* [AM 58]. From *The Americans* (New York: Aperture, 1959). Copyright Robert Frank, courtesy Pace/MacGill Gallery, New York. Photograph: The Museum of Fine Arts, Houston.

to Frank's listening eye. (I see him in the face of the young woman grooving on the sounds coming from the jukebox in *Candy Store—New York City*, and in the hands of the young man mimicking a clarinetist in the foreground; so much for the "lack of culture" sometimes seen in Frank's depiction of America.)

The photographs may look like the anti-American documents of a Commie Jewish spy stealing military secrets, peeking around a corner at the shoes on the recruiting officer's desk in a strangely dislocated *Navy Recruiting Station, Post Office—Butte, Montana* (AM 7), or catching a glimpse of a wary noncom crossing a street in *Savannah, Georgia* (AM 6); but they also reveal that spy "caught looking" by vigilant American outsiders—the motorcyclists of *Newburgh, New York* (AM 40,) or the alert black couple sunning themselves in a park in *San Francisco* (AM 72).

Frank's great gift was his ability to convey alienation (that all-purpose cliché) from up close and within, a position of sympathy, intimacy, and participation. America may be a segregated society (see *Trolley—New Orleans* [AM 18]), but it is also a place where racial mixing is as natural as mother's milk (*Charleston, South Carolina* [AM 13]) or the sounds coming from the jukebox. It may have a tawdry, commercial sense of religious piety, as expressed in the Styrofoam crosses and plastic flowers of *Department Store—Lincoln, Nebraska* (AM 64), mock the salvation offered by a gas station promising to "SAVE" the passing motorist in *Santa Fe, New Mexico* (AM 42), or offer a sarcastic parody of blessing in *St. Francis, Gas Station, and City Hall—Los Angeles* (AM 48). But it also unveils a melancholy aura in the most unlikely places, as in *Crosses on Scene of Highway Accident—U.S. 91, Idaho* (AM 49; fig. 72), where the photographic "accident" of a solar flare on the camera lens creates the effect of celestial light bursting on a humble crucifixion scene. Nothing better typifies Frank's method of appropriating what would otherwise be seen as a technical flaw, a botched print, and making it look like a miraculous apparition.

Sometimes the ambivalence of Frank's photos is shown in juxtapositions and contrasts of different images, but it also saturates many of the individual photographs. The picture of the black nurse and white baby in *Charleston, South Carolina* [AM 13], for instance, seems to be straining to find an equilibrium in the gray scale between black and white: the slightest push of tonality in one direction or another would make the baby disappear into the ambient whiteness, or the black woman's facial texture dissolve into undifferentiated blackness. The riders in *Trolley—New Orleans*

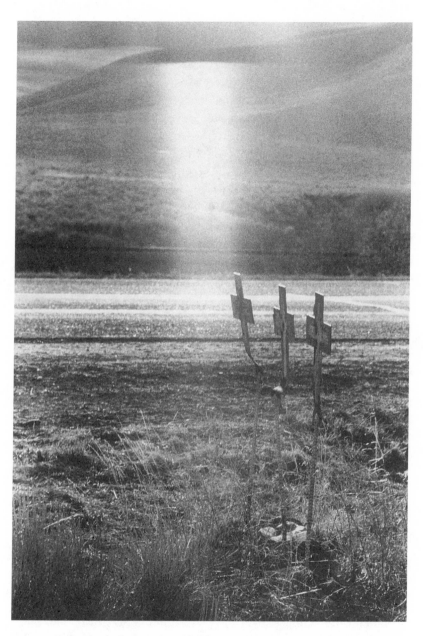

FIGURE 72 Robert Frank, *Crosses on Scene of Highway Accident—U.S. 91, Idaho* [AM 49]. From *The Americans* (New York: Aperture, 1959). Copyright Robert Frank, courtesy Pace/MacGill Gallery, New York. Photograph: The Museum of Fine Arts, Houston.

[AM 18] are divided by the segregated seating, by the white window frames that echo the strips of a photographic proof sheet; but they are united in their gaze on the spectacle (perhaps a parade) behind the photographer, its shapes becoming monumental abstractions or blurry photos in the parallel row of the windows above the passengers.

These observations could be disputed, of course, and many other interpretations are possible. My point is only to suggest a way into these photographs that does not reduce them either to tendentious social criticism or to nostalgic relics of the fifties. This point is equally important with our formal sense of the photographs, which have sometimes been characterized as deliberately fragmented in their look, a deviation from the cool formalism of Walker Evans. For every image that strikes us as random, chaotic, and confused—the chance shot of passersby in *Canal Street—New Orleans* [AM 19] or the labyrinth of vegetation and trash in *Backyard—Venice West, California* [AM 39]—another stuns us with its formal perfection and compositional clarity, as in the geometry of the sousaphone and flag bunting on the blank textured wall in *Political Rally—Chicago* (AM 58; fig. 71) or the sublime symmetry of the infinite *U.S. 285, New Mexico* (AM 36) arrowing off into the distance, shot from just to the right of the centerline in the face of headlights from an oncoming car going (no doubt) at full throttle. Moreover, pictures such as *Movie Premiere—Hollywood* (AM 66; fig. 73), which look disorganized or even incompetent at first glance, turn into perfectly realized compositions on further inspection. The out-of-focus starlet in the foreground breaks every rule of professional photography, until we realize that the revelation of the photograph is the way American "star" images function as blank, unfocused blurs for the projection of fantasy (call it the "Botox Effect"), and that this blankness is countered by the precision and differentiation of the faces of the adoring female spectators in the background. I do not read this, in other words, as a picture that ridicules the supposed homogeneity of mass spectatorship; rather, it reveals the phenomenon as complex, mobile, and differentiated, ranging (in this image) through expressions of intense longing, supreme satisfaction, and eager anticipation. At the same time, the picture's effect depends in part on the misreading it invites, as a straightforward satire on the emptiness of Hollywood stardom. Any other photographer would have blurred the crowd and focused on the star. Frank forces us to see what we systematically overlook, what had previously been invisible to American photography, just as surely as the work of Walker Evans, Dorothea Lange, and the

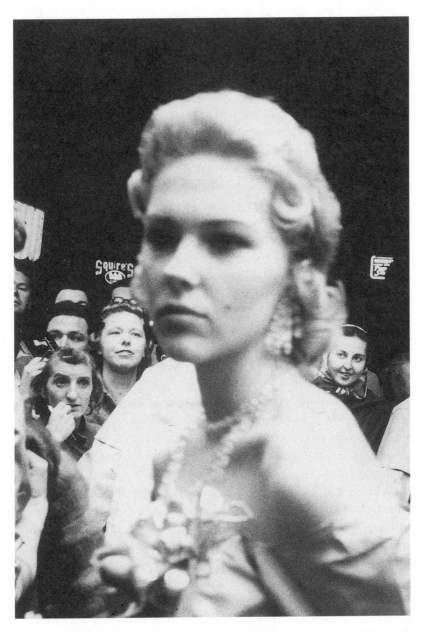

FIGURE 73 Robert Frank, *Movie Premiere—Hollywood* (blurred face, crowd behind) [AM 66]. From *The Americans* (New York: Aperture, 1959). Copyright Robert Frank, courtesy Pace/MacGill Gallery, New York. Photograph: The Museum of Fine Arts, Houston.

dust bowl photographers made the Great Depression a visible part of national iconography.

Perhaps even more striking than Frank's ability to bring order out of chaos is his mastery of the reverse technique—the image that first strikes us as self-evident and formally coherent, only to reveal itself gradually as a scene of disfigurement or mutilation. The opening image of *The Americans, Parade—Hoboken, New Jersey* (AM 1; fig. 70), is virtually a parody of modernist pictorial values, asserting the flatness of a picture plane in which geometrical organization and textural contrasts are foregrounded. The picture plays quite self-consciously on the metaphor of the architectural facade as a kind of *face,* with the windows serving as eyes in which the bodies of the women become "pupils," taking in their specular lesson in national pedagogy by watching an unseen parade, and displaying their responsiveness with the flag treated as bunting and window shade. When we come to this photograph (and its caption) armed with insider's knowledge—for instance, that Stieglitz liked to identify himself as an American photographer from Hoboken, New Jersey—the artfulness of the whole composition begins to seem, despite its obvious spontaneity and improvisatory character, almost contrived. This is an effect we can also trace in the numerous compositions that deliberately echo specific images in Walker Evans's *American Photographs.*[18]

What disturbs the sense of formal cohesion in *Parade—Hoboken, New Jersey,* however, is its violation of the oldest and simplest rule of professional photography: don't cut off the heads of your subjects. What Frank recognizes here is that the heads must be "cut off," as it were, to allow the women's bodies to have any chance of becoming "pupils" in the facade of patriotic spectatorship. The flag, then, is a kind of guillotine. This motif of "decapitation" runs throughout *The Americans.* Sometimes it is quite explicit, as when the head of Eisenhower seems to float free of a headless mannequin in *Store Window—Washington, D.C.* (AM 59); or when a shadowy headless pedestrian follows the direction indicated by a neon arrow in an overhead shot in *Los Angeles* (AM 61); or when an old man with a cane becomes a headless pillar holding up the stairs in *Rooming House—Bunker Hill, Los Angeles* (AM 20); or a headless sun worshipper in *Backyard—Venice West, California* (AM 39) uses the American flag as an awning like the one in Hoboken.

18. See Papageorge, *Walker Evans and Robert Frank.*

Photographic decapitation is naturalized, of course, when it is the head that appears without the body rather than the body without the head. The conventions of the portrait and the "head shot" let us accept this without much question. But Frank's way of framing his heads or cutting off their bodies even manages to estrange this convention, as noted earlier with the Eisenhower head and the headless mannequin. The bodiless head of Santa Claus in *Ranch Market—Hollywood* (AM 14) makes the waitress's head below it seem to lift off her body. The Mussolini-like orator in *Political Rally— Chicago* (AM 3) has a head shot of Estes Kefauver on his shirt front, and a classical sculpted head supporting the parapet beneath his feet; but he has been "cut off at the knees" (as we say in Chicago), just as the Navy recruiter in *Butte, Montana* (AM 7) is cut off at the ankles. The unkindest cut of all may be the one imposed on the sleeping tattooed man in *Public Park— Cleveland, Ohio* (AM 74), where the link with castration is made unavoidable by a composition that bisects the man's body with a vertical tree trunk.

But perhaps the most striking reflection on American decapitation comes in the figure of the sousaphone player in *Political Rally—Chicago* (AM 58; fig. 71). I stress this photograph partly because the stone or concrete wall in the background *foregrounds* so conspicuously the grainy, gray texture of Frank's photographs, as if he were looking for a motif in the world that answered to the material and optical features of his medium.[19] But this image also specifies the instrument of decapitation: the sousaphone itself, the bass line of American military music, named for its most famous composer of national marches and anthems, John Philip Sousa. Here Frank provides a portrait of another kind of artist—the musician— as a figure whose instrument graphically cuts off his head, blocking it from view. But this is a symmetrical reflection of the photographer himself, whose camera, held up to his eye, blocks him from the view of the photographed subject. It's as if the sousaphone here is an acoustic counterpart/ antitype to Frank's camera, the black hole of its bell "looking back" at the black hole of the aperture. I mentioned earlier that Frank's images of jukeboxes implied a "listening eye," as if it were just as important for the photographer to use his ears as his eyes. Frank was notoriously quiet himself,

19. Dennis Wheeler remarks: "I once thought that photographs picked up where the built-in limits of language left off and that like cement, the steely grey surface of the emulsion caught once and for all that it was (is) like this." "Robert Frank Interviewed," in *Autobiography: Film/Video/Photography,* ed. John Stuart Katz (Toronto: Art Gallery of Ontario, 1978), 20.

content to use his instrument not as a mouthpiece for the pompous blasts of oom-pah! associated with the sousaphone, but as an extension of a thirsty, voracious eye that silently drinks in the reality around it—Kerouac's "pink juice of human kind."

John Szarkowski anticipates my "headless" reading of this photograph: "the human situation described is not merely faceless, but mindless. From the shiny sousaphone rises a comic strip balloon that pronounces once more the virtue of ritual patriotism."[20] But I would want to qualify his reading by differentiating the "headless" from the "mindless." For all we know, the sousaphone player, devoutly promoting the virtues of Adlai Stevenson, is as mindful or mindless as the photographer himself, whose head is also cut off by his instrument. As Szarkowski notes, this "flatulent black joke on American politics can be read as either farce or anguished protest. It is possible that Frank himself was not sure which he meant" (ibid.). My guess would be that Frank meant to include this image when he said that *The Americans* would "defy explanation," his own included.

The connection between decapitation and citizenship in a modern nation probably needs no explaining in France, where it is central to the primal scene of nation formation—but what is it doing in America? Was Frank aware of the American legends that Washington Irving's Headless Horseman was the ghostly vestige of the American Revolution?[21] Did he know that Nathaniel Hawthorne's *Scarlet Letter*, the hypercanonical American novel on the disfiguration and mutilation endemic to national fantasy, had an alternate "ghost title and authorship": the *Posthumous Papers of a Decapitated Surveyor*?[22] Those who come too close to the center of the American national labyrinth lose their heads or suffer mutilation. The "American Eagle," notes Hawthorne, who guards the gateway to the nation (the custom house) "with outspread wings, a shield before her breast, and . . . a bunch of intermingled thunderbolts and barbed arrows in each claw," is a vixen who is "apt to fling off her nestlings with a scratch of her claw, a dab of her beak, or a rankling wound from her barbed arrows" (7). (It is hard

20. See John Szarkowski, *Looking at Photographs: 100 Pictures from the Collection of the Museum of Modern Art* (New York: The Museum of Modern Art, 1973), 176.

21. I am grateful to Lauren Berlant for reminding me of this theme in Hawthorne's writing. See her important study, *The Anatomy of National Fantasy: Hawthorne, Utopia, and Everyday Life* (Chicago: University of Chicago Press, 1991).

22. "The Custom House," preface to Nathaniel Hawthorne, *The Scarlet Letter* [1850], ed. Harry Levin (Boston: Houghton Mifflin, 1960), 46.

not to think of this image when contemplating Frank's photograph of Billie Holiday singing under the looming figure of the American eagle in the Apollo Theater.) Hawthorne saw that with every change of an American head of state, political appointees were sent to a figurative "guillotine" (43). When Zachary Taylor was elected president, Hawthorne's "own head was the first that fell" (44) in the U.S. Custom-House, where he held a political appointment. The press promptly took up the affair, presenting Hawthorne "through public prints, in my decapitated state, like Irving's Headless Horseman" (45). Frank's decapitated Eisenhower in a department store window marks, in 1959, the end of an era in American national innocence as well as in the medium of photography.

Hawthorne's decapitation, like Frank's and Eisenhower's, is only figurative, but that doesn't mean it wasn't serious. "The moment when a man's head drops off is seldom or never . . . the most agreeable of his life" (44). The period of Frank's naturalization as a U.S. citizen coincides with his photographic survey of the American people and with his discovery of the kinds of mutilation a nation can perpetrate on its citizens. Did he deliberately mutilate the figures in his photographs? Was decapitation a motif that emerged intuitively in his American survey, or did he go looking for it? Or is this merely an accidental feature, an automatism of the medium itself, which inevitably "cuts" into a scene or figure in the moment of framing or cropping? All the evidence I have been able to gather renders these questions undecidable. Frank continually speaks of his intuitive way of working, yet he also made it clear, especially after his arrest in Arkansas on suspicion of being a Communist spy, that he was trying to express his opinions about America in these photographs. My sense is that the decapitation motif is the point of convergence between Frank's intuitive practices, the automatism of photography, and the kind of wound he was sensing in the national character and in himself as he was becoming a citizen and an "American photographer."

Two photographs in *The Americans* that may be thought of as Frank's "self-portraits" may help to illustrate this point. In the well-known *Barber Shop through Screen Door—McClellanville, South Carolina* (AM 38), Frank shows us the central site of rural America's public sphere, the place where the barber "cuts heads" and the customers gather for conversation. He depicts this scene as empty, without visible human figures; with the shadow of his own head and the silhouette of his hands holding the camera up to his eye, he penetrates the screen-door lattice that masks it. Frank's head,

eye, and camera have dissolved in this picture into a shadow that infiltrates the surface appearances and reveals an interior which is also an external appearance. When one thinks about the image of the photographer this implies, a shadowy head moving among interior and exterior appearances, one glimpses, perhaps, some of the terror of still photography, the way in which the medium itself isolates, disembodies, and decapitates the photographer. The still photographer is in danger of becoming a spy, ghost, spook, specter; a shadow flitting among the surfaces of things; a vampire sucking out the pink juice of human kind, leaving nothing but a gray residue.

Frank provides a more straightforward portrait of the artist as invisible man in the final image of *The Americans, U.S. 90, en route to Del Rio, Texas* (AM 83; fig. 74), his one "family photo" in the entire book. It has often been remarked that *The Americans* is an ironic reflection on the cheery sentimentality of Steichen's *The Family of Man*, with its happy projection of the American nuclear family onto the entire world. In *U.S. 90*, Frank shows his family cut in two. A one-eyed car holds a sleepy Mary and Pablo, his wife and son, in the early morning hours in the middle of nowhere, piles of laundry in the back window echoing the profile of the distant mountains. The car is bisected by the frame of the photograph, so that the driver's seat, the place of the father, the photographer, Frank himself, is amputated. Every American father knows this: they rarely appear in the spontaneous family photos, only in the formal ones. Otherwise, the father is himself the photographer, the absent presence, a shadow cast on the image, frame, screen, or medium itself. In *The Americans* the fathers who are visible are in the distance, absent, or cut in half. In groups they look dangerous: Frank shoots the cowboys in *Bar—Gallup, New Mexico* (AM 29) "from the hip," a low angle that makes them loom over the composition in menacing attitudes. In Frank's photo-essay, the men are never shown with children. The women, by contrast, are usually shown as warm, sweet, and nurturing, enveloping and protecting the children.

In a photograph entitled *My Family* (not in *The Americans*), Frank shows Mary nursing a newborn Pablo on the floor of a loft, a pair of kittens playing in the foreground. The polished floor reflects light from windows beyond the frame, and Mary is lit from a source evidently behind the photographer, who shoots from the shadows. Mary's direct, inviting glance at the camera is echoed by the invitation of her single bare breast, exposed to the photographic gaze. Jacques Lacan notes that "light may travel in a straight line, but it is refracted, diffused, it floods, it fills—the eye is a sort

FIGURE 74 Robert Frank, *U.S. 90, en route to Del Rio, Texas* [AM 83]. From *The Americans* (New York: Aperture, 1959). Copyright Robert Frank, courtesy Pace/MacGill Gallery, New York. Photograph: The Museum of Fine Arts, Houston.

of bowl" where light is gathered.[23] The evil eye, *invidia* (from *videre*), "the eye filled with voracity," is credited with "drying up the milk of the animal on which it falls" (115), and is linked by St. Augustine to the emotions "of the little child seeing his brother at his mother's breast" (116). We have seen that Frank's still camera eye is a mouth that drinks in the "pink juice of human kind" and converts it to the gray residue of grainy photographic images. But it also thirsts for pure white, milky light—from the celestial flare illuminating the roadside crosses that memorialize a fatal accident to the baroque radiance of jukeboxes. The voracity of Frank's eye can even find nourishment in the lone headlight of the family car, which, like Mary's single exposed breast, offers light to the photographer's gaze. In *U.S. 90, en route to Del Rio, Texas*, the missing head of the family pauses to take a pee by the roadside, and to drink in the milky light of morning.

But what does all this have to do with the nation, with American-ness? This American family is found on U.S. 90 at an anonymous, unmarked stop somewhere on the nation's nascent interstate highway system. These highways are among the most frequent locations of Frank's images—U.S. 1, 30, 66, 90, 91, 285, and the public places that line them: bars, casinos, office buildings, hotels, markets, cafeterias, parks, department stores. Private interiors, domestic spaces (of the sort Frank shows in *My Family*) are almost completely absent. This iconography renders a lone roadside mailbox worthy of its own portrait, as in *U.S. 30 between Ogallala and North Platte, Nebraska* (AM 30), witnessed by a telephone pole in the middle ground and the farm buildings on the distant horizon, traversed by a dirt road across a scrubby field.

America is truly everywhere and nowhere in Frank's photos. It is, above all, on the road, in a car, coming, going, or pausing. He depicts the car from cradle to grave as place of recreation and refuge, and the site for mating, dying, and being laid to rest; the ghostly *Covered Car—Long Beach, California* (AM 34) is echoed immediately in the next picture by the shrouded corpses of *Car Accident—U.S. 66, between Winslow and Flagstaff, Arizona* (AM 35).

There is a stark homogeneity about Frank's America, where democratic, leveling spaces erase regional, local identity, and unite the nation with highways, telephones, the postal system, and the military. This effect is most pronounced in the disjunctive sequencing of the images, which resist regional groupings and bear absolutely no relation to Frank's actual linear

23. Jacques Lacan, *The Four Fundamental Concepts of Psychoanalysis*, trans. Alan Sheridan (New York: Norton, 1978), 94.

movement through real space or time. *The Americans* represents the United States as a homogeneous grid in which any point can be reached from any other instantaneously, without mediation, at the turn of a page, and in which any aspect of American life can be found anywhere. *Ranch Market— Hollywood* is adjacent to a gritty scene of urban squalor in *Butte, Montana. Rodeo—Detroit* is sandwiched between a funeral in South Carolina and a military couple in Georgia. This effect is reinforced by the ironic counterpoint between texts and photos, which subverts the normal securing or anchoring of the visual in the verbal. The captions usually designate things that cannot be seen in the picture (parades, rodeos, political rallies) or name larger settings (cities, states, highways) that cannot be signaled in a photograph containing no iconic monuments, landmarks, or other signs. Frank strips these local markers away (except, perhaps, for the palm trees of California), refusing all landscapes, all sites of American *nature* in its familiar photographic, pictorial stereotypes. No mountains, valleys, or river vistas. No New England. Frank "crops" the whole iconography of American ideal nature in order to focus on the nation-state and its citizens. The highway system, the telephone, the post office, the military—these are everywhere, just as cowboys and rodeos are in Chicago and New York. The only American monuments present are the heads of presidents in shop windows and bars, and the flag, which is everywhere—awning, parasol, wall-covering, it ornaments flat surfaces like a trompe-l'oeil curtain or veil, through which Americans must pass like ghosts.

The first photo Frank made for *The Americans* was *Fourth of July—Jay, New York* (fig. 75), with its flag almost filling the picture plane. Little girls in white dresses pass beneath the translucent veil. A boy in the foreground prepares a firecracker, while two strolling men on the right are on a collision course with the flag. The left edge of the flag is decapitating a walking man; its center bisects a group of women. And then the all-too-literal *punctum:* the veil is torn on the lower left. Not only does the picture show the merging of the photographic medium with the national icon (an "American photograph" in the most literal sense), but it implies that the naturalized American citizen photographer must pass through the veil as well. If we turn this into a moving image, the camera eye moves directly forward until the flag fills the entire frame and the striped veil becomes identical with the photographic surface, like a gray Jasper Johns. The very first photo Frank made for *The Americans* contains the teleology of the whole essay: the merging of nation, photographer, and photography. The end of American photography has been reached.

FIGURE 75 Robert Frank, *Fourth of July—Jay, New York* [AM 17]. From *The Americans* (New York: Aperture, 1959). Copyright Robert Frank, courtesy Pace/MacGill Gallery, New York. Photograph: The Museum of Fine Arts, Houston.

That ending was also a beginning for much of American photography after Frank. One can ask endlessly why it was—or seemed to be—such a dead end for him. Why could he not turn his still-photographic eye to other subjects, in or out of America? Why does the completion of his American survey seem to exhaust not merely the subject matter but the medium of still photography itself? Is it that Frank feels "American photography" has become a redundancy, that still photography, conducted under the protocols of truth, revelation, and solitary observation that had become specific to its most advanced capacities, had nowhere else to go? To do photographic surveys of other nations would have been no solution, only a repetition of the solitary, spectral search for a truth that has already imprinted itself so deeply in the photographer's eye that it can see nothing else.[24] Anywhere Frank could have gone with his Leica would still have been America, and he would still have been an American photographer. So he renounces the whole business and retreats into private, self-referential, "underground" image-making. He produces family albums and home movies, activities that allow him to work collaboratively with friends and family, attempting to recover the body that he lost in the labyrinth of American photography. "Since being a film maker," he remarks, "I have become more of a person. I am confident that I can synchronize my thoughts to the image, and that the image will talk back—well, it's like being among friends. That eliminated the need to be alone and take pictures."[25] Being with the images of The Americans was like being haunted by strangers, corpses that had an uncanny half-life, figures of the undead.[26] When Frank does look at his "American photographs," these lonely, terrifying pictures that demanded far too much from their creator, it is to mutilate them, to drive a stake through their hearts as if they were ghostly vampires who are still lusting for the pink juice of human kind. The lesson this story holds for others who enter this labyrinth is still being determined.

24. See Bourdieu, Photography, A Middle-Brow Art, chap. 5, on the loneliness of the photographic art.

25. Quoted in Robert Frank: New York to Nova Scotia, ed. Anne Wilkes Tucker (Boston: Little Brown, 1986), 55.

26. Among the many anecdotes surrounding these pictures, one comes to mind here. The girlfriend of the motorcyclist who catches Frank in the act of photographing him in Newburgh, New York is reported to have seen her boyfriend's image in a copy of The Americans and phoned Frank in Nova Scotia to enlist his help in getting her boyfriend out of jail. Most of the Americans in The Americans remain, however, anonymous strangers.

Living Color
Race, Stereotype, and Animation in Spike Lee's *Bamboozled*

Images always appear in some material medium—paint, film, stone, electronic impulses, or paper. And yet a crucial feature of the lives of images is their ability to circulate from one medium to another, to move from the page to the screen, from the screen to the performances of everyday life, and back to the page. But what causes images to move? Why don't they stay put? What gives them this uncanny ability to spread like a virus through human consciousness and behavior? It seems that images are not just things that appear *in* media, but also in some sense a medium, perhaps a *meta*-medium that transcends any specific material incarnation, even as it always requires some concrete form in which to appear.

The mobility of images is a symptom, of course, of their indispensable role in human life. In everything from ornaments to monuments, toys to territorial surveys, images acquire forms of surplus value and excess vitality.[1] This is the point where the "lives of images" intersect with the "loves of images," where the animation of icons is called forth by desire, attraction, need, longing. Robert Frank's desire for truthful photographic images of a nation produced a repertoire of representations that seemed to have their own unbearable, perhaps inhuman, desires, enigmatic signifiers that

This chapter began its life as the W. E. B. Du Bois Lecture at Humboldt University in Berlin, May 2002. I am grateful to Klaus Milich for his generous invitation, and to the excellent audience that convened for the occasion. I also wish to thank Ellen Esrock, Jackie Goldsby, Teresa de Lauretis, Daniel Monk, Donald Pease, and Jackie Stewart for their helpful comments.

1. See chapter 4 of the present text.

"defy explanation" and, like vampires, suck out the "pink juice" of humanity. If our only access to media is through images or metapictures in which media show themselves concretely, how, then, are we to understand the phenomenon of images themselves as a metamedium?

As always, I find myself compelled to answer this question with the examination of a case, a specific work of art that reflects on the mobility of images across media, including the media of everyday life. The work is Spike Lee's film *Bamboozled*, a metapicture that explores the media of television, cinema, writing, sculpture, dance, and the Internet as well as specific generic usages of media in fashion, advertising, news, stand-up comedy, and the minstrel show. The image-repertoire that circulates across these media is that of racial stereotypes, specifically blackface, or "cooning," the stockpile of racist images of African Americans. This case study, then, is an exploration of the lives and loves of images in a racialized context. It asks how stereotypes come alive and reproduce themselves, and what they have to do with love. The brief answer to this question is, of course, that stereotypes are images that we love to hate and hate to love.

Images come alive, as we have seen, in two basic forms that vacillate between figurative and literal senses of vitality or animation. That is, they come alive because viewers believe they are alive, as in the case of weeping Madonnas and mute idols that demand human sacrifice or moral reformation. Or they come alive because a clever artist/technician has engineered them to *appear* alive, as when the puppeteer/ventriloquist animates his puppet with motion and voice, or the master painter seems to capture the life of the model with the flick of a brush. Thus the notion of images as life-forms always equivocates between questions of belief and knowledge, fantasy and technology, the golem and the clone. This middle space, which Freud called the Uncanny, is perhaps the best name for the location of images as media in their own right.

The stereotype is an especially important case of the living image because it occupies precisely this middle ground between fantasy and technical reality, a more complexly intimate zone in which the image is, as it were, painted or laminated directly onto the body of a living being, and inscribed into the perceptual apparatus of a beholder.[2] It forms a mask, or what

2. The perceptual template of the stereotype is diagnosed tellingly by Vron Ware and Les Black in *Out of Whiteness: Color, Politics, and Culture* (Chicago: University of Chicago Press, 2002).

W. E. B. Du Bois called a "veil," that interposes itself between persons.[3] Unlike the "freestanding" forms of animated imagery—the puppets, talking pictures, evil dolls, and sounding idols—stereotypes are not special or exceptional figures but invisible (or semivisible) and ordinary, insinuating themselves into everyday life and constituting the social screens that make encounters with other people possible—and, in a very real sense, impossible. They circulate across sensory registers from the visible to the audible, and they typically conceal themselves as transparent, hyperlegible, inaudible, and invisible cognitive templates of prejudice. The stereotype is most effective, in other words, when it remains unseen, unconscious, disavowed, a lurking suspicion always waiting to be confirmed by a fresh perception. The confirmation of the stereotype is thus usually accompanied by the disclaimer, "I have nothing against . . . , but . . ." or "I am not a racist, but . . ."

We all know that stereotypes are bad, false images that prevent us from truly seeing other people. We also know that stereotypes are, at a minimum, a *necessary* evil, that we could not make sense of or recognize objects or other people without the capacity to form images that allow us to distinguish one thing from another, one person from another, one class of things from another. This is why the face-to-face encounter, as every theorist from Levinas to Sartre to Lacan has insisted, never really takes place. More precisely, it is never unmediated, but is fraught with the anxiety of misrecognition and riddled with narcissistic and aggressive fantasy. These fantasies and misrecognitions become especially heightened when they are exacerbated by sexual and racial difference, and by histories of oppression and inequality. When Franz Fanon describes the white girl exclaiming to her mother, "Look, a Negro," or when Du Bois describes the refusal of his visiting card by a white girl at his school, the primal scene of racist stereotyping is being staged:

In a wee wooden schoolhouse, something put it into the boys' and girls' heads to buy gorgeous visiting cards—ten cents a package—and exchange. The exchange was merry, till one girl, a tall newcomer, refused my card—refused it peremptorily, with a glance. Then it dawned upon me with a certain suddenness that I was different from the others; or like, mayhap, in heart and life, and longing, but shut out from their world by a vast veil. (7)

The poignancy of this scene is not its scandalousness or exceptional character but its perfect ordinariness. What child of any race or sex has ever

3. W. E. B. Du Bois, *The Souls of Black Folk* (Chicago: McClurg, 1903), 7.

grown up without some version of this experience? To say this is not to deny the specificity of racist attitudes toward African Americans, but to see them as woven subtly into the entire fabric of American life, indeed, of social life as such. It is to see why Fanon's question, "What does the Black man want?" or Freud's question about what women want, or what Homi Bhabha has called "the Other Question" turn out also to be the question, what do pictures want? For it is the pictures—the stereotypes, the caricatures, the peremptory, prejudicial images that mediate between persons and social groups—that seem to take on a life of their own—and a deadly, dangerous life at that—in the rituals of the racist (or sexist) encounter. And it is precisely because the status of these pictures is so slippery and mobile, ranging from phenomenological universals, cognitive templates for categories of otherness, to virulently prejudicial distortions, that their life is so difficult to contain.

Probably the most dramatic and vivid case of this form of stereotyping, and its realization in a whole range of concrete, objective images, is to be found in the stereotypes of African Americans in what is known as blackface minstrelsy. This image-repertoire cuts across the media, from film to television to cabaret and theatre, to cartoon figures and sculpted objects, dolls, toys, and collectibles, to the behavior of ordinary people in everyday life.

The life of the African-American stereotype has been the subject of a large body of scholarship—most recently important books by Michael Rogin and Eric Lott—and has been an object of controversy throughout the history of black culture.[4] Blackface (along with "Yellowface," anti-Semitism, prejudices against "rednecks," Arabs, and other Others) comprises an image-repertoire that seems absolutely despicable and worthy of destruction, and yet it also acts very much like a virus that resists all efforts at eradication or immunization. If any set of images seems to have a "life of its own," it would seem to be the racial stereotype. And yet there is something paradoxical in saying this, insofar as the usual notion of the stereotype is that it is a static, inert form of representation, an unchanging, compulsively repeated

4. Michael Rogin, *Blackface, White Noise: Jewish Immigrants in the Hollywood Melting Pot* (Berkeley and Los Angeles: University of California Press, 1996); Eric Lott, *Love and Theft: Blackface Minstrelsy and the American Working Class* (New York: Oxford University Press, 1993). See also W. T. Lhamon Jr., *Raising Cain: Blackface Performance from Jim Crow to Hip Hop* (Cambridge, MA: Harvard University Press, 1998); Robert Toll, *Blacking Up: The Minstrel Show in Nineteenth Century America* (New York: Oxford University Press, 1974); Carl Wittke, *Tambo and Bones: A History of the American Minstrel Stage* (Durham, NC: Duke University Press, 1930); and David Leventhal, *Blackface* (Santa Fe: Arena Editions, 1999).

schematism. Our stereotype of the stereotype, in other words, is of a *sterile type*, not of a living or lively image, much less of an image that is true to the life of its model. If a stereotype had any life, in fact, it would seem to be antithetical to that of the living individual that it represents. The life of the stereotype resides in the death of its model, and the perceptual deadening of those who carry it in their heads as a schematic "search template" for identifying other people. What the stereotype wants, then, is precisely what it lacks—life, animation, vitality. And it obtains that life by deadening its object of representation *and* the subject who uses it as a medium for the classification of other subjects. Both the racist and the object of racism are reduced to static, inert figures by the stereotype. Or perhaps more precisely, we should define their condition as a kind of "living death," the zombielike condition of the borderline between the animate and the inanimate.

The question of what is to be done with racial stereotypes clearly does not become any easier when they are considered in the framework of a model of pictorial vitality and desire rather than power. If stereotypes were just powerful, deadly, mistaken images, we could simply ban them, and replace them with benign, politically correct, positive images. As I have noted many times, however, this sort of straightforward strategy of critical iconoclasm generally succeeds only in pumping more life and power into the despised image. A more complex strategy of "sounding the idols" of racism is offered by Spike Lee's *Bamboozled*, which insists on looking steadily and directly at the repertoire of African-American stereotypes, and which stages the stereotypes quite literally as freestanding, living images—animated puppets, windup toys, dancing dolls. The film concerns a black television writer named Pierre Delacroix (played by Damon Wayans) who is under pressure to produce an attention-getting show to boost the sagging ratings of his network. Pierre responds by proposing to revive the minstrel show, with black performers wearing blackface. The resulting "New Millennium Minstrel Show" is, surprisingly, a great *success de scandal* and becomes the hottest new show on television. White audiences begin to wear blackface, and the N-word is liberated from its taboo status as everyone embraces the status of negritude. All of the traditional black caricatures are exhumed from their tombs of political correctness: Aunt Jemima, Stepin Fetchit, Jim Crow, Sleep 'n' Eat, and Man Tan step forth in living color and reprise their traditional roles.

Pierre's motivation for reviving these racist stereotypes is anything but clear. Is he trying to save his job or lose it? Is he proposing something so

outrageous that it will get him fired and help him escape his contract, or is he in the grip of creative inspiration, reviving the stereotypes as instruments of satire on the networks and their white audiences? The film opens with Pierre giving us a definition of satire as the use of derision to attack vice and folly, and his express hope is that the revival of blackface will rub the white audience's face in the racism that he believes is still rampant in American society. What he does not take into account is that the caricatures of satire will take on a life of their own and become deadly to those they touch. His idea is quickly appropriated and commodified by the network, he begins to doubt himself, and he loses the respect of his own closest friends and family for having revived the "coon" stereotypes. Finally, Man Ray (Savion Glover), his star tap dancer, who is reviving the figure of Man Tan, becomes so disgusted with the whole thing that he refuses to wear blackface and is thrown off the show, only to be abducted by a gang of anarchist hip-hoppers, the Mau Maus, who stage Man Tan's public execution on a television Internet hookup. Satire descends into tragedy, the living images of comic black caricature turn into murderous death masks, and the virtuosity of the tap dance makes its final reprise in a dance of death. The figures of "Sambo art," the dolls, puppets, and animated figures that Pierre has collected as part of his research into black stereotyping, come to life around him. He is then shot by his trusted assistant and former lover, Sloan Hopkins (Jada Pinkett Smith), and forced to watch a montage of classic blackface moments in American cinema, from *Birth of a Nation* to *The Jazz Singer,* interwoven with film/television caricatures such as Amos 'n' Andy, the Jeffersons, Man Tan, Stepin Fetchit, Buckwheat, Uncle Remus, Uncle Tom, and Aunt Jemima. As he lays dying with his "Jolly Nigger" bank in his arms, Pierre intones a voice-over monologue drawing contradictory moral conclusions: on the one hand, James Baldwin's solemn warning that people are punished for their mistakes by the lives they lead; on the other, the advice of Pierre's father (who is a standup comedian in black night clubs) to "always keep them laughing."

The film concludes with the painted face of Man Tan, garish and perspiring, accompanied by mocking laughter (fig. 76). As the credits roll, a procession of animated dolls and puppets appear—a tap-dancing dandy, a female "Ubangi" figure whose outsize lips clap together, a figure who is kicked over backwards as he attempts to milk a mule, and other animated caricatures. The only relief from the bitterness of the satire is the accompanying music, the haunting strains of "Shadowlands," a meditation on the

FIGURE 76 The final shot of Spike Lee's *Bamboozled* (2000) is of the ghastly visage of Man Tan.

sadness of moral compromise as written and sung by Bruce Hornsby, a white musician.

It is hardly surprising that *Bamboozled* was a commercial failure and had a rather mixed critical reception.[5] Like Lee's *Do the Right Thing*, it was denounced for seeking its resolution in violence, and for its improbable and politically incorrect revival of coon stereotypes. Unlike *Do the Right Thing*, the film quickly disappeared from commercial theaters, only to reappear to overwhelming interest in academic and artistic venues, where its difficult issues had some chance of receiving adequate discussion. As the film was dying at the box office in November of 2000, it was already being discussed by overflow crowds at Harvard University and NYU. It is, in my view, destined to become a classic of American cinema, and an indispensable case for thinking through the nature of stereotypes and the critical and artistic strategies for dealing with them.

5. Armond White's "Post-Art Minstrelsy," *Cineaste* 26, no. 2 (2001), is perhaps the most negative, denouncing the film as morally and politically confused, rhetorically excessive, and obsessed with "the now-passed issue of blackface" (13). White also accuses Spike Lee of distracting attention from more-worthy black filmmakers who lack Lee's "industry backing" (12–14). See as well the more positive reviews by Saul Landau, Michael Rogin, Greg Tate, and Zeinabu Irene Davis in the same issue in "Race, Media, and Money: A Critical Symposium on Spike Lee's *Bamboozled*," 10–17.

Bamboozled is a metapicture—a picture about pictures, a picture that conducts a self-conscious inquiry into the life of images, especially racial images, and the way they circulate in media and everyday life. Here is Lee's own comment on this:

I want people to think about the power of images, not just in terms of race, but how imagery is used and what sort of social impact it has—how we talk, how we think, how we view one another. In particular, I want them to see how film and television have historically from the birth of both mediums, produced and perpetuated distorted images. Film and television started out that way, and here we are, at the dawn of a new century and a lot of that madness is still with us today.[6]

There's a crucial equivocation in Lee's remarks on images. He talks sometimes as if he had achieved a standpoint outside the "madness" of images, the "distorted" images of film and television. And yet if there is one thing *Bamboozled* makes clear, it is just how difficult it is to find this critical standpoint, to achieve a "just estimation" of images that transcends distortion and madness. *Bamboozled* has been criticized harshly, in fact, for its sense of moral confusion, its tendency to proliferate agitprop and demagogic scenes, demeaning images of all sorts of social groups—blacks and whites, men and women, Jews and hip-hoppers. No one is spared the lash of caricature and stereotype in this picture. The closest thing to a normative figure in *Bamboozled* is Pierre's assistant, Sloan, a "sensible" young woman who nevertheless is complicit (despite her better judgment) in the minstrel show revival, and who is perceived (perhaps correctly, it turns out) as fulfilling the stereotype of the ambitious young woman who uses sex to advance her career.[7] The revolutionary Mau Maus, who offer an "anarchist" alternative to the corruption of big media and capital, are treated just as scornfully as the network moguls.

Above all, the figure of Pierre Delacroix, the black television writer who comes up with the notion of reviving minstrelsy, is treated mercilessly as an Oreo, a sellout, a figure of ambivalence and self-doubt. And Pierre, we must note, is the closest the film comes to providing us with a portrait of

6. Spike Lee, interview in *Cineaste* 26, no. 2 (2001): 9.

7. Sloan vehemently denies that she has slept with Pierre or anyone else to advance her career, but later admits that she did sleep with him, and knows now that it was "a mistake," leaving it ambiguous as to whether it was an emotional mistake (sleeping with the wrong man) or a moral failing (sleeping with a man for the wrong reason).

FIGURE 77 *Bamboozled* still: Pierre holding his "Jolly Nigger" bank.

the auteur, Spike Lee himself (fig. 77). The satirical alibi that Pierre pro-
vides for the revival of the minstrel show is also Spike Lee's alibi. In his di-
rector's voice-over commentary Lee complains that some critics seem to
have missed the satirical point of the film, and he presents his own motive
as simply exposing a repertoire of hateful, disgusting images that were used
to justify discrimination against black people, and that are still alive in the
world today in less recognizable forms. But this is an alibi that the movie
thoroughly deconstructs, insofar as it shows the satirist satirized and de-
stroyed by the very weapons of stereotype and caricature that he has un-
leashed. The relentlessly logical magic of the images in *Bamboozled* makes
it impossible to simply instrumentalize them and safely deploy them as
weapons against other people. They wind up destroying the artist who
brings them back to life, as Pierre indicates when he describes himself as a
Dr. Frankenstein. Satire turns into tragedy, and the joyful virtuosity of the
tap-dancing Man Tan turns into a dance of death. Something more is go-
ing on here than a satire on vice and folly, something more than a critical
exposure and destruction of hateful stereotypes.[8]

8. See Michael Rogin's "Nowhere Left to Stand: The Burnt Cork Roots of Popular Cul-
ture," in the *Cineaste* symposium on *Bamboozled*, "Race, Media, and Money," 14–15. Rogin

This "something more" is the surplus value of the stereotypical images themselves, their tendency to exceed all the strategies of containment that are brought to bear on them—including Spike Lee's own opinions about them. This is most dramatically illustrated by the dissonance between Lee's voice-over commentary and the on-screen images being shown during the closing credits.[9] While Lee's voice expresses outrage at the hatred he sees expressed in these images, his camera lingers with fascination, even with a kind of love, on their artistry. "Can you believe how much they hated us?" he asks. But he might equally well have asked, "Can you believe how much they cared about us, to turn us into comic characters in a racial melodrama, to put on blackface and mimic the caricatures of a people they supposedly despised?"

The meaning of blackface, as cultural historians Michael Rogin and Eric Lott have demonstrated, was never purely negative. It included elements of affection, love, and even envy.[10] Why else would blackface minstrelsy have become the first popular culture industry in America? Why else would black music, dance, clothing, and ways of speaking become so widely imitated and appropriated by the white majority? Why is it that black people, as the white character Dunwitty (Michael Rapaport) reminds us, set the

notes the way the film undercuts any redemptive normativity—including the position of the auteur himself, "who deliberately deprives himself of any uncompromised ground" (15).

9. This voice-over, it must be noted, is *not* part of the film text proper, but a feature available only to those who view the film in DVD format. This raises a whole other set of questions, of course, about the "proper" boundaries of the film text within a new technical horizon of exhibition.

10. This is not to suggest any consensus on the moral or political valences of blackface, which remain deeply contested. As Rogin puts it, "admiration and ridicule, appropriation and homage . . . deception and self-deception, stereotyped and newly invented, passing up and passing down, class, sex, and race—all these elements in contradictory combination can play their role in masquerade" (*Blackface, White Noise*, 35). Lott's *Love and Theft*, as its title suggests, uncovers the lineaments of interracial desire in blackface, identifying it as an American carnivalesque tradition linked with rituals of transgression and the subversion of racial and class divisions. Lhamon, in *Raising Cain*, argues similarly that working-class youth revolt was a crucial part of blacking up. Rogin critiques these positive recuperations of blackface by pointing out that "they dwell insufficiently both on the exclusion of actual African Americans from their own representations and on the grotesque, demeaning, animalistic blackface mask The color line was permeable in only one direction" (*Blackface, White Noise*, 37). On the use of blackface to reinforce rather than subvert class division, see David Roediger, *The Wages of Whiteness: The Making of the American Working Class* (London: Verso, 1991).

trends for what is cool, hip, and avant-garde in American culture? Why is it that the racist figures dancing for us over the closing credits have become highly prized "collectibles," fetish objects of curatorial longing for black as well as white collectors? Why does one member of the terrorist Mau Maus lapse into laughter and confess that he finds the New Millennium Minstrel Show "funny," even as he denounces it? *Bamboozled* shows us that an adequate theory of the stereotype will never reduce it to an unmixed expression of hatred, but will always reveal it as an ambivalent complex of love and hate, mimicry and aversion.

The social performance of this ambivalence is vividly illustrated in the relationship between Pierre and Dunwitty, who mirror each others' stereotypical roles as the Oreo and the Wannabe, the black man who wants to be white, and the white man who wants to be black. Each is portrayed as awkward, somewhat mechanical figures, as if they were living beings trapped inside bodies that don't quite respond to their commands. Dunwitty mimics black speech, but with a constant misplacement of the word *yo* and an exaggerated use of obscenity (he knows that the New Millennium Minstrel Show is a great idea because it makes his dick hard). We never forget that he is Michael Rapaport, a Jewish comedian in behavioral blackface. Pierre is a caricature of the Harvard-educated, white-identified sellout whose blackness is only skin deep, and whose language, both verbal and gestural, is filled with exaggerated mannerisms of rhetorical eloquence. The opening and closing scenes, which place Pierre in a lavish apartment inside a clock tower near the Brooklyn Bridge, underscore his entrapment inside a mechanical system, like the windup figures and automatons he gathers around him. The mortgage on this apartment is among the explicit motivations for his betraying his convictions in the minstrel show revival. Is Pierre finally the satirist or the sellout? The final scene tips the balance. Without quite realizing it, Pierre is mimicking the "Jolly Nigger" bank that he cradles in his arms while dying, giving The Man what he wants so that coins will be thrown into his mouth.[11]

The stereotype's dialectics of love and hate, desire and derision are further complicated when we move to the level of judgments, whether cognitive or moral. Are stereotypes true or false? Are they adequate instruments in assessing the moral characters of other people? Common sense tells us

11. See Rogin's discussion of the historical original of this figure in actual minstrel performances, in which the performer would catch coins in his mouth.

that stereotypes are false, corrupt forms of judgment. *Bamboozled*'s answer is that they are both true and false, and it deploys its array of stereotypes not merely as singular figures but as a whole society constituted by inter-locking critical judgments, some of which the audience is bound to share. Consider Pierre's outrage at Dunwitty's insistence on using the N-word; Sloan's hesitation over the wisdom of the minstrel revival; Dunwitty's scorn for Pierre's ignorance about his own culture; Dela's mother, who expresses her disappointment that her son has produced a coon show; Womack's (Tommy Davidson) judgment that his partner Man Ray has become an arrogant diva as a result of his success; Man Ray's awakening to the fact that his partner, Womack, has been exploiting their partnership by taking three-fourths of their pay ("I's the brains. You is the feet"); the mutual ac-cusations of "house nigger" and "field nigger" between Sloan and her drug-addicted brother; Pierre's contempt for the Jewish "niggerologist" from Yale's African American studies program who is brought in to put a politi-cally correct face on the patent offensiveness of the minstrel show; the Mau Maus' judgment that Man Ray deserves public execution for playing the coon role of Man Tan, while they themselves act out the most stereotypical and mindless clichés of hip-hop culture, complete with fashions supplied by "Tommy Hilnigger." The corrosive nature of the satire reaches beyond the film at this point into Spike Lee's own forays into fashion and commer-cialism. In the world of the stereotype, everyone is both judge and judged, victim and executioner. Putting on blackface (a process documented by the film in careful detail) is a dangerous game that burns the flesh, and draws a divisive color line not only around facial features but between persons, and through the split psyches of the characters themselves. In the script of *Bamboozled,* the "white" member of the Mau Maus, a Wannabe named One-Sixteenth Black, tries in vain to reassert his whiteness to save his skin when the police SWAT team closes in on the gang. But in the final cut of the film, his role is reversed: he loudly asserts his blackness, demanding that he be killed when the police refuse to shoot him because he has white skin.

We would, of course, like to contain and resolve these contradictions, either by denouncing Spike Lee as a confused polemicist and agitator, or by quarantining the film as an exercise in grotesque exaggeration. The vocab-ulary of stereotype and caricature can itself be mobilized to defend our-selves against the film with the insistence that the figures in the story are not "realistic characters" but merely mechanical, pasteboard imitations—the "stereotype of stereotype" and "caricature of caricature" that prevent

us from really understanding either term. But the true genius of *Bamboo-zled* is its heading off of this kind of disavowal by presenting the full range of images that exemplify these terms. The film insists throughout on a continuum between the mechanical figures and the flesh-and-blood individuals; between the stereotypes (the generic, typical figure like the Oreo, the Coon, or the Wannabe) and the particularized caricatures (the specific modifications of the stereotypes performed by the actors); between the caricatures (as grotesque or comic exaggerations) and the characters (the recognizably human figures like Dela, Sloan, and Dunwitty, who make the moral choices that lead toward tragedy). This continuum is reinforced by the film's generic transition from satire to tragedy, and its breaching of the "fourth wall" by addressing the audience directly and nesting its media frames inside one another. *Bamboozled* is thus a film about television (in the mode of *Network*); it stages a television show that reframes the blackface minstrel show; it stages blackface minstrelsy as a popular form that radiates out into the entire history of American cinema, and into the realm of popular culture, collectible curios, and everyday life.

A final defense against the film would, I suppose, be on the grounds of aesthetics and the pleasure principle, that it is such a relentlessly negative and grotesque spectacle no one could possibly enjoy it, just as no one could possibly laugh or take any pleasure in a prime-time TV revival of blackface minstrelsy. Again, Spike Lee has found a way to walk the knife edge of the color line by courting scandal and celebrating virtuosity. The scandal, of course, is the whole premise of the film, the utter unacceptability of its narrative, and the ambivalence it portrays in the first trial runs of the minstrel show, when audience members are shown as stunned, offended, amused, uncertain, and (finally) looking at each other to decide whether it is okay to laugh at the outrageous novelty and its uncanny familiarity. The virtuosity resides in the performances of the actors, in their ability to move us from stereotype to caricature to character and back again; in the audiovisual virtuosity of Spike Lee's film team, from the intimate rendering of "blacking up," to the montages of Hollywood's long-running love affair with blackface, to the marvelous original musical performances that weave a subliminal counterpoint throughout the film.

The most conspicuous and central example of this virtuosity is, of course, the brilliant casting choice of Savion Glover, the greatest tap dancer of his generation, as Man Ray/Man Tan. Glover's role and performance crystallize all the intractable paradoxes that enliven the figures—human or

mechanical—in the film. The tap dancer is an undecidedly ambiguous figure, moving from virtuosic grace and athleticism to awkwardness and loss of control in the blink of an eye. Tripping, slipping, and sliding, herky-jerky, falling motions and puppetlike gestures must be combined with split-second timing and pinpoint percussive accuracy. In Man Ray's first street performance, Womack cries out "Don't hurt 'em," to Man Ray, as if he is worried that the dancer will hurt his own feet with his performance, and he interrupts the dance to shine Man Ray's shoes while the dancer sustains the percussive rhythm without any break. Like break dancing (pioneered by the original Man Tan),[12] like scat singing (which, according to legend, was invented by Louis Armstrong as a virtuosic improvisation when the chart containing the lyrics dropped to the floor),[13] tap dancing is a high-risk composite art form that threads its way from "just walking" or tapping the foot to the wildest flights of virtuosity. And all this virtuosity walks the tightrope between the mechanical puppets who tap dance through the concluding credits, and the dance of death rehearsed in animated cartoons and performed in flesh and blood at Man Ray's execution.

So *Bamboozled* deconstructs the conventional aesthetics of the grotesque or ugly stereotype right along with its conventional moral and epistemological status as a figure of unmixed hatred and false judgment. Perhaps the refrain of the New Millennium Minstrel Show—"Niggers is a beautiful thing"—is not completely ironic, and perhaps Dunwitty's remark—"I don't care what that prick Spike Lee says. 'Nigger' is just a word"—is not completely off the mark, as long as we understand what it is to be "just a word" or "merely an image." *Nigger* is the word that Pierre's father, Junebug, repeats to himself one hundred times every morning in order to keep his teeth white. As a black comedian performing in black nightclubs, he has a right to the word, we may suppose, and is using it in the right places. *Bamboozled* insists on questioning anyone's right to the word by pronouncing it in all the wrong places and putting it in the mouths of the wrong people. It questions anyone's right to blackface by applying it to the wrong faces at the wrong time. The film's untimeliness is perhaps its most salient characteristic; it is either far too late or too early for its audience. W. E. B. Du Bois

12. A brief clip of the original Man Tan, Bert Williams, vibrating his body across the floor, appears in the blackface film history montage that Sloan forces Pierre to watch.

13. Brent Hayes Edwards, "Louis Armstrong and the Syntax of Scat," *Critical Inquiry* 28, no. 3 (Spring 2002): 618–49: "Scat begins with a fall, or so we're told" (618).

opened our era by declaring that "the problem of the twentieth century is the problem of the color line." *Bamboozled* makes a similar declaration at the dawn of the twenty-first century, when blackface has been declared dead and buried and racial discrimination (we are told) has been overcome. Rogin notes that "blacking up" has been a repeated rite of passage for assimilation into the "melting pot" of American culture.[14] First the Irish blackened their faces in minstrel shows, and then the Jews in Hollywood movies. An optimist would say that it is now the turn of black people to put on blackface, to mark their transition into mainstream America. Spike Lee would probably say it's just the same old racist shit.

What *Bamboozled* has to say is far less determinate, and that is its great virtue as a film about the very process by which race is pictured. It makes visible and intelligible the full meaning of the phrase "color line," which is, taken literally, something of an oxymoron. Color is, in traditional pictorial aesthetics and epistemology, the "secondary" characteristic—evanescent, superficial, and subjective—in relation to the "primary quality" of line, which connotes the real, tangible features of an object, and which is the central feature of the stereotype and caricature as linear figures. Color cannot be delineated or touched, we suppose; it only appears to the eye—and not to all eyes, or to all eyes in the same way. It is, at best, a kind of "vital sign" that expresses the desire for life, as when we say "Look, the color is returning to her cheeks," or paint the face of a corpse to make it look lifelike, or paint the face of the living to transform identity. *Bamboozled* shows us how color becomes line, becomes a tangible substance and a boundary, why every line is colored, and why "living color" is something all of us do, one way or another.

14. But "assimilation," as Rogin (*Blackface, White Noise*) also observes, continues to involve the adoption of normative whiteness and the exclusion of some form of racial otherness.

15

The Work of Art in the
Age of Biocybernetic Reproduction

Until you were born, robots didn't dream, they didn't have desires.
Said to the robot boy David by his designer in AI *(Steven Spielberg, 2000)*

The life of images has taken a decisive turn in our time: the oldest myth about the creation of living images, the fabrication of an intelligent organism by artificial, technical means, has now become a theoretical and practical possibility, thanks to new constellations of media at many different levels. The convergence of genetic and computational technologies with new forms of speculative capital has turned cyberspace and biospace (the inner structure of organisms) into frontiers for technical innovation, appropriation, and exploitation—new forms of objecthood and territoriality for a new form of empire. Steven Spielberg registers this change by telling a story about the invention of an image that is, quite literally, a "desiring machine." David, the contemporary answer to Pinocchio, is a robot boy with dreams and desires, with an (apparently) fully elaborated human subjectivity. He is programmed to love and to demand love, a demand that becomes so obsessive (he is in competition with his real human "brother" for the love of his mother) that he is rejected and orphaned. To the question, what do pictures want? the answer in this instance is clear: they want to be loved, and to be "real."

The genius of AI *is not in its narrative, which is full of clunky, implausible*

This chapter was written at the request of John Harrington, the dean of humanities at Cooper Union, on the occasion of the inauguration of its new president in November of 2000. It was later published in the journal *Modernism/Modernity*, a publication of the Johns Hopkins University Press (10, no. 3 [September 2003]: 481–500).

moments, but in its vision of a new world and its new objects and media. David is a perfectly photogenic, adorable simulacrum of a boy. He is loveable, endearing in every way. The filmic point of view encourages us to identify with him throughout, and to despise his mother for rejecting him. Yet underlying the sickeningly sweet fantasy of mother-son bliss (a utopian resolution of the Oedipus complex?) is the horror of the double, the encounter with one's own mirror image rendered autonomous, a horror that even the robot boy is capable of feeling when he sees scores of his own duplicates on the assembly line, ready to be packaged for the Christmas shopping season. The fantasy of AI, then, is an extreme exaggeration of the uncanny, when the old, familiar phobia or superstition is realized in an unexpected way. This fantasy was, of course, always already predicted from the moment of the creation of Adam from the red clay of the ground, the creation of the first drawing with the red earth of vermilion, the casting of the golden calf from Egyptian gold. In our time, the materials are organic substances, proteins, cells, and DNA molecules, and the shaping, casting procedures are computational. This is the age of bio-cybernetic reproduction, when (as we suppose) images really do come alive and want things. What follows is an attempt to sketch out a thick description of this moment, and to assess some of the artistic practices that have accompanied it.

The current revolutions in biology and computers (signified here by the images of the double helix and the Turing Machine [figs. 78, 79]) and their implications for ethics and politics raise a host of new questions for which the arts, traditional humanistic disciplines, and Enlightenment modes of rationality may seem ill prepared. What good is it even to talk about the human if a humanist like Katherine Hayles is right in arguing that we live in a posthuman age?[1] What is the point of asking the great philosophical questions about the meaning of life when we seem to be on the verge of reducing this most ancient question of metaphysics to what philosopher Giorgio Agamben has called "bare life," a matter of technical means, a calculable chemical process?[2] And what about the ancient mystery of death in a time of neomorts, indefinitely extended comas, and organ transplants? Is death now merely a problem to be solved by engineering and adjudicated by

1. Katherine Hayles, *How We Became Posthuman: Virtual Bodies in Cybernetics, Literature, and Informatics* (Chicago: University of Chicago Press, 1999).

2. Giorgio Agamben, *Homo Sacer: Sovereign Power and Bare Life* (Stanford, CA: Stanford University Press, 1998).

FIGURE 78 Double helix. Digital Media Laboratory, University of Chicago.

FIGURE 79 Turing Machine. Digital Media Laboratory, University of Chicago.

lawyers? What is the structure of scientific and technical knowledge itself? Is it a set of logically validated statements and propositions, a self-correcting discursive system? Or is it riddled with images, metaphors, and fantasies that take on a life of their own, and turn the dream of absolute rational mastery into a nightmare of confusion and uncontrollable side effects? To what extent are the widely heralded technical innovations in biology and computation themselves mythic projections or symptoms, rather than determining causes? And, above all, who is in a position to reflect on these questions, or rather, what disciplines have the tools to sort out these issues? Do we call on the artists or the philosophers, the anthropologists or the art historians, or do we turn to the proponents of hybrid formations like "cultural studies"? Do we rely on the genetic engineers and computer hackers to reflect on the ethical and political meaning of their work? Or do we turn to the new field called bioethics, a profession that requires fewer credentials than we expect from a hairdresser, and which is in danger of becoming part

of the publicity apparatus of the corporations whose behavior they are supposed to monitor—or, in the case, of George W. Bush's Presidential Council on Bioethics, a front for the reassertion of the most traditional Christian pieties and phobias about the reproductive process?[3]

I wish that I could promise you clear and unequivocal answers to these questions, a set of dialectical theses on the order of Walter Benjamin's 1935 manifesto, "The Work of Art in the Age of Mechanical Reproduction." All I can offer, unfortunately, is a target for inquiry, the concept of "biocybernetic reproduction." The questions, then, are as follows: What is biocybernetic reproduction? What is being done with it by way of critical and artistic practice, and what could be done?

First, a definition. Biocybernetic reproduction is, in its narrowest sense, the combination of computer technology and biological science that makes cloning and genetic engineering possible. In a more extended sense it refers to the new technical media and structures of political economy that are transforming the conditions of all living organisms on this planet. Biocybernetics ranges, then, from the most grandiose plans to engineer a brave new world of perfect cyborgs to the familiar scene of the American health club, where obese, middle-aged consumers are sweating and straining while wired up to any number of digital monitors that keep track of their vital signs and even more vital statistics—especially the number of calories consumed. It is not just the scene of the pristine lab populated with white-coated technicians and electronically controlled media, but the world of the messy, chaotic computer station, destructive viruses, and carpal tunnel syndrome.

That is why I adopt the polysyllabic, tongue-twisting term *biocybernetics* rather than the more compact *cybernetics* in order to foreground a fundamental dialectical tension in this concept. The word *cybernetics* comes from the Greek word for the steersman of a boat, and thus suggests a disci-

3. See, for instance, Leon Kass's "Testimony Presented to the National Bioethics Advisory Commission," March 14, 1997, Washington, DC (http://www.all.org/abac/clontx04.htm, May 21, 2003), for a sample of what passes for reasoning about human cloning: "[R]epugnance is often the emotional bearer of deep wisdom, beyond reason's power fully to articulate it. Can anyone really give an argument fully adequate to the horror which is father-daughter incest (even with consent) or having sex with animals or eating human flesh, or even just raping or murdering another human being? Would anyone's failure to give full rational justification for his revulsion at these practices make that revulsion ethically suspect? Not at all. In my view, our repugnance at human cloning belongs in this category."

pline of control and governance. Norbert Wiener, who invented the concept, called cybernetics "the entire field of control and communication theory, whether in the machine or animal" (*OED*, 1948 ed.). *Bios*, on the other hand, refers to the sphere of living organisms which are to be subjected to control, but which may in one way or another resist that control, insisting on "a life of their own." *Biocybernetics*, then, refers not only to the field of control and communication, but to that which eludes control and refuses to communicate. In other words, I want to question the notion that our time is adequately described as the age of information, the digital age, or the age of the computer, and suggest a more complex and conflicted model, one which sees all these models of calculation and control as interlocked in a struggle with new forms of incalculability and uncontrollability, from computer viruses to terrorism.[4] The age of information might better be called the age of mis- or dis-information, and the era of cybernetic control is, if my daily newspapers are telling me the truth, more like an epoch of loss of control. The digital age, in short, far from being technically determined in any straightforward way by computers and the Internet, spawns new forms of fleshly, analogue, nondigital experience; and the age of cybernetics engenders new breeds of biomorphic entities, among which we must number intelligent machines such as "smart bombs" and those even more intelligent machines known as "suicide bombers." The final result and the whole tendency of the smart bomb and the suicide bomber are the same, namely, the creation of a biocybernetic life-form, the reduction of a living being to a tool or machine, and the elevation of a mere tool or machine to the level of an intelligent, adaptable creature.

In invoking the concept of the *bios* as a zone of resistance and incalcul-

4. The notion of digitization as a universal solvent has been a commonplace in media studies, from Marshall McLuhan's vision of an electrified global village to Friedrich Kittler's claim that "any medium can be translated into any other" in the age of computers. See *Gramaphone, Film, Typewriter* (Stanford, CA: Stanford University Press, 1999), 2. This sort of statement underestimates the effects and difficulties of translation. The age of cybernetic "communication" and "translatability" would be better described as an electronic Babel in which every device requires an intermediate device to speak to every other device. I'm happy to see, in this regard, that new media theorists like Lev Manovich are now rejecting the digital as a master term, but I'm not reassured by Manovich's substitution of the "programmable" as its substitute, since that only raises the dialectical problem of the unprogrammable. See *The Language of New Media* (Cambridge, MA: MIT Press, 2001). See also Brian Massumi, "On the Superiority of the Analog," in *Parables for the Virtual* (Durham, NC: Duke University Press, 2002), 143, for a similar argument against the idea of a "digital age."

ability, then, I do not mean to posit some reservoir of "vital forces" that stand against the mechanical and rational operations of cybernetics. My aim, rather, is to observe that within the very heart of the cybernetic the *bios* rears its head in very concrete forms, most conspicuously in the computational virus, but also in subtler forms such as the decay of information found in the phenomenon of "Lossy compression."[5] I also want to stress the two-way operations of the disintegration of oppositions between the mechanical and the organic. It's not just that living things become like machines, but that machines more than ever behave now like living things, and that the line between hardware and software is increasingly entangled with a third zone that might be called "wetware." At the more global level of macro-organisms, it's impossible to ignore the emergence of a biocybernetic paradigm in the work of computer researchers such as Alberto Laszlo-Barabasi, who remarks that "internet researchers are like doctors trying to figure out what their patient looks like." "Redundancy in the network" has reached a complexity "that resembles what biologists have found in living organisms," while (on the other side) "some biologists hope that such studies [of the Internet] may help them find clues to the deeper mysteries of nature."[6] Internet artists such as Lisa Jevbratt take quite seriously the metaphor of the Internet as a living organism. Jevbratt, in fact, believes that it is a *dying* organism, and her work is devoted to making visible its vital processes and pathological tendencies.[7]

It might be useful here to pause for a brief theoretical interlude, to put this whole matter in a larger theoretical and historical framework, the standpoint of semiotics and iconology (the study of signs and images). In this larger perspective, the relation of the *bios* and the cyber is a rewriting of the traditional dialectics between nature and culture, human beings and their tools, artifacts, machines, and media—in short, the whole "man-made world," as we used to put it. It is also a reenactment of the ancient struggle between the image and the word, the idol and the law. The cyber-

5. For more on this phenomenon, see Manovich, *The Language of New Media*, 54.

6. Laszlo-Barabassi's remarks are quoted in Jeremy Manier's article, "Evolving Internet Boggles the Mind of Its Originators," *Chicago Tribune*, October 6, 2002, p. 1. See Barabassi's *Linked: The New Science of Networks* (New York: Perseus Publishing Co., 2002).

7. Jevbratt is a member of the arts faculty at the University of California–Santa Barbara. Her remarks on the Internet as life-form were part of her presentation at the conference/exhibition "Rethinking the Visual/Mapping Transitions" at the University of Colorado, Boulder, September 13–14, 2002.

steersman is the digital code, the alphanumeric system of calculation and iterability that makes language and mathematics the controlling instruments of human rationality, from cunning calculation to wise estimation. As literary theorist Northrop Frye once noted, the real gift to humans on Mt. Sinai was not the moral law (which was already known in oral tradition) but the semiotic law, which replaced pictographic writing systems with a phonetic alphabet, analog writing with digital.[8] The Cyber is the judge and differentiator, the one who rules by writing the code. *Bios*, on the other hand, tends toward the analogical register, or the "message without a code," as Roland Barthes put it in speaking of photography.[9] It is the domain of perception, sensation, fantasy, memory, similitude, pictures—in short, what Jacques Lacan calls the Imaginary.

Traditionally, these categories stood in stable hierarchies: reason, the logos, the Symbolic was supposed to rule, and the image was relegated to the sphere of emotions, passions, and appetites. That is why admonitions against idolatry and fetishism are so often associated with accusations of materialism and sensuality. But here is the curious twist in our time. The digital is declared to be triumphant at the very same moment that a frenzy of the image and spectacle is announced. Which is it? The word or the image? Raymond Bellour notes that "all French reflection for half a century has been drawn between the pincers of the word and the image," a pattern that he traces in Lacan, Deleuze, Roland Barthes, and Foucault. Bellour compares this weaving of word and image, discourse and figure, fantasy and the law to a "double helix" of signs and sensations that constitutes the evolution of new media and new "image species" in our time.[10] As Bellour's metaphor of the helix suggests, the word-image dialectic seems to be reappearing at the level of life processes themselves. An image of this appearance is provided in a film still from *Jurassic Park* (fig. 80), in which a velociraptor is caught in the projector beam of the park's orientation film, its skin serving as a screen for the display of the DNA codes that were used in cloning the creature from fossil traces of living tissue. This image provides a metapicture of the relation of digital and analogical codes, the script of DNA and the visible organism that it produces.

8. Northrop Frye, *Fearful Symmetry* (Princeton, NJ: Princeton University Press, 1947), 416.

9. Roland Barthes, "The Photographic Message," in *Image/Music/Text,* trans. Stephen Heath (New York: Hill & Wang, 1977), p. 19.

10. Raymond Bellour, "The Double Helix," in *Electronic Culture: Technology and Visual Representation,* ed. Timothy Druckrey (New York: Aperture, 1996), 173–99.

FIGURE 80 Digital raptor. Still from *Jurassic Park* (dir. Steven Spielberg, 1993).

I will spare you a detailed argument that something like biocybernetic reproduction is indeed the technical and scientific dominant of our age, that biology has replaced physics at the frontiers of science, and that digital information has replaced the physical quanta of mass and energy as the dominant form of imagined materiality. Anyone who has read science historian Donna Haraway on cyborgs or watched science fiction movies over the last twenty years cannot fail to be struck by the pervasiveness of this theme.[11] Films like *Blade Runner, Alien, The Matrix, Videodrome, The Fly, The Sixth Day, AI,* and *Jurassic Park* have made clear the host of fantasies and phobias that cluster around biocybernetics: the specter of the "living machine," the reanimation of dead matter and extinct organisms, the destabilizing of species identity and difference, the proliferation of prosthetic organs and perceptual apparatuses, and the infinite malleability of the human mind and body have become commonplaces of popular culture.

The contrast between the mechanical and the biocybernetic model is vividly illustrated by the "new-model" cyborg of Arnold Schwarzenegger's

11. Among Donna Haraway's recent publications on this subject, see *Modest_Witness@ Second Millenium.FemaleMan_Meets_OncoMouse* (New York: Routledge, 1997). See also *The Cyborg Handbook,* ed. Chris Hables Gray (New York: Routledge, 1995).

FIGURE 81
Still from *Terminator 2: Judgment Day* (dir.
James Cameron, 1991): cyborg Arnold
Schwarzenegger's face has peeled off,
revealing the metal beneath his skin.

FIGURE 82
T2 still: mercurial T 2000 cyborg.

FIGURE 83
T2 still: T 2000 as a tiled floor.

Terminator 2: Judgment Day (figs. 81, 82, 83). Schwarzenegger plays the role
of a traditional robot, a mechanical assembly of gears, pulleys, and pistons,
driven by a computer brain and the most advanced servo-motors. He is
faced, however, with a new-model terminator composed of "living metal,"
a shape-shifting chimera that is a universal mimic, capable of taking on any
identity. By the end of this film, we are prepared to be nostalgic for the good
old days of mechanical men who could express regret for their inability to
cry, and to feel horror at the new figure of infinite mutability and mutation,
remorselessly pursuing the extinction of the human species.[12]

12. The mimetic gifts of the robot boy, David, of Spielberg's *AI* are thus much more dis-
turbing than the new-model Terminator, whose skills never enlist audience sympathy, even
in his moment of spectacular "meltdown," when he morphs rapidly through all the personas
he has adopted during the film. Perhaps the most terrifying moment in the film is when the
Terminator impersonates the voice of the son, and then the body of his mother, playing both
sides of the Oedipal drama that structures *AI*.

I will state it as a bald proposition, then, that biocybernetic reproduction has replaced Walter Benjamin's mechanical reproduction as the fundamental technical determinant of our age.[13] If mechanical reproducibility (photography, cinema, and associated industrial processes like the assembly line) dominated the era of modernism, biocybernetic reproduction (high-speed computing, video, digital imaging, virtual reality, the Internet, and the industrialization of genetic engineering) dominates the age that we have called postmodern. This term, which played its role as a placeholder in the 1970s and '80s, now seems to have outlived its usefulness, and is ready to be replaced by more descriptive notions such as biocybernetics, although even as we move toward this more positive description, it will be important not to forget the workings of the concept of the postmodern, as an effort to go beyond narrow notions of technical determination to reconstruct the entire cultural framework of an era.[14]

To have a new label, however, is only to begin the inquiry, not to conclude it. If we pursue the question in the spirit of Walter Benjamin's "The Work of Art in the Age of Mechanical Reproduction," then every term needs to be re-examined. *Art* or *kunst*, as Benjamin already saw, does not merely signify the traditional arts of painting, sculpture, and architecture, but the entire range of new technical media (photography, cinema, radio, television) that were emerging in his time. The "work" itself is highly ambiguous as to the art object (the *kunstwerk*), the medium of art, or the very task (the work as *kunstarbeit*) to which the arts ought to be committed. *Reproduction* and *reproducibility* mean something quite different now when the central issues of technology are no longer "mass production" of commodities or "mass reproduction" of identical images, but the reproductive processes of the biological sciences and the production of infinitely malleable, digitally animated images. What does it mean when the paradigmatic object on the

13. One could debate whether Benjamin intended "mechanical" reproduction in its strictest sense; the key word in the title of his essay could also be translated—or even transliterated—as *technical*, not *mechanical*. This translation has now achieved a kind of independent authority, however, and in any case the claim that we are dealing with new forms of "technical reproduction" (biocybernetic rather than mechanical) would still obtain.

14. It seems clear that postmodernism has now become a historicist, period term for the era beginning with the sixties and ending somewhere around the fall of the Berlin Wall, roughly 1968–1990. My sense is that it had its greatest leverage on historical thinking in the 1980s, when it served as the rallying point for numerous projects in the critique of politics and culture.

FIGURE 84 Still from *eXistenZ* (dir. David Cronenberg, 1999): organismic assembly line.

assembly line is no longer a mechanism but an engineered organism (fig. 84)? And how is the life of this organism altered when the medium in which it thrives is a fusion of digital and analogical codes—the "eyewash," as media theorist Friedrich Kittler puts it, of the apparent sensuous output, and the stream of alphanumeric ciphers that lies beneath it?[15]

I want to focus on three consequences of the new mode of biocybernetic reproduction, each of which has its counterpart in Benjamin's analysis of mechanical reproduction. I'll put them as three categorical claims: first, the copy is no longer an inferior or decayed relic of the original, but is in principle an improvement on the original; second, the relation between the artist and work, the work and its model, is both more distant and more intimate than anything possible in the realm of mechanical reproduction; and third, a new temporality, characterized by an erosion of the event and a deepening the relevant past, produces a peculiar sense of "accelerated stasis" in our sense of history.[16]

First, the issue of original and copy entailed in "reproducibility." Benjamin famously argued that the advent of photographic copies was producing a "decay of the aura"—a loss of the unique presence, authority, and mystique of the original object. Biocybernetic reproduction carries this

15. Kittler, *Gramaphone, Film, Typewriter*, 1.

16. Each of these transformations has, of course, been discussed extensively in the literature on Benjamin and in other contexts. The problem of the copy is perhaps most famously theorized in Baudrillard's concept of the simulacrum, and the problem of temporality has been discussed extensively by Fred Jameson. For a recent treatment of this issue, see Jameson, "The End of Temporality," *Critical Inquiry* 29, no. 4 (Summer 2003): 695–714.

displacement of the original one further step, and in doing so reverses the relation of the copy to the original. Now we have to say that the copy has, if anything, even *more* aura than the original. More precisely, in a world where the very idea of the unique original seems a merely nominal or legal fiction, the copy has every chance of being an improvement or enhancement of whatever counts as the original. The digital reproduction of sounds and visual images, for instance, need not involve any erosion of vividness or lifelikeness, but can actually improve on whatever original material it starts with. Photographs of artworks can be "scrubbed" to remove flaws and dust; in principle, the effects of aging in an oil painting could be digitally erased, and the work restored to its pristine originality in a reproduction. Of course this would still constitute a loss of the aura that Benjamin associated with the accretion of history and tradition around an object; but if aura means recovering the original vitality, literally, the "breath" of life of the original, then the digital copy can come closer to looking and sounding like the original than the original itself. And the miraculous programming framework of Adobe Photoshop even preserves the "history" of transformations between original and copy so that any transformations can be reversed.

This point becomes even more evident when we think about the manipulation of *genetic* copies and originals. Cloning is a process which, in principle, is meant not only to produce an identical twin of the original organic tissue or organism, but to produce an improved and enhanced copy. Our children or our cloned descendants will give "she is the image of her mother" a new meaning, and of course the implied promise is that the child's genetic makeup will have been "scrubbed" of the flaws that made the parent a less than perfect specimen. The film *Gattacca*, whose title is composed of the four letters of the DNA molecular code, provides a vivid imagining of the brave new world promised by this process of ever-improved copying of life-forms. Eduardo Kac's experiments with transgenic artworks promise to produce surprising new organisms by creating a Web site which responds interactively to "hits" from visitors by producing mutations in microorganisms. Kac's experiments in splicing rabbit DNA with jellyfish protein are designed to produce a rabbit that glows in the dark, a copy that has more aureole, if not aura, than its original.

The second consequence of biocybernetics is its transformation in the relation of artist and work, work and model introduced by new tools and apparatuses. In a striking analogy, Benjamin contrasts the era of manual and mechanical reproduction with the figures of the magician and the sur-

geon, the painter and the cameraman: "The surgeon," he says, "represents the polar opposite of the magician. The magician heals a sick person by the laying on of hands; the surgeon cuts into the patient's body. . . . Magician and surgeon compare to painter and cameraman. The painter maintains in his work a natural distance from reality, the cameraman penetrates deeply into its web."[17] In the age of biocybernetic reproduction, two new figures have appeared on the scene. The cameraman is replaced by the designer of virtual spaces and electronic architectures, and the surgeon adopts the new techniques of remote, virtual surgery. The surgeon operates at an unnatural distance from the patient's body, performing his gestures in a remote location—another room, perhaps even another country. He moves his hands inside data gloves like a shaman, making passes over a virtual body and removing a virtual tumor with sleight of hand. He is able to rehearse his movements on a virtual body many times before the actual operation takes place. The digital miniaturization of his movements allows him to cut deeper and finer than any operation conceivable in traditional manual surgery. Similarly, the cyber artist operates simultaneously within a closer and a more distant relationship to the real. In the case of a performance artist like Stelarc, the materiality of the work is the artist's own body, subjected to prosthetic surgeries to graft on additional limbs, while the actualities of performance may involve wiring the artist's body up to remote locations in other countries, so that an interactive performance may be conducted with spectators controlling the movements of the artist's body. The relationship of artist to work to corporeal reality is thus made more intimate than ever, at the same time the artist's subjectivity is dispersed and fragmented across the circuitry of prosthetic limbs and remote-control spectatorship (figs. 85, 86, 87).

But it is above all the sense of temporality that is transformed in the age of biocybernetics. The very notion of an "age" defined by technical determination has a different feel at the threshold of the twenty-first century. Benjamin wrote in the uneasy interim between two world wars that had raised the technologies of mass death and extermination of civilian populations to unprecedented heights, a time of crisis and immediate danger punctuated by irreversible catastrophes and dramatic technical innovations. We live in a time that is best described as a limbo of continually de-

17. Walter Benjamin, "The Work of Art in the Age of Mechanical Reproduction," in *Illuminations,* ed. Hannah Arendt (New York: Schocken Books, 1969), 223–24.

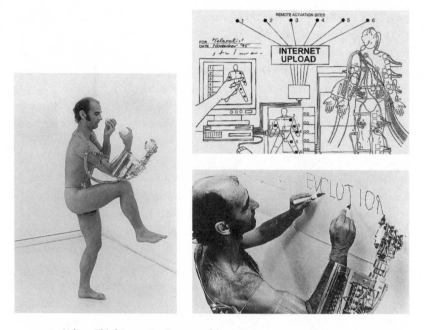

FIGURE 85 Stelarc, *Third Arm*, 1982. Courtesy of the artist.

FIGURE 86 Stelarc, *Third Arm* diagram. Courtesy of the artist.

FIGURE 87 Stelarc, *Evolution* (writing one word simultaneously with three hands), Maki Gallery, Tokyo, 1983. Photograph by Akiro Okada. © Stelarc. Courtesy of Stelarc.

ferred expectations and anxieties. Everything is about to happen, or perhaps it has already happened without our noticing it. The ecological catastrophe of Don DeLillo's *White Noise* is a nonevent. The Gulf War, according to Jean Baudrillard, did not take place (although he conceded that 9/11 very likely was an Event of some sort, but exactly what sort is still to be worked out). The human genome—the very "secret of life" itself—is decoded, and everything remains the same. The heralded new computer you bought last week will be obsolete before you learn to use it properly. The simplest conceivable mechanism for rationalizing political life with a decisive, calculable event (namely, a "free election") turns out to be not so simple, and the leadership of the world's most powerful nation is determined by a debate about whether human hands or machines should be trusted to count the vote. Needless to say, the human hands lost.

Even war, the most dramatic and defining historical event human be-

ings can experience, turns out in our time to take on a radically indeterminate and nebulous shape. As I write, the United States is in a state of war, but a new kind of ambiguous, undeclared war in which the enemy is nowhere and everywhere, without a definite territory or identity; located in faraway places like Afghanistan or Iraq, but living among us in Florida; hiding in caves and secret bases, or dwelling in the open; driving their minivans to the mall, like "sleeper cells" that can awaken without warning to unleash plagues and destruction. The onset of this war was experienced as a wrenching, visceral catastrophe of mass death and destruction, and as a media event suffused by unreality and disbelief. The conduct of the war will range from espionage to diplomacy, and commando raids to full-scale preemptive wars. It will be a war without a front, a back, or a middle, a war of indefinite and probably unattainable objectives. It already has established a permanent state of emergency designed to consolidate the power of a single political party, and indeed, of a small faction within that party. To call this a new form of fascism is not to engage in name-calling, but to call a situation by its true name.

Meanwhile, at the same moment that terrorism is being defined as the greatest evil of our age, the most popular movie of our time is *The Matrix*, a film that glorifies a small band of hacker terrorists who are determined to bring down the entire world economic and political system because they resent that computers control human life. We live in a very peculiar time, in which more media circulate more information to more people than ever before, and yet the phenomenon of "disconnection" has never been more dramatically evident. Polls of the American electorate show widespread discontent with practically every major policy position of the ruling party at the same time that its leader continues to enjoy unprecedented popularity, and his party rolls to one victory after another. Every pundit expresses wonder at the "disconnect" that plagues American public consciousness (if such a phrase still has any meaning), and every analysis of this "consciousness" suggests that it has become so irreconcilably divided that it is as if Americans were living on two different planets.

Meanwhile, Walter Benjamin's prediction that the human race might be capable of viewing its own destruction as an aesthetic experience of the first order has come true in a long-running series of apocalyptic disaster films. Moreover, the scenes broadcast from New York on September 11, 2001, had, as many observers noted, been anticipated numerous times by Hollywood; it was even suggested that the terrorists timed the second plane's collision

with the south tower of the World Trade Center in the full expectation that hundreds of video cameras would capture the event live, and broadcast it over and over again around the world.

Every present moment has to define itself against some notion of the past, and ours is no exception. Benjamin noted that modernity and mechanical reproduction seemed to bring along with them a revival of primitive and archaic formations; that modernist painting, for instance, was riddled with traces of fetishism, and that modern cinema was fulfilling the ancient dream of a universal hieroglyphic language that would repair the damage done at the Tower of Babel. Our time has its share of fascination with primitive pasts, and the new literalizing of the living, desiring image is, as I've tried to show, the occasion for numerous revivals of archaic and premodern fantasies about the creation of life. But now our sense of the revived past is even deeper than the time frames of archaeology and anthropology. Now paleontology, the study of ancient extinct life-forms (most notably the dinosaur), looms as the temporal framework for some of the most innovative achievements in art, media, and technology. The still image of the raptor from *Jurassic Park* (fig. 80), like a petrified fossil extracted from the stream of living time, captures the paradox of biocybernetics perfectly. With its skin lit up with the DNA codes that brought it to life, it is a dialectical image of the most up-to-date and the most ancient forms of life—a world dominant life-form that predates the advent of mammals, much less humans, on the face of the earth. The inseparable but contrary twins of biotechnology, constant innovation and constant obsolescence, the creation and extinction of life, reproductive cloning and the annihilation of a species, are fused here in a single gestalt.

Art historian T. J. Clark has recently written about the modern era, the time of Benjamin and Picasso and Lenin, as a period so remote from our present as to require an "archaeology" to understand it.[18] My own view is that the present is, in a very real sense, even more remote from our understanding, and that we need a "paleontology of the present," a rethinking of our condition in the perspective of deep time, in order to produce a synthesis of the arts and sciences adequate to the challenges we face. Artists such as Robert Smithson, Allan McCollum, and Mark Dion, who have pioneered the introduction of natural history themes into their art practices, have given us some guidance in thinking about the task of art in relation to issues

18. T. J. Clark, *Farewell to an Idea* (New Haven, CT: Yale University Press, 1999), 1.

of deep ecology and the specter of extinction. Smithson saw his *Spiral Jetty* as a cosmic hieroglyphic, a product of modern earthmoving technologies, and a geological trace, like the footprints of the dinosaurs, spiraling into a "deep time" which makes our own historical and even archaeological time sense seem brief and shallow by comparison. McCollum brought painted concrete castings of dinosaur thighbones into the classical atrium of the Carnegie Museum in Pittsburgh to evoke the way in which America's sense of the past has, at least since Thomas Jefferson's time, simultaneously summoned classical Greece and the Roman Empire—and the even deeper past of a natural history that links our nation's heritage to the fate of the giant erect reptiles that once ruled the world, as America does now. Dion's installation *Dinos R U.S.: When Dinosaurs Ruled the Earth* inquires into the obsession of typical American first-graders with extinct creatures that dominated the world 70 million years ago. Why is it that the most familiar, most highly publicized animal group on planet earth at this time is a group of creatures that have never been seen outside museums and movies?

The first conclusion of such a paleontology of the present might be summed up by political theorist Fred Jameson's remark: "it is now easier to imagine the death of the human species than the end of capitalism." In Walter Benjamin's time, the greatest accumulations of power were located in the nation-state, the collective life-forms symbolized by Hobbes's Leviathan. Theodor Adorno called the dinosaur a monument to the monstrous total state, but in our time it has become a figure for a new monster, the multinational corporation, locked in a Darwinian struggle of survival of the fittest in which new strategies of downsizing, flexibility, and rapid adaptation (the virtues of the Velociraptor) have replaced the emphasis on the giantism of the old corporate giants (the power of the T. Rex).

Any critique of this mode of production, then, that does not address the corporation as life-form and *kunstwerk,* and multinational capitalism as its habitat, will miss the outer frame of this subject. Capitalism is now the only game in town, a second nature that operates by and appeals for legitimation to the impersonal, Darwinist logic of a first nature that is red in tooth and claw. It is not merely that biotech corporations are rapidly appropriating the copyrights to genetic codes of newly engineered species of plants, animals, and foodstuffs, or that they will soon be copyrighting human genes and farming human embryos, but the deeper fact that these corporations are themselves biocybernetic "forms of life," collective organisms that must destroy or devour their rivals in order to survive. If cybernetics is

the science of number and computation, it is perhaps the perfect modus operandi for the new-model corporation based in speculative finance capital (as distinct from innovative, entrepreneurial capital), exemplified by the dot-com bubble and the fabulous accounting procedures that made Enron appear to be so profitable. (The Enron "partnerships" that were designed to gobble up debt and improve the parent company's balance sheet were, tellingly, called "Raptors.") Standing over against these legitimate or "normal" corporate entities, of course, are their dark counterparts, the cartels of terrorism and international crime organizations, complete with private armies and legitimate "front" operations. As Hyman Roth said so prophetically to Michael Corleone in *Godfather II:* "Michael, we're bigger than General Motors."

What, then, is the "work" of art in this era? What is its task in the face of biocybernetics and the new corporate and physical bodies it is spawning? The sheer volume and variety of new artistic production that deals with the themes and issues of biocybernetics make any summary very difficult indeed. When I wrote the first draft of this chapter in the fall of 2000, a single show at Exit Art Gallery in New York was able to assemble twenty artists who had something to say or show on this topic. Since that time, scores of exhibitions and shows explicitly on this theme have been organized. Of course there is little agreement on what, exactly, the "theme" in question is. For some artists, such as Janet Zweig, it appears to be an eternally recurring issue, one that is continuous with the first artistic imitations of life, the legendary cave paintings of Lascaux (plate 15). Zweig transfers hand-painted copies of these cave paintings onto the side of a spool of computer tape imprinted with the genetic codes of similar animals, as if to say that the relation of *bios* and cyber has always been with us. Others treat genetic technologies as the content of traditional media like painting and sculpture. Alexis Rockman's *The Farm* (fig. 88) depicts a soybean field that, according to the artist's instructions, "is to be read from left to right. The image begins with the ancestral versions of internationally familiar animals, and moves across to informed speculation about how they might look in the future."[19] Laura Stein's *Smile Tomato* (fig. 89) carries the notion of genetically altered fruits and vegetables to its logical extreme. If we can engineer pro-

19. All quotations from artists in the Exit Art show are taken from the gallery's publication *Paradise Now: Picturing the Genetic Revolution,* curated by Marvin Heiferman and Carol Kismaric, September 9–October 28, 2000.

duce to maintain its fresh appearance (if not its taste) indefinitely, why not design fruits and vegetables with smiley faces?[20] Ron Jones's human-sized rendering of "the genetic structure of cancer" in the mode of Jean Arp's abstract sculptures (fig. 90) reminds us of the very specific role that sculptural modeling has played in genetic research. Biologist Robert Pollack, one of the pioneers of DNA research, notes that "the double helix was often compared to a Constructivist monument," and argues that "the relation of DNA to the protein structures which 'manifest' or 'express' them is like that of a *sentence* to a *sculpture* which enacts the sentence's meaning."[21] Sculptural magnification is also at issue in Bryan Crockett's OncoMouse, "the first patented transgenic lab mouse" (fig. 91), which gives the engineering of designer laboratory animals a grotesquely monumental treatment. Crockett justifies the human scale of his six-foot-tall mouse by linking it to the Christ figure, calling it *Ecce Hommo Rattus,* the principal sacrificial animal in the rituals of cancer research.[22]

Perhaps the most disturbing and provocative sort of biocybernetic art, however, is work that does not attempt to represent the genetic revolution but instead participates in it. Eduardo Kac's installation, *Genesis 1999,* is a "transgenic artwork linked to the internet," an interactive work that translates visits, or "hits," on the installation's Web site into instructions for random genetic mutations of microorganisms. Transgenic art is, in Kac's words, "a new art form based on the use of genetic engineering techniques to transfer synthetic genes to an organism or to transfer natural genetic material from one species into another in order to create unique living beings." Kac's most notorious work is a rabbit named "Alba," produced by

20. Evonne Levy raises an interesting question about Laura Stein's tomato in relation to the artistic tradition of idealization. The notion of an idealizing function for the artist, as a perfecter and improver of images (and perhaps of life-forms), seems to be displaced by work of this sort by an idealization of the biological scientist, who works to improve species through genetic engineering. Does this mean that the artist now is mainly consigned to counterimages of idealization, in which the "improvements" promised by genetics are critiqued, mocked, and satirized by the artist? Or is there still room for a positive role for the artist in the age of biocybernetics?

21. Robert Pollack, *Signs of Life* (New York: Houghton Mifflin, 1994), 71–72.

22. Laura Schleussner, a Berlin artist working with genetic issues, has suggested the idea of a natural history exhibition of the "sacrificial animals" of modern science, one which would elevate them from the anonymity and generic status of the species/specimen and restore to them the individuality of the proper name. For more on the OncoMouse, see Haraway, *Modest_Witness.*

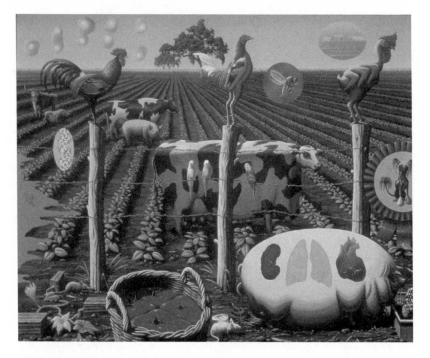

FIGURE 88 Alexis Rockman, *The Farm*, 2000. © 2003 Alexis Rockman / Artists Rights Society (ARS), New York. Courtesy Gorney Bravin + Lee, New York.

splicing jellyfish protein with rabbit DNA. Alba is thus engineered to be a fluorescent rabbit, though reportedly her "aureole" is only visible if one parts the fur and examines the skin under a special light. There is, in addition, a problem with actually exhibiting Alba, since the French government–sponsored lab that engineered the rabbit has declined to release it to the artist.

Kac's work dramatizes the difficulty biocybernetic art has in making its object or model visible. In looking at the *Genesis* installation or hearing about the synthetic rabbit, one is basically taking it on faith that the work exists and is doing what it is reported to be doing. There is, in a very real sense, nothing to see in the work but documents, gadgets, black boxes, and rumors of mutations and monsters. Perhaps this is the point, and Kac's work is best viewed in the context of conceptual art, which often renounces visual payoff. The object of mimesis here is really the invisibility of the genetic revolution, its inaccessibility to representation. The real subject

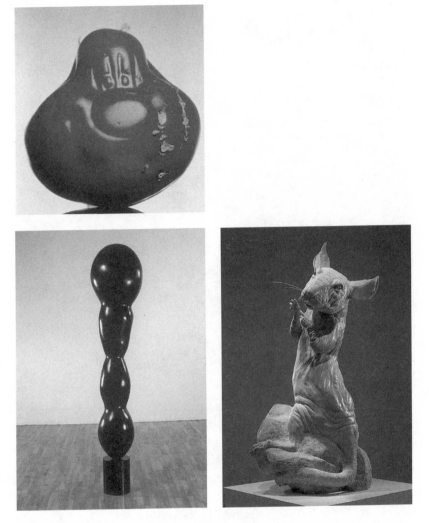

FIGURE 89 Laura Stein, *Smile Tomato*, 1996. Courtesy of the artist.

FIGURE 90 Ronald Jones, *Untitled (DNA fragment from Human Chromosome 13 carrying Mutant Rb Genes, also known as Malignant Oncogenes that trigger rapid Cancer Tumorigenesis)*, 1989. Courtesy of the artist and Metro Pictures.

FIGURE 91 Bryan Crockett, *Ecce Homo Rattus*, 2000. Marble, epoxy, and stainless steel, 108 × 42 × 42". Collection of JGS, Incorporated. Courtesy of Lehmann Maupin Gallery, New York.

FIGURE 92 Larry Miller, *Genomic License No. 5 (Alison Knowles Properties)*, 1992–97. Detail.
Courtesy of the artist.

matter, then, becomes the idea of the work and the critical debate that sur-
rounds it as much as its material realization. In response to the predictable
objection that the work is a kind of irresponsible "playing" with genetic
technologies, Kac's equally predictable response is that purposeless play is
at the heart of the aesthetic gesture as such.[23]

A more pointed, simple, and direct use of conceptual art strategies is
offered by Larry Miller's *Genomic License* project (fig. 92), which plays
upon the patenting of animal and plant breeds by extending the notion of
commodification and property rights to the personal genes of human be-
ings. Miller copyrighted his own DNA in 1989, and since then has contin-
ued the project of distributing genetic copyright forms as, in his words, "a
contribution to 'Genesthetics,'" or artworks that link art, science, theology,
and capitalism. A related project is The Creative Gene Harvest Archive,
part of an ongoing work by artists Karl S. Mihail and Tran T. Kim-Trang

23. For further information on Kac's projects, see his Web site, http://www.ekac.org/.

entitled "Gene Genies Worldwide Corporation." This project, advertising itself as the "the cutting edge of art and genetic engineering," aims to compile an archive of the genes of "creative geniuses" to improve the human species.

The blank irony and deadpan humor of these projects seems to leave any critical perspective to the spectator. One art project that stands out for its explicitly critical approach to biocybernetics is an Internet-based artist's collective known as Rtmark. One of the most notable productions of this collective is *Biotaylorism 2000* (fig. 93), a half-hour automated PowerPoint presentation designed by Natalie Bookchin of Cal Arts. As a Web-based entity, Rtmark presents itself as a new mutual fund designed to highlight the risks and opportunities of biotechnological corporate partnerships which are, according to its voice track, "scavenging the Third World and the interiors of bodies for valuable genes." Rtmark links the contemporary race to commodify the human genome with earlier state-sponsored programs in racial eugenics and the rationalization of industrial processes known as Taylorism, the subjection of every biological process to calculation and control. Bobbing and weaving between deadpan humor, feigned enthusiasm for the glorious profits to be made in biotech futures, and mordant historical reminders of the questionable past of biocybernetics, Rtmark has managed to insert itself into the corporate culture of biotechnology as a kind of resident virus. The collective has, on occasion, even been mistaken for a legitimate mutual fund, and has received invitations to trade shows and to private consulting sessions with biotechnology startups hungry for venture capital. Their proposals to make dazzling profits on world hunger and designer babies sound very attractive in a conversation riddled with optimistic projections about feeding the poor and improving the lives of everyone. Rtmark has also developed a new software application entitled Reamweaver (the name is a spin-off on Dreamweaver, one of the leading hypertext programs for the creation of Web sites). Reamweaver targets existing Web sites such as the Celera Corporation or Monsanto, analyzes their content, and automatically weaves a parodic counter–Web site in which the images of corporate hype are systematically undermined. And it does all this, Rtmark promises, while you sleep![24]

As should be evident, there is no consensus on artistic strategies in biocybernetics. And there is a real question about how well this art can find a

24. Rtmark can be found on the Web at http://www.rtmark.com/.

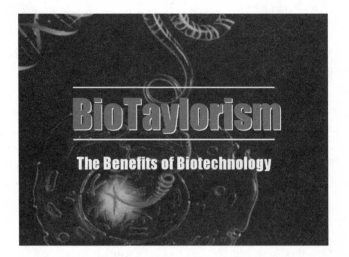

FIGURE 93 Natalie Bookchin, *Biotaylorism 2000*, slide 1, 2000. Courtesy of the artist.

place in the traditional spaces of the gallery or museum, given its invisible, often technical content, and considerable uncertainty about what sort of medium or form it ought to employ. Biocybernetics has probably found its best medium in the cinema, where horror and science fiction provide spectacular images and narratives of bio-dystopias like the world of *The Matrix* or *Gattacca*.

But I want to consider works by two artists who have found ways, in my view, to compete with the effects of cinema within a more or less traditional gallery space. The first is Damien Hirst, whose experiments with "vitrine art," the art of the glass box that preserves the biological specimen from the pickled shark to the embryo to the bisected cow, have drawn so much attention. In a recent work entitled *Love Lost* (plate 16), Hirst presents us with a massive, ten-foot-high vitrine filled with water and live fish swimming around a gynecological examination room. The room contains, in addition to the examination table with its stirrups, a computer station. The whole scene is rendered as if all the objects had been underwater for a considerable period of time, as if we were looking at a scene from a sunken city, a lost civilization like Atlantis. Hirst stages one of the critical scenes of contemporary biocybernetics, the control of women's bodies and reproductive processes, as an archaic "lost world" whose meaning is to be interpreted by the forensic imagination of the spectator. And indeed, when I first saw this

FIGURE 94 Antony Gormley, *Sovereign State*, 1989–90. Courtesy of the artist.

work at the Gagosian Gallery in New York, spectators were swirling around it obsessively, like the fish inside the tank, examining and interpreting every detail, as if they were detectives or archaeologists inspecting the scene of a crime or disaster.[25]

The most concentrated sculptural rendering I have seen of the dystopia of biocybernetics is Antony Gormley's *Sovereign State* (fig. 94). This is a mathematically expanded concrete casting of the artist's own body lying on its side in a fetal position. Large rubber hoses are attached to the body's orifices, as if draining and drinking, output and input were all tangled together in an image of waste products recycled as food. This is a figure of the neomort, neonatal, or comatose human body as if in suspended animation, like a cryogenic incubator keeping someone alive till the next millennium; or (if wired to a virtual reality network) one could imagine it as the exact counterpart of the human inhabitants of *The Matrix*. As the title of the piece suggests, this is a portrayal of absolute sovereignty, the subject at

25. Recall here Walter Benjamin's claim that Atget photographed the empty Paris streets "like scenes of crime" ("The Work of Art," 226). Hirst does something similar, I suspect, with enigmatic installations that elicit a forensic response from the beholder. What Hirst's "pictures" want, then, is precisely a decoding, a tabulating of clues, traces, and indices that leads the spectator to the construction of a scenario or narrative.

one with itself, in harmonious, self-enclosed equilibrium. It is also the reduction of *bios* to *zoe*, the living form to bare life.

I conclude by returning to the image of the "digital raptor" (fig. 80) from Spielberg's *Jurassic Park*. Like Gormley's *Sovereign State*, this image captures the dream of biocybernetics, but carries it to the final illusion. This dream is not just the indefinite maintenance of a life-form in perfect self-regulating equilibrium, but the resurrection of extinct life with cybernetic codes. The dream of control over life, its reduction to calculable processes, is here projected as the ultimate fantasy: not just the conquest of death (as in the biocybernetic myth of *Frankenstein*) but the conquest of *species* death by cloning the DNA of extinct creatures. This fantasy of cybernetic control is, of course, exactly what the film's narrative puts into question. At the moment of this film still, the raptor has just broken into the control room of the dinosaur park, and is looking to devour the controllers. The DNA codes which express mastery over the reproductive processes of extinct animals have unleashed flesh-and-blood creatures who have taken over their own means of reproduction.

The digital dinosaur is a biocybernetic updating of the oldest myth about the creation of life, that life begins with the word of God, and the word is made flesh, a corporeal image of the Creator—an image that, as we know, inevitably rebels against its Creator. Biocybernetics is about the attempt to control bodies with codes, images with language. The analogy between biogenetic engineering of organisms and digital animation of graphic images is perfected in this figure, as if someone had hit the Reveal Codes button to expose the digital basis of both the creature itself and its cinematic representation.

Perhaps this, then, is one task of art in the age of biocybernetic reproduction: to reveal the codes and expose the illusion of the ultimate mastery of life. Another task would be the elaboration of what I have called a "paleontology of the present," a discipline that would begin by acknowledging that contemporaneity is perhaps even more mysterious to us than the recent or distant past, and that would proceed by insisting on the connectedness of all forms of life—a project that might put cybernetics to work for human values. Still another task is the rearticulation of what we mean by the human, by humanism, and the humanities, an inquiry in which all the things we have learned about "identity" and identity politics in the postmodern era would be applied to the ultimate question of *species* identity. Finally, there would be the question of the image, and the Imaginary, itself.

If we indeed are living in a time of the plague of fantasies, perhaps the best cure that artists can offer is to unleash the images, in order to see where they lead us, how they go before us. A certain tactical irresponsibility with images, what I will (in the next chapter) call "critical idolism" or "secular divination," might be just the right sort of homeopathic medicine for what plagues us.

Walter Benjamin concluded his meditation on mechanical reproduction with the specter of mass destruction. The dangerous aesthetic pleasure of our time is not mass destruction but the mass creation of new, ever more vital and virulent images and life-forms—terms that apply figuratively, as we have seen, to everything from computer viruses to terrorist "sleeper cells." The epithet for our times, then, is not the modernist saying, "things fall apart," but an even more ominous slogan: "things come alive." Artists, technicians, and scientists have always been united in the imitation of life, the production of images and mechanisms that have, as we say, "lives of their own." Perhaps this moment of accelerated stasis in history, when we feel caught between the utopian fantasies of biocybernetics and the dystopian realities of biopolitics, between the rhetoric of the posthuman and the real urgency of universal human rights, is a moment given to us for rethinking just what our lives, and our arts, are for.

Showing Seeing
A Critique of Visual Culture

What is "visual culture" or "visual studies"? Is it an emergent discipline, a passing moment of interdisciplinary turbulence, a research topic, a field or subfield of cultural studies, media studies, rhetoric and communication, art history, or aesthetics? Does it have a specific object of research, or is it a grab-bag of problems left over from respectable, well-established disciplines? If it is a field, what are its boundaries and limiting definitions? Should it be institutionalized as an academic structure, made into a department or given programmatic status, with all the appurtenances of syllabi, textbooks, prerequisites, requirements, and degrees? How should it be taught? What would it mean to "profess" visual culture in a way that is more than improvisatory?

I have to confess that, after almost ten years of teaching a course called Visual Culture at the University of Chicago, I still do not have categorical answers to all these questions.[1] What I can offer is my own take on where

This chapter was first written for "Art History, Aesthetics, and Visual Studies," a conference held at the Clark Institute, Williamstown, Massachusetts, in May 2001. I'm grateful to Jonathan Bordo, James Elkins, Ellen Esrock, Joel Snyder, and Nicholas Mirzoeff for their valuable comments and advice. The chapter later appeared in the institute's proceedings of that conference, *Art History, Aesthetics, Visual Studies,* ed. Michael Ann Holly and Keith Moxey, pp. 231–50 (Williamston, MA: Sterling and Francine Clark Art Institute, 2002) and in *The Journal of Visual Culture* 1, no. 2 (Summer 2002).

1. For anyone interested in my previous stabs at them, however, see W. J. T. Mitchell, "What Is Visual Culture?" in *Meaning in the Visual Arts: Essays in Honor of Erwin Panofsky's 100th Birthday,* ed. Irving Lavin (Princeton, NJ: Princeton University Press, 1995), and "Interdisciplinarity and Visual Culture," *Art Bulletin* 77, no. 4 (December 1995): 540–44.

the field of visual studies is going today, and how it might avoid a number of pitfalls along the way. What follows is based mainly on my own formation as a literary scholar who has been involved as a migrant worker in the fields of art history, aesthetics, and media studies. It is also based on my experience as a teacher attempting to awaken students to the wonders of "visuality," practices of seeing the world and especially the seeing of other people. My aim in this teaching has been to overcome the veil of familiarity and self-evidence that surrounds the experience of seeing, and to turn it into a problem for analysis, a mystery to be unraveled. In doing this, I suspect that I am rather typical of those who teach this subject, and that this is the common core of our interest, however different our methods or reading lists might be. The problem is one of staging a paradox that can be formulated in a number of ways: that vision is itself invisible; that we cannot see what seeing is; that the eyeball (*pace* Emerson) is never transparent. I take my task as a teacher to be to make seeing show itself, to put it on display, and make it accessible to analysis. I call this "Showing Seeing," a variation on the American elementary school ritual called show and tell, and I will return to it at the conclusion of this chapter.

The Dangerous Supplement

Let me begin, however, with the gray matters—the questions of disciplines, fields, and programs that are intersected by visual studies. I think it's useful at the outset to distinguish between visual studies and visual culture as, respectively, the field of study and the object or target of study. Visual studies is the study of visual culture. This avoids the ambiguity that plagues subjects like history, in which the field and the things covered by the field bear the same name. In practice, of course, we often confuse the two, and I prefer to let "visual culture" stand for both the field and its content, and to let the context clarify the meaning. I also prefer "visual culture" because it is less neutral than "visual studies," and commits one at the outset to a set of hypotheses that need to be tested—for example, that vision is (as we say) a "cultural construction," that it is learned and cultivated, not simply given by nature; that therefore it might have a history related in some yet-to-be-determined way with the history of arts, technologies, media, and social practices of display and spectatorship; and (finally) that it is deeply involved with human societies, with the ethics and politics, aesthet-

ics and epistemology of seeing and being seen. So far, I hope (possibly in vain) that we are all singing the same tune.[2]

The dissonance begins, as I see it, when we ask what the relation of visual studies is to existing disciplines such as art history and aesthetics. At this point, certain disciplinary anxieties, not to mention territorial grumpiness and defensiveness, begin to emerge. If I were a representative of cinema and media studies, for instance, I would ask why the discipline that addresses the major new art forms of the twentieth century is so often marginalized in favor of fields that date to the eighteenth and nineteenth centuries.[3] If I were here to represent visual studies (which I am), I might see the triangulation of my field in relation to the venerable fields of art history and aesthetics as a classic pincers movement, designed to erase visual studies from the map. The logic of this operation is easy enough to describe. Aesthetics and art history are in a complementary and collaborative alliance. Aesthetics is the theoretical branch of the study of art. It raises fundamental questions about the nature of art, artistic value, and artistic perception within the general field of perceptual experience. Art history is the historical study of artists, artistic practices, styles, movements, and institutions. Together, then, art history and aesthetics provide a completeness; they "cover" any conceivable question one might have about the visual arts. And if one conceives them in their most expansive manifestations, art history as a general iconology or hermeneutics of visual images, aesthetics as the study of sensation and perception, then it seems clear that they already take care of any issues that a "visual studies" might want to raise. The theory of visual experience would be dealt with in aesthetics; the history of images and visual forms would be dealt with in art history.

Visual studies, then, is from a certain familiar disciplinary viewpoint quite unnecessary. We don't need it. It adds on a vague, ill-defined body of

2. If space permitted, I would insert here a rather lengthy footnote on the many kinds of work that have made it possible to even conceive of a field such as "visual studies."

3. For a discussion of the peculiar distancing between visual studies and cinema studies, see Anu Koivunen and Astrid Soderbergh Widding, "Cinema Studies into Visual Theory?" in the online journal *Introdiction* at http://www.utu.fi/hum/etvtiede/preview.html. Other institutional formations that seem notably excluded are visual anthropology (which now has its own journal, with articles collected in *Visualizing Theory*, ed. Lucien Taylor (New York: Routledge, 1994), cognitive science (highly influential in contemporary film studies), and communications theory and rhetoric, which have ambitions to install visual studies as a component of introductory college-level writing programs.

issues that are covered quite adequately within the existing academic struc-
ture of knowledge. And yet here it is, cropping up as a quasi field or pseudo-
discipline, complete with anthologies, courses, debates, conferences, and
professors. The only question is: what is visual studies a symptom of? Why
has this unnecessary thing appeared?

It should be clear by this point that the disciplinary anxiety provoked by
visual studies is a classic instance of what Jacques Derrida called "the dan-
gerous supplement." Visual studies stands in an ambiguous relation to art
history and aesthetics. On the one hand, it functions as an internal com-
plement to these fields, a way of filling in a gap. If art history is about visual
images, and aesthetics about the senses, what could be more natural than a
subdiscipline that would focus on visuality as such, linking aesthetics and
art history around the problems of light, optics, visual apparatuses and ex-
perience, the eye as a perceptual organ, the scopic drive, and so on? But this
complementary function of visual studies threatens to become supplemen-
tary as well, first in that it indicates an incompleteness in the internal co-
herence of aesthetics and art history, as if these disciplines had somehow
failed to pay attention to what was most central in their own domains; and
second, in that it opens both disciplines to "outside" issues that threaten
their boundaries. Visual studies threatens to make art history and aesthet-
ics into subdisciplines within some "expanded field" of inquiry whose
boundaries are anything but clear. What, after all, can "fit" inside the do-
main of visual studies? Not just art history and aesthetics but scientific and
technical imaging, film, television, and digital media, as well as philosoph-
ical inquiries into the epistemology of vision, semiotic studies of images
and visual signs, psychoanalytic investigation of the scopic "drive," phe-
nomenological, physiological, and cognitive studies of the visual process,
sociological studies of spectatorship and display, visual anthropology,
physical optics and animal vision, and so forth and so on. If the object of
"visual studies" is what art critic Hal Foster calls "visuality," it is a capacious
topic indeed, one that may be impossible to delimit in a systematic way.[4]

Can visual studies be an emergent field, a discipline, a coherent domain
of research, even (*mirabile dictu*) an academic *department*? Should art his-
tory fold its tent, and, in a new alliance with aesthetics and media studies,
aim to build a larger edifice around the concept of visual culture? Should
we just merge everything into cultural studies? We know very well, of

4. Hal Foster, *Vision and Visuality* (Seattle: Bay Press, 1988).

course, that institutional efforts of this sort have already been under way for some time at places like Irvine, Rochester, Chicago, Wisconsin, and no doubt others of which I am unaware. I have been a small part of some of these efforts, and have generally been supportive of institution-building enterprises. I am mindful, however, of the larger forces in academic politics which have, in some cases, exploited interdisciplinary efforts like cultural studies in order to downsize and eliminate traditional departments and disciplines, or to produce what art historian Tom Crow has called a "de-skilling" of whole generations of scholars.[5] The erosion of the forensic skills of connoisseurship and authentication among art historians in favor of a generalized "iconological" interpretive expertise is a trade-off that ought to trouble us. I want both kinds of expertise to be available, so that the next generation of art historians will be skilled with *both* the concrete materiality of art objects and practices *and* the intricacies of the dazzling Power-Point presentation that moves effortlessly across the audiovisual media in search of meaning. I want visual studies to attend *both* to the specificity of the things we see, *and* to the fact that most of traditional art history was already mediated by highly imperfect representations such as the lantern slide, and before that by engraving, lithographs, or verbal descriptions.[6]

So if visual studies is a "dangerous supplement" to art history and aesthetics, it seems to me important neither to romanticize nor to underestimate the danger, but also important not to let disciplinary anxieties lure us into a siege mentality, circling our wagons around "straight art history," or narrow notions of tradition.[7] We might take some comfort from the precedent of Derrida's own canonical figure of the dangerous supplement, the phenomenon of *writing*, and its relation to speech and the study of language, literature, and philosophical discourse. Derrida traces the way that writing, traditionally thought of as a merely instrumental tool for recording speech, invades the domain of speech once one understands the general condition of language to be its iterability, its foundation in repetition

5. See Crow's response the questionnaire on visual culture in *October* 77 (Summer 1996): 34–36.

6. For a masterful study of art-historical mediations, see Robert Nelson, "The Slide Lecture: The Work of Art History in the Age of Mechanical Reproduction," *Critical Inquiry* 26, no. 3 (Spring 2000): 414–34.

7. I'm alluding here to a lecture entitled "Straight Art History" given by O. K. Werckmeister at the Art Institute of Chicago several years ago. I have great respect for Werckmeister's work, and regard this lecture as a regrettable lapse from his usual rigor.

and re-citation. The authentic *presence* of the voice, of the phonocentric core of language, *immediately* connected to meaning in the speaker's mind, is lost in the traces of writing, which remain when the speaker is absent—and ultimately even when he is present. The whole ontotheological domain of originary self-presence is undermined and restaged as an effect of writing, of an infinite series of substitutions, deferrals, and differentials.[8] This was heady, intoxicating, and dangerous news in the 1970s when it hit the American academy. Could it be that not only linguistics but all the human sciences, indeed all human knowledge, was about to be swallowed up in a new field called "grammatology"? Could it be that our own anxieties about the boundlessness of visual studies are a replay of an earlier panic brought on by the news that there is "nothing outside the text"?

One obvious connection between the two panic attacks is their common emphasis on *visuality* and *spacing*. Grammatology promoted the visible signs of written language, from pictographs to hieroglyphics to alphabetic scripts to the invention of printing and finally of digital media, from their status as parasitical supplements to an original, phonetic language-as-speech, to their position of primacy, as the general precondition for all notions of language, meaning, and presence. Grammatology challenged the primacy of language as invisible, authentic speech in the same way that iconology challenges the primacy of the unique, original artifact. A general condition of iterability or citationality—the repeatable acoustic image in one case, the visual image in the other—undermines the privilege of both visual art and literary language, placing them inside a larger field that, at first, seemed merely supplementary to them. "Writing," not so accidentally, stands at the nexus of language and vision, epitomized in the figure of the rebus or hieroglyphic, the "painted word" or the visible language of a gesture-speech that precedes vocal expression.[9] Both grammatology and iconology, then, evoke the fear of the visual image, an iconoclastic panic that, in the one case, involves anxieties about rendering the invisible spirit of language in visible forms; in the other, the worry that the immediacy and concreteness of the visible image is in danger of being spirited away by the

8. See Jacques Derrida, ". . . That Dangerous Supplement," in *Of Grammatology*, trans. Gayatri Spivak (Baltimore: Johns Hopkins, 1978), 141–64.

9. For further discussion of the convergence of painting and language in the written sign, see W. J. T. Mitchell, "Blake's Wondrous Art of Writing," in *Picture Theory* (Chicago: University of Chicago Press, 1994).

dematerialized, visual copy—a mere image of an image. It is no accident that intellectual historian Martin Jay's investigation of the history of philosophical optics is mainly a story of suspicion and anxiety about vision, or that my own explorations of "iconology" tended to find a fear of imagery lurking beneath every theory of imagery.[10]

Defensive postures and territorial anxieties may be inevitable in the bureaucratic battlegrounds of academic institutions, but they are notoriously bad for the purposes of clear, dispassionate thinking. My sense is that visual studies is not quite as dangerous as it has been made out to be (as, for instance, a training ground "to produce subjects for the next phase of globalized capitalism"),[11] but that its own defenders have not been especially adroit in questioning the assumptions and impact of their own emergent field either. I want to turn, then, to a set of fallacies or myths about visual studies that are commonly accepted (with different value quotients) by both the opponents and proponents of this field. I will then offer a set of countertheses which, in my view, emerge when the study of visual culture moves beyond these received ideas, and begins to define and analyze its object of investigation in some detail.[12] I have summarized these fallacies and countertheses in the following broadside (followed by a commentary). The broadside may be handy for nailing up on the doors of certain academic departments.

Critique: Myths and Countertheses

TEN MYTHS ABOUT VISUAL CULTURE

1. Visual culture entails the liquidation of art as we have known it.
2. Visual culture accepts without question the view that art is to be defined by its working exclusively through the optical faculties.
3. Visual culture transforms the history of art into a history of images.
4. Visual culture implies that the difference between a literary text and a painting is a nonproblem. Words and images dissolve into undifferentiated "representation."

10. Martin Jay, *Downcast Eyes* (Berkeley and Los Angeles: University of California Press, 1993); W. J. T. Mitchell, *Iconology: Image, Text, Ideology* (Chicago: University of Chicago Press, 1986).

11. A phrase that appears in the *October* 77 questionnaire on visual culture, p. 25.

12. For more on the notion of a specific theoretical concept of visual culture, see my essay, "The Obscure Object of Visual Culture," in *The Journal of Visual Culture* (Summer 2003).

5. Visual culture implies a predilection for the disembodied, dematerialized image.
6. We live in a predominantly visual era. Modernity entails the hegemony of vision and visual media.
7. There is a coherent class of things called "visual media."
8. Visual culture is fundamentally about the social construction of the visual field. What we see, and the manner in which we come to see it, is not simply part of a natural ability.
9. Visual culture entails an anthropological, and therefore unhistorical, approach to vision.
10. Visual culture consists of "scopic regimes" and mystifying images to be overthrown by political critique.

EIGHT COUNTERTHESES ON VISUAL CULTURE

1. Visual culture encourages reflection on the differences between art and non-art, visual and verbal signs, and the ratios between different sensory and semiotic modes.
2. Visual culture entails a meditation on blindness, the invisible, the unseen, the unseeable, and the overlooked; also on deafness and the visible language of gesture; it also compels attention to the tactile, the auditory, the haptic, and the phenomenon of synesthesia.
3. Visual culture is not limited to the study of images or media, but extends to everyday practices of seeing and showing, especially those that we take to be immediate or unmediated. It is less concerned with the meaning of images than with their lives and loves.
4. There are no visual media. All media are mixed media, with varying ratios of senses and sign types.
5. The disembodied image and the embodied artifact are permanent elements in the dialectics of visual culture. Images are to pictures and works of art as species are to specimens in biology.
6. We do not live in a uniquely visual era. The "visual" or "pictorial turn" is a recurrent trope that displaces moral and political panic onto images and so-called visual media. Images are convenient scapegoats, and the offensive eye is ritually plucked out by ruthless critique.
7. Visual culture is the visual construction of the social, not just the social construction of vision. The question of visual *nature* is therefore a central and unavoidable issue, along with the role of animals as images and spectators.

8. The political task of visual culture is to perform critique without the comforts of iconoclasm.

Note: most of the fallacies above are quotations or close paraphrases of statements by well-known critics of visual culture. A prize will be awarded to anyone who can identify all of them.

COMMENTARY

If there is a defining moment in the concept of visual culture, I suppose it would be in that instant that the hoary concept of "social construction" made itself central to the field. We are all familiar with this "Eureka!" moment, when we reveal to our students and colleagues that vision and visual images, things that (to the novice) are apparently automatic, transparent, and natural, are actually symbolic constructions, like a language to be learned, a system of codes that interposes an ideological veil between us and the real world.[13] This overcoming of what has been called the "natural attitude" has been crucial to the elaboration of visual studies as an arena for political and ethical critique, and we should not underestimate its importance.[14] But if it becomes an unexamined dogma, it threatens to become a fallacy just as disabling as the "naturalistic fallacy" it sought to overturn. To what extent is vision *unlike* language, working (as Roland Barthes observed of photography) like a "message without a code"?[15] In what ways does it *transcend* specific or local forms of "social construction" to function like a universal language that is relatively free of textual or interpretive elements?

13. This defining moment had been rehearsed, of course, many times by art historians in their encounters with literary naiveté about pictures. One of the recurrent rituals in teaching interdisciplinary courses that draw students from both literature and art history is the moment when the art history students "set straight" the literary folks about the nontransparency of visual representation, the need to understand the languages of gesture, costume, compositional arrangement, and iconographic motifs. The second, more difficult moment in this ritual is when the art historians have to explain why all these conventional meanings don't add up to a linguistic or semiotic decoding of pictures, why there is some nonverbalizable surplus in the image.

14. See Norman Bryson, "The Natural Attitude," chap. 1 of *Vision and Painting: The Logic of the Gaze* (New Haven, CT: Yale University Press, 1983).

15. See Roland Barthes, *Camera Lucida* (New York: Hill & Wang), 4: "it is the absolute Particular, the sovereign Contingency . . . the *This* . . . in short, what Lacan calls the *Tuche*, the Occasion, the Encounter, the Real."

(We should recall that the eighteenth-century philosopher Bishop Berkeley, who first claimed that vision was like a language, also insisted that it was a universal language, not a local or national one.)[16] To what extent is vision *not* a "learned" activity but a genetically determined capacity, and a programmed set of automatisms that has to be activated at the right time but that is not learned in anything like the way that human languages are learned?

A dialectical concept of visual culture leaves itself open to these questions rather than foreclosing them with the received wisdom of social construction and linguistic models. It expects that the very notion of vision as a *cultural* activity necessarily entails an investigation of its *non*-cultural dimensions, its pervasiveness as a sensory mechanism that operates in animal organisms all the way from the flea to the elephant. This version of visual culture understands itself as the opening of a dialogue with visual *nature*. It does not forget Lacan's reminder that "the eye goes back as far as the species that represent the appearance of life," and that oysters are seeing organisms.[17] It does not content itself with victories over "natural attitudes" and "naturalistic fallacies," but regards the seeming naturalness of vision and visual imagery as a problem to be explored, rather than a benighted prejudice to be overcome.[18] In short, a dialectical concept of visual culture cannot rest content with a definition of its object as the "social construction of the visual field," but must insist on exploring the chiastic reversal of this proposition, *the visual construction of the social field*. It is not just that we see the way we do because we are social animals, but also that our social arrangements take the forms they do because we are seeing animals.

The fallacy of overcoming the "naturalistic fallacy" (we might call it "the naturalistic fallacy fallacy," or "naturalistic fallacy²") is not the only received idea that has hamstrung the embryonic discipline of visual culture.[19]

16. Bishop George Berkeley, *A New Theory of Vision* [1709], in *Berkeley's Philosophical Writings*, ed. David Armstrong (New York: Collier Books, 1965).

17. Jacques Lacan, "The Eye and the Gaze," in *Four Fundamental Concepts of Psychoanalysis* (New York: W. W. Norton, 1977), 91.

18. Bryson's denunciation of "the natural attitude," which he sees as the common error of "Pliny, Villani, Vasari, Berenson, and Francastel," and no doubt the entire history of image theory up to his time (*Vision and Painting*, 7).

19. I owe this phrase to Michael Taussig, who developed the idea in our joint seminar, "Vital Signs: The Life of Representations," at Columbia University and NYU in the fall of 2000.

The field has trapped itself inside of a whole set of related assumptions and commonplaces that, unfortunately, have become the common currency of both those who defend visual studies and those who attack it as a dangerous supplement to art history and aesthetics. Here is a resume of what might be called the "constitutive fallacies" or myths of visual culture, as outlined in the broadside above:

1. Visual culture means an end to the distinction between artistic and nonartistic images, a dissolving of the history of art into a history of images. This might be called the "democratic" or "leveling" fallacy; it is greeted with alarm by unreconstructed high modernists and old-fashioned aesthetes, and heralded as a revolutionary breakthrough by the theorists of visual culture. It involves related worries (or elation) at the leveling of semiotic distinctions between words and images, digital and analog communication, art and non-art, and different kinds of media or different concrete artifactual specimens.

2. It is a reflex of, and consists in a "visual turn" or "hegemony of the visible" in, modern culture, a dominance of visual media and spectacle over the verbal activities of speech, writing, textuality, and reading. It is often linked with the notion that other sensory modalities such as hearing and touch are likely to atrophy in the age of visuality. This might be called the fallacy of the "pictorial turn," a development viewed with horror by iconophobes and opponents of mass culture, who see it as the cause of a decline in literacy, and with delight by iconophiles, who see new and higher forms of consciousness emerging from the plethora of visual images and media.

3. The "hegemony of the visible" is a Western, modern invention, a product of new media technologies, not a fundamental component of human cultures as such. Let's call this the fallacy of technical modernity, a received idea which never fails to stir the ire of those who study non-Western and nonmodern visual cultures, and which is generally taken as self-evident by those who believe that modern technical media (television, cinema, photography, the Internet) simply *are* the central content and determining instances of visual culture.

4. There are such things as "visual media," typically exemplified by film, photography, video, television, and the Internet. This, the fallacy of the "visual media," is repeated by both sides as if it denoted something real. When media theorists object that it might be better to think of at least some of these as "audiovisual" media, or composite, mixed media that combine image and text, the fallback position is an assertion of the dominance of the

visual in the technical, mass media. Thus it is claimed that "we watch TV, we don't listen to it," an argument that is clinched by noting that the remote control has a mute button, but no control to blank out the picture.

5. Vision and visual images are expressions of power relations in which the spectator dominates the visual object and images and their producers exert power over viewers. This commonplace "power fallacy" is shared by opponents and proponents of visual culture who worry about the complicity of visual media with regimes of spectacle and surveillance, the use of advertising, propaganda, and snooping to control mass populations and erode democratic institutions. The split comes over the question of whether we need a discipline called visual culture to provide an oppositional critique of these "scopic regimes," or whether this critique is better handled by sticking to aesthetics and art history, with their deep roots in human values, or media studies, with its emphasis on institutional and technical expertise.

It would take many pages to refute each of these received ideas in detail. Let me just outline the main theses of a counterposition that would treat them as I have treated the naturalistic fallacy fallacy—not as axioms of visual culture but as invitations to question and investigate.

1. The democratic or "leveling" fallacy. There is no doubt that many people think the distinction between high art and mass culture is disappearing in our time, or that distinctions between media, or between verbal and visual images, are being undone. The question is: is it true? Does the blockbuster exhibition mean that art museums are now mass media, indistinguishable from sporting events and circuses? Is it really that simple? I think not. That some scholars want to open up the "domain of images" to consider both artistic and nonartistic images does not automatically abolish the differences between these domains.[20] One could as easily argue that, in fact, the boundaries of art/non-art only become clear when one looks at both sides of this ever-shifting border and traces the transactions and translations between them. Similarly, with semiotic distinctions between words and images, or between media types, the opening out of a general field of study does not abolish difference, but makes it available for investigation, as opposed to treating it as a barrier that must be policed and never crossed. I have been working between literature and visual arts and between

20. I am echoing here the title of James Elkins's recent book, *The Domain of Images* (Ithaca, NY: Cornell University Press, 1999).

artistic and nonartistic images for the last three decades, and I have never found myself confused about which was which, though I have sometimes been confused about what made people so anxious about this work. As a practical matter, distinctions between the arts and media are ready to hand, a vernacular form of theorizing. The difficulty arises (as G. E. Lessing noted long ago in his *Laocoon*) when we try to make these distinctions systematic and metaphysical.[21]

2. The fallacy of a "pictorial turn." Since this is a phrase that I have coined,[22] I'll try to set the record straight on what I meant by it. First, I did not mean to make the claim that the modern era is unique or unprecedented in its obsession with vision and visual representation. My aim was to acknowledge the perception of a "turn to the visual" or to the image as a *commonplace*, a thing that is said casually and unreflectively about our time, and is usually greeted with unreflective assent both by those who like the idea and those who hate it. But the pictorial turn is a *trope*, a figure of speech that has been repeated many times since antiquity. When the Israelites "turn aside" from the invisible God to a visible idol, they are engaged in a pictorial turn. When Plato warns against the domination of thought by images, semblances, and opinions in the allegory of the cave, he is urging a turn away from the pictures that hold humanity captive and toward the pure light of reason. When Lessing warns, in the *Laocoon*, about the tendency to imitate the effects of visual art in the literary arts, he is trying to combat a pictorial turn that he regards as a degradation of aesthetic and cultural proprieties. When Wittgenstein complains that "a picture held us captive" in the *Philosophical Investigations*, he is lamenting the rule of a certain metaphor for mental life that has held philosophy in its grip.

The pictorial or visual turn, then, is not unique to our time. It is a repeated narrative figure that takes on a very specific form today, but which seems to be available in its schematic form in an innumerable variety of circumstances. A critical and historical use of this figure would be as a diagnostic tool to analyze specific moments when a new medium, a technical invention, or a cultural practice erupts in symptoms of panic or euphoria (usually both) about "the visual." The invention of photography, of oil painting, of artificial perspective, of sculptural casting, of the Internet, of writing, of mimesis itself are conspicuous occasions when a new way of

21. See the discussion of Lessing in Mitchell, *Iconology*, chap. 4.
22. Mitchell, *Picture Theory*, chap. 1.

making visual images seemed to mark a historical turning point for better or worse. The mistake is to construct a grand binary model of history centered on just one of these turning points, and to declare a single "great divide" between the "age of literacy" (for instance) and the "age of visuality." These kinds of narratives are beguiling, handy for the purposes of presentist polemics, and useless for the purposes of genuine historical criticism.

3. It should be clear, then, that the supposed "hegemony of the visible" in our time (or in the ever-flexible period of "modernity," or the equally flexible domain of "the West") is a chimera that has outlived its usefulness. If visual culture is to mean anything, it has to be generalized as the study of all the social practices of human visuality, and not confined to modernity or the West. To live in any culture whatsoever is to live in a visual culture, except perhaps for those rare instances of societies of the blind, which for that very reason deserve special attention in any theory of visual culture.[23] As for the question of "hegemony," what could be more archaic and traditional than the prejudice in favor of sight? Vision has played the role of the "sovereign sense" since God looked at his own creation and saw that it was good, or perhaps even earlier when he began the act of creation with the division of the light from the darkness. The notion of vision as "hegemonic" or nonhegemonic is simply too blunt an instrument to produce much in the way of historical or critical differentiation. The important task is to describe the specific relations of vision to the other senses, especially hearing and touch, as they are elaborated within particular cultural practices. Descartes regarded vision as simply an extended and highly sensitive form of touch, which is why (in his *Optics*) he compared eyesight to the sticks a blind man uses to grope his way about in real space. The history of cinema is in part the history of collaboration and conflict between technologies of visual and audio reproduction. The evolution of film is in no way aided by explaining it in terms of received ideas about the hegemony of the visible.

4. Which leads us to the fourth myth, the notion of "visual media." I understand the use of this phrase as a shorthand figure to pick out the difference between, say, photographs and phonograph records, or paintings and novels, but I do object to the confident assertion that "the" visual media are really a distinct class of things, or that there is such a thing as an exclusively,

23. See Jose Saramago's marvelous novel *Blindness* (New York: Harcourt, 1997), which explores the premise of a society suddenly plunged into an epidemic of blindness spread, appropriately enough, by eye contact.

a purely visual medium.[24] Let us try out, as a counteraxiom, the notion that all media are mixed media, and see where that leads us. One place it will not lead us is into misguided characterizations of audiovisual media like cinema and television as if they were exclusively or "predominantly" (echoes of the hegemonic fallacy) visual. The postulate of mixed, hybrid media leads us to the specificity of codes, materials, technologies, perceptual practices, sign-functions, and institutional conditions of production and consumption that go to make up a medium. It allows us to break up the reification of media around a single sensory organ (or a single sign-type or material vehicle) and to pay attention to what is in front of us. Instead of the stunning redundancy of declaring literature to be a "verbal and not a visual medium," for instance, we are allowed to say what is true: that literature, insofar as it is written or printed, has an unavoidable visual component which bears a specific relation to an auditory component, which is why it makes a difference whether a novel is read aloud or silently. We are also allowed to notice that literature, in techniques like ekphrasis and description, as well as in more subtle strategies of formal arrangement, involves "virtual" or "imaginative" experiences of space and vision that are no less real for being indirectly conveyed through language.

5. We come finally to the question of the power of visual images, their efficacy as instruments or agents of domination, seduction, persuasion, and deception. This topic is important because it exposes the motivation for the wildly varying political and ethical estimations of images, their celebration as gateways to new consciousness, their denigration as hegemonic forces, the need for policing and thus reifying the differences between "the visual media" and the others, or between the realm of art and the wider domain of images.

While there is no doubt that visual culture (like material, oral, or literary culture) can be an instrument of domination, I do not think it is productive to single out visuality or images or spectacle or surveillance as the exclusive vehicle of political tyranny. I wish not to be misunderstood here. I recognize that much of the interesting work in visual culture has come out of politically motivated scholarship, especially the study of the construc-

24. See Mitchell, *Picture Theory,* chap. 1, for a fuller discussion of the claim that "all media are mixed media," and especially the discussion of Clement Greenberg's search for optical purity in abstract painting (chap. 7). Indeed, natural, unmediated vision itself is not a purely optical affair but a coordination of optical and tactile information.

tion of racial and sexual difference in the field of the gaze. But the heady days when we were first discovering the "male gaze" or the feminine character of the image are now well behind us, and most scholars of visual culture who are invested in questions of identity are aware of this. Nevertheless, there is an unfortunate tendency to slide back into reductive treatments of visual images as all-powerful forces and to engage in a kind of iconoclastic critique which imagines that the destruction or exposure of false images amounts to a political victory. As I've said on other occasions, "Pictures are a popular political antagonist because one can take a tough stand on them and yet, at the end of the day, everything remains pretty much the same. Scopic regimes can be overturned repeatedly without any visible effect on either visual or political culture."[25]

I propose what I hope is a more nuanced and balanced approach located in the equivocation between the visual image as instrument and agency: the image as a tool for manipulation on the one hand, and as an apparently autonomous source of its own purposes and meanings on the other. This approach would treat visual culture and visual images as "go-betweens" in social transactions, as a repertoire of screen images or templates that structure our encounters with other human beings. Visual culture would find its primal scene, then, in what Emmanuel Levinas calls the face of the Other (beginning, I suppose, with the face of the Mother): the face-to-face encounter, the evidently hard-wired disposition to recognize the eyes of another organism (what Lacan and Sartre call the gaze). Stereotypes, caricatures, classificatory figures, search images, mappings of the visible body, of the social spaces in which it appears would constitute the fundamental elaborations of visual culture on which the domain of the image—and of the Other—is constructed. As go-betweens or "subaltern" entities, these images are the filters through which we recognize and of course misrecognize other people. They are the paradoxical mediations which make possible what we call the "unmediated" or "face-to-face" relations that Raymond Williams postulates as the origin of society as such. And this means that "the social construction of the visual field" has to be continuously replayed as "the visual construction of the social field," an invisible screen or latticework of apparently unmediated figures that makes the effects of mediated images possible.

Lacan, you will recall, diagrams the structure of the scopic field as a cat's cradle of dialectical intersections with a screened image at its center. The

25. W. J. T. Mitchell, "What Do Pictures Want?" *October* 77 (Summer 1996): 74.

two hands that rock this cradle are the subject and the object, the observer and the observed. But between them, rocking in the cradle of the eye and the gaze, is this curious intermediary thing, the image and the screen or medium in which it appears. This phantasmatic "thing" was depicted in ancient optics as the "eidolon," the projected template hurled outward by the probing, seeking eye, or the simulacrum of the seen object, cast off or "propagated" by the object like a snake shedding its skin in an infinite number of repetitions.[26] Both the extramission and intramission theory of vision share the same picture of the visual process, differing only in the direction of the flow of energy and information. This ancient model, while no doubt incorrect as an account of the physical and physiological structure of vision, is still the best picture we have of vision as a psychosocial process. It provides an especially powerful tool for understanding why it is that images, works of art, media, figures, and metaphors have "lives of their own" and cannot be explained simply as rhetorical, communicative instruments or epistemological windows onto reality. The cat's cradle of intersubjective vision helps us to see why it is that objects and images "look back" at us; why the "eidolon" has a tendency to become an idol that talks back to us, gives orders, and demands sacrifices; why the "propagated" image of an object is so efficacious for propaganda, so fecund in reproducing an infinite number of copies of itself. It helps us to see why vision is never a one-way street but a multiple intersection teeming with dialectical images; why the child's doll has a playful half-life on the borders of the animate and inanimate; and why the fossil traces of extinct life are resurrected in the beholder's imagination. It makes it clear why the questions to ask about images are not just what do they mean? or what do they do? but what is the secret of their vitality? and what do they want?

Showing Seeing

I want to conclude by reflecting on the disciplinary location of visual studies. I hope it's clear that I have no interest in rushing out to establish programs or departments. The interest of visual culture seems to me to reside precisely at the transitional points in the educational process—at the introductory level (what we used to call "Art Appreciation"), at the passage-

26. See David Lindbergh, *Theories of Vision from Al-Kindi to Kepler* (Chicago: University of Chicago Press, 1976).

way from undergraduate to graduate education, and at the frontiers of advanced research.[27] Visual studies belongs, then, in the freshman year in college, in the introduction to graduate studies in the humanities, and in the graduate workshop or seminar.

In all of these locations I have found it useful to return to one of the earliest pedagogical rituals in American elementary education, the show-and-tell exercise. In this case, however, the object of the show-and-tell performance is the process of seeing itself, and the exercise could be called "Showing Seeing." I ask the students to frame their presentations by assuming that they are ethnographers who come from, and are reporting back to, a society that has no concept of visual culture. They cannot take for granted that their audience has any familiarity with everyday notions such as color, line, eye contact, cosmetics, clothing, facial expressions, mirrors, glasses, or voyeurism, much less with photography, painting, sculpture, or other so-called "visual media." Visual culture is thus made to seem strange, exotic, and in need of explanation.

The assignment is thoroughly paradoxical, of course. The audience does in fact live in a visible world, and yet has to accept the fiction that it does not, and that everything which seems transparent and self-evident is in need of explanation. I leave it to the students to construct an enabling fiction. Some choose to ask the audience to close their eyes and to take in the presentation solely with their ears and other senses. They work primarily by description and evocation of the visual through language and sound, telling "as," rather than "and" showing. Another strategy is to pretend that the audience has just been provided with prosthetic visual organs, but do not yet know how to see with them. This is the favored strategy, since it allows for a visual presentation of objects and images. The audience has to pretend ignorance, and the presenter has to lead them toward the understanding of things they would ordinarily take for granted.

The range of examples and objects that students bring to class is quite broad and unpredictable. Some things routinely appear: eyeglasses are favorite objects of explanation, and someone almost always brings in a pair of "mirror shades" to illustrate the situation of "seeing without being seen" and the masking of the eyes as a common strategy in a visual culture. Masks and disguises more generally are popular props. Windows, binoculars,

27. It may be worth mentioning here that the first course in visual culture ever offered at the University of Chicago was Art 101, which I gave in the fall of 1991 with the invaluable assistance of Tina Yarborough.

kaleidoscopes, microscopes, and other pieces of optical apparatus are commonly adduced. Mirrors are frequently brought in, generally with no hint of an awareness of Lacan's mirror stage, but often with learned expositions of the optical laws of reflection, or discourses on vanity, narcissism, and self-fashioning. Cameras are often exhibited, not just to explain their workings but to talk about the rituals and superstitions that accompany their use. One student elicited the familiar reflex of "camera shyness" by aggressively taking snapshots of other members of the class. Other presentations require even fewer props, and sometimes focus directly on the body image of the presenter by way of attention to clothing, cosmetics, facial expressions, gestures, and other forms of "body language." I have had students conduct rehearsals of a repertoire of facial expressions, change clothing in front of the class, perform tasteful (and limited) evocations of a strip-tease, put on makeup (one student put on white face paint, describing his own sensations as he entered into the mute world of the mime; another introduced himself as a twin, and asked us to ponder the possibility that he might be his brother impersonating himself; still another, a male student, did a cross-dressing performance with his girlfriend in which they asked the question of what the difference is between male and female transvestism). Other students who have gifts for performance have acted out behaviors like blushing and crying, leading to discussions of shame and self-consciousness at being seen, involuntary visual responses, and the importance of the eye as an expressive as well as receptive organ. Perhaps the simplest "gadget-free" performance I have ever witnessed was by a student who led the class through an introduction to the experience of "eye contact," which culminated in that old first-grade game, the "stare-down" contest (the first to blink is the loser).

Without question, the funniest and weirdest show-and-tell performance that I have ever seen was by a young woman whose "prop" was her nine-month-old baby boy. She presented the baby as an object of visual culture whose specific visual attributes (small body, large head, pudgy face, bright eyes) added up, in her words, to a strange visual effect that human beings call "cuteness." She confessed her inability to explain cuteness, but argued that it must be an important aspect of visual culture, because all the other sensory signals given off by the baby—smell and noise in particular—would lead us to despise and probably kill the object producing them, if it were not for the countervailing effect of "cuteness." The truly wondrous thing about this performance, however, was the behavior of the infant.

While his mother was making her serious presentation, the baby was wiggling in her arms, mugging for the audience, and responding to their laughter—at first with fright, but gradually (as he realized he was safe) with a kind of delighted and aggressive showmanship. He began "showing off" for the class while his mother tried, with frequent interruptions, to continue her "telling" of the visual characteristics of the human infant. The total effect was of a contrapuntal, mixed-media performance which stressed the dissonance or lack of suturing between vision and voice, showing and telling, while demonstrating something quite complex about the very nature of the show-and-tell ritual as such.

What do we learn from these presentations? The reports of my students suggest that the Showing Seeing performances are the thing that remains most memorable about the course, long after the details of perspective theory, optics, and the gaze have faded from memory. The performances have the effect of acting out the method and lessons of the curriculum, which is elaborated around a set of simple but extremely difficult questions: What is vision? What is a visual image? What is a medium? What is the relation of vision to the other senses? To language? Why is visual experience so fraught with anxiety and fantasy? Does vision have a history? How do visual encounters with other people (and with images and objects) inform the construction of social life? The performance of Showing Seeing assembles an archive of practical demonstrations that can be referenced within the sometimes abstract realm of visual theory. It is astonishing how much clearer the Sartrean and Lacanian "paranoid theories of vision" become after you have had a few performances that highlight the aggressivity of vision. Merleau-Ponty's abstruse discussions of the dialectics of seeing, the "chiasmus" of the eye and the gaze, and the entangling of vision with the "flesh of the world" become much more down to earth when the spectator/spectacle has been visibly embodied and performed in the classroom.

A more ambitious aim of Showing Seeing is its potential as a reflection on theory and method in themselves. As should be evident, the approach is informed by a kind of pragmatism, but not (one hopes) of a kind that is closed off to speculation, experiment, and even metaphysics. At the most fundamental level, it is an invitation to rethink what theorizing is, to "picture theory" and "perform theory" as a visible, embodied, communal practice, not as the solitary introspection of a disembodied intelligence.

The simplest lesson of Showing Seeing is a kind of de-disciplinary exercise. We learn to get away from the notion that "visual culture" is "covered"

by the materials or methods of art history, aesthetics, and media studies. Visual culture starts out in an area beneath the notice of these disciplines— the realm of nonartistic, nonaesthetic, and unmediated or "immediate" visual images and experiences. It comprises a larger field of what I would call "vernacular visuality" or "everyday seeing" that is bracketed out by the disciplines addressed to visual arts and media. Like ordinary language philosophy and speech act theory, it looks at the strange things we do while looking, gazing, showing, and showing off—or while hiding, dissembling, and refusing to look. In particular, it helps us to see that even something as broad as "the image" does not exhaust the field of visuality; that visual studies is not the same thing as "image studies," and that the study of the visual image is just one component of the larger field. Political regimes which ban images (like the Taliban) still have a rigorously policed visual culture in which the everyday practices of human display (especially of women's bodies) are subject to regulation. We might even go so far as to say that visual culture emerges in sharpest relief when the second commandment, the ban on the production and display of graven images, is observed most literally, when seeing is prohibited and invisibility is mandated.

One final thing the Showing Seeing exercise demonstrates is that visuality—not just the "social construction of vision" but the visual construction of the social—is a problem in its own right that is approached by but never quite engaged by the traditional disciplines of aesthetics and art history, or even by the new disciplines of media studies. That is, visual studies is not merely an "indiscipline" or dangerous supplement to the traditional vision-oriented disciplines, but an "interdiscipline" that draws on their resources and those of other disciplines to construct a new and distinctive object of research. Visual culture is, then, a specific domain of research, one whose fundamental principles and problems are being articulated freshly in our time. The Showing Seeing exercise is one way to accomplish the first step in the formation of any new field, and that is to rend the veil of familiarity and awaken the sense of wonder, so that many of the things that are taken for granted about the visual arts and media (and perhaps the verbal ones as well) are put into question. If nothing else, it may send us back to the traditional disciplines of the humanities and social sciences with fresh eyes, new questions, and open minds.